The Double Content of Art

STUDIES IN ANALYTIC PHILOSOPHY

Quentin Smith, *Series Editor*

The Double Content of Art
John Dilworth

God and Metaphysics
Richard M. Gale

The Ontology of Time
L. Nathan Oaklander

Reference and Essence, 2nd edition
Nathan U. Salmon

The Double Content of Art

John Dilworth

Prometheus Books

59 John Glenn Drive
Amherst, New York 14228-2197

Published 2005 by Prometheus Books

Inquiries should be addressed to
Prometheus Books
59 John Glenn Drive
Amherst, New York 14228–2197
VOICE: 716–691–0133, ext. 207
FAX: 716–564–2711
WWW.PROMETHEUSBOOKS.COM

09 08 07 06 05 5 4 3 2 1

Library of Congress Cataloging-in-Publication Data

Dilworth, J. (John)
 The double content of art / John Dilworth.
 p. cm. — (Studies in analytic philosophy)
 Includes bibliographical references and index.
 ISBN 1-59102-235-5 (hardcover : alk. paper)
 1. Aesthetics. 2. Representation (Philosophy) 3. Arts—Philosophy. I. Title.
II. Series.

BH301.R47D55 2004
111'.85—dc22
 2004019583

Printed in the United States of America on acid-free paper

For my family,

Rosemary, Karen, Heather,
John T., Matthew, and Andrew

Contents

PART TWO: VISUAL ARTS

PART THREE: ARTWORKS, DESIGNS, AND ORIENTATION

7. *Artworks and Designs* 129

8. *Reorienting Artistic Printmaking* 149

9. *Varieties of Visual Representation* 169

PART FOUR: REPRESENTATION

PART FIVE: FURTHER DEVELOPMENTS

Preface

There is no trace in the body of this book of the actual genesis of its ideas, so here, for the sake of completeness, is a brief account of those origins. Being greatly dissatisfied with more standard views—both about the nature of artworks and the nature of representation—the idea for an alternative *representational* theory of art, which would view artworks as *the contents of concrete representations* of them, first came to me a few years ago in the form of two compelling analogies to visual artworks. The first was that of *mirror images*, which are both nonconcrete or unreal in some sense, and distinct from the physical mirror that in some way displays or provides access to them.

My thought experiment was to imagine that such an image might somehow be *fixed* relative to the mirror, so that the relation of the mirror to the image would be more closely analogous to the relation between a physical painting and the visual artwork that it displays. Thus on this analogy the visual artwork itself would be *nonconcrete* in much the same way as is a mirror image, and also be displayed or *represented* by the physical painting, much as a mirror displays or apparently "represents" its image.

As it happens, in fact mirrors *cannot* represent their mirror images, for reasons given in section 11.3, such as that one can "see through" a mirror to see its actual subject and any changes in it in real time, which "seeing through" is not possible for genuine representations. Thus a fixed mirror image would not really be a mirror image at all, and so the analogy breaks down.

The other compelling analogy was provided by the *virtual images* that may be seen through lenses, as studied in the science of optics. My thought was that perhaps a physical painting is like a *lens*, that can in some way represent, or provide some other kind of perceptual access to, an artwork that is *virtual* rather than real—and again, distinct from the lens or painting that

represents or provides the visual access to it. Here again, the analogy breaks down because one can "see through" lenses just as one can see through mirrors, so that strictly speaking neither can represent their associated images.

Nevertheless, those two provocative but dubious analogies did prompt me to start looking for a better theory in which artworks would be regarded as being the contents of appropriate concrete representations, such as the theory developed here.

As for the origins of the chapters of the book themselves, most of them are based on a series of recently published articles, as listed below. However, the book is more than a mere collection of articles, because each of them was itself written as part of an organized plan of attack on the initial major obstacles to a representational theory of art. Thus the articles were themselves originally written as chapters in an imagined, *prospective* book—which book is now actual.

Because of the origin of the chapters, there are some minor overlaps in coverage of topics from chapter to chapter, suppression of which would have made some of the chapters harder to read and understand, particularly since almost all of the material in the book is entirely new. Thus the occasional redundancy for some may be a welcome benefit for other readers.

The published articles from which most of the chapters are adapted are as follows. Chapter 1 is from "Theater, Representation, Types and Interpretation," *American Philosophical Quarterly* 39, no. 2 (April 2002): 197–209; chapter 2 is from "The Fictionality of Plays," *Journal of Aesthetics and Art Criticism* 60, no. 3 (Summer 2002): 263–73; chapter 3 is from "Theater, Representation, Types and Interpretation" and "A Counter-Example to Theatrical Type Theories," *Philosophia* 31 (2004); chapter 4 is from "A Representational Theory of Artifacts and Artworks," *British Journal of Aesthetics* 41, no. 4 (October 2001): 353–70, by permission of the British Society of Aesthetics; chapter 5 is from "Medium, Subject Matter and Representation," *Southern Journal of Philosophy* 41, no. 1 (Spring 2003): 45–62; chapter 6 is from "Three Depictive Views Defended," *British Journal of Aesthetics* 42, no. 3 (July 2002): 37–56, by permission of the British Society of Aesthetics; chapter 7 is from "Artworks Versus Designs," *British Journal of Aesthetics* 41, no. 2 (April 2001): 162–77, by permission of the British Society of Aesthetics; chapter 8 is from "Pictorial Orientation Matters," *British Journal of Aesthetics* 43, no.1 (January 2003): 39–56, by permission of the British Society of Aesthetics; chapter 9 is from "Varieties of Visual Representation," *Canadian Journal of Philosophy* 32, no. 2 (June 2002): 183–205; chapter 10 is from "Four Theories of Inversion in Art and Music," *Southern Journal of Philosophy* 40, no. 1 (Spring 2002): 1–19; and chapter 11 is from "Internal versus External Representation," *Journal of Aesthetics and Art Criticism* 62, no. 1 (Winter 2004): 23–36. My thanks to the original publishers for permission to reprint the relevant material, and to referees and colleagues for many helpful suggestions.

Introduction

This book offers an original theory of the nature of artworks, centered round the general thesis—the "representational content" or RC thesis—that all artworks occur solely as the *representational content* of some concrete representation. On this view, concrete artifacts or events *represent* artworks, rather than themselves being, or being instances or tokens of, artworks.

However, since artworks in general are also arguably representational in the additional sense that they are about something, or have a subject matter, this means that on the current view all such representational artworks involve *two* levels or kinds of representation: a first stage in which a concrete artifact represents an artwork, and a second stage in which that artwork in turn represents its subject matter. Thus the RC theory to be presented could more specifically be described as a *double representational content* theory of artworks—or just as a *double content* (DC) theory, since arguably all content is the content of some representation or other.

The "double content" or DC view is, at least initially, most intuitively defensible in the case of performing arts such as theater, so the book starts with a discussion of theatrical works involving narrative fictions, such as Shakespeare's play *Hamlet*, in the first two chapters: chapter 1 provides some initial motivation, while chapter 2 investigates the issues in detail. Chapter 3 defends the emerging DC view, and includes arguments against common *type* views of artworks, which are a major competitor to the DC view presented here. (Other arguments against type theories are included in chapters 4 and 7.)

In chapters 4 through 6 discussion shifts to *visual* arts such as painting. On the face of it, such nonperforming, "concrete" art forms present a formidable challenge to the double content view, in that such artworks are usually regarded as being closely identified with particular *physical objects* such as

15

painted canvasses or photographic prints. But that view of artworks as physical objects is undermined with a series of counterexamples in chapter 4, while in chapters 5 and 6 it is shown how a positive theory may be developed that allows for *two* distinctive kinds of content—"medium" content as well as "subject content" or subject matter—with artworks being identified with a specific kind of "medium content."

Chapters 4 through 6 also point out some significant advantages of this approach to artworks, including a natural treatment of stylistic and intentional aspects of art, along with, in chapter 6, perhaps the first clear and adequately motivated defense of a "twofoldness" or *inseparability* argument for representational artworks and their subject matters.

Chapters 7 through 10 bring in additional considerations in favor of the DC view, which have been neglected by alternative views of art. Chapter 7 shows that *artworks* must be distinguished from *designs*, where designs are a special category of *humanly meaningful types*—not previously defined in this way—that have physical artifacts as their tokens. It is shown that a single sculptural artifact could be associated with *two* distinct artworks, which is inconsistent with each of those artworks being a distinct type. The result also shows that two distinct artworks could each share the *same* design, hence showing that neither of them can be identical with that design. Thus either way a type theory of art fails—whether one tries to regard the distinct artworks as *distinct* types, or as a *single* type.

Chapters 8 through 10 bring in an even more completely neglected factor, that of the *spatial orientation* of artifacts associated with artworks. Generally these chapters show that artworks are associated not with physical objects or events in themselves, but rather with particular *orientations* of such objects or events, so that, for instance, a single artistic print or painting could be associated with several *distinct* artworks. Arguably, only the current DC view—or something very similar to it—could adequately account for such cases.

Chapter 8 shows how an artistic printmaker could create *distinct* artworks simply by changing the orientation of a series of her prints, and it also defends the legitimacy of this procedure. The discussion here additionally shows the need to introduce two new concepts of interpretation—of *identifying* and *constitutive* interpretations—to adequately account for the printmaker's artistic activities.

Chapter 9 argues that, once orientational factors are recognized, then it must also be acknowledged that specifically *pictorial* representation cannot be the *only* kind of visual representation. It is argued that there are no less than *three* additional, *delineative* kinds—which involve only a *single* kind of content—and that pictorial representation is distinguished from them by its conforming to a principle of *oriented subject matter invariance* (the OSMI principle).

The DC view has a natural explanation of this difference, in that "delin-

eative" kinds of representation are *simple* or *single-stage* kinds of representation, whereas *pictorial* representation instead has the same double content or *two*-stage representational structure as argued for in the earlier chapters. And, as the third of these "orientational" chapters, chapter 10 extends the orientational points to apply to the structure of musical themes—of a theme, versus its musical inversion—and finds close parallels with cases of *spatial* inversion for paintings, as well as investigating four possible specific theories as to the nature of these cases. The orientational results of chapters 8 through 10 are generalized in chapter 12.

Chapter 11 investigates the concept of representation itself more thoroughly. It shows that there is a sense in which the concept of representation is *ambiguous*—between "internal" representation of subject matter versus "external" representation of actual subjects—and it connects the results with issues concerning the status of fictional entities as discussed in chapters 1 and 2, as well as issues concerning the structure of the DC theory itself.

Finally, chapter 12 provides a comprehensive integration and further development of the major themes of the book, including a generalization of the concept of orientation that shows how the *oriented subject matter invariance* (OSMI) principle of chapter 9 is simply another form of the chapter 5 principle that a given subject matter can be associated with various distinct commentaries on it, hence providing strong further support for the DC view of artworks. This final chapter also works out in further detail a comprehensive *theory of representation*—applicable to any representations, not simply to artwork-related ones, and to both double content and single content cases—based on the chapter 9 orientational distinction between aspect representation and intrinsic representation. Thus the resulting theory may claim to be justified both as a theory of the nature of art and as a general theory of the nature of representation.

In conclusion, the results of this book provide some significant theoretical advances, not only with respect to the relevant aesthetic and philosophical topics, but more broadly for cognitive science and psychology, as well as for artists and educators.

Part 1

Performing Arts

The Representational
Content View of Artworks

This book arose out of a profound dissatisfaction with extant theories in aesthetics, both of the nature of artworks, and of the nature of artistic and other kinds of representation. However, a book full of carping criticisms, but with no positive alternative offered, would be of little use to anyone. So I have taken a more balanced approach, in which criticisms of standard views in the chapters are presented in the context of developments of a novel alternative view. Also, effective and responsible criticism require that one's own theory be both comprehensive, and developed in a systematic way, so that a genuine theoretical alternative both in breadth and depth is provided. This I have tried to do, as follows.

Are all artworks the same kind of entity, and if so, what kind of entity is a work of art? In this book I shall investigate a novel answer to that ontological question, namely that any work of art, no matter of what kind, is the representational content of some associated artifact that represents it. Call this general view the *representational content* (RC) view. For example, on the RC view an artistic painting is not the physical canvas that hangs on a wall, but instead it is the artwork that is represented by that physical artifact. Or a novel is not the original author's manuscript, nor any of the printed copies, but instead it is the artwork that is represented both by that manuscript and by those printed copies. The RC view or approach will be developed into an RC theory of art here.[1]

However, since artworks in general are also arguably representational in the additional sense that they are about something, or have a subject matter, this means that on the current view all such representational artworks involve

1. The concept of representation itself is investigated in chapter 11.

two levels or kinds of representation: a first stage in which a concrete artifact represents an artwork, and a second stage in which that artwork in turn represents its subject matter. Thus the RC theory to be presented could more specifically be described as a double representational content theory of artworks—or just as a *double content* (DC) theory, since arguably all content is the content of some representation or other. Thus the double content (DC) theory to be presented is a more specific form of a representational content (RC) theory of art. I shall start by arguing for the more generic RC thesis here and in section 1.1, and then introduce the specific DC thesis in section 1.2.

In the case of the performing arts, such as music, dance, and theater, an RC theory must deal with issues both about performing artworks, such as plays, and performances of them. Shakespeare wrote the play *Hamlet* in manuscript form, from which printed copies were made just as in the case of a novel—but in addition theater companies present performances of the play, which may differ from each other in various ways.[2]

However, it is an advantage of the RC view that it can handle this additional layer of complexity—of there being, for instance, performances of plays as well as plays themselves—simply by regarding performances of plays as being another kind of concrete artifact or event that represents the play in question. Thus in the performing arts, there are typically three kinds of concrete representation of the relevant artwork, namely manuscripts, copies, and performances, whereas with novels there are only two (manuscripts and copies). By contrast, visual arts such as painting, drawing, and sculpture typically involve only a single kind of representation, namely the concrete artifact which is usually regarded as being the relevant painting, drawing, or sculpture.

But more modern or historically recent art mediums such as radio, film, and video can be quite representationally complex, in spite of the fact that they are not performing arts. For example, the traditional, nondigital medium of film minimally involves at least three kinds of concrete representations: the original negative film stock on which scenes for a film were shot, positive copies of that master negative as are distributed to movie theaters for viewing, and projections on the theater screen of that positive copy. On the RC view, all of these are concrete representations, though of different kinds, of the artwork—the film itself.

An additional advantage of the RC view is that it can also handle, in the same straightforward representational manner, any number of more minor or technical variants on, or offshoots of, an artwork in any medium, such as sketches, layouts, and photographic, video, or digital computer-based copies

2. As an additional level of detail, plays also may be given different *productions* under different directors and theater companies, each of which productions may involve a series of similar but nonidentical performances.

of it: all of these may be regarded as being an appropriate kind of concrete representation of the artwork in question.

1.1. A MINIMALIST ARGUMENT FOR THE RC VIEW OF PLAYS

Any theory of art needs to be defended, justified, and situated in a historical context. But in the case of the RC theory or view, there seems to be no historical context beyond the purely personal, authorial history briefly mentioned in the preface. Also, discussion of the more important theoretical relations of an RC theory to other extant theories of art will be postponed until chapter 3, so as to allow some basic defense and justification of an RC theory to be presented, to which task we now turn.

Here is a very basic and minimal rationale or line of argument for an RC theory, which is based on the idea of trying to simplify the theoretical complexity of ontological and other issues about the performing arts.

As already noted, in the performing arts, including music, theater, dance, and so on, theoretical issues both about artworks and about performances of them must be dealt with, so that their theoretical analysis is inherently more complex and troublesome than that of nonperforming arts such as painting or film, in which primarily only artworks need to be discussed. Thus it is especially desirable in the case of the performing arts to look for defensible broad theoretical simplifications or generalizations that could serve to unify and potentially comprehensively explain these difficult cases.

It is generally agreed that at least some artworks are representational rather than nonrepresentational or abstract in nature, in that in some way they represent commonly recognizable entities or events. Thus we distinguish representational from abstract painting, broadly representational narrative works of fiction—including narrative plays—from formalist literary exercises, with similar distinctions being made for other art forms.

Thus it might be thought that a claim that fictional narrative plays, or performances thereof, are representational in nature is merely to state the obvious—and thus not to give a theory about the nature of such plays or performances, but merely to clarify the kind or category of play, about which genuine theories of plays or performances might be developed. (Henceforth any unqualified mention of plays or performances will be about fictional narrative plays, or performances thereof.)

However, this is where the previous point about the desirability of theoretical simplification comes in: since we cannot avoid giving some kind of representational analysis of narrative fictional plays, since by definition such

plays are representational, why not try to extend whatever is the minimum core of required representational analysis in such cases, so as to include the whole range of issues about the nature and interrelations of such plays and their performances?

Next, what would be the simplest way in which this could be done? Since the concept of representation is a relational one, which relates representing objects to that which they represent, an account of optimum simplicity would be one which assigned plays as a group, and performances as a group, to one or the other side of the representing relation.

In the case of performances, the choice is easy: a performance already has to represent the characters and events involved in a narrative fictional play, so presumably performances must be representations, that is, be on the representing side of the relation.

However, in the case of plays themselves, the choice is not so immediately clear. Kendall Walton has argued that artworks in general, including plays, are themselves "props" or representations,[3] but it will turn out that there are—among other issues—significant epistemic reasons for thinking that choice to be unsatisfactory as a core theoretical position.[4]

Another difficulty is that paradigm cases of representational entities are concrete particulars such as paintings, or concrete events such as performances of plays. But whatever plays are, it seems clear enough that they could not be concrete particulars or events, because of the multiplicity of performances associated with them, so that a claim that plays are representations would be immediately saddled with theoretical difficulties about how nonparadigm, nonconcrete entities could nevertheless serve as representations.

Also, such a theory could not simplify the theoretical complexity of the relations of plays and performances, for it would be forced to maintain that complexity via its regarding each such category as being associated with a distinct basic category or kind of representing object.[5]

On the other hand, if plays are instead regarded as entities that are all represented by other entities, then such difficulties vanish, and a significant simplification can be achieved as well, as follows.

First, recall that we cannot avoid giving some kind of representational analysis of narrative fictional plays, since by definition such plays are representational. It is common to regard such a play more specifically as repre-

3. Kendall L. Walton, *Mimesis as Make-Believe: On the Foundations of the Representational Arts* (Cambridge, MA: Harvard University Press, 1990).

4. I discuss such issues in contrasting my account with that of Walton in section 2.2. See also fn. 5 below.

5. However, in the next section I shall show how to recover some of the attractiveness of this "representing" view of plays, without incurring the theoretical costs just discussed.

senting in some way a *fictional world*, which world is made up of the fictional characters and events which the play is about.[6]

But second, if the play in question is identified with the relevant fictional world—at least as an initial theoretical approximation—then a very economical theoretical structure results, since it is no longer necessary to postulate the existence of plays as distinct entities, existing independently of the relevant fictional world whose postulation is minimally required in any case.

Thus the initial picture coming out of this preliminary investigation is one in which a performance of a play is (one kind of) representation of that play. This view also allows a unified account to be given of the various other significant kinds of entities associated with a play, such as the author's original manuscript of the play, printed copies of it, a stage director's enhanced or marked-up version of the script as used in rehearsals of her specific interpretation or production of the play, video or movie versions of a performance of such a production, and so on: all of them are, on this account, differing kinds of representations of one and the same play, whose differences can be explained as differences in the specific mode of representation of that play by each such kind of representation.

At the same time, the narrative fictional play itself is regarded as being inseparable from, or necessarily co-occurrent with, the fictional world associated with it. Thus my initial view could appropriately be described as that of the *fictionality of plays*.

Now clearly this account requires much more elaboration and defense. But to explicitly address an obvious initial concern, this account has a ready reply to the objection that on such a view, plays don't exist to any greater degree than do fictional worlds themselves—that is, not at all. The reply is that strictly speaking this is true, but that nevertheless the various ways in which plays plainly do exist as cultural institutions can be explained in terms of the fully acknowledged existence of the many different kinds of concrete representations of such a play.[7]

6. Whether or not such talk of fictional worlds is a mere *façon de parler* is a matter for further debate, of course; see the discussion of this in section 2.1.

7. For example, Peter Lamarque in his book *Fictional Points of View* (Ithaca, NY: Cornell University Press, 1996), p. 9, says: "Any adequate aesthetics of literature must acknowledge that literary works are not primarily psychological objects so much as institutional objects. . . . Without the existence of a complex social practice or institution in which texts fulfill determinate functions bound by convention, there could be no literary works." On my view such concrete texts have a primary *representational* function, in virtue of which they are also able to fulfill such social-practice functions.

1.2. HAVING AND EATING ONE'S REPRESENTATIONAL CAKE

I mentioned in section 1.1 that the identification of a play with its corresponding fictional world—the "fictionality of plays" thesis—was an "initial theoretical approximation," rather than the final word on the topic.[8] In this section some of the attractiveness of a "representing" view of plays will be recovered, without incurring the theoretical costs discussed in the previous section.

The key to thus recovering a "representing" view of plays, in which a play would represent a fictional world rather than strictly being identical with it, is based on a realization that that claim is completely consistent with our main claim, namely, that plays themselves, as objects of reference, occur only as represented by relevant concrete performances, texts, and so on. Or in other words, our more complete or refined theoretical picture of talk about plays is one in which such talk is about the play as represented by some concrete representing entity, but which represented play is, in its turn, itself a representation of something else, namely its own fictional world. This more refined view is, of course, the more specific double content (DC) form of the RC thesis.

Thus the theoretical situation is analogous to that occurring in the case of a representational painting A, in which one of the items B represented by A is itself a representational painting, which in turn represents some other item or "representational content" C. A play is analogous to the painting B, as represented by the main painting A, while a fictional world is analogous to what is in turn represented by painting B, namely, its representational content C.[9]

This more refined DC account is also compatible with the claim in the previous section that on our account, a narrative fictional play is not independent of, but rather inseparable from, the fictional world associated with it—where the relevant concept of inseparability is that of necessary co-occurrence, that is, that one could not occur without the other.

In the case of a play, the inseparability issue is about the relations of the play—as represented by a text or performance—and the fictional world that the play in turn represents. Here is a brief demonstration of their inseparability. First, it is clear that a play such as *Hamlet* would lose its identity if any

8. A more sophisticated "fictionality of plays" thesis will be discussed in chapter 2.

9. The term *representational content* is useful because it is noncommittal as to whether there actually *is* such an object thus represented. For example, clearly a picture of "a man" does *represent* a man, whether or not there was some *actual* man used by the artist as her subject, about whom one could say that *he* is the man represented by the picture. See chapter 11 for more details.

alterations were made in its fictional world, in that the play could not be identified as the play *Hamlet* independently of its being the play which represents that particular "Hamlet" fictional world. Thus it is not the case that the play *Hamlet* could be associated with, or represent, several distinct fictional worlds.

At the same time, arguments to be introduced in section 2.8 will establish—in concert with the refinements introduced in this chapter—that the "Hamlet" fictional world itself is not simply a series of generic characters and events, which could serve as a common fictional world for several distinct plays, but that instead it has certain unique external relational properties, such as having been initiated as an object of reference by its author Shakespeare at a particular time and place, that tie it uniquely to the play *Hamlet*, which has exactly the same external relational properties, so that the "Hamlet" fictional world occurs only as represented by the play *Hamlet*.[10]

1.3. ADVANTAGES OF THE DOUBLE CONTENT APPROACH

Now that the basic "inseparability" theoretical credentials of the more refined—and more specific—DC approach have been provisionally established, here briefly are some of its advantages over the initial conception. First, intuitively it does seem appropriate to say that a play such as *Hamlet* represents (rather than its simply being identical with) the fictional world associated with it, even though, as just shown, that does not prevent a strong case being made for the inseparability of a play and its associated fictional world.[11]

And more generally, the refined account can potentially explain whatever intuitive plausibility there is to accounts such as that of Walton, which views plays primarily as being representations, without having to incur the theoretical costs of such views as discussed in section 1.1.

Another potential advantage of the refined account might be thought to be that it leaves theoretical room for a representational theory of nonrepresentational arts, if there are any. For on the refined DC account, performances of a narrative fictional play themselves represent the play, which in turn—since such narrative fictional plays are "representational" in the conventional sense—represents the appropriate fictional world. But then an account of nonrepresentational plays might simply appeal to the first part of this analysis: in such a case, a performance or other concrete representation of the artwork in question still does represent the relevant play, but there

10. Also see chapter 6 for a more comprehensive inseparability argument for represented artworks with respect to their own representational contents.

11. Which account is reinforced in section 2.8.

would be no need to postulate that such a play in turn represents something else, since by definition such plays would be themselves nonrepresentational.

However, that theoretical option, of postulating that there are some nonrepresentational artworks, involving only a single level of representation, will not be exercised here.[12]

The account in this book will rather seek to explain all artistic qualities of artworks, including their style, expressive qualities, the intentions of their artists, and so on, in terms of the full, twofold DC representational structure being discussed—so that the advantages of the refined DC approach in general are that it will enable a systematic and unified account of all of these matters to be given.

However, a more basic argument for the refined DC theory is a very simple and direct one. Insofar as an RC theory of artworks must explain many kinds of artworks, including those that are themselves representational—in the sense of having a subject matter, or something that they are about—it inevitably must appeal to two levels or stages of representation in such cases, in the first of which a concrete artifact represents the artwork (CA representation), and in the second of which the artwork represents its subject matter (AS representation). Thus calling this DC version of the theory "refined" is no longer necessary, since actually it is no more than the bare minimum theoretical structure needed to completely account, within a generic RC theoretical framework, for ordinary representational artworks.

To be sure, representational cases involving only a single level of representation are still theoretically important, but I shall argue in chapter 9 that such cases have, in paradigm cases of visual representations such as pictures, traditionally been confused with genuine double representation cases, so that we actually need to define some new, "delineative" representational concepts to account for such single-level cases of representation, while at the same time explaining more traditional concepts such as that of a picture in double representation terms.

12. Others have rejected a nonrepresentational concept of art for different reasons, such as Walton, *Mimesis as Make-Believe*.

More on Plays

Now that a brief overview and rationale for a double content (DC) approach to plays is available from chapter 1, this chapter will provide a more detailed survey and justification of a DC approach to plays, using arguments and discussing topics that complement those already presented in the first chapter.

2.1. PLAYS AND FICTIONAL WORLDS

To begin, then, Hamlet is one of the fictional characters in the play *Hamlet* by Shakespeare, which also includes, in some way, various other fictional characters and events. Now presumably, to say that Hamlet is a fictional character is to say, among other things, that he is not a real person, but merely an imagined character, and hence that Hamlet himself does not actually exist—and so on for the other fictional characters and events in the play, or in general for the "content" of the play. But what is the relation between those characters and events, and the play *Hamlet* itself?

As a preamble to answering that question, consider (what could be called) the "world" of the play. On one natural construal the characters and events of the play make up a *fictional world*, which world includes all of the contents (the characters and events, etcetera), associated with the play.[1] As to the world itself, it is also fictional, because it is entirely made up of such fictional contents.

1. Authors discussing some concept of a "fictional world" include Gregory Currie, *The Nature of Fiction* (New York: Cambridge University Press, 1990), sec. 2.1; Peter McCormick, *Fictions, Philosophies, and the Problems of Poetics* (Ithaca, NY: Cor-

The initial question, as to the relation between the play Hamlet and its characters and events, can now be supplemented by an additional question about the relation between the play *Hamlet* and the fictional world of *Hamlet*. My answer to this additional question, as will be clear from section 1.2, is that we should regard the play *Hamlet* as both representing the *Hamlet* fictional world, while nevertheless at the same time being inseparable from it,[2] one symptom of this inseparability being that both the play and the fictional world are *represented by* the same concrete entities, such as performances or scripts.

Thus an answer to the initial question, concerning the relation between the characters and events of the play *Hamlet*, and the play itself, is also now available, namely, that the play, since it is inseparable from the relevant fictional world, must *itself* be fictional, just as are the associated fictional world, and the characters and events which are its constituents.

However, this initial account of a play and its associated fictional world is somewhat oversimplified, because of course a fictional world is not an actual or real world, for which it could actually be true that it is constituted by or made up of its constituents such as people and events. An important symptom of this difference is the fact that we also want to say that the *Hamlet* world, as associated with the play *Hamlet*, is itself *about* its events and characters, so that such a fictional world can also be described as having a certain dramatic structure involving its characters and events in complex ways, as being a suitable subject for critical literary discussion, and so on. And indeed, a similar point applies to the characters and events that the fictional world is about: they, too, may be viewed as topics for critical discussion or argument. This dual nature of fictional worlds, and of their characters and events, is connected with the common distinction between *external* and *internal* views of the characters and events of a play, to be discussed in sections 2.3, 2.5, 2.7, and 2.8.

To continue, further proof of the thesis that a play such as *Hamlet* is fictional, just as is its corresponding fictional world, requires some substantive argument, including dealing with various alternative views, and various kinds of objections to it. To this task I now turn. To simplify the discussion I shall describe this part of my DC thesis as that of the *fictionality of plays*. This thesis will be interpreted broadly as implying in addition that any true statements about plays must be explicable as being either external or internal statements about such a fictional play, its associated fictional world, or both.

nell University Press, 1988), chap. 7; Thomas G. Pavel, *Fictional Worlds* (Cambridge, MA: Harvard University Press, 1986); and Kendall L. Walton, *Mimesis as Make-Believe: On the Foundations of the Representational Arts* (Cambridge, MA: Harvard University Press, 1990), chap. 1.

2. A fuller account of this inseparability is given in section 2.8.

2.2. COMPARISONS WITH WALTON'S VIEW

Since both my thesis that plays are fictional, and my strategy of defending it—via identifying any nonfictional, actual items, or artifacts associated with a play as being *concrete representations* of it—are unusual, it may be helpful at this stage to compare and contrast my view with the well-known view of Kendall Walton, as expressed in his book *Mimesis and Make-Believe*.[3]

According to Walton, works of art are props in games of make-believe, and a prop itself is a representation that generates various propositions, which together constitute a fictional world associated with the prop.[4] The main point of similarity between our views is the idea that in artwork cases a representation can be associated with a *fictional world*,[5] which world is in some sense generated by the representation.

However, on my view a fictional world is, in the case of fiction and plays, *made up of* the characters and events described in a representation of it—such as a printed copy of the play—rather than, as in Walton's account, its being a set of fictional propositions. But it should be noted that this account of Walton's is his "considered" view rather than his initial one, on which a proposition was said to be fictional just in case it was "true in a fictional world" (sec. 1.9). Thus my account of fictional worlds is similar to that of his initial intuitions (and common ways of speaking), rather than to his more developed view. My view is the intuitively natural one that such a set of propositions *describes* rather than *constitutes* a fictional world.

Nevertheless, my view need involve no greater degree of ontological commitment to fictional worlds or entities than does Walton's view. Such worlds of course aren't real and don't actually exist, but notwithstanding that, a theory such as mine that explains references to plays as inseparably involving references to fictional worlds could still be theoretically defensible—and possibly preferable to other accounts—even if at some deeper level of analysis all references to fictional entities or worlds were to be explained away.[6]

Now it might be thought that Walton's view that it is specifically *imaginings* of a fictional world that are generated by representations should make a difference in this discussion. However, on my view the specific mental or cognitive attitude entertained toward a fictional world—whether it be imagined, conceived, thought about, supposed or posited, questioned, emotion-

3. See fn. 1.

4. Ibid., chap. 1.

5. Ibid., sec. 1.9.

6. Walton in his *Mimesis as Make-Believe*, sec. 1.9, attempts to minimize his own dependence on such references. Also see section 2.3 below for further discussion of my point.

ally reacted to, and so on—is not relevant to the issues at hand. I think that discussions of plays themselves should center on issues concerning representations and fictional worlds rather than on the very miscellaneous possible mental attitudes we might have toward such items in various contexts.

Next I shall compare our views with respect to plays such as *Hamlet*. For the purposes of this discussion, I shall ignore our differing interpretations of fictional worlds, concentrating instead on their relations to representations. A critical passage showing Walton's view of plays is as follows:

> Is it *Gulliver's Travels* and *Macbeth* themselves that are props, or just *copies* of the novel and *performances* of the play? What the reader or spectator is to imagine depends on the nature of the work itself, the novel or play; copies or performances serve to indicate what its nature is. So the work is a prop. In the case of *Macbeth* peculiarities of a particular performance—costumes, gestures, inflections—enjoin imaginings in addition to those prescribed by the work, so the performance is a prop also.[7]

Encapsulated in this paragraph is a clause that succinctly describes my view: "copies or performances serve to indicate what its [the work] nature is," in that on my view such copies or performances indicate or represent the fictional world that (on my account) is *inseparably connected* with (the nature of) the artwork in question.

However, Walton is clearly *not* intending to use the term *indicate* in this passage in a *representational* sense that implies that copies or performances are thereby props; indeed, on his account performances only count as props because of the additional work that they do in enjoining "imaginings in addition to those prescribed by the work."

Thus Walton is forced to use some such term as *indicate* to describe the relation of copies or performances to works, but it remains unclear why the term *indicate* is not representational in his sense, and why copies in particular aren't props on his view. Also, if he regards a play itself as being a prop, then his account of props has moved far from his paradigm cases of representational props such as treestumps and rocking-horses, which are concrete particulars. It is an advantage of my account that, according to it, *works themselves* are not concrete props or representations, but instead they are *represented by* the concrete copies or performances which are indeed representations or props in a normal, everyday sense.

However, in spite of these differences, I agree with Walton's basic point[8] as expressed in the first part of his sentence "What the reader or spectator is

7. Ibid., p. 51, fn. 32.

8. I present arguments for it, as reinterpreted in terms of my own theory, in the next two sections.

to imagine depends on the nature of the work itself, the novel or play; copies or performances serve to indicate what its nature is," and hence I agree with the whole of his sentence when *indicate* is reinterpreted, as above, as itself being a representational concept.

Nonetheless, there is an important issue on which Walton is silent with respect to the *prescriptivity* of works. This issue involves a distinction between *epistemic* versus broadly *ontological* or *factual* issues concerning a work. Though I agree that it is the work itself, or facts about it, which has (or have) prescriptive force,[9] nevertheless there are epistemic issues concerning *authoritative sources of information* about such a work that also need to be considered, which information can only adequately be accounted for by invoking facts about certain representations of a work. Thus on my view, the primary source of *evidence* we have for what constitutes a play such as *Hamlet* is provided by items such as the printed copies and performances thereof that *represent* the work, so that a Walton-style account of what a play prescribes must be fleshed out with an account of the *representational conditions under which we have adequate grounds for claiming* that a work is a certain way, or that it prescribes certain descriptions of it.[10]

A prime issue concerning such representational conditions is that of when they do, or do not, count as being *authoritative* as sources of information concerning the work in question. Certain representations have a *privileged* status as sources of information for accurately assessing the content of a work, namely those I shall call *originative* representations in the case of music, literature, and theater, or *original* representations in the case of the visual arts such as painting and sculpture.[11]

An *originative* representation is an item such as the original score of a musical composition by Beethoven penned in his own hand,[12] or the original typed or handwritten manuscript of a play or novel as produced by its author. As the name suggests, an originative representation usually originates or initiates a series of other representations of the same work, but only the originative representation is privileged, in that it alone is the direct causal out-

9. However, as will become clear, on my view the prescriptive force prescribes not imaginings, but rather which statements should be taken as being accurate descriptions of the work.

10. Of course, each art form or medium will have its own characteristic representational conditions, so that no epistemic uniformity across the arts, or even within a given art form at different times, is to be expected. For example, presumably the standards for authentic or accurate performance in the ballet and dance world changed significantly upon the introduction of an adequate choreographic notational system.

11. See section 4.3 for more details.

12. Here I ignore aspects of scores in which they function as instructions to performers rather than as representations of a work, on which see Stephen Davies, *Musical Works as Performances* (New York: Oxford University Press, 2001), chap. 3.

come of the artist's successful creative efforts with respect to the artwork in question. Thus an originative representation typically provides the ultimate degree of epistemic authority in assessing the content of a fictional world, whereas nonoriginative representations typically[13] only have a derived authority, depending on their degree of fidelity in accurately copying an appropriate originative representation.

This distinction of originative from nonoriginative representations is significant because it shows that the actual issues of authority in the assessment of the content of a fictional world, and hence an assessment of what the work may legitimately be taken to prescribe, are issues to be settled by examining various representations of a work in their *actual historical contexts* relative to the inception of the work in (one or more) originative representations as produced by the artist in question. Thus a Walton-style abstract appeal to that which is mandated by *a work* itself, conceived of as something that is independent of such historically situated representations, has by comparison little or no epistemic value.

Walton's account of performances as props, on which peculiarities of a particular performance—costumes, gestures, inflections—enjoin imaginings in addition to those prescribed by the work, is also suspect, in that the peculiarities of a particular performance have no presumptive authority to mandate anything, for they might just amount to ad hoc representations, such as tree stumps being imagined as bears,[14] which Walton denies are (strictly speaking) props. Here again, it is the authority of an actual performance history for a play that determines which peculiarities of a particular production of a work count as contributing to an authoritative or legitimate performance of the work, as opposed to mere eccentricities which in performance obscure rather than illuminate the work's fictional world. Thus, here too my account can potentially give a more plausible account than that of Walton on the relations of performances to fictional worlds.

One further point not adequately brought out yet is as follows. For me it is artworks as *representing their inseparable fictional worlds* that have prescriptive force,[15] whereas for Walton it is instead *concrete representations*—which on his view are artworks—that have prescriptive force. Thus, with my dis-

13. "Typically" only, because, for example, a senile author might make various mistakes in some of his sentences, while a knowledgeable assistant—or a later editor—might correct these errors so as to produce a more authoritative text or representation, which yet is not strictly itself an originative representation of the work.

14. Walton, *Mimesis as Make-Believe*, sec. 1.5.

15. Again, for me this prescriptive force is merely that of prescribing which propositions about a fictional world should be taken as being true of it, rather than, as in Walton's case, its involving the prescription of certain imaginings. (In the next section I shall introduce the idea of the *facts* or *factual basis* of a fictional world or artwork as that which prescribes the true propositions in question.)

tinction above between the epistemic authority of representations versus the prescriptivity of artworks in mind, I can criticize Walton for in effect conflating the *epistemic* authority of some representations with the quite different idea of the prescriptivity of artworks, which on my view holds not for *concrete representations* but rather for the artworks *represented by* them.

2.3. PREMATURE THEORIZING, AND EXPLANATION OF FICTIONS

It is time to step back and take a wider view of the issues. I think that my view, on which a play is inseparable from its relevant fictional world, with both of them always being associated with concrete representations of the play such as performances or copies, is intuitively the most natural one to take. However, I also have a diagnosis as to why this view seems not to have been previously defended in the literature. On one plausible diagnosis it is a result of (what could be called) *premature theorizing* about fictional worlds.

It will generally be agreed that references, or apparent references, to fictional entities or worlds are philosophically problematic. However, such problems concerning fiction are simply one particular case of much wider philosophical issues concerning the relations between ontology and semantics when references, or apparent references, to nonexistent entities are at issue. Thus an account of the nature of fictional artworks such as plays should, in my view, be developed and argued for independently of any consideration of those general semantic and ontological issues, since those issues, and possible ways of resolving them, are generic issues which have no direct bearing on the specific nature of *fictional* entities and *fictional* reference, as opposed to other kinds of ontological or referential issues in other cases of reference to nonexistent things.

The "premature theorizing" I mentioned occurs when fiction is approached with some general solution in mind to those generic problems, in such a way that one's whole account of the nature and structure of fiction is motivated primarily, or even exclusively, by a desire to make fiction conform to one's preferred solution to the generic problems. Or, to put the issue in another way, the intuitively natural or pretheoretical issues concerning the specific nature of fiction have a *surface structure* that should be respected and investigated *in its own right*, prior to any attempts to explain it, or explain it away, on more generic philosophical grounds. Premature theorizing occurs when that surface structure is brushed aside as irrelevant to the "real" philosophical issues.[16]

16. Related points are made by Gareth Evans, *The Varieties of Reference* (New York: Oxford University Press, 1982), pp. 366–67, who holds that we should not impute to the discourse of ordinary people discussing fiction excessively sophisticated

But what then *is* the surface structure of fiction? There is of course plenty of room for disagreement, including theoretical disagreement, about this; my point against premature theorizing was merely intended to forestall a takeover or swamping of specific intuitive or theoretical issues about *fiction* itself by generic ontological and referential theories.

On my view, a critical issue of surface theory is that of (what could be called) the *explanatory center of gravity* of issues concerning fiction, namely, What is it that accounts of fiction are primarily *about*? My view is that they are primarily about fictional characters and worlds, and that all other issues about fiction should be seen as ancillary issues, which are to be related to and explained by that primary focus. This position is also a natural methodological corollary to my claim that plays are fictional. I shall defend this view via a discussion of a well-known issue, which is as follows.

There is in the literature a much-discussed distinction between *internal* versus *external* approaches to fictional characters. Internal approaches deal with the fictional world and characters themselves, while external approaches instead deal with characters insofar as they are discussed, evaluated, or compared with other characters or worlds by critics.[17] For example, "Hamlet is the Prince of Denmark" is about Hamlet considered as an *internal* character, while "Hamlet is one of the most discussed fictional characters" is about Hamlet considered *externally*.[18]

I have tried to state this distinction without prejudging whether the considering of a character internally or externally amounts to a consideration of two distinct entities or objects of reference. The majority of theorists have views that claim or presuppose that the two are *distinct*, or that one can be referred to but the other can not—which comes to the same thing, in that such a view similarly denies that there is one entity that can be referred to in both internal and external ways.[19]

theoretical views about the nature of fiction; and Charles Crittenden, *Unreality: the Metaphysics of Fictional Objects* (Ithaca, NY: Cornell University Press, 1991), chaps. 2 and 3, who argues that there undeniably are references to fictional objects, no matter what further theoretical construal we might attempt to give them.

17. For example, Crittenden, *Unreality*, pp. 94–95; Lamarque, *Fictional Points of View*, chap. 1; and Amie L. Thomasson, "Fiction, Modality and Dependent Abstracta," *Philosophical Studies* 84, nos. 2–3 (1996): 295–320, p. 301.

18. A related distinction of referential versus formal properties of a character is provided by Dauer in Francis W. Dauer, "The Nature of Fictional Characters and the Referential Fallacy," *Journal of Aesthetics and Art Criticism* 53, no. 1 (1995): 31–38, where formal properties relate to the function played by a character in a work of art.

19. Including Currie, *The Nature of Fiction*; Lamarque, *Fictional Points of View*; Amie L. Thomasson, *Fiction and Metaphysics* (Cambridge, UK: Cambridge University Press, 1999); Walton, *Mimesis as Make-Believe*; and Peter Van Inwagen, "Creatures of Fiction," *American Philosophical Quarterly* 14 (1977): 299–308.

However, in my view such theorists cannot be right, because their view violates an intuitive feature of the surface structure of fiction, in which the character Hamlet in the play is the *same* character who is said actually not to exist, and who literary critics compare and contrast with other fictional characters.[20]

To repeat, perhaps all of such intuitively natural surface views might be explained away at some deeper level of analysis, but the identity of the fictional Hamlet with the character discussed by literary theorists is a central feature of the surface structure of fiction, which has to be respected by any theory of fiction as providing at least an initial or pretheoretical requirement of adequacy for such theories.

Given the requirement that internal and external views must be about the *same* entity, there are consequently two possible surface views concerning the "explanatory center of gravity" of fiction. In one of these, any internal references to a fictional character would be explained by reference to external facts about the character,[21] while in the other—a "fictionalist" view such as mine—the order of explanation would be reversed, with external references being explained by reference to facts about an internal character. I shall now proceed to explain and defend the fictionalist approach. For the sake of brevity and convenience, I shall talk of fictional characters purely in surface terms, assuming that, at this level, they may be taken to be entities that can be referred to, be said to have properties, and so on.

2.4. A DEFENSE OF THE FICTIONALIST APPROACH

To begin with, here is an argument for (what could be called) the *primacy of the fictional character*, which goes as follows. There could not be any external, literary discussion of fictional characters without there already being internal fictional characters to be thus discussed; but on the other hand, there could be internal fictional characters without there being any external discussion of them at all, if we had plays and novels but no critical writings about them. Hence fictional characters considered *internally* have a basic explanatory priority over *external* views of them. And a corresponding principle of the primacy of fictional *worlds* holds for fictional worlds instead of fictional characters, and so on for fictional events, etcetera. I shall henceforth use the term *fictions* to apply indifferently to the characters, events, and fictional worlds

20. Crittenden, *Unreality*, pp. 42–44, argues for this view.

21. On a charitable reading, perhaps authors such as those cited in fn. 18 may be taken as being engaged in some form of this activity, in spite of their denial that reference may be made to fictional characters considered internally.

associated with fictional works, so that my general thesis here is that of the *primacy of fictions*.

In what does this primacy or explanatory priority of fictions consist? One way of conceiving it is in terms of truth: it is internal facts about fictions which are what *make true* any external or internal statements about them, whereas the converse does not hold. Or a notion of *dependency* could be appealed to, in that it could be claimed that the truth of any external statements about a fiction is dependent, in one way or another,[22] on the truth of various internal statements about the fictional facts in question.[23]

Parenthetically, it is such fictional facts, of course, that provide what I have also referred to as the "factual basis" for various claims about a fiction, whether they are everyday descriptive claims, or of some more theoretical kind such as the explanatory and epistemological kinds I discuss. Thus, for example, the external statement that Hamlet is one of Shakespeare's most ambiguous leading characters is *made true*, if it is true, by internal facts about Hamlet and other Shakespearean characters, whereas it is not the case that statements of the internal facts of Shakespearean plays are made true by any external statements about the plays.

Second, if a literary critic discusses the character Hamlet, the *evidence* or *epistemic factual basis* for any claims that she makes, whether of an external or internal kind, must in the first place[24] be provided by *internal* facts about Hamlet, such as facts about what he says or does in various fictional situations.[25]

Thus, for example, someone in an external discussion of a fiction may cite some writings of a critic as being authoritative concerning the work, but a *more basic* epistemic warrant for such a reference must involve an assumption that the critic in question himself had an adequate factual or evidential basis for his views provided by *internal facts* about the play.[26]

22. An account of the kinds of dependency involved will have to await another occasion.

23. In the case of both conceptions, the explanatory priority is explained in terms of the semantic concept of truth, so that no ontological issues about fictions are raised. Of course, with truth as with reference, some might argue that at some deeper level of explanation there are not really any internal truths about fictional entities. But as before, this does not affect the current surface-level discussion of fictional entities.

24. See the discussion below on levels of epistemic justification.

25. It is these internal facts that, in section 2.2, I (in effect) argued to be the source of the prescriptivity of a play, in mandating which propositions about the work are to count as being true.

26. An analogy is provided by a language dictionary: words may be defined in terms of other words, but the ultimate evidential basis for meaning is provided by so-called ostensive definitions in which words are linked to extralinguistic entities. In the case of fiction, it is the sayings and doings of fictional entities that, at a surface level of explanation, provide the analogous factual basis of extralinguistic entities.

This second principle could be called that of the *factual justification of fictional claims*, or the *factual justification* principle for short. Unlike the first explanatory primacy principle, it is an *epistemic* principle concerning the factual basis that warrants or justifies statements about a fiction.

To be sure, there are also related issues of interpretation that would need to be addressed in a more complete account, but for the present it may be taken that differing interpretations of an artwork either involve the postulation of different fictional worlds, or differing opinions about the contents of a single fictional world. I also do not address here issues about the "basic" contents of a world, namely those directly described in a play, versus possibly various kinds of "implied" fictive content, which may reasonably be inferred from the basic contents, and which also could be regarded as issues concerning interpretation of a work.

The epistemic *factual justification* principle just presented should also be related to the discussion in section 2.2 of *authoritative representations* of a fiction. The overall picture being developed is one in which there are actually *three* stages or levels of epistemic justification of a claim—external or internal—about a fiction. In the first, lowest-level stage just discussed, a claim about fictional world X is supported by appealing to relevant facts about X; for example, the claim that "Hamlet is the prince of Denmark" is supported by appealing to the corresponding fact or facts that provide its factual basis in the *Hamlet* fictional world.

But a second stage of epistemic justification is also needed, as an answer to the question "But how do you *know* that world X is indeed the *Hamlet* world?"—rather than its being some similar but irrelevant fictional world, facts about which would have no bearing on the justification of claims about *Hamlet*. Or, otherwise put, the question is that of how one justifies a claim that a given fictional world X possesses precisely the appropriate *Hamlet*-related properties, and no others.

Here my discussion in section 2.2 of authoritative representations provides an appropriate answer: one can justify the claim that world X is indeed the *Hamlet* world by appealing to the existence of an *authoritative representation* Y of the play *Hamlet*, which play represents precisely world X rather than some other fictional world, no matter how similar it may be to X.

Yet a third stage of epistemic justification may also be required, because someone might still ask "But how do you know that representation Y *is* an authoritative representation of the play, and hence of its inseparable *Hamlet* world?"[27]

27. It is a plausible assumption that the representation relation must be *transitive* in such inseparability cases. For example, if physical painting A represents picture B, and B inseparably represents its subject matter C, it seems self-evident that painting A must also *itself* represent the subject matter C. One might attempt an epis-

This is where the causal, historical, and intentional factors discussed in section 2.2 become relevant: it is by virtue of a representation's having the right or appropriate connections of those kinds that it counts as authoritative in representing correctly the *Hamlet* world.[28] Thus, in epistemic terms, the primary or ultimate justification for claims about a play is provided by the third stage just outlined. However, in explanatory or semantic terms, it is the fiction itself that is primary, in some such way as was outlined above.

A possible objection to both of my principles—the primacy of fictions, and the factual justification principle—should be briefly considered, according to which it is not anything fictional, but instead either the *text*, tokens of which are provided by copies of the work, or *performances* of a work that provide the factual basis for a fictional work.

However, as pointed out in section 2.2, one must distinguish between the *epistemic* authority of a text or performance, and the prescriptive or factual basis of a play. In the former case a copy of a text may be authoritative because of its direct causal link with the author of the fiction, which has the implication that any other text differing from this one fails to be authoritative as a source of *information* about its fictional characters. Thus, though an originative text is typically an authoritative source, this is not to say that it is the text itself that provides the factual basis for claims about its fictional characters. Instead, it is those characters, and their characteristics, as *represented by* the authoritative text that provide the factual basis for claims about the characters.

2.5. FICTIONS AND THE REAL WORLD

Some further discussion of various issues concerning the relations of fictions to the real world will now be provided. Returning to my claim that both external and internal statements may be about the same fictional entity, it is helpful to first indicate how a fictional world is *located* relative to the real world. A fictional world is on my view something that is genuinely related to the real world, in that it is typically created by one actual person at some particular time, in spite of the fact that it is, of course, a fictional or imaginary

temic justification of the transitivity as follows: only concrete entities A can provide ultimately authoritative evidence as to which represented entities B represent which subject matters C; but they could only *provide* such evidence by themselves *actually* representing C.

28. A perceptual analogy to the three stages of justification just outlined would be as follows. On one common realist view, one justifies a claim that snow is white by appeal to the fact of snow being white, which claim in turn is justified by an appeal to the veridicality of perception of the fact of snow being white, which claimed veridicality itself requires some appropriate third stage of epistemic justification.

world that is thus created. Minimally this implies that the characters and events in a fictional world are related both to each other, defining their internal properties and relations, and also to the real world in which they were created, thought about and discussed, which defines their external properties and relations.

Another way to describe the differences between internal and external statements concerning a fictional world is as follows. If a real person, such as Richard Nixon, appears in a fictional work, one can distinguish the properties *ascribed* to him in the story, which constitute his *internal* properties in the story, from those properties that he has as a real person, *independently* of those ascribed to him in the story, which instead constitute his *external* properties. One can make a similar distinction for fictional characters and events as well: they both have internal properties, namely those ascribed to them in a story, or implied by those thus ascribed, as well as external properties which they have independently of their fictionally ascribed or implied properties, such as that of having been created or represented by a particular author at a particular time, or of being discussed by some literary critic at a later time.[29]

An advantage of this characterization of internal and external properties of a fictional character is that it can help to explain how certain *modal* statements about a character could be true of him. For example, the claim that "Hamlet could have had some characteristics different from those he does have" could be explained as an external statement claiming that Shakespeare could have ascribed different properties to Hamlet when creating the play *Hamlet*.

Something should also be said about an opposing view at this point. As noted previously, it is common for writers to assume that it is, strictly speaking, impossible to refer directly to a fictional character such as Hamlet, when such putative references are understood as being to the "internal" character of a story; instead, it is claimed, one merely *pretends* or *imagines* (or "make-believes") that one thus refers. Or more formally, it may be claimed that the whole linguistic context in which the apparent reference occurs is within the scope of an opaque story or fictional operator, so that for instance "it is fictional that Hamlet is the prince of Denmark" does not involve any reference to Hamlet or to supposed predications of him.[30]

My claim on the contrary is that, at a surface level at least, it *is* possible to refer to Hamlet and to make predications of him. However, my position is consistent with the following apparently related view, namely that, when

29. I have adapted this general point from a related one given by Thomasson in her "Fiction, Modality and Dependent Abstracta," pp. 300–301, but her view of fictional characters is very different from mine, in that she takes *external* rather than internal properties as being primary.

30. Both views are very common, for example, Currie, *The Nature of Fiction*; Lamarque, *Fictional Points of View*; and Walton, *Mimesis as Make-Believe*.

one character in a story refers to another character in the same story, no *actual* reference occurs. Thus I can agree that if it is fictional that Jane referred to Bill—in an innocuous, nonopaque sense of "it is fictional that," in which it merely indicates that a fictional case is being dealt with—then there is no implication that anybody *actually* referred to anyone. This is so because on my view Jane, her act of referring to Bill, and Bill himself are all fictional rather than actual.

In sum, fictional characters are not real persons, nor are their actions real actions, but any necessary distinction between being a real versus fictional person is adequately captured by the fact that fictional entities have some different properties and relations from those of real entities, such as that of being a fictional character, or of being incomplete in various characteristic ways,[31] so that, as one would expect, references to fictional characters are in some ways like, but in other ways unlike, references to real entities. It is unnecessary to additionally deny that fictional entities can be *referred* to, along with consequent logical adjustments such as the bringing in of opaque fictional operators.

2.6. AN APPARENT COUNTEREXAMPLE

In this section I shall briefly discuss an apparent kind of counterexample to the fictionality of plays thesis as defined in section 2.1. Suppose someone claims that "*Hamlet* is a very popular play." On the current fictionalist view, this statement claims that the *fictional play* Hamlet, that inseparably represents the fictional world of *Hamlet*, is a very popular play. However, it could be objected that most of the evidence relevant to the popularity of the play, such as large sales of copies of the play, or abundant performances of it, is not evidence that is about, or directly relevant to, the *fictional entity Hamlet* and its associated fictional world at all, but instead it is evidence relevant to the play considered as a *concrete social institution*. Thus external statements of this kind fail to refer to, or be about or true of the corresponding *fictional* entities, and hence such statements violate my fictionality of plays thesis.

Two kinds of replies are relevant here. In the first place, I agree that a play may legitimately be regarded as a social institution, but my analysis of what is *involved* in that institutionality (as given in section 2.1) is that, strictly speaking, one is then talking about *representations* of the play rather than the play itself. On this interpretation, the original popularity statement amounts to saying something like "*representations* of the play *Hamlet* are very popular,"

31. Terence Parsons, *Nonexistent Objects* (New Haven, CT: Yale University Press, 1980), chap. 1, discusses such issues.

which casts no doubt on the fictionality of plays thesis since it is about con-
crete representations such as copies or performances rather than being about
the play itself.

A second kind of reply is as follows. One may distinguish the *evidence* for
popularity—such as high copy sales and frequent performances, which, as
just noted, strictly speaking concern concrete representations rather than the
play itself—from the claimed *fact* of the play's popularity, and then argue that
the admittedly representational evidence strongly supports an *inference* to the
popularity of the fictional play and world (which play and world are repre-
sented by such copies or performances). Indeed, viewed thus, this case is a
straightforward instance of the *second stage of epistemic factual justification* (see
section 2.4), in which a factual claim that the play and world are externally
popular is justified by evidence drawn from authoritative representations of
the play and world.

2.7. SPATIOTEMPORAL LOCATION AND EXISTENCE

In this section I shall briefly discuss issues concerning the spatiotemporal
location and existential status of fictions. A useful foil for my view is the
recent view of Thomasson, according to which fictional characters are exis-
tent but abstract entities, which are abstract primarily because they lack a
spatiotemporal location.[32]

However, on my view this is typically incorrect. For example, Hamlet, as
the prince of Denmark, is presumably located in Denmark, during some his-
torical period which happens not to be further specified by the author, but
which must be assumed to be some particular time since Hamlet is, in the
story, a real individual with a definite location in space-time, as is possessed
by any real individual. Thus as far as the internal view of Hamlet goes, he *does*
have a spatiotemporal location in such stories—which is not to deny that it
might be possible to construct a convincing story about characters who did
not have any spatiotemporal location. It is a failing of Thomasson's exter-
nalist view that it is unable to give due weight to such basic facts about typ-
ical fictional characters.

Second, since both internal and external references to Hamlet are, on
my view, references to the *same* internal fictional character, there is no other
character-like entity about which further questions could be raised con-
cerning its spatiotemporal location. Hence my general answer to the ques-
tion is that it depends on the content of a fictional story as to whether or not

32. Thomasson, *Fiction and Metaphysics*, e.g., pp. 36–37.

its characters have a spatiotemporal location. This shows again that my account of the surface structure of fictions, and talk about them, is able to avoid ontological issues such as that of whether fictional characters are abstract or concrete entities. I could also give a similar story-relative account of the issue as to whether fictional characters are *individual* versus *general* entities such as universals: here, too, I can simply reply that it depends on whether or not the relevant characters are *represented as* individuals, or as universals, in the fictional story.

As for the issue of existence, Thomasson claims that characters come into existence on being created by an author, and go out of existence when no copies or memories of them remain.[33]

But for me, plays and characters do not ever exist.[34] Instead, artistic creation simply makes a play or character become *available as an object of reference or thought* via its representation by an originative representation, which itself *does* come into existence at the time of its creation by the artist, where previously the play or character was not thus available; and similarly the demise of a play or character at a given time consists in their becoming *unavailable as objects of reference* after that time, because of the destruction of any remaining representations of them—whether physical or in human memory. Thus for me, external issues about the spatiotemporality of characters do not arise, since there are no existent characters about whom such issues could be raised. Admittedly, on my view Hamlet may be externally named or referred to when appropriate representations exist, but such references are only to the same nonexistent or fictional individual Hamlet who is also the object of any internal references to him.

Perhaps it would be useful to clarify at this point how it is nevertheless possible for one and the same entity, such as the fictional character Hamlet, to both "exist in the play" and yet not exist in reality. Formally the answer is that the relevant existence and nonexistence claims are not incompatible, because they may be taken to claim that different *relational* properties hold (or do not hold) for Hamlet. To say that Hamlet exists in the play is to say that, *relative to the fictional world* in which he is a character, he has the same status as other characters or events that count as real in the story. And in this internal manner the fictional world of Hamlet itself counts as real, in that on an internal view it is entirely made up of such internally real characters, and so forth.

On the other hand, to say that Hamlet does not exist in an external sense is to say that, *relative to the real world*, Hamlet does not have the same existential status as other inhabitants of the real world. And similarly for the "Hamlet" fictional world itself: it too, externally speaking, does not have the

33. Ibid., chap. 1.

34. Or at least, not in the standard or absolute sense of existence, as opposed to the relational sense discussed in the next footnote.

same existential status as the real world. Thus, since the reference classes for each of these relational properties are different, one and the same character Hamlet can both exist, relative to the fictional world, and not exist, relative to the real world, with similar points applying to the corresponding fictional world itself.[35]

2.8. MORE ON THE INSEPARABILITY OF PLAY AND FICTIONAL WORLD

In this section I shall briefly further defend the inseparability of a play and its fictional world, as previously discussed in sections 1.2 and 2.1, by drawing out the implications of two related threads in the previous discussion in this chapter.

The first thread, from sections 2.2 and 2.4, is that an originative representation, such as a playwright's original manuscript for his play, typically is the ultimate source of epistemic authority as to the nature of a play. However, that point also applies with equal force to the *fictional world* of the play: the nature both of the play and the fictional world are equally supported by the *same* authoritative source of information concerning them. But this being so, there could not be any evidence that would reliably link the play to some *different* fictional world, or the relevant fictional world to some *different* play. Thus there could not be any *adequate epistemic evidence* that either the play or the relevant fictional world could occur without the other, and hence there is strong epistemic support for the claim that the play and fictional world are inseparable, in the usual sense of being necessarily co-occurrent.

The second thread picks up on the point in section 2.7 that, though an artwork such as a play is not *itself* created—nor its corresponding fictional world—nevertheless an *originative representation* of both play and fictional world *is* created by a particular artist at a particular place and time. In terms of the terminology of external versus internal views of a play and fictional

35. This account is compatible with the standard nonrelational concept of existence, in terms of which fictions do not exist (absolutely). But my relational account is all that is needed to explain the sense in which fictional characters do typically exist "in a story," as opposed to their not existing "in reality." To be more explicit, the two concepts (of what could be called *relational* or *R-existence*, and *nonrelational* or *NR-existence*) are related as follows. R-existence in a fictional world is a nonontological concept, having no implications as to the NR-existence status of an object. R-existence (or nonexistence) in the real world for an object entails that the object also NR-exists (or does not NR-exist). Throughout this book, whenever the term *exists* is used without qualification, it is the standard concept of NR-existence that is being used.

world,[36] this means that both the play and the fictional world have precisely the same *external* properties or relations to the artist who created them, the time and place of his so doing, and to the relevant originative representation created by him. But no *other* play or fictional world could have those same external properties or relations; hence on these logical grounds also the relevant play and fictional world must be inseparable.[37]

2.9. MORE ON INTERNAL VERSUS EXTERNAL VIEWS

The topic of internal versus external views of fictional items still needs some clarification.[38] Usually it has been assumed that such differing views of items—or statements about, or properties of them—apply only to *fictional worlds* or their constituents, not to plays *as such* as well.[39]

However, I shall briefly show that there can be both internal and external views of plays themselves, as well as of their fictional worlds. Consider the true statement "the play *Hamlet* has five acts." This is surely an internal statement about the play *Hamlet* itself, rather than being a statement about its fictional world. While at the same time, the statement "Shakespeare wrote the play *Hamlet*" is equally clearly an *external* statement, about the external relations of the play *Hamlet* to its author, Shakespeare.[40] Thus there can be both internal and external views of plays, just as much as of fictional worlds or characters.

To be sure, on my view the distinction between internal and external views of plays or fictional worlds turns out to be just the familiar *logical* distinction between the intrinsic versus the extrinsic or relational properties of any item, so that my account is a deflationary one which *denies* that the distinction marks any important semantic or ontological differences between the items to which it is applied.

36. On which see the next section.

37. Chapter 6 adds an additional experiential argument for the inseparability, roughly to the effect that an experience of an artwork would not count as being correct unless it also involved an experience of the relevant subject matter, and vice versa.

38. It has previously been mentioned or discussed in sections 2.1, 2.3, 2.5, 2.7, and 2.8.

39. Which is not surprising, since the thesis that plays themselves are fictional seems not to have been previously defended.

40. Though strictly speaking of course, Shakespeare wrote the *originative representation* of the play rather than the play itself, and so the relevant external relations of the play are to be understood accordingly.

2.10. CONCLUSION

In conclusion, here is a brief rationale for the double content (DC) position as applied to plays, on the basis of this chapter.

First, the fictionality of plays thesis is one legitimate but previously unoccupied theoretical position on the status of narrative plays (and potentially, of other fictional artworks too), which deserves to be investigated in any case so that its strengths and weaknesses (if any) relative to more standard positions can become clearer.

Second, the account is a natural and parsimonious one that does not need either to postulate any new entities[41] or to introduce elaborate paraphrases or reductions of natural referential ways of speaking about fictional entities.[42]

And third, the distinction of plays from concrete representations of them, which is integral to my theory, enables important distinctions to be articulated between explanatory and epistemic issues with respect to plays and other artworks, which have been largely neglected by alternative accounts.[43] For this reason too, the current DC approach deserves consideration.

41. Such as does Thomasson's view in *Fiction and Metaphysics*, according to which fictional characters are existent abstract entities.

42. As does, for instance, Currie's account in *The Nature of Fiction*.

43. Such as that of Walton in *Mimesis as Make-Believe*.

Criticisms of Type Theories of Plays

Chapters 1 and 2 have introduced the double content (DC) approach to artworks in terms of some basic DC theory as applied to plays, though the analysis provided would work equally well for *any* works of fiction, such as fictional novels, poems, or short stories. Thus those first two chapters were attempting to *justify* the DC approach, by showing how appropriate and effective it could be as a theory of the referential, ontological, explanatory, and epistemic structure of the particular art form of *narrative fictional plays*.

However, a theory of art also needs to be *defended* against its competitors by showing their relative inadequacies in various respects. So before applying the DC approach to other art forms, this chapter will consider the relative merits of a major competitor to the DC approach to plays, namely the view that plays are *types* that have scripts or performances as their *tokens*. I shall show that such views have some fundamental flaws, whereas the DC theory itself will emerge unscathed.

3.1. THE NONTYPEHOOD OF REPRESENTATION

There is a fairly common view concerning the performing arts that pieces of music, plays, dances, and so on are *types*, and that particular *performances* of such works are *tokens* of those types.[1] Such "type" views are also common for

1. Support for a "type" view as applied to the performing arts is provided by (among others) Noël Carroll, *A Philosophy of Mass Art* (Oxford, UK: Clarendon Press;

*non*performing arts such as literature and film, and even as applied to apparently particular artworks such as paintings.[2]

I shall now show why the current "representational content" approach to the arts, including the performing arts, must *reject* such a type-token view. The reason is simple: it is that if an object A represents an X, then object A is by definition *not itself* an X. For if A were itself an X, then that would automatically debar it from representing an X.[3]

For example, a *picture* of a cow—one kind of representation of a cow—is not itself a cow, whereas in genuine cases of a type-token or kind-instance relationship, the token or instance must, of course, itself be an *instance* of the type or kind in question. Thus an individual cow is a token of the type "cow," because such an individual cow is indeed an *instance* of the *kind* "cow," that is, it is itself a cow. But in thus *being* a cow, it is debarred from simultaneously being a *representation* of a cow, since, as noted, a representation of a cow cannot itself be a cow.

The outcome of this conceptual argument is that a representation of X cannot be a token of X, so that type-token and representational explanations of artistic cases are inevitably theoretically *immiscible* or *conflicting*. Some implications of this difference will serve as important elements in contrasting the two approaches in succeeding sections.

To be sure, these points by themselves do not show that type-token approaches to the arts are wrong. But there is some independent evidence of the wrongness of type-token views in nontheatrical arts,[4] and the remainder of this chapter will provide new examples specifically demonstrating the failure of "type" views in *theatrical* contexts—which failures, in sum, show a need to replace type-token theory, as applied to plays and the other arts, with some other kind of theoretical model that has a comparable level of generality or comprehensiveness.[5]

New York: Oxford University Press, 1998); Gregory Currie, *An Ontology of Art* (New York: St. Martin's Press, 1989); Joseph Margolis, *Art and Philosophy* (Brighton, Sussex, UK: Harvester, 1980); and Richard Wollheim, *Art and Its Objects: With Six Supplementary Essays*, 2nd ed. (Cambridge, UK, and New York: Cambridge University Press, 1980).

2. Such views will be criticized in chapters 4 and 7.

3. The principle in question may be protected from trivial counterexamples, such as that a picture could be a representation of a picture, by requiring that the "X" in question be specified in as specific a form as possible. Thus, for example, if X is a picture of Y, then a representation of X would be *a representation of a picture of Y* rather than itself simply being a picture of Y, as is X.

4. See chapters 4 and 7.

5. However, this is not to say that type-token concepts have no role whatsoever to play in discussions of the arts, but only that they should be confined to subsidiary or complementary roles. For example, in chapter 7 it is argued that designs, which indeed are types that have physical objects as their tokens, should be distinguished from artworks that may be associated with such tokens.

I would claim that something like the current representational theory is the only plausible potential replacement that is available in the theoretical landscape.

3.2. THE VARIETY OF REPRESENTATIONS OF PLAYS

Section 1.1 mentioned that there are a variety of kinds of representation of a play, including texts, performances, and recordings of the play. Here is a brief supporting argument for that view.

First, it is a commonplace that in general there can be a great variety of representations of *anything whatsoever*, including many kinds of conventional symbolic representations, relatively nonconventional pictorial representations of various kinds, and so on. So one would expect that plays too would be representable in a correspondingly broad variety of ways. This much presumably could be agreed on by all, including those with differing views as to the nature of plays and performances, since the current approach is distinctive only in claiming that plays occur, or are referred to, *solely* as thus represented.

Second, in the case specifically of narrative fictional plays, which are in the conventional sense "representational" plays, any kind of representation of the *fictional world* associated with a play will—if our inseparability thesis is correct for plays and their fictional worlds—result in that representation also counting as a representation of the corresponding *play*.

Thus, for example, an *initial outline* by a playwright of the *plot* or *story* of a play she intends to write will, at least minimally, count as a *schematic* or *generic* representation of the relevant play, even before the play is written out in full, because of the hard-to-deny fact that the outline does indeed (schematically) represent the relevant fictional world. And hence the final textual version of the playwright's play, which undeniably represents the fictional world of the play to whatever greater degree of specificity is desired by the playwright, is also undeniably an equally specific representation of *the play itself*.

Presumably even that claim need not necessarily be disputed by theoretical opponents, because it might be held by them to be irrelevant to issues concerning the logic and ontology of plays and performances. On the other hand, a view specifically claiming that a play is a *type*, of which the text is a *token*, is *inconsistent* with the claim, since, as noted in the previous section, a token of a type X cannot also be a representation of X.

In the case of *performances* of a play whose text thus represents the play, it seems equally undeniable that they do represent the fictional world of the play, and hence represent the play itself.

As for auditory or visual recordings of performances of the play, there are two possible senses in which these might be "copies" of a performance. First, they might in some unusual cases count as genuine performances in their own right, if the director of the production of the play in question *intended* her performance primarily to be viewed via a recording of it, in which case such recordings might count as direct representations of the play, as with any other performances of it. On the other hand, any recording or copy that is not itself a genuine performance will at least be a *representation* of such a performance, and if it has a sufficiently high degree of fidelity or accuracy such a representation *of* a representation of the play will, at least for all practical purposes, be *usable as* a representation of the play.

3.3. TYPES, TOKENS, AND INTERPRETATIONS

After the foregoing theoretical extensions and clarifications of the double content or DC view of plays, I shall now proceed to give some reasons as to why that view might be preferable to other accounts of plays and their performances. As previously noted, I shall concentrate on two related common assumptions about plays: first, that a play is a *type*, performances of which are *tokens*, and second, that performances are *interpretations* of plays. Some well-known views of Richard Wollheim will provide a useful source of entry into the issues.

Wollheim introduced the type-token distinction into discussions of artworks, including plays and performances,[6] and generic forms of his views on the topic have become commonly accepted presuppositions about plays. A critical issue about types and tokens is that of the properties belonging to each, and of their relations. In Wollheim's view, types and tokens may not only share properties, but also *transmit* them, in the sense that one of them may "transmit" or "pass" a property to the other *because* the former has the property.[7]

Wollheim then makes three "observations" about, or conditions on, the relations of tokens and types, two of which I shall discuss in some detail. The first of these is that ". . . there are no properties or sets of properties that cannot pass from token to type,"[8] which we shall call the *property transfer* condition.

Wollheim justifies his property transfer condition as follows:

With the usual reservations [excluding properties pertaining only to tokens, such as location in space and time, and others pertaining only to types, such as being invented by some person], there is nothing that can be predicated of a performance of a piece of music that could not also be predicated of that

6. Wollheim, *Art and Its Objects*, secs. 35–38.

7. Ibid., p. 76.

8. Ibid., p. 81.

piece of music itself. This point is vital. For it is this that ensures what I have called the harmlessness of denying the physical-object hypothesis in the domain of those arts where the denial consists in saying that works of art are not physical *objects*. For though they may not be objects but types, this does not prevent them from having physical properties. There is nothing that prevents us from saying that Donne's *Satires* are harsh on the ear, or that Durer's engraving of St. Anthony has a very differentiated texture, or that the conclusion of "Celeste Aida" is *pianissimo*.[9]

I have quoted Wollheim at length on this point because one may agree with his assumption that any adequate theory of art, including a theory of plays, must have *some* way of explaining apparent attributions of physical properties to artworks,[10] and that, given the specific theoretical resources of a type theory, his property transfer condition is an unavoidable, core feature of such a theory.

However, in the next section it will be shown that it, in conjunction with a very plausible view about the relations of plays, texts, and performances, leads either to the theoretical collapse, or to the inconsistency, of type theory as applied to plays.

3.4. HOW THE PROPERTY TRANSFER CONDITION ENSURES THE FAILURE OF TYPE THEORY

Now I shall show, as announced, that the first of Wollheim's observations, his "property transfer" condition that ". . . there are no properties or sets of properties that cannot pass from token to type," has the effect of ensuring that a type theory of plays and performances must fail. As a preliminary, it will be helpful to quote some prior remarks of his about the genesis and identification of artistic types:

> In the case of any work of art that it is plausible to think of as a type, there is what we have called a piece of human invention: and these pieces of invention fall along the whole spectrum of cases. . . . At one end of the scale, there is the case of a poem, which comes into being when certain words are set down on paper. . . . At the other end of the scale is an opera which comes into being when a certain set of instructions, i.e. the score, is written down, in accordance with which performances can be produced.[11]

9. Ibid., pp. 81–82.

10. The current view that plays are fictional means that they cannot *actually* have physical properties, but certainly their representations can have such properties.

11. Wollheim, *Art and Its Objects*, pp. 79–80.

These remarks so far concern only the *genesis*, or coming into being, of the works, not the identification of any relevant types. However, Wollheim goes on to recognize that any relevant types and tokens might be identified in different ways:

> There is little difficulty in all this, so long as we bear in mind from the beginning the variety of ways in which the different types can be identified, or (to put it another way) in which the tokens can be generated from the initial piece of invention. . . . For instance, it might be argued that, if the tokens of a certain poem are the many different inscriptions that occur in books . . . , then "strictly speaking" the tokens of an opera must be the various pieces of sheet music or printed scores. . . . Alternatively, if we insist that it is the performances of the opera that are the tokens, then . . . it must be the many readings or "voicings" of the poem that are *its* tokens.[12]

To be sure, it is clear enough that Wollheim has his own preferences among these "arguments" as applied to plays and their performances, but my first point is that he is surely correct that the identifications *could* reasonably be done in those different ways.

Noël Carroll makes a related point about "considering" different ways of identification as follows:

> The difference [of plays from film] is partly a function of the fact that plays may be considered either as literary works or performance works. When a play, like the dramatic text of *Strange Interlude*, is considered as a literary work, then my copy of *Strange Interlude* is a token of the art-type *Strange Interlude*. . . . But when regarded from the perspective of theatrical performance, a token of *Strange Interlude* is a particular performance. . . .[13]

Thus both Wollheim and Carroll agree that in the case of performance arts such as music or theater, identifications of relevant types and tokens are (what could be called) *attitude-relative*: it depends on how some particular person wishes to argue a case, or alternatively how one wishes to "consider" it.

But surely this position serves only to show the *total ineffectiveness* or *collapse* of type theory as applied to plays: the initial appearance of presenting an objective, ontological theory about the nature of plays and performances has given way in each case to a tepid "it all depends on how you look at it" view.

However, without that attitude-relative view, type-token theories would be unable to cope with the plain fact (as Wollheim and Carroll in effect acknowledge by asserting their attitude-relative views) that there are good reasons for regarding *both* texts *and* performances as having the same rela-

12. Ibid., p. 80.
13. Carroll, *A Philosophy of Mass Art*, p. 213.

tion to plays—which relation cannot be that of token to type, on pain of contradiction. For either plays are types that have *texts* as tokens, or they are types that have *performances* as tokens—but not both, because of Wollheim's *property transfer* condition (namely that "... there are no properties or sets of properties that cannot pass from token to type"), which entails that a single type would have *contradictory* properties if both texts and performances were its tokens.

At this point the DC theory shows its strength. According to the DC theory both texts and performances *do* have the same relation to plays, namely that of *representation*: texts and performances can *both* represent plays, each in their own characteristically different ways, without any contradiction. Thus a DC theory of plays has a fundamental advantage over a type theory in handling such basic relations of texts, performances, and plays.

3.5. INTERPRETATION AND WOLLHEIM'S INCOMPLETENESS CONDITION

Wollheim's second condition is that "... though any single property may be transmitted from token to type, it does not follow that all will be: or to put it another way, a token will have some of its properties necessarily, but it need not have all of them necessarily."[14]

That second condition serves as preamble to a third, *incompleteness*. Wollheim observes that

> ... in the case of *some* arts it is necessary that not all properties should be transmitted from token to type. ... The reference here is, of course, to the performing arts—to operas, plays, symphonies, ballet. ... [I]n such cases there is essentially an element of *interpretation*, where for these purposes interpretation may be regarded as the production of a token that has properties in excess of those of the type.
>
> "Essentially" is a word that needs to be taken very seriously here. For there are certain factors that might disguise from us the fact that every performance of a work of art involves, or is, an interpretation.[15]

Thus, in Wollheim's view a play is a type that has performances as its tokens, but those tokens are *essentially* interpretations of the type, in the sense that they *must* have additional properties not possessed by the type itself. Thus Wollheim's view is that a play itself is *logically incomplete*, in the sense

14. Ibid., p. 82.
15. Ibid., pp. 82–83.

that, in order to achieve a genuine token or instance of the play, the play itself—the type—must be *interpreted*, in the sense of *supplemented* or *augmented*, with extra properties. Call this the *incompleteness condition*.[16]

A sign of how influential this incompleteness condition has become is that, in a recent symposium on "Staging Interpretations,"[17] none of the three participants (Saltz, Hamilton, and Carroll) directly disputes either it, or its type-theoretic basis—and the same goes for Wollheim's other conditions as well. To be sure, both Saltz and Hamilton deny that performances have to involve interpretations, but their denials apply only to richer and more intuitively natural concepts of "interpretation" that go beyond Wollheim's bare-bones "logical incompleteness" thesis. Indeed, all of the discussants seem to take it for granted that performances possess various properties over and above those belonging to the play itself.

However, from the point of view of a double content or DC theory, both Wollheim's incompleteness condition, and much of the content of such ensuing debates about interpretation, are confused or misdirected from the start by their acceptance of type theory, as I shall now briefly show.

First, on the DC view, Wollheim's issues about sharing or passing of properties from tokens to types are only applicable *within a type-token framework*. To be sure, his "observations" may be legitimate conditions as applied to *genuine* tokens or instances of *genuine* types, but they are simply *inapplicable* to the entities invoked by a rival DC theory, since it is a commonplace of representational theory that a representing object need not significantly resemble, or be similar to, that which it represents.[18] Also relevant is the previous section 3.1 discussion of how a representation of X, by definition, is not itself an X that has all the necessary properties of an X.

Another commonplace of representational theory is that there can be a great variety of *different kinds* of representation, or ways of representing of, one and the same object or entity. Thus, from the point of view of a DC theory, it is an obvious non sequitur to argue from the fact of the *variety* of possible performances of a given play—which performances are representations of the play on a DC theory—to a conclusion that therefore those various performances must in some way be representing or "interpreting" *the play itself* differently. Clearly that would involve a significant confusion of properties of *a representing event*—a performance—with properties of *what* is thus represented by that performance-event, namely the *relevant play itself.*

16. However, Wollheim does deny that this logical incompleteness amounts to a *defect* in the types that are plays: see *Art and Its Objects*, pp. 83–84.

17. David Z. Saltz, James R. Hamilton, and Noël Carroll, "Symposium: Staging Interpretations," *Journal of Aesthetics and Art Criticism* 59, no. 3 (2001): 299–316.

18. E.g., see Dominic Lopes, *Understanding Pictures* (Oxford, UK: Clarendon Press; New York: Oxford University Press, 1996), chap. 1.

To be sure, these points do not preclude that some putative performance of a given play might, because of ways in which its own properties differ from those of other performances, *fail* to represent exactly the same play as is represented by the other performances—or, otherwise put, that it might thereby *succeed* in instead representing a distinct, "interpreted play" whose differences from the original play have some indirect connection to that performance's own idiosyncratic properties. My point is rather that such a case would have to be *specifically argued for*, since mere differences in properties *as such* between performances have no implications as to precisely what is consequently *represented by* those performances.

Thus, in sum, a DC theory will naturally reject Wollheim's logical incompleteness condition for plays, along with any arguments for the "interpretive" nature of performances that are based on it; and indeed a DC theory will regard any such arguments, based as they are on the *mere variety* of possible performances of a play, as fallacious.

3.6. A DOUBLE PERFORMANCE COUNTEREXAMPLE TO TYPE THEORY

Another consideration counting against a type theory is more powerful because of its complete independence from the previous considerations. In this section I shall show that there is a logical feature of type theory which makes it impossible for such a theory to satisfactorily explain a possible *double performance* case: one in which a single play performance is actually a performance of two *different* plays. I shall also show that, on the other hand, a corresponding DC theory *is* able to explain the unusual case in question.

As a preliminary point about the related performing art of music, it is generally recognized that musical compositions cannot be individuated purely by their scores, for it is possible that two different composers might produce *textually identical musical scores*, which nevertheless would provide the textual basis for two *distinct* pieces of music—both because of the fact that there are two different composers involved, and because of their differing artistic intentions concerning their respective musical works.[19]

A similar point applies to the texts of literary works as well, as Borges showed with his well-known example of a fictitious work by one "Pierre Menard," the text of which was word-for-word identical with the text of a section of Cervantes' *Don Quixote*, but whose aesthetic qualities were quite different, hence ensuring its identity as a literary artwork distinct from the

19. E.g., see Jerrold Levinson, *Music, Art, and Metaphysics: Essays in Philosophical Aesthetics* (Ithaca, NY: Cornell University Press, 1990), chaps. 4 and 5.

relevant part of *Don Quixote* itself.[20] With these generally acknowledged antecedents in mind, I shall assume that a similar point holds for plays also—that is, that there could be two distinct *plays*, written by different authors with different intentions, which nevertheless had identical texts.

Now I shall begin to construct the case, which draws initially on an interesting musical example provided by Jerrold Levinson, which involves two distinct but identically scored musical waltzes by composers Y and Z:

> . . . suppose I intend to play a famous waltz by Y I have not heard and have never seen the score of. Someone devilishly gives me a score of the Dadaistic composer Z's recent waltz, which strangely enough has the same S/PM [sound-performance means] structure as Y's waltz. [Which therefore has the same score as Y's waltz.] I think that the sound event I produce is a performance of Y's waltz, not of Z's waltz. . . . This suggests that at least in some cases it is what you think you are producing or performing, not what copies or scores you are actually using, that determines what work the result belongs to. . . .[21]

I am inclined to agree with Levinson about this specific case—though not, of course, with the type-theoretic framework within which he embeds it—but things become more equivocal if the situation is expanded as follows. First, suppose that famous playwright A has written a play AT, which the Janus theater company is preparing to stage. A sends them his script T1, but it is intercepted by a scheming rival playwright B, who has written another play BT, yet which, strangely enough, has a script T2 that is word for word identical with the script T1 of A's play. B is determined to get his play staged by the Janus company, and so he sends his script T2 to Janus in place of A's script T1, without informing them of the substitution.

Now so far there is no difference from Levinson's example: presumably if the Janus company mounts a performance that uses B's script T2 for his play BT, they will nevertheless still be performing A's play AT rather than B's play BT, since their *intention* is to perform A's play AT.

But second, suppose that B realizes the ineffectiveness of simply sending his own script T2, and devilishly decides to improve his chances by actually *taking part* in the Janus rehearsals himself—not, I hasten to add, *as* himself, but instead *disguised as* famous playwright A!

Third, suppose that B's deception is successful, and that the Janus company happily accepts B's suggestions as to matters of staging, interpretation,

20. J. L. Borges, "Pierre Menard, Author of the *Quixote*," in *Labyrinths* (Harmondsworth, Middlesex, UK: Penguin, 1985).

21. Ibid., pp. 99–100. See also the useful discussion of such cases in Stephen Davies, *Musical Works and Performances*, pp. 166–81.

and so on with respect to their developing production, in the belief that they are taking direction from A himself concerning A's play AT.

Now I claim that, if one imagines an ordered range of cases with varying amounts of influence by B on the developing production, from very slight to very great influence, then intuitively it will be hard to deny that the cases must fall into *one of three, nonempty ordered categories*,[22] as follows. First, if the influence by B is only *very slight*, then it is as if B were not present at all, and so the company is still performing A's play AT. Thus there is a "slight" *category 1*, a range of cases in which B's presence essentially makes no difference.

Jumping now to the other extreme, if B's influence on the Janus company is *very great*, or even *overwhelming*—to the extent that their whole conception of the play they are trying to perform is molded and directed by B—then it seems hard to deny that under these conditions it is *B's play BT* that they are performing, rather than A's play AT. These are *category 3* cases of *conclusive* or *definitive* influence by B, a range of cases in which B's presence makes *all* the difference as to which play is being performed by the company. This case could still be made to fit Levinson's (appropriately translated) view that the intentions of the company determine which play is being performed. For, among other things, they intend to perform *the play authored by the man who is giving them directions and suggestions*, which man happens to be B himself rather than A—so that even on intentional grounds, there is a clear sense in which they intend to perform (what is in fact) B's play, even though they also have some false beliefs about B.

However, the main point of this whole example is that there will inevitably also be an *intermediate* range of cases, defining a *category 2*, in which B has *some* influence, or moderate influence, on the company's production—so that his influence is not merely "slight" as in category 1—but not *so* significant an influence as to make B's influence "conclusive" as in category 3.

Now my question is: which play, or plays, is being performed when category 2 kinds of moderate influence by B obtain?

Let us review the options. First, as any theater-goer at a performance of the relevant production could attest, there definitely is *some* play or other that the Janus company is performing, because the audience members are actually watching and experiencing a performance of some play. So the issue cannot be dodged by denying that *any* play is being performed.

Second, though there is a continuous range of influence cases, there is no continuous range of *plays* to be considered, no "intermediate" play in between A's play AT and B's play BT. Indeed, it is unclear what that could even mean, since such an "intermediate" play would be unintended and au-

22. A more scrupulous account would have five categories, the extra two being unclear or borderline cases between categories 1 and 2, and categories 2 and 3; but that refinement would make no difference to my argument.

thorless. Hence whatever play or plays is being performed must be selected from the group of AT and BT: there are no other possible candidates.

Third, neither AT by itself, nor BT by itself, is a valid choice as to which play or plays is being performed. For either choice would amount to a denial that there *are* any intermediate, category 2 cases, which are essentially cases in which an *equally or equivalently good* case can be made for each play that it is being performed by the company.

Finally, then, the only remaining possibility is that the company is, under those conditions of prior moderate influence by B, performing *both plays simultaneously*. For a condition of *moderate* influence is one in which it is the case, both that the influence of B is not so strong as to positively *prevent* A's play AT being performed—as with category 3 cases—yet also one in which it is the case that the company is *enough* influenced by B so that they are *also* performing B's play BT (unlike category 1 cases).

Note that the argument here does not depend on any substantive assessment of the strength of any *particular* arguments for or against a particular play being performed under various conditions, because such arguments would merely show a need to shift or reset the boundaries of categories 1, 2, and 3 appropriately. Thus for instance, an argument to the effect that, under certain specified conditions of uncertainty, there should be a default presumption that it is *solely A's play AT* that is performed would merely show a need to shift the boundaries of category 2 so that it starts *above* that area of uncertainty.

Nor could such particular arguments show that category 2 is *empty*, because, for instance, any arguments about the presumptive strength of play *AT*'s claim to be performed, to the extent that they are successful, would ipso facto have some legitimate weight even in cases when the evidence is *also* strong (because of the strength of playwright B's influence) that play BT is performed as well.

I conclude that the above case shows that it is *epistemically possible* that there are conditions under which the Janus company could *justifiably be claimed* to be performing both play AT and play BT simultaneously.

Now I take it that it would be agreed that a condition of adequacy on any *logical* or *ontological* theory of the nature of plays and performances is that it should not foreclose on, or judge as logically or ontologically *impossible*, any situation that is genuinely *epistemically possible* in the manner just described.

But it is easy to show that any *type theory* cannot allow the ontological possibility of a single performance simultaneously being a performance of two distinct plays. For since plays are types, according to a type theory, then *distinct plays* must be *distinct types*. But for types of the same general kind (such as the assumption by a type theory that there could be two types which were both *plays*), distinctness must be defined as *disjointness* of the sets of their tokens.

Example: for two biological species to be *distinct types* of species, such as pigs and cows, it must be the case that there is no animal that is both a pig and a cow, that is, the set of pigs and the set of cows must be disjoint.[23] Hence on the "type" view, according to which a performance is a *token* of a play *type*, a single performance could not simultaneously be a token of two *distinct* play types.

I conclude that any type theory of plays must fail to meet the above adequacy condition on nonforeclosure of genuine epistemic possibilities, and so any such theory must be rejected. And as a final note, perhaps it is clear enough that an equivalent musical example could easily be constructed, so that type theories must fail for musical works as well.

However, the competing double content or DC theory is not subject to any such problems since there is no logical bar to a single object or event, such as a performance, *representing* more than one entity (such as two different plays) simultaneously. Although a single performance event could not itself *be* a token or instance of two distinct, conflicting *kinds*, that does not prevent such a single event from standing in the much weaker relation of *representation* to two distinct entities such as distinct plays.

3.7. PLAYS ARE PARTICULARS RATHER THAN TYPES

To conclude the current arguments against type theories, I shall now present a much simpler or more basic independent argument against the possibility of individual plays being types, which invokes some metaphysical first principles.

To begin, an important logical or metaphysical fact about either the type-token, or the kind-instance, relation is this: that a token or instance is the *lowest-level* or most *particular* element in a hierarchical, genus-species-individuals system of classification, so that a token or instance of a type or kind cannot *itself* be a type or kind that could in turn have its own tokens or instances. Thus tokens or instances are *particulars* or *individuals*.

Alternatively put, any *particular entities* to which a system of classification is applied, whether they be concrete or abstract particulars, have their particularity *absolutely*, in the sense that the concept of particularity applying to them is not relative to levels of classification (as if an item that was "particular" at one level might nevertheless itself be a kind or type relative to even lower levels of particularity).

A related point is that the distinction between universals and particulars does seem to be metaphysically fundamental, so that particulars cannot be ana-

23. See also the discussion of these issues in chapter 7, in which I also present a related antitype "double artwork" case, involving the (nonperforming) art of sculpture.

lyzed away as mere bundles or structures of universals—and that metaphysical fact is arguably what undergirds the logical or classificatory facts just presented.

Next, given the fact that particulars or individuals such as tokens or instances cannot be types, if we can show that plays are *themselves* tokens or instances, this will suffice to prove that they cannot (also) be types. This we shall now do.

First, one thing that is definitely true of individual plays such as *Hamlet* or *Othello* is that each of them is *a play*, or more explicitly, that each of them bears some relation to the *type* or *kind* "play." But what is that relation?

The conclusion seems unavoidable that individual plays are *instances* or *tokens* of the type or kind "play," which is in turn a subspecies of the more generic kind "artwork." Now to be sure, there are *different kinds* of play, such as representational and nonrepresentational plays, but that merely shows that the type or species of "play" itself has various *subspecies*; it does nothing to undercut the conclusion that individual plays are the particular, lowest-level members of each such subspecies. Hence we conclude that individual plays are indeed individuals or *particulars*, which cannot themselves in turn be types.

As for the DC approach to plays, it has no problem at all with plays being individuals or particulars, since some paradigm cases of representation are cases of representation of particulars, such as particular persons, objects, or scenes, whether fictional or nonfictional. Of course, this is not to deny that there may be fundamentally different *kinds* of particulars that may be thus represented, with fictional entities perhaps having a different status than concrete particulars. My point is merely that all of them are "particulars" in the inclusive sense of their *not* being *types* or *kinds*.

3.8. CONCLUSION

I hope to have made some headway in this chapter in showing that a representational approach to plays, texts, and performances has at least the potential to be a significant competitor to more standard accounts of their relations, such as the type-theoretic views that have been the main focus of our criticisms here. But because of the complexity of the many issues about plays, it was only possible to briefly touch on such important topics as that of whether *performances* of plays are inevitably *interpretations* of them. But at least I hope to have set the stage for more thorough discussions of such issues elsewhere.

Also neglected in this chapter have been issues about the generalizability of the DC representational account to other performing arts, such as music,

and then to the arts generally. But perhaps it is clear enough that if the current criticisms of type-theoretic approaches to plays are successful, then similar or related arguments could be deployed against their application in other areas of the arts as well.[24]

24. See again chapters 4 and 7.

Part 2

Visual Arts

An RC Theory of the Visual Arts

Now that the generic representational content (RC) and more specific double content (DC) theory of art has been defended in the case of fictional plays, it is time to investigate *visual* arts such as painting, drawing, and photography, to see whether the RC approach to artworks can be successfully applied to them as well. This chapter will concentrate on defending the more generic RC theory, though chapters 5 and 6 will defend the full DC theory in some novel ways, not already presaged in the previous discussions of plays.

On the face of it, the difficulties faced by an RC theory in the visual arts are much more formidible than those already investigated for plays or other literary works, in that paintings or drawings seem to be very intimately associated with *particular physical artifacts* such as pieces of stretched and painted canvas, or sheets of marked paper, as prepared by the relevant artists. However, in chapters 4 to 6 I shall show how this initial "presumption of physicality" for visual artworks may be broken down.

As a related issue, such visual artworks also seem to be distinct from plays, novels, and the like in their *conditions of originality*. It is usually assumed that even an *exact duplicate* of an artist's original painting would not count as being the *same* work of art as the original, but that instead it would be a mere *copy* of it, or at best—even if it did count as an artwork—an artwork that would be *distinct* from the artist's own original painting.[1]

On the other hand, in the case of plays or novels, the author's original manuscript and copies of it are equally regarded as being legitimate copies of

1. Such works are described as *autographic* by Nelson Goodman: N. Goodman, *Languages of Art: An Approach to a Theory of Symbols* (Indianapolis, IN: Bobbs-Merrill, 1968), chap. 3, sec. 3, "The Unfakable."

the play or novel in question, one implication of which is that there is no one unique physical artifact with which the artwork in question might plausibly be identified.[2]

The outcome of this point is that such visual works, in being *autographic* rather than allographic, may for this reason too—in addition to the more general "presumption of physicality" for such works—seem to be necessarily linked to a particular physical artifact.[3]

Thus my task in the first two sections of this chapter is to show two things. First, the autographic status of unique visual artworks can be *maintained* on the representational content view—since the RC view is not intended to undermine common intuitions about visual artworks, but rather to be supported by them. Second, the "presumption of physicality" for such visual artworks can be *undermined*, hence leaving room for the RC view, according to which such physical artifacts *represent* such artifacts, rather than being identical with, or in some way necessarily associated with them. Thus my view will be that neither are an artwork (such as a painting) and its associated artifact identical, nor is the artifact in any sense *part* of the painting in question.[4]

I shall proceed initially through presentation of some counterexamples to common assumptions as to the relations of artifacts and artworks, and then explain how the double content theory could provide a more adequate theory of their relations.

4.1. ARTIFACTS, ARTWORKS, AND COUNTEREXAMPLES

Stephen Davies in his book *Definitions of Art* provides a useful overview of various positions on artifacts and artworks.[5] He defines one primary type of

2. Goodman describes such works as being "allographic" rather than autographic in his *Languages of Art*. Other allographic art forms would include performing arts such as music and dance, as well as film and video works.

3. Though in the case of some other autographic visual artworks, such as a set of original prints, there may be more than one original of a given work. See section 4.1 on Rembrandt etchings, and also chapter 8 on printmaking.

4. Various writers hold that there is some kind of nonidentical, part-whole relation between artifacts and artworks; for Danto, an artwork is a whole which includes an artifact and an interpretation as its parts, e.g., see A. C. Danto, *The Transfiguration of the Commonplace: A Philosophy of Art* (Cambridge, MA: Harvard University Press, 1981), while for Margolis an artwork is embodied in an artifact, e.g., see J. Margolis, *Art and Philosophy* (Brighton, Sussex, UK: Harvester, 1980).

5. Stephen Davies, *Definitions of Art* (Ithaca, NY: Cornell University Press, 1991).

artifact as follows: "In its primary (a) sense 'artifact' means that which is modified by work, by contrast with that which occurs in its natural state."[6]

On Davies's view, an (a)-type artifact is material in that its progenitor (for example, a piece of wood) is a locatable, modifiable individual, which becomes artifactualized in having a stool carved from it.[7] Davies assumes, as do many other writers, that at least some artworks are (a)-type artifacts.[8]

As noted previously, I shall attempt to refute this view (in fact, via refutation of some weaker forms of it), initially through presentation of some counterexamples, and then by presenting an alternative theory of the relations of artifacts and artworks. Thus, as might be expected, I shall concentrate my discussion on (a)-type artifacts (and their associated artworks).[9]

I shall now proceed by showing, as promised, that three perhaps initially plausible claims concerning the relations of artifacts and artworks are false for paintings, but that nevertheless the autographic thesis for paintings can still be maintained. All three claims to be investigated share a common assumption, namely that to each artwork there corresponds, at a given time, exactly one actual artifact.

The first claim is that an artifact is identical with its corresponding artwork. If this were true, then the identity-criteria for an artwork would be the same as those for its corresponding physical artifact, which would ensure the truth of the autographic thesis, since any physical object has distinct identity-conditions from any other (hence permitting unique identification of an original artwork as causally related to its creator, and thereby ensuring its distinctness from any copies, that will have their own different causal histories).[10]

Rather than attempting to directly provide counterexamples to this claim, I shall instead do so for the succeeding two weaker claims, whose falsity will entail the falsity of the identity claim. (However, the identity claim itself has already been thrown into question in the literature. For example, Danto's indiscernibility examples seem to show that there can be indiscernible artifacts, one of which is a work of art and the other of which is not, from which he concludes that a work of art and its associated artifact must be distinct.)[11]

6. Ibid., pp. 123–24.

7. Ibid., p. 124.

8. Ibid., pp. 120–21, 140.

9. However, my account would also cover those unusual cases in which some object (such as an exhibited piece of driftwood) may be associated with an artwork in an artifact-like way, but which has not actually had any work performed upon it, and so strictly does not conform to Davies's definition of an (a)-type artifact (ibid., p. 128 and passim).

10. Goodman, *Languages of Art*.

11. Danto, *The Transfiguration of the Commonplace*, chap. 1. Others providing arguments for the distinctness of artifacts and artworks include Margolis, *Art and Philosophy*, and R. Wollheim, *Art and Its Objects: With Six Supplementary Essays*, 2nd ed. (Cambridge, UK, and New York: Cambridge University Press, 1980).

The second claim is that a necessary condition of the identity of a given painting is the inclusion (in some sense) in it of a given particular associated artifact. This could be called the *necessary artifact* claim. As with the first identity claim for artifacts and artworks, the necessary artifact claim, if true, would also support the truth of the autographic thesis, in that each genuine artwork would be uniquely individuated by its corresponding necessary artifact.

An implication of the necessary artifact claim is that, for a given artwork X that includes artifact A, no other physically distinct artifact B could be substituted for A, on pain of X losing its identity as artwork X, even if B is qualitatively indistinguishable from A. Another related implication of the claim is that two numerically distinct artifacts (whether or not they are indiscernible) must be parts of distinct works of art, even if each is given the same interpretation.[12]

The necessary artifact claim might initially seem unobjectionable, as a mere spelling out of what is involved in claiming that a given physical artifact is in some way an integral part of its corresponding artwork. However, counterexamples to the claim can be produced, as I shall now show.

One class of counterexamples can be generated from various contingencies arising in connection with the creation of paintings. For example, Leonardo's painting *Mona Lisa* has as its associated artifact a certain piece of stretched canvas A, currently located in the Louvre, in Paris. However, Leonardo might instead have used some other canvas B as the basis for this painting, and he might also have used different particular containers of paint with which to paint canvas B, so that artifacts A and B have no parts in common. Nevertheless, it seems intuitively clear that the resulting painting (with associated artifact B in place of artifact A) would still be the same painting *Mona Lisa*.

As an argument in favor of this interpretation, consider how absurdly constricting it would be to a creative artist if even trivial choices about which particular samples of materials to use inevitably forced her into decisions about the identity of her artwork, quite independently of her specifically artistic decisions that are what most relevantly determines the identity of a resulting work of art. Such an artifact-constricted concept of artwork identity clearly is not one that is actually used by artists and critics.[13] Hence the necessary artifact claim should be rejected.

A second class of counterexamples to the necessary artifact claim is provided by cases of alterations to an initial artifact A (associated with artwork

12. Danto, *The Transfiguration of the Commonplace*, regards an interpretation as being partly constitutive of a work of art, but nevertheless his account is not developed enough for it to be clear whether he would accept either of these implications.

13. Compare Wollheim's view, in *Art and Its Objects*, pp. 172–73, that Vasarely's unusual theory of art is not one that an artist could integrate into his normal working practices.

X) that gradually change it into an entirely different artifact B that has no parts in common with artifact A. For example, suppose that an artist finds to her horror that a favorite early work of hers has begun to deteriorate, with its cheap paint peeling off the canvas. She decides to restore it to its original condition and does so by carefully removing the original paint, one section at a time, and then repainting each section exactly as it was originally.

Some time later she is also disconcerted to find that the original canvas (which was as cheap and perishable as the original paint) has deteriorated, so she carefully removes the old canvas from the layer of new paint and replaces it with a new piece of canvas.

In this case, the resultant painting-artifact has no parts in common with the original painting-artifact, but it seems hard to deny that the resulting artifact is still the same painting (considered as a work of art), particularly since the artist herself authorizes and carries out each stage of the restoration work on her own painting to her own satisfaction.

In further support of this kind of example, it is commonly accepted that paintings may legitimately be restored in cases of deterioration without the artwork in question being thereby compromised or destroyed. Usually this involves some limited change to some part or parts of the artifact in question (such as the removal of a surface layer of darkened varnish), but if change to some parts of an artifact is allowed, with no resulting compromise to the integrity and identity of the original artwork at any stage, it is hard to see how further incremental changes could be objected to, even if they have the result that eventually all of the parts of the original artifact have been replaced. Hence I conclude that such artifact-alteration cases too (as with the previous contingency cases) show that the necessary artifact claim should be rejected.

The two kinds of counterexample just given to the necessary artifact claim both depend on pointing out some kind of contingency in the relation of an artifact to its corresponding artwork: either the artifact might have been a different one, or it might have been replaced with a different artifact at different times. This suggests a need to examine a third claim, to be called the *contingent artifact* claim, which is immune to these kinds of counterexamples.

The contingent artifact claim states that a necessary condition of the identity of a given painting is the inclusion (in some sense) of *some* particular associated artifact. (This differs from the necessary artifact claim in that now *some* one artifact is necessary, rather than one given particular artifact.)

As with the previous two claims, the contingent artifact claim, if true, would also support the truth of the autographic thesis, in that each genuine artwork would have in actuality a unique artifactual causal history, even if artifactual changes were part of that causal history, and even if it is also true that the causal history in question could have been different.

However, the contingent artifact claim is also vulnerable to counterex-

amples, as I shall now demonstrate. These are based on a denial of the common factor in all three claims being considered, namely that to each artwork there corresponds, at a given time, exactly one actual artifact. In order to show that the contingent artifact claim is false (and hence the others too), it would be sufficient to find cases in which more than one artifact is simultaneously associated with a given artwork. This I shall now proceed to do.

The first case is that of an artist who paints artwork X (with associated artifact A), then subsequently comes to believe on good evidence that A, and hence X, have been destroyed in a fire. So the artist proceeds to recreate the same artwork X (with a new associated artifact B). However, as a matter of fact, by some fortunate chance the initial painting X was not destroyed after all; so after the re-creation of X by the artist, there are now not one but *two* distinct artifacts A and B associated with the given artwork X, hence showing the falsity of the contingent artifact claim.

The second case addresses a doubt that some may have concerning the first case, based on the temporal separation of the creation of the two different realizations of the given artwork. In this second case, a painter has an excellent recollection of what he intends to paint, but (perhaps because of illness or senility) has only a very poor memory of his recent actions in the last day or so. Noting this, an assistant of his hits on an ingenious scheme by which to ensure that the artist will produce not one but two concurrent realizations of the same artwork.

On day one the assistant gives the artist artifact A, who then performs some initial painting on it. On day two the assistant instead produces artifact B for the artist to work on, perhaps quieting any doubts that the artist might have (based on vague memories of the first day's work) by saying that the artist must be remembering some preliminary sketches rather than an actual start on the work. So the artist proceeds to carry out the same initial painting activities on artifact B as he had initially carried out on artifact A on day one.

On day three the assistant again produces artifact A for further painting, with day four involving the same further painting activities as applied instead to artifact B, and so on for subsequent days, until each of the identical realizations is finished. The result is two artifacts A and B, each of which is associated with the same artwork X, and each of which was produced concurrently, with the artist intending for each of them that it should be the same unique work of art.

This case is also perhaps harder to deny than the first, in that any doubts as to whether each artifact is the *same* work of art can be put aside. For each artifact A and B, it is true that the painter intended *it* to be the first and only realization of artwork X, and neither has more or less claim to be a realization of artwork X than the other. In addition, for either A or B it would be true that, had the assistant not brought in the other, the creation of artwork

X would have proceeded as normal, with exactly the same stages of intentions and painting activities applied to the chosen artifact as those that actually were applied to it, the only difference being the irrelevant one of the similar activities being performed, on intervening days, upon the other artifact. (Surely we cannot impugn an account of artistic identity for a given artifact merely on the grounds that the artist was also doing other things during the period in question, and that he tended to be forgetful about some things.)

There might be an attempt to evade the force of these counterexamples to the contingent artifact claim in the following two ways. First, it might be claimed that, since several distinct artifacts are found in some such cases, then this simply shows that the artworks in question are types rather than particulars. However, I shall demonstrate the inadequacies of a type-view in section 4.2, and also provide an alternative view that can maintain the particularity and autographic status of a work of art in spite of its having multiple cases, and hence reinforce my view that the above counterexamples are legitimate.

A second way of evading the counterexamples might claim that in the "multiple" cases the paintings in question are, simply in virtue of their multiplicity, thereby shown not to be examples of autographic art after all, and so in effect the examples merely demonstrate the truism that nonautographic or "allographic" art (in Goodman's terminology)[14] can have multiple instances. However, Goodman acknowledges that some autographic art forms permit multiple instances (for example, a Rembrandt etching can exist in multiple copies, each of which is a genuine, original Rembrandt etching).[15] Therefore the mere existence of multiple copies of an artwork does not debar a work from being autographic.

Nevertheless, there is a legitimate deeper concern here, namely that a painting is normally intended to be a single, unique artwork by its artist, and so at least this feature should be preserved in any account of the manner in which a painting (as opposed to an etching) is autographic.

However, in the examples given, each artist *did* intend, for each artifact worked upon, that it should be the sole artifact associated with the corresponding artwork. Also, a distinction can still be preserved between the artist's original artifacts associated with artwork X, and any other mere copies or forgeries of those original artifacts, so that such multiple realizations of a given artwork still conform to Goodman's definition of autographic art, in that even the most exact duplication of them does not count as producing the same work of art.

Thus, in summary, all three claims (the identity, necessary artifact, and contingent artifact claims) have been shown to be false. Yet in spite of their falsity, the autographic thesis as applied to paintings has been maintained.[16]

14. Goodman, *Languages of Art*, p. 113.
15. Ibid., pp. 114–15.
16. I further discuss the autographic thesis in section 4.3.

4.2. TYPE-TOKEN THEORY
VERSUS THE RC VIEW

Given the falsity of the three claims considered in section 4.1, there remains a significant open issue, namely that of finding some logic and ontology of works of art that is consistent with the falsity of the three claims concerning the relations of artworks to their associated artifacts.

One possibility sometimes invoked in such contexts is the view that visual works of art (and hence paintings) are *types* or kinds. If they were types or kinds (proponents would say), then multiple artifacts associated with a work of art would become unproblematic, because each artifact could be regarded as a token of the type in question, or as an instance of the relevant kind.[17]

However, this view of visual artworks is inadequate for several reasons.[18] I shall not claim to decisively refute this view of visual artworks here, but I hope to throw enough initial doubt on it so that the desirability of finding an alternative view becomes evident.[19] One problem is that types and kinds are "general" entities rather than individuals. But works of art such as paintings or (many) sculptures seem to be paradigm cases of particular individuals, so it is unclear how a type theory could give a satisfactory account of them.[20]

A grammatical argument can reinforce this point. With ordinary types or kinds, such as in the case of two animals that are cows, we would say of them that each is a distinct cow, even though each is the *same kind or type* of animal (namely, a cow). Thus in usual contexts, cases of kinds are "flagged" with respect to their kindhood by it being explicitly said that the sameness in question is with respect to (some specific) kind or type. However, in the case of a work of art, the type analyst is in effect claiming that no such flagging is necessary: the theory presumably asserts that two tokens or instances of an artwork are the *same artwork* (not the *same type of artwork*).

But the most such analysts are entitled to claim is that the two instances or tokens are *tokens* of the same *type* of artwork. However, just as two cows are distinct cows even though each is a token of the type "cow," so also (on a

17. Support for a "type" view as applied to visual works of art is provided by G. Currie, *An Ontology of Art* (New York: St. Martin's Press, 1989), and Margolis, *Art and Philosophy*.

18. Recall also that a type view of *plays* has already been seriously questioned in chapter 3.

19. Further arguments against a type view as applied to visual artworks are given in chapter 7.

20. Margolis, *Art and Philosophy*, chap. 2, attempts to have his cake and eat it too on this issue, by declaring that not types but only tokens-of-a-type exist. This retains the particularity of artworks, but arguably at the cost of abandoning the claim that artworks literally are types.

proper type analysis) we would have to say that there are two distinct art-works, even though each is a token of the same "type" artwork in question. Hence a type theory fails to account for how several artifacts (as discussed in my counterexamples) could be such that each can, in usual contexts, be correctly described as being *the same* work of art as the others.

Type theorists might reply that such apparent failings are unimportant, in that the main persuasiveness of a type view is to be found in cases of artworks that naturally exist in multiple copies (paradigm cases of which include movies and literary works), and that the strength of a type analysis in such cases could make it acceptable to overlook a certain awkwardness in a type analysis of paintings and other such individual artworks.

However, a type analysis of movies and literary works is open to at least one significant criticism that is perhaps even harder to deflect than those just given for paintings. This criticism could be called the *diversity of tokens* problem: a movie, for example, can exist in many different forms, including the original film negative which results from the shooting of the movie, positive film copies taken from the negative, screen images caused by the projection of positive copies, videotaped or digital video disk (DVD) copies of the movie, displays on TV screens or other video display units, computerized copies stored in an encrypted form on a computer hard drive, displays of such on a computer screen, and so on. Or a work of literature such as a novel can also exist in a great variety of forms: as a handwritten manuscript, as typed, as printed in various editions, as translated into other languages, and in spoken form as well.

Thus a question for the type theorist arises, namely, how could each of this great diversity of items possibly be tokens of the same type, given that the tokens themselves are so different in each case? Or in more traditional terms, if a movie or work of literature is a kind that has many instances, how could such diverse instances all count as instances of the same kind?

This problem for the type theorist is initially easy not to notice, for after all we know (or assume) that there must be *some* relation between a movie or work of literature and their diverse cases that makes each of them a case of the artwork in question, and in the absence of an alternate theory it is assumed that the relation in question must be that of type to token (or kind to instance). However, the assumption with respect to types only needs to be questioned for its problematic status to be revealed.

Given the (at least initial) failure of type-based views of the ontology and identity of artworks, what other possibilities remain? The RC view, on which an artifact *represents* an artwork, rather than being part of it or a token of it, has already been shown to work well for artworks such as plays, and now I shall show how it may be adapted so as to provide effective solutions to problems in the visual arts also.

With respect to movies and literary works, an RC view has a ready solu-

tion to the "diversity of tokens" problem as discussed above. The great differences between movie negatives, prints, screenings, and so on can be explained by the fact that each *represents* the movie in its own way, using its own characteristic mode of representation. Hence the differences can be explained as differences in mode of representation rather than in what is represented.[21]

In the case of literature, an RC theory potentially has even greater advantages over a type theory. Linguistic symbols are of course largely conventional, and so in addition to the "diversity of tokens" problem, there is also the issue of how any *one* of the supposed tokens could indeed be a token of some relevant literary (as opposed to merely linguistic) type. To illustrate the problem, the claim of a type-theorist that a token word such as "pig" is a token of the type-word "pig" does nothing to explain how either the tokens, or the type, denote or refer to actual pigs (or the kind "pig"). Denotation is a semantic concept, an integral part of the many ways in which linguistic symbols are, of course, symbolic or representational (in a wide sense). Thus in the case of literature, a (suitably wide) representational theory framework could be viewed as providing an intuitively natural starting point for investigations into the nature of literature generally, in addition to the specific case of literary plays.

Returning to the main issues of this chapter, concerning paintings and other autographic art forms, an RC theory can also explain the sense in which two copies or cases A and B of the same painting could indeed be the *same* painting (and not merely: tokens of the same type of painting).[22]

The logic of representation is such that if artifact A represents painting X, then A can be seen or recognized as X.[23] Reports of such a recognition could naturally be described as cases in which one sees that "A is X." A similar recognition in the case of artifact B (which, recall, is another copy of the painting in question) supports the claim that "B is X." This joint situation (of A being seen as X, and B being seen as X) is naturally described as one in which one sees the *same* painting X in each case.

The RC theory analysis of this situation is that the "is" in "A is X" is really an "is" of representation, so that "A is X" is analyzed as "A represents X" (or as "A is seen as representing X"). Thus artifacts A and B both represent the *same* painting X, hence supporting the claim that one sees the same painting X when looking at either A or B.

21. Two useful works on this and other features of visual representation are D. Lopes, *Understanding Pictures* (Oxford, UK: Clarendon Press; New York: Oxford University Press, 1996), and R. Wollheim, *Painting as an Art* (Princeton, NJ: Princeton University Press, 1987).

22. Such as cases resulting from my counterexamples to the "contingent artifact" claim, as discussed at the end of section 4.1. Or two genuine, artist-produced prints of the same etching or photograph would provide another example.

23. Lopes, *Understanding Pictures*, chap. 7 defends such a view.

4.3. FEATURES OF AN RC THEORY OF VISUAL ARTWORKS

First I shall briefly motivate an RC theory of art as applied to paintings and other visual artworks. There are already familiar cases in which we talk of a representation of a painting, for example, in the case of Velasquez's work *Las Meninas*, in which a representation of his own painting is included as part of the subject matter of the work. Now imagine another painting in which the depicted or represented painting no longer occupies just one small part of the canvas, but where instead it is first spatially rotated so as to be perpendicular to the line of sight, and then enlarged so that the represented painting (minus its frame) occupies the *whole* of the area of the canvas. But surely, if it was a representation of a painting when it was unrotated and occupied less than the whole of the canvas, it will not cease to be thus merely because it has been rotated and enlarged. Thus there is nothing inherently mysterious or problematic about an RC theory of paintings and other visual artworks, because such representations are already recognized to have a familiar (though limited) role in our current artistic culture.[24]

Now, as to some of the basic features of an RC theory of visual art. One useful approach to this task is to show how an RC theory can provide solutions to the various problems raised in the first section concerning the ontology and identity of works of art. Recall that the criteria for a satisfactory solution include: (a) works of art are individual rather than general entities; (b) artworks have a doubly contingent relation to their corresponding artifacts, in that a given artifact is only contingently connected with a given artwork, and also that it is a contingent matter how many artifacts are thus connected with a given work; and (c) more than one artifact may be associated with a given artwork, depending on its history of production, but that in any case the work in question should still count as autographic (hence permitting a distinction between genuine and forged cases of the work).

The first requirement (a) is that works of art are individual rather than

24. Iterations of my procedure should also briefly be considered, to show that they are benign. On my account a physical painting artifact is a representation of a painting, so that any further painting depicted within it (in the manner of Velasquez's *Las Meninas*) is a representation of a representation of a painting, which could in turn be imagined to be enlarged so that the resulting painting is itself a representation of a representation of a painting. However, though this thought experiment does indeed (harmlessly) legitimate such a description of a painting (and so on for further iterations), there is no obvious theoretical or explanatory value in using such higher iterative descriptions, whereas (I claim) the first iterative description does have significant explanatory value.

general entities. This requirement is easy for an RC theory to satisfy because paradigm cases of things that can be represented are themselves particulars (real historical personages, a particular actual landscape, and so on).

The second requirement (b) is that artworks have a doubly contingent relation to their corresponding artifacts, in that a given artifact is only contingently connected with a given artwork, and also that it is a contingent matter how many artifacts are thus connected with a given work. This requirement also is easy for an RC theory to satisfy, because contingent alterations to the properties of some artifacts can of course affect whether or not one of them counts as a representation of X (hence satisfying the first part of the requirement), and also there can be any number of different representations of a given thing X (satisfying the second part of the requirement).

The third requirement (c) is that more than one artifact may be associated with a given artwork, depending on its history of production, but that in any case the work itself should still count as autographic (hence permitting a distinction between genuine and forged cases of the work). This requirement can also be satisfied by an RC theory, but it does require more discussion than the previous two requirements.

To begin with, it is usually assumed that cases of forgery are cases in which an artwork itself is forged. However, from the vantage point of an RC theory, there is another candidate to consider, namely some *artifact* which *represents* that artwork. I shall argue that forgery of artworks is best viewed as primarily consisting in the forgery of a special or privileged artifact, namely that artifact which is usually considered to be the original artwork itself in the case of the visual arts (which work is also usually assumed to be autographic in Goodman's sense), or of (what I shall call) the *originative representation* in the case of arts usually assumed to be allographic, such as music, theater, and literature.

By an *originative representation* I have in mind items such as the original score of a musical composition by Beethoven, penned in his own hand, or the original typed or handwritten manuscript of a play or novel as typed or written by its author. As the name suggests, an originative representation usually originates or initiates a series of other representations of the same work, but only the originative representation is privileged, in that it alone is the direct causal outcome of the artist's successful creative efforts with respect to the artwork in question.[25]

This account of forgery, according to which forgery primarily consists in attempts to forge either an original representation (in the case of autographic arts) or an originative representation (in the case of allographic arts), has the advantage that it can explain both standard or typical examples of allographic

25. But see fn. 28 for a case of forgery involving instead merely a *representation* of an originative representation.

arts, and also certain atypical cases in which it does seem reasonable to say that an (otherwise) allographic artwork can be forged.[26] Typical cases such as printed copies of a musical score (or performances thereof) cannot be forged, on my account, because they are not originative representations of the work in question.[27]

On the other hand, in an atypical case such as that of someone attempting to forge the lost original score for some musical work of Mozart, it does seem reasonable to regard such attempts as possible and even potentially successful, because in such a case it is an *originative representation itself* of which forgery is being attempted.

One special kind of case must be noted. Peter Kivy in "How to Forge a Musical Work" points out that ". . . a work can perfectly well be forged without the added difficulty of manuscript forgery if a proper narrative is concocted for the source of the work forgery" (p. 234), such as a claim by the forger that he had copied the work from a now-destroyed original source which was the originative representation. I would analyze such a case as one in which an item is claimed to be a *representation* of an originative representation, so that such second-order representations also can be forged (as a means to forging that which they represent). Thus the category of forgeable artwork items must be enlarged to cover both originative representations, and representations (or purported representations) thereof.

This categorical enlargement applies also to autographic art forms, in that it would be admittedly unusual, but not inconceivable, for a forger to forge not an original work itself, but a *copy* of that original work, for example, if he claimed to have copied a certain painting of his from a supposed, otherwise unknown original painting by some famous artist. In such a case it is a *representation* of an original representation that is forged, as an indirect way of forging a (supposed) original painting.[28]

26. For example, P. Kivy, "How to Forge a Musical Work," *Journal of Aesthetics and Art Criticism* 58, no. 3 (Summer 2000): 233–35, argues that musical works can be forged under certain conditions.

27. Thus I can agree with the arguments deployed by Christopher Janaway in C. Janaway, "What a Musical Forgery Isn't," *British Journal of Aesthetics* 39, no. 1 (1999): 62–71, and C. Janaway, "Two Kinds of Artistic Duplication," *British Journal of Aesthetics* 37, no. 1 (1997): 1–14, to the effect that, in general, forgery of musical works is not possible, since he takes no account of my "atypical" cases.

28. It might be thought that, strictly speaking (in both autographic and allographic cases), such extended cases are not really extended at all, since instead they should be analyzed as being direct or nonextended forgeries of the second-order representations in question (namely the respective items actually produced by some forger) which are thus conceived of as original or originative works in their own right. However, though it is correct to say that there are such direct forgeries of second-order representations in these cases, nevertheless such a view obscures the critical

Now for some further defense of my views on forgery, which will also serve to defend my RC view of artworks generally. Kivy in "How to Forge a Musical Work" has a view according to which it is possible to forge an item that pretends to be a new version of a musical work, but if an authentic, original instance of that very same version were to turn up, then it would turn out that the supposed forgery was not a forgery after all (since on his view it is the same version of the same music).[29]

I find this to be counterintuitive, as does perhaps Jerrold Levinson, who writes:

> If you believe you are concocting something, and represent the result as other than what you believe it to be (that is, your concoction), then I don't see why that isn't forgery, even when the result is, by "improbable coincidence," a "happy" one [in that the putative forgery happens to coincide note-for-note with the newly discovered original version].[30]

I agree with Levinson's remarks here, and my RC account (whether of first- or second-order forgeries) has the advantage that a forger's attempt at forgery remains a forgery whether or not a genuine original or originative representation of the work in question is ever found.[31]

As an additional argument in favor of my account of second-order forgeries, consider an alternative account that tried instead to extend my concept of an original or originative representation being the *direct causal outcome* of an artist's successful creative efforts with respect to the artwork in question. On such an extended account, in the (supposed) absence of such a direct causal link, a secondary (supposed) causal link might be invoked (such as a supposed act of copying an original or originative representation), which on this view would make such a copy count as a forgery because it was the *best* or *most direct* causal link to the artist's original creative activity that is *currently available* (given the assumed contemporary nonexistence of the copied artwork). However, if the original or originative representation were to be actu-

connection with the *first-order* original or originative representations of artworks that make such forgeries of second-order representations *also*, or *thereby*, forgeries of those first-order representations.

29. Kivy, "How to Forge a Musical Work," pp. 234–35. The strength of a representational view of forgery is that it enables one to distinguish between an artwork and (original or originative) representations of it, whereas Kivy's alternate view, which does not make that distinction, is thereby unable to explain how forgery is possible in the present case.

30. Ibid., fn. 3.

31. See also Kivy's reply to my comments here, in "Intentional Forgeries and Accidental Versions: A Response to John Dilworth," *British Journal of Aesthetics* 42, no. 4 (2002): 419–22.

ally found, this view has the crippling flaw that under those conditions the copy would no longer count as a forgery since its indirect causal link to the artist's creative activity would no longer be the most direct causal link currently available to us. This failure underlines the importance of regarding secondary forgeries as *representations* of original or originative representations, rather than merely as being causally derivative from them.

4.4. RC THEORY VERSUS DANTO

Now that the initial outlines of an RC theory solution to the visual artwork definition problem have been presented, I shall bring out some initial contrasts between an RC theory and a representative nonrepresentational theory. For simplicity I shall also restrict my account to paintings that are representational in the conventional sense, that is, which are about something or that have a recognizable subject matter.

To begin with, on both representational and nonrepresentational theories, there are two basic entities or kinds of concept involved in the definition of an artwork (i.e., an account of its ontology and identity-conditions), namely artifacts and artworks. On the other hand, the ancillary concept of the subject matter of artworks will naturally receive somewhat different treatment under each kind of theory.

I shall use Danto's theory as one well-known exposition of a nonrepresentational theory. His theory is a good choice for a comparison, because he also rejects type/token approaches to artwork identity, and he is also sensitive (in some ways) to distinctions between artifacts and artworks. According to Danto, an artwork results when an artifact (which is a "mere real thing" on his treatment) is given an interpretation, so that the resulting artwork may be identified with the whole whose parts are the artifact and its interpretation.[32]

On Danto's account, such artifact-plus-interpretation artworks are representational in the conventional sense already discussed, in that they have a subject matter, or are about something.[33]

However, there is an awkward logical problem with this approach, in that on Danto's account, strictly speaking it is only the *artifact* that (after being interpreted) acquires a subject matter or becomes about something, rather than its being the (whole) artwork itself that may be so characterized. Indeed, it looks like a fairly fundamental category mistake to predicate of the whole (the artwork) what properly can be predicated only of one of its parts (the artifact).

32. Danto, *The Transfiguration of the Commonplace.*
33. Ibid., and A. Danto, *The Philosophical Disenfranchisement of Art* (New York: Columbia University Press, 1986).

This problem is not a trivial or isolated case, because such category mistakes will arise for any claims Danto makes about the nonontological or nonformal characteristics of works of art. The root cause of this problem is that Danto gives us no conceptual resources with which to understand how in general true statements can be made about the properties or characteristics of works of art themselves, whenever such statements go beyond a bare listing of the basic structure of artworks.

To return to the specific topic of the subject matter of artworks, an RC theory would in contrast handle the issue in a much more straightforward way than does Danto. On an RC theory, an artifact represents an artwork, and that artwork in turn represents its subject matter. (Thus, recall, on an RC theory that representational cases of art involve *two* stages of representation rather than just one, leading more specifically to a *double content* [DC] theory of art.)

A related issue on which Danto's account is problematic is that of predications of artifacts making use of (what he calls) the "is" of artistic identification.[34] Here is a central paragraph from his initial account of this special "is":

> There is an *is* that figures prominently in statements concerning artworks which is not the *is* of either identity or predication; nor is it the *is* of existence, of identification, or some special *is* made up to serve a philosophic end. Nevertheless, it is in common usage, and is readily mastered by children. It is the sense of *is* in accordance with which a child, shown a circle and a triangle and asked which is him and which his sister, will point to the triangle saying, "That is me"; or, in response to my question, the person next to me points to the man in purple and says "That one is Lear"; or in the gallery I point, for my companion's benefit, to a spot in the painting before us and say "That white dab is Icarus." We do not mean, in these instances, that whatever is pointed to stands for, or represents, what it is said to be, for the *word* "Icarus" stands for or represents Icarus; yet I would not in the same sense of is point to the word and say "That is Icarus." . . . For want of a word I shall designate this *the is of artistic identification*; . . . it is a necessary condition for something to be an artwork that some part or property of it be designable by the subject of a sentence that employs this special *is*.[35]

Danto has never succeeded in clarifying this sense of "is" to any greater degree than he achieves here.[36] My diagnosis as to why this is so is that he too quickly dismisses an alternative that he himself suggests in the paragraph,

34. A. Danto, "The Artworld," *Journal of Philosophy* 61 (1964): 571–84.
35. Ibid., pp. 576–77.
36. Others have found it unhelpful too. Davies provides a summary of the critical literature in Davies, *Definitions of Art*, p. 162.

namely, "We do not mean in these instances, that whatever is pointed to stands for, or represents, what it is said to be, for the *word* 'Icarus' stands for or represents Icarus; yet I would not in the same sense of *is* point to the word and say 'That is Icarus.'"

Danto is right about the word "Icarus," but he does not consider that there might be other, nonlinguistic forms of representation for which this account would be exactly what is needed. As noted at the end of section 4.2, a representational theory would analyze a claim such as "That is Icarus" as "That represents Icarus," which captures both that no identity-claim is being made, and that the object in question can be seen as Icarus, because pictorial representations are specifically designed so as to be identifiable as that which they represent.[37]

This initial representational analysis has not yet gone deep enough to distinguish the two stages of representation mentioned above, in the first of which an artifact represents an artwork, and in the second of which an artwork represents its subject matter. As an entry point to doing so, another lacuna in Danto's theory will be discussed.

Remarkably, Danto never considers what would seem to be a prime class of candidates requiring analysis using the "is" of identification, namely those in which it is asserted of an artifact that "this is a painting" (or in general, "this is a work of art"). On Danto's own account, such cases cannot involve a normal use of "is," because on his analysis they would literally be false (since artifacts are neither identical with artworks, nor can they correctly be described as being artworks).

Indeed, such cases could reasonably be taken as *paradigm cases* of artistic identification—of identifying something as a work of art—from which other cases are derivative in some way. Thus, it is arguable in artistic cases that in order to identify a white dab of paint as Icarus, and hence of assenting to "That white dab is Icarus," one must have already identified (or assumed an identification) of the artifact in question as being associated with a painting or work of art. For without such a prior identification (or assumption, or context setting), an assertion such as "That white dab is Icarus" would merely be mystifying. It is only in the context of further description of an object already taken to be a picture that such remarks make any sense.[38]

Returning to Danto, my diagnosis of why Danto does not consider these artwork identification cases is because if he did so, they would likely raise

37. See Lopes, *Understanding Pictures*, chap. 7.

38. This suggests that the correct analysis of a statement such as "That white dab is Icarus" is, in normal cases, one in which (one part of) the *work of art* in question (namely, that containing the white dab) is taken to represent Icarus, in preference to an alternative analysis in which "That white dab" is taken to refer to one physical part of the *artifact* in question.

doubts concerning his own theory, by showing that it is too simple and leads to distortions.[39]

As noted previously, Danto's account of the "is" of identification closely ties it to the concepts both of interpretation and of aboutness in such a way that to interpret an artifact is to take it as being about something. However, if he were to accept that identifying an artifact as a work of art is at least one kind of paradigm case of artistic identification, he would then be forced to acknowledge that there are in reality *two* logically distinct cases of artistic interpretation or aboutness to be considered: first, that in which an artifact may be interpreted as (or as being about) a work of art, and second, that in which a work of art may be interpreted as (or as being about) some subject matter.

It is precisely this distinction that an RC theory, and more specifically a DC theory, respects in holding that artistic cases of representation involve *two* stages of representation (in which, of course, the artifact represents an artwork, which then in turn represents its subject matter).

4.5. OVERCOMING AN OBJECTION

One further issue should be considered before closing this chapter, which can be put in the form of a possible basic objection to an RC theory in the visual arts. There might seem to be something distinctly counterintuitive in the claim that, when an artist paints a painting, the outcome of her efforts is, not the painting itself, but instead (only) a *representation* of the painting in question.

However, a basic intuition can be countered with another basic intuition, as I shall now proceed to do. For much of the history of painting, painters would often produce, prior to painting a finished work, various sketches, studies, or draft versions of the painting as guides as to how they should proceed with the final, finished version of the painting in question. Now intuitively, it seems undeniable that a sketch of the final painting is indeed a representation or depiction of that painting, or of what it will look like; indeed, one primary reason for painting a preliminary sketch or study is to produce something that (when the sketch, etc., is successful) shows some aspect of the

39. A recent debate between Danto and Joseph Margolis usefully draws attention to other problematic issues concerning Danto's view: see J. Margolis, "Farewell to Danto and Goodman," *British Journal of Aesthetics* 38, no. 4 (October 1998): 353–74; A. Danto, "Indiscernibility and Perception: A Reply to Joseph Margolis," *British Journal of Aesthetics* 39, no. 4 (October 1999): 321–29; and J. Margolis, "A Closer Look at Danto's Account of Art and Perception," *British Journal of Aesthetics* 40, no. 3 (July 2000): 326–39.

final painting (or of how some aspect of it will look, or be seen as—still a representational notion).[40]

Suppose then that an unusually diligent artist produces a whole series of such representational sketches, each of which approaches closer and closer to how the final version should be. Such an artist might naturally adopt a mode of working in which the final version of the painting is simply the last and most acceptable of these sketch or draft versions. But then that final version (as with all of the previous versions) must itself be a *representation* of the painting rather than the painting itself. Or in other words, the intuition that drafts are representations, plus the open possibility that a maximally satisfactory draft could be accepted by an artist as being *itself* the final version of the painting, validates the intuition that the finished painting after all *is* a representation of the painting in question.

A logical or grammatical argument can also be appealed to. It seems unavoidable (as above) that when discussing drafts of a painting in relation to a final outcome, that one talks about not the painting itself *tout court*, but instead of various *versions* of a painting, from relatively sketchy or unfinished versions to the final fully finished version. But if the final, fully finished version of a painting is indeed a *version* of the painting, then it seems that "the painting" itself cannot be identified with any one of its versions (including the final version). A representational theory can explain this logical feature of discourse about versions as being a matter of a progression from sketchy and incomplete representations of a painting, through more adequate and complete representations, and culminating in a final, fully adequate, and complete representation of the painting in question.[41]

In the next chapter this initial RC account of visual artworks will be extended to provide a more complete double content (DC) theory of such artworks.

40. To be sure, an artist's sketch might primarily be undertaken as a sketch of (some part of) the *subject matter* of a painting, but that is quite compatible with the same sketch also representing (more or less perfectly) some part of the finished painting. And in general, there would be no point in an artist making sketches "for" a work at all, unless they did have some such integral relation to the final work.

41. The possibility of sketchy or incomplete representations of a painting also serves to further secure my representational account, because in more familiar cases of representation it is similarly possible to distinguish between accurate or true versus incomplete or distorted representations of things.

Artistic Medium
and Subject Matter

U
p to this stage in the book it would be fair to say that the specific
double content (DC) form of the generic representational content
(RC) theory remains somewhat undeveloped, in that it has not yet revealed its
full potential. To be sure, if the generic RC theory is true, then in the case of
conventionally representational artworks—namely ones that are about some-
thing, or that have a subject matter—there must be two stages of representa-
tion involved, in the first of which a physical artifact represents an artwork,
and in the second of which that artwork represents its subject matter; so that
if an RC theory is true of such works, then so also must be a DC theory.

However, so far the relations of the two kinds of representational con-
tent involved—the artwork content of such physical artifacts, and the subject
matter content of the artworks—have mainly been characterized in terms of
their inseparability. This is important, and fine as far as it goes, but discus-
sion of the theory has not yet investigated the presumably complementary
ways in which artwork content and subject matter content inseparably
interact with each other. This deficiency will be remedied in this and the fol-
lowing chapter, as a result of which a DC theory will have something inter-
esting to say about those characteristics of genuine artworks, such as inten-
tional, stylistic, and expressive elements, which distinguish them from
nonartistic representations such as mere snapshots or "record" photographs,
and also about the ways in which artists are able to create such artworks in
the first place.[1] Chapter 6 will also significantly strengthen the intuitive case
for the inseparability of an artwork and its subject matter.

Another function of chapter 5 is to develop an even more compelling

1. Chapter 9 will further distinguish double representations from single ones.

case for the basic RC theory itself. Previously it has been argued that the RC approach is both plausible in itself and better than its competitors, such as type theory. However, here I argue that the only metaphysically possible source of artistic meaning in an artwork must come from the way in which it indicates or represents the actions of the artist in creating it, so that artistic meaningfulness must itself be a content-based concept.

In addition, both chapters 5 and 6 develop and illuminate the concept of an artistic medium in a novel way. It is argued that artworks must include not only the usual subject matter content, but also a kind of artistic medium-related content as well—a form of which "medium content," as one might expect, will be identified with an artwork itself at the end of this chapter, so that a much richer concept of the complementary functioning of artwork content and subject matter content will by then be available, adding significant further support to the DC theory of art.

5.1. ART MEDIA AND MEDIUM CONTENT

It is a truism about art that each art form, or art medium, provides a characteristic language, or set of methods and procedures, that artists may use to express themselves or their ideas about certain topics or subject matters. But exactly how is an art medium related to the ideas and the like which it may be used to express about some subject matter?

Clearly, representational artworks[2] such as pictures are typically created through use of some recognizable traditional art medium, including painting, drawing, film, literature, or dance, and each medium is associated with its own characteristic kinds of expressive possibilities and artistic meaning. But the nature of a medium itself, as thus used to represent some subject matter in characteristic, medium specific ways, is little understood beyond our general assent to the opening truism.[3]

2. I shall use the term "representational" broadly to cover any cases in which a picture (for example) has some *subject matter*, even if that subject matter is "abstract" in not being readily recognizable as some familiar kind of object or person, etc. This usage roughly corresponds to Richard Wollheim's broad term "representation," and I too would reserve the term "figurative" for the narrower subclass of readily recognizable things as just described. See R. Wollheim, *Painting as an Art* (Princeton, NJ: Princeton University Press, 1987), p. 21. Also, even with figurative representations, their *subject matter* (or "representational content") should be distinguished from their "actual subject" (if any), for some pictures are simply of "a man" rather than of some particular actual man. (On which see Wollheim, ibid., pp. 67–71).

3. Wollheim provides some suggestive but fragmentary remarks about the nature of a medium in relation to the materials of painting in the early sections of his *Painting as an Art*.

Also little understood are the ways in which the intentions,[4] expressions, and styles of individual artists are somehow associated with, or present in (or exhibited or expressed by), their individual works of art—as distinguishable from, yet nevertheless integrally connected with, the subject matters of those representational works.

I shall try to mutually illuminate these obscure topics—of the nature of a medium when used representationally, and the nature of expressive,[5] stylistic, and intentional aspects of representational art—by arguing that one central strand in the concept of a medium is of a distinctive kind of meaningful content associated with an artwork, that is distinct from its subject matter or representational content, and which content is also the locus for a work's expressive, stylistic, and intentional aspects.

Thus in broader terms I shall be attempting to distinguish two different kinds of meaning or content associated with representational artworks: first, their referential meaning, concerning their subject matter or representational content (or what the work is about)—which meaning or content is relatively well understood already[6]—and second, their medium-specific meaning or content, which I shall describe as *medium content* (or medium-related content).

As for medium content itself, in order to provide the promised illumination I shall both have to describe its nature and provide evidence of its existence, and also explain how artists can create and make use of medium content in producing the expressive, stylistic, and intentional aspects of their own individual works. I shall primarily draw my examples from the visual arts, mainly because they present the most challenging obstacles to an account such as mine, as will shortly become clear.

5.2. NONPHYSICAL ASPECTS OF MEDIA

A prominent obstacle to an account of medium content is the apparent physicality of many media, that is, that they seem to be closely associated or iden-

4. Which term I shall use as a "portmanteau" word from now on, to cover the whole range of feelings, emotions, intentions, attitudes, expectations, and so on that an artist might wish to express in a work—or that might be expressed anyway, irrespective of the artist's intentions. (Wollheim uses the term "intention" in a similarly broad fashion: ibid., p. 86.)

5. For a more detailed analysis of expression in interpretive representational terms, see my paper "Artistic Expression as Interpretation," *British Journal of Aesthetics* 44, no. 1 (January 2004): 10–28.

6. E.g., see Dominic Lopes, *Understanding Pictures* (Oxford, UK: Oxford University Press, 1996), who discusses the distinction of representational content from (actual) subject on pp. 3–4.

tified with certain characteristic physical materials or physical properties. This is particularly true for the visual arts, whose products such as paintings or drawings might seem to be constituted by various physical items or attributes, such as particular canvas or paper sheets along with the layers of paint or graphite, having various physical properties, that have been applied to their surfaces.[7] Thus an account such as mine that seeks to find some kind of meaningful content associated with a medium itself must somehow overcome an initial "presumption of physicality" of the nature of such media.[8] This I shall now attempt to do.

A realistic painting of a given natural scene will have certain characteristic differences from a realistic drawing of the same scene, and each will be characteristically different from either a black and white, or a color, photograph of the same scene (which photographs in turn will have their own characteristic differences). But in what do these characteristic differences consist?

An initial reply might be that each work represents the same subject matter or scene, but that each does so using characteristically different physical materials—paint in the case of a painting, charcoal or graphite in a drawing, and typically (colored or uncolored) silver compounds and gelatin in the case of the (black-and-white or color) photographs.

But at best this account is incomplete, in that arguably an artistic medium cannot adequately be characterized merely in terms of the physical materials used by artists in the medium. For example, for much of the history of photography a "photograph" consisted of a paper backing rendered light sensitive by a layer of silver salts and gelatin on its surface, which, after exposure to light (and subsequent development and fixing), would be chemically changed into other more light-resistant silver compounds. However, increasingly photographers are now using quite different methods and mate-

7. Whereas other media, including literary genres such as the novel or poetry, are less clearly linked to specific physical items.

8. Michael Podro has emphasized the medium versus materials distinction, e.g. in M. Podro, "Review of Wollheim, *Art and Its Objects*, 2nd Ed.," *Burlington Magazine* 124, no. 947 (February 1982): 100–102, and M. Podro, "Depiction and the Golden Calf," in *Philosophy and the Visual Arts: Seeing and Abstracting*, ed. Andrew Harrison (Dordrecht, Holland: D. Reidel, 1987). But Podro's account is couched primarily in terms of a concept of a particular artist's intentional *use* of a medium, and so arguably it is too specialized to explain the characteristic ways in which artistic media *as such* differ from each other (see P. L. Maynard, "Seeing Double," *Journal of Aesthetics and Art Criticism* 52, no. 2 [1994]: 155–67, for related comments on Podro's views). Nevertheless, there are some affinities between Podro's view and mine. In chapter 6 I shall also develop some views of Richard Wollheim on the medium/materials distinction. For another account of the distinction, with useful discussion and references, see David Davies' book *Art as Performance* (Oxford, UK: Blackwell, 2004).

rials to achieve original artistic photographs, including digital, filmless cameras (or digital scanning of negatives produced from traditional cameras), and direct printing onto a substrate using jets of ink in place of the familiar traditional darkroom technology. Yet the result of such a process is now generally regarded as being just as much a photograph (that is, a work produced squarely within the medium of photography) as is any more traditionally produced photograph.[9]

More broadly, the general availability of computer technology, along with specialized software and appropriate printing methods, means that virtually any artistic effects associated with traditional media, from drawings, watercolor, or pastel to the appearances of prominent brush or palette knife strokes in heavy paint impasto, can be produced by use of such computer-based methods—which could collectively be thought of as providing the material basis for a new kind of general-purpose visual art medium, by means of which the artistic effects of any traditional medium can readily be obtained.

However, some caution is required in interpreting this result. Skeptics are likely to object that it merely shows that it is now possible to simulate (or copy, or reproduce) artworks executed in traditional media—or to simulate the effects of traditional media—using computer technology, so that the result does not immediately demonstrate that such works could be genuine instances of works executed in traditional media, rather than merely being copies or simulations of such works (or of effects associated with such works).

In reply, at least in the case of digitally produced photographs their status as genuine photographs seems to be already secure, in that they are no longer regarded as merely providing an inexpensive means of reproducing other more traditional photographs (though of course either variety of photograph could be used for merely reproductive purposes).

And in general, the skeptic's point depends on a contrast between original artworks (and the integral artistic effects associated with them) versus copies or reproductions of such, which distinction has no obvious relevance to the discussion of media themselves, since there seems to be no reason why an artist should not, for example, use a computer "paint" program along with an appropriate printer to produce an original artwork of hers, which she regards as being a genuine painting—which painting might then be laboriously copied by another less talented artist using traditional painting methods, to produce a mere copy or reproduction of it, or of the artistic effects involved in it. Thus the original/copy distinction cannot be used to impugn

9. In addition, Quentin Williams in "Projected Actuality," *British Journal of Aesthetics* 35, no. 1 (1995): 273–77, suggests that some paintings by Vermeer are "photographic pictures" in that they achieve characteristic effects of the *medium* of photography while using only the *materials* of painting. A musical example would be the use of synthesizers to achieve orchestral effects normally achieved using traditional instruments.

the (at least prima facie) distinction between a medium, and various physical materials that may be actually or potentially associated with that medium.

The possibility of a general purpose, computer-based medium discussed above also undercuts another potential skeptical objection, namely that perhaps a medium is still purely physical, in that it could be regarded as consisting of several different kinds of physical materials—so that a medium just is, or is identifiable with such materials, or with a disjunction of such, but of a broader class than traditionally conceived. The problem for such a view is that a general-purpose class of materials (as provided by computer technology) would occur as part of the definition of almost all media, so that the intuitively great differences between different media could not be accounted for on such a physicalist account of their nature.

To sum up the discussion so far, particular media have at least initially been distinguished from the physical materials and properties associated with them, so that the initial "presumption of physicality" for media has been weakened: it is now at least a logical possibility, in that it is no longer logically ruled out, that an art medium might be closely associated with some kind of characteristic, nonphysical meaningful content. I turn next to more specific arguments in favor of such a possibility.

5.3. A "MEANING NONTRANSMISSION" ARGUMENT

In this section I shall develop a *meaning nontransmission* argument, to the effect that artists cannot directly transmit meaning to their artworks, and therefore must do so indirectly instead. To begin, the only means available for an artist to expressively carry out her artistic intentions, using her own unique style, is through the physical manipulation, in various appropriate ways, of some specific artistic materials associated with her chosen medium. Thus any artistic meaning[10] that an artist wishes to be associated with her artwork must somehow be initially embodied by the artist in her actions or activities of working with those materials in producing her artwork.

Second, those physical artistic actions are logically distinct from the resultant causal effects of those actions upon the developing artwork itself,[11]

10. Any further unqualified mention of "artistic meaning" will be assumed to be of the relevant stylistic, expressive, or intentional kinds, as opposed to referential or subject matter–related meaning.

11. For expository convenience I shall, until section 5.9, ignore an important distinction between an *artwork* and the physical *artifact* associated with it, which latter is, strictly speaking, what the artist works upon.

just as any physical group of causes are distinct from their physical effects on other objects. Thus for instance, a certain movement of the artist's arm, while holding a stick of charcoal in contact with a sheet of paper, would result in her depositing some charcoal in a certain configuration on the paper; but that intentional, stylistically expressive action of hers—of a specific kind of "charcoal deposition"—cannot be identical with the resultant charcoal configuration itself on the paper.

Thus any (successful) drawing or painting activity by an artist will include (at some stage) the actual depositing of some kind of pigment on a suitable surface. Now it is easy to confuse the depositing of the pigment with the deposited pigment itself; but the artist's action or activity of depositing that pigment (which activity expresses her intentions and style) is all that the artist herself is able to do; the deposited pigment itself is no more than a trace or record of her artistic activity in so depositing the pigment[12]—which fact is already recognized in connection with the work of "action painters" such as de Kooning, in that it may even be claimed that their whole works are in some sense no more than such a trace or record of their meaningful painterly actions in producing them.[13]

The point being made here is a completely general one, which applies not only to drawings or paintings but also to sculptures (molded or carved), films, literary or musical manuscripts, and so on: in all cases, the artist's actions in working on those artifacts must be distinguished from the causal results of those actions, which at best can merely provide a trace of the relevant actions.

Third, given the logical distinctness of actions and results, it follows that any artistic meaning that the artist has embodied in her actions cannot be directly transmitted or transferred by her to the artwork itself. For I take it that it would generally be agreed that the embodiment of meaning is specific to its particular vehicle: actions are meaningful in different ways than are objects.

12. An analogy may be helpful. If an angry person swings her arm and hits someone, that action is distinct from its effects on the victim, such as any resultant bruises. Thus in the case of a watercolor, the eventual effect, after the artist's action of applying the wet pigment to the surface, is a kind of "bruise" which is the result of the spreading and drying of the pigment; but clearly that eventual, dried effect or "bruise" is distinct from the artist's antecedent action of applying wet pigment to the surface.

13. E.g., E. H. Gombrich, *Art and Illusion; A Study in the Psychology of Pictorial Representation*, 2nd ed. (London, UK: Phaidon Press, 1962), pp. 243–44: ". . . he must make us read his brushmarks as traces of his gestures and actions. . . . This, I take it, is what the 'action painter' aims at." A related phenomenon can be found in photography as well: Patrick Maynard in P. L. Maynard, "Drawing and Shooting: Causality in Depiction," *Journal of Aesthetics and Art Criticism* 44 (1985): 115–29, argues (on p. 124) that blurs in photographs are "traces or manifestations" of the photographer's movements in taking them.

Thus an artwork cannot literally be meaningful in the same sense as that in which the actions that produced it were literally meaningful—or at least, there is no magical process by which the meaning of actions can automatically or directly be transmitted to their otherwise meaningless causal results.

Of course, I have no wish to deny that artworks can in some sense be meaningful, and that in some way they acquire their meaning "as a result of" the artist's activities. What I am denying is only that a work could acquire its meaning via a direct transmission of the meaningfulness of artistic actions to the causal results of those actions. I shall now present an alternative, indirect account of how artworks acquire their nonreferential meaning.

5.4. ACTIONS, TRACES, AND MEDIUM

I see the key to understanding how artworks can acquire meaning as being centered round the point, emerging above, that the results of artistic actions are, or provide, traces, manifestations, or records of those actions that causally acted upon them, or more broadly, that they signify, indicate, or provide information about the actions that caused them to be as they now are. For example, if one steps outside and finds the ground to be wet, this provides a generally reliable indication that it had previously rained—one can thus acquire information about the likely causes of the current wetness results that one is observing. Similarly, in observing a finished watercolor picture, one can acquire information about the likely artistic actions that resulted in the picture having the features that it now has.

Thus on this account the meaning in artworks is provided in a broadly symbolic or significatory way: artworks do not, strictly speaking, themselves literally possess meaning, but instead they symbolize or indicate or provide information about the relevant artistic actions that did literally possess the relevant kinds of meaning. Thus on this view, artistic meaning is associated with a species of symbolic or indicative content—though a kind of content (to be called "medium content," as initially mentioned) distinct from the usual referential or representational content or subject matter of an artwork.

But where, it might be asked, does the concept of a *medium* come into all of this? Here is the crucial connection: that insofar as the meaning of artworks is related to their broadly symbolic functions, the concept of a medium provides the structure and details of the language in which an artwork is able to symbolize the relevant artistic activities. Thus the medium of watercolor, or of painting, and so on provides a necessary structure of artistic conventions that enables a suitably informed viewer of an artwork in a given medium to understand, on the basis of her perceptions of the artwork, pre-

cisely which medium-specific artistic actions—and with which features—are symbolized or indicated by the work.

Otherwise put, without art media any artwork would symbolize too indefinitely—symbolizing anything, or nothing. Artists avoid this problem by constraining themselves to work within a specific medium on a given project, so that viewers of their works can have legitimate or correct expectations and receive reliable indications from the work as to which medium-specific meaningful actions of the artist were involved in its creation.[14]

As an example showing the importance of correct medium expectations, and hence the indispensability of the language provided by a specific medium in understanding artworks, consider the medium of engraving, which makes much use of cross-hatching and repeated lines to achieve its effects. Thus an engraving of a woman, as normally perceived, would typically represent the outlines of and modeling in her features by use of such linear, engraving-related methods. However, it is quite possible that someone unfamiliar with the medium of engraving might instead mistakenly see such an engraving as a picture of a woman with lines, or a variegated mesh, covering her face.[15]

In such a case, what has gone wrong? An explanation can be extracted from an account of each case of perception of the engraving with correct versus incorrect expectations as follows. Each case involves a different perceptual interpretation of the engraving, in the first of which it is interpreted in the normal way, such that the lines and cross-hatching are seen correctly as an "engraving" kind of medium-related content, which in turn represents the woman's features as its subject matter.

On the other hand, in the second (more unusual or deviant) interpretation, the original physical lines are instead interpreted as medium content of some other kind, such as would be found in some other medium (such as in realistic painting using only black and white pigments, or black-and-white

14. To be sure, mixed media works are possible, including those in relatively well-defined genres such as opera—a fusion of drama plus vocal and orchestral music. Such cases are more complex, but though they increase the complexity or difficulty of the artist's task of providing her audience with legitimate expectations and reliable indications, it seems unlikely that they require a different kind of theory altogether, dependent as they are on mixings of preexisting media involving more standard expectations and indications.

15. This example is adapted from one given by Andrew Harrison, "Dimensions of Meaning," in *Philosophy and the Visual Arts: Seeing and Abstracting*, ed. A. Harrison (Boston, MA: Kluwer Academic Publishers, 1987), p. 63, but who sees the mistake not as being medium-related, but rather as a failure to understand the "logical grammar" or projective model involved in the engraving in question. See also Gombrich, *Art and Illusion*, p. 78: "To say of a drawing that it is a correct view of Tivoli does not mean, of course, that Tivoli is bounded by wiry lines."

photography), with that (incorrect) medium content in turn being seen as representing both a woman and a meshlike series of lines across her face.

Thus my account can explain both how each interpretation is a genuine pictorial interpretation of the engraving, and also how one is correct and the other incorrect. For what makes the former interpretation correct is (presumably) that the artist did indeed intend his engraving to be interpreted as an engraving—as a work produced using the medium (and not merely the materials) of engraving. Whereas the second interpretation is one in which, as explained above, the viewer's incorrect assumption as to the medium involved led him to misinterpret the work.

Thus to conclude this section, I would argue that it is through use of the emerging theory being described here that the initial truism that began this chapter—that each art form, or art medium, provides a characteristic language, or set of methods and procedures, which artists may use to express themselves or their ideas about certain topics or subject matters—may potentially be vindicated.

5.5. OBJECTIONS

It might be objected that the above account of artistic meaning has things backward. Artists intend to produce certain artistic results, and their actions are focused on achieving such results, so that any meaning they intend to produce in the artwork is "result-oriented" meaning or content. But on my account, the objection charges, the meaningful content of those results is instead "action-oriented" content in that it is a kind of symbolic or indicative content that symbolizes or indicates only the artist's actions, rather than her intended results.[16]

However, this objection fails in at least two ways. First, it fails to recognize the force of the metaphysical fact that one cannot literally endow physical resulting objects (and their nonartistic properties) with meaning of any kind, whether action-oriented or result-oriented meaning: all one can do is to cause them to be certain ways, that is, to be in a certain physical state with certain physical properties, which state and properties may then more or less reliably indicate the meaningful actions (and their features) that produced them. Thus any intuitions we may have about the nature of "result-oriented meaning" must themselves be accommodated to this unavoidable metaphysical fact.

16. This criticism is along similar lines to one of Jerrold Levinson's criticisms of Gregory Currie's "Action Type Hypothesis" theory of art, as given by Levinson in his article "Art as Action," reprinted in his book *The Pleasures of Aesthetics* (Ithaca, NY: Cornell University Press, 1996), pp. 138–49.

The second failing of the objection is that it conflates indication of an artist's actions with indication of certain properties of those actions—in particular, their property of expressing certain result-oriented meanings. Just because it is inevitable, metaphysically speaking, that artworks can only *indicate* actions (and their properties), it does not follow that therefore they can indicate only "action-oriented" content in so doing. For, as with any indication or representation, resultant art objects can indicate both concrete entities or events—such as the artistic actions that caused them—and also properties of those concrete events, such as their property of expressing certain result-oriented meanings. Thus artworks can acquire "indicative content" that indicates, or is indicative of, both artistic actions and their properties of expressing intentional, expressive, and stylistic kinds of result-oriented meaning.[17]

Thus the indicated, meaning-related properties are complex—such as a property of expressing a certain intention—rather than simple, such as an indication of "an intention" simpliciter. This feature is needed (among other things) to satisfy the intuitive requirement that artworks can, via their indicative powers, express intentions (just as do actions) instead of merely "having" intentions.

However, an objector might try to reply to the above account with a kind of "excessive complexity" objection: that since one can simply see both the subject matter and expressive properties of an artwork in most cases, this simple basic phenomenology cannot be adequately explained by the kind of "indirect meaning" analysis I have given, which involves at least the following cognitive stages. First, an art object and its properties must be identified. And second, one must use one's general knowledge as to the most likely causes of the observed physical properties to identify a package of "informational content" associated with the artwork, each item of which must be seen as resulting from the object's indicating of some feature or property of the relevant causes—which indicated properties are themselves complex in that they are, broadly speaking, expressive properties (expressing either "meaning content" or referential content) of the relevant causes (artistic actions). Is not this an excessively "noisy" or complex analysis of the actual, phenomenologically simple experiences we have of artworks?[18]

An initial rejoinder is that, viewed in terms of the general perspective of cognitive science, there could easily be many complex kinds or layers of information processing concerning artworks that occur at a subperceptual or subdoxastic level: the apparent simplicity of conscious perception clearly is

17. As well, of course, as those artworks acquiring their better-understood *representational* content—the referential or subject matter "meaning" of an artwork—which will also be acquired from appropriate properties of the actions in question.

18. "Simple" in that we directly perceive their meaningful properties, even if they are otherwise complex in involving many different meaningful properties.

not a reliable guide to the actual information processing tasks that may be involved in producing such perceptual experiences.

Nevertheless, I believe that it would be a mistake to completely reject or ignore the "complexity" objection. For a main thesis of this chapter is, in effect, that successful artists use a particular medium in such a way as to reduce as far as possible the complexity of that processing task faced by a viewer of their work. Technically fluent artists are those who learn how, through use of a particular medium, to give their works the specific appropriate physical properties that will best, or most clearly and simply, provide a viewer (through the indirect procedure discussed) with the desired kinds of meaningful content with respect to the work in question.

As well as such a general account, the issue of complexity reduction can also be discussed in more detail, as follows. In almost all genres of art,[19] one way of reducing the complexity of the viewer's task is to eliminate in a finished work, as far as possible, any indications that would draw attention specifically to various physical properties of an artist's actions, such as the amount of pressure she applied to a brush in making a brushstroke, or the speed or momentum of the movement of her arm in depositing pigment in a given area of the work—hence the truism that typically the best art is "art that conceals art," in other words, that does not obtrusively indicate such physical efforts, or associated craftlike techniques, that may have been used by the artist.

Thus by and large an artist should construct her artwork in such a way that a viewer is free to concentrate on the indicated expressive, stylistic, and intentional properties of an artist's actions, without any discordant or complicating indications of their specifically physical attributes, in spite of the fact that medium content is, of metaphysical necessity, "backward-looking" content—looking or indicating back to the actions that caused its physical basis (namely the resultant artifact) to have the physical properties that it does.

5.6. MEDIUM CONTENT VERSUS SUBJECT MATTER CONTENT

It is time to reintroduce the referential or subject matter content that is also present in any case of representational art. Such representational content

19. Other than, for instance, "action painting" as mentioned earlier, in which the indication of overtly physical aspects of an artist's actions might be considered as being at least a central part of the essence of the genre.

could be described as "outward-looking" in that such works in typical cases[20] at least purport[21] to represent something external to the artwork itself.

However, as already noted in the initial exposition, referential content must also (as with medium content) be initially acquired through a process of backward-looking or indirect indication of actions and their features, since a work cannot be directly endowed with any kind of content, including referential content. Nevertheless referential content, once thus validated or established indirectly through action indication of an artist's subject matter intentions as expressed through her actions,[22] may also then take on a more primary indicative or symbolic role as specifically representational (outward-looking) content—perhaps for some of the familiar traditional reasons, such as resemblance to some actual subject.[23]

Clearly then a discussion of the differing functional roles of both referential (subject matter) content and medium content is needed, for it is a natural, derivative thesis of this chapter that in order to understand representational art one has to understand the contributions of both primarily outward-looking (referential) content and primarily backward-looking (medium) content to the total meaningfulness or informativeness of any given work.

In terms of C. S. Peirce's tripartite classification of signs[24] as icons (which resemble their subjects), indices (which typically point to some actual entity), and symbols (which conventionally signify something), an artwork is a sign that is usually primarily iconic with respect to its referential content, in that it typically resembles some actual entity of the kind represented, whereas with respect to its medium content, though some iconic elements may be involved,[25] it is also significantly indexical (referring back to the

20. I shall ignore atypical cases such as an artwork made of materials that easily deteriorate, which might be intended to represent its own impermanence.

21. "Purport" only, in that, as mentioned in fn. 1, a picture may merely be of "a man" rather than of a particular actual man.

22. Compare Wollheim, *Painting as an Art*, pp. 46–59, on the difference between merely seeing a subject matter *in* a surface, versus its specifically *representing* that subject matter. On my account it is the validation that is provided by indication of artistic action that makes the difference.

23. Though see, e.g., Lopes, *Understanding Pictures*, for doubts about such resemblance accounts.

24. See *Collected Papers of Charles Sanders Peirce*, ed. C. Hartshorne and P. Weiss (Cambridge, MA: Harvard University Press, 1931–1958).

25. The relative prominence of such medium-related iconic elements probably varies widely, depending on the medium, with photography being one extreme example having strong iconicity, in that the photographer's actions and procedures typically allow most of the visual data structures present in the light impinging on a photographic emulsion to be retained in that emulsion after appropriate development and fixing.

actions that brought it about) and symbolic (in that it makes use of standard artistic conventions as to how elements in the relevant medium should be used and interpreted).[26]

However, though those relatively technical points about modes of signification of artworks are of some theoretical interest, it is more pressing at this stage to discuss further the broadly functional connections of the two kinds of content with each other. In order to do so I shall introduce another useful truism: that artists generally seek not merely to accurately represent the subject matter of their artworks, but also to interpret it, that is, to provide a visual commentary on it (with analogous forms of commentary for other nonvisual art forms). Or, to put the truism in stylistic terms, in the case of artworks how a subject is represented, or the way in which it is depicted, is as important as what the subject matter itself is of a work.

Now since medium content is closely connected with artistic intentions, style, and expression—all of which are integrally involved in an artist's commentary on her subject matter—it seems inescapable that it is medium content that should be viewed as having the function of providing the visual commentary, or "interpretive" aspects of an artwork, while on the other hand the representational content of an artwork of course functions as its subject matter.

Thus the concept of medium content not only functions (as previously) as an explanation of the medium-specific language in which an artwork's meaning is expressed, but it also naturally takes up the functional role of providing an artist's interpretation, construal, or commentary on some specific subject matter. For an artist comments on her subject in ways that are specific to the particular medium that she chooses to use, which medium is the visual language in terms of which her meaningful commentary is expressed.

To be sure, these are points of great generality, but the completely natural way in which our two kinds of truism dovetail with each other—first, a point about a medium (in the form of medium content) as providing a language for expression of meaning, and second, a point about its also providing, in specific uses of medium content by an artist, a commentary on or interpretation of the relevant subject matter—strongly suggest a central and perhaps even indispensable role for a concept of medium content in any fully adequate analysis of representational artworks.

26. Thus, previous discussions as to distinctions between pictorial and *linguistic* representations (which are primarily "symbolic" in Peirce's sense) have inevitably been incomplete to the extent that they have not discussed these indexical and symbolic aspects of pictorial signs.

5.7. THE POSSIBLE INDISPENSABILITY OF MEDIUM CONTENT

It might seem unduly provocative to claim (as I just did) that the concept of medium content may be indispensable in analyzing representational artworks. As a brief defense of this claim, consider two well-known and quite different accounts of the meaning of artworks, namely those of Arthur Danto and Kendall Walton.[27]

Danto has argued that suitable physical objects become meaningful artworks by being appropriately interpreted by viewers, while Walton instead regards artworks as props in games of make-believe engaged in by their viewers. Both of these accounts of the meaning of artworks may seem remote from mine, but my claim is that neither approach can by itself explain the genesis of meaning, that is, how artworks initially acquire their meaning—or more precisely in the case of these authors, how artworks acquire appropriate dispositional meaning properties, such that acts of interpretation can be both appropriate and successful when applied to them (in the case of Danto), or such that appropriate games of make-believe are licensed or mandated by a work (in the case of Walton).

My most basic claim is that backward indication of actions and their properties—which defines, among other things, the medium content of a work—is metaphysically the only possible way in which a work itself can acquire any (relatively) objective, viewer-independent meaning,[28] no matter how much theories of representational art may otherwise differ as to the subsequent nature of viewer involvements (whether interpretive, imaginative game playing, and so on) with art objects having such viewer-independent meanings.

Thus at least backward-looking meaningful content, no matter how described, is an unavoidable postulate of any theory of representational art. Then my additional claims are that such meaningful content would not be possible without the resources of specific art media (so that specifically the content must be medium-related content), and also that such content is in addition inevitably in the form of a commentary, since that is the appropriate general category to which intentional, expressive, and stylistic kinds of meaning belong.

27. Arthur C. Danto, *The Transfiguration of the Commonplace* (Cambridge, MA: Harvard University Press, 1981), and Kendall L. Walton, *Mimesis as Make-Believe* (Cambridge, MA: Harvard University Press, 1990).

28. Here I exclude from consideration referential or subject matter meaning, in that, for example, a piece of driftwood might suggest, as a result of features it had previously acquired through natural processes, a subject matter prior to any actions of a sculptor upon it.

5.8. HOW ARTWORKS MAKE STATEMENTS

I shall now integrate two threads in the current chapter: first, my initial view that medium content is a trace or indication of the artist's actions in producing it, and second, the more recently discussed view that medium content provides a (medium-specific) commentary on its subject matter.

To begin with, it might seem as if I have ended up abandoning any significant role in my view of an artwork for the artist's actions with respect to it as such, since it is only indications of those actions—along with a generally strong de-emphasis of indications of the physical properties of those actions—that explain the meaningfulness of medium content on my account. However, with the introduction of the point that medium content provides a commentary on subject matter the way is open to re-emphasize the active nature of the artist's commentary, in spite of the fact that it is only indicated by the finished work. For it is through her physical actions in producing the work that the artist expresses her commentary on the subject matter, and in thus commenting on a subject she is engaging in an expressive activity—which expressive activity is part of what is indicated by the relevant medium content.

Thus the underlying structure of the meaning of a work, from a semantic point of view, is initially focused on the role of a verb as in a sentence such as "Artist A comments on subject matter B." Or more precisely (since an artwork expresses a first- rather than a third-person point of view), the artist's medium-specific statement is, after appropriate linguistic translation, of the form "I thus comment on this subject matter," which semantically involves an indexical reference to the artist herself (by "I"), and two demonstrative references, first to the manner in which the artist is commenting ("thus comment") and second to the relevant subject matter ("this subject matter").[29]

What this means is that, logically or semantically speaking, medium content provides an adverbially qualified verbal rather than adjectivally qualified noun kind of content—of a manner or way in which the artist's action of commenting is carried out by her, rather than an adjectivally described substantive object, which categories would apply instead to the relevant subject matter of the artist's work. Thus, medium content and representational content function in complementary ways at the semantic level as well as in the other ways previously discussed.

One could sum up these points by saying that medium content is adver-

29. This is my alternative to Wittgenstein's views as to the logical syntax of pictures, such as were expressed in his *Tractatus Logico-Philosophicus* (London, UK: Routledge, 1922).

bial (that is, adverbially modified verbal content),[30] and that on my view another truism about artworks—that one understands an artwork when one understands the statement that an artist makes by means of it—can also be given a relatively precise validation, in the semantic terms just discussed.

Of course, none of this is to deny that an artist's actions can also be regarded as substantive events having adjectival properties, which events cause changes in a resultant artwork. The point is rather that the meaningful content of an artwork is (after appropriate linguistic translation) of the above first person, adverbial form, rather than of various more scientific or impersonal forms that may also convey accurate information concerning the artist, events, properties, and artwork in question.

5.9. BROADER HORIZONS

I shall conclude both by discussing perception of medium content and by briefly extending the results of this chapter so as to integrate them with the double content (DC) theory of art. This section could also be viewed as providing a kind of justification of the DC theory, which is relatively independent of previous justifications.

To begin, consider a typical van Gogh picture of a cornfield, with prominent vigorous brushstrokes covering all of the visible areas of the picture. Now my first point is that strictly speaking there are not, and cannot be, any genuine brushstrokes in the picture, because of course a brushstroke is an action by an artist of depositing some pigment with a brush; as discussed previously, what are usually called "brushstrokes" are in fact traces or indications of the artist's brushstrokes. In the discussion below I shall assume that the term "brushstroke" refers to such resultant traces of the artist's actions.

Next, an issue that has not been raised in this chapter yet is that of the identity of an artwork. It is natural to assume that the physical artifact, which is the result of the artist's actions, plays at least some role in the identity conditions of the relevant artwork. Here is an argument for that view. It seems, intuitively or pretheoretically speaking, as if much of what one sees when one looks at such a picture is not directly related to its subject matter: though of course the brushstrokes represent the cornfield, their particular structures and characteristic configurations seem to be noticeable "in their own right,"

30. This adverbial view naturally supports the traditional view of *style* as giving the "how" of "what" is represented by a picture; on which see Dale Jacquette, "Goodman on the Concept of Style," *British Journal of Aesthetics* 40, no. 4 (2000): 452–66 (I was the commentator on an earlier version of his paper, delivered at the American Society for Aesthetics, Washington, DC, October 27–30, 1999).

independently of their representational function in depicting parts of a corn-
field. Thus in the absence of a concept of medium content, it may seem
obvious that at least part of what one sees when looking at the picture is those
physical brushstrokes themselves (that is, the physical traces of brushstrokes),
with their characteristic physical configurations.[31]

However, once the concept of medium content is introduced, the issue
is no longer so clear. For the nonrepresentational "extra" seeing or noticing
of features of the brushstrokes could now be regarded as instead supplying
indications as to their causal and intentional origins, that is, as involving a
noticing of another kind of content—medium content—in addition to one's
noticing of their representational content. Using one's understanding of the
medium of painting, one can now interpret what are, in fact, physical traces
of brushstrokes as a particular case of van Gogh's commenting, in a medium-
specific, painterly way, on the cornfield that is his subject matter.

Thus it is no longer obvious that this integrated visual perception and
pictorial understanding must involve perception or awareness of specifically
physical aspects of the brushstrokes. For just as fluent users of a language can
communicate with no thought as to the physical characteristics of the letters
or sounds they use, one could similarly hold that visually fluent viewers of van
Gogh's painterly communications could equally understand them without
having to notice their physical characteristics. (Which view is quite consistent
with also holding that nonfluent viewers, including those seeing a painting for
the first time, may have to pay careful attention to its physical characteristics
as a preliminary to thus accurately perceiving its medium content.)

One possible upshot of this line of thought is that, just as the meaningful
content of a linguistic utterance (a statement or proposition) may usefully be
regarded for theoretical purposes as being an entity distinct from its lin-
guistic vehicle—as a structured package of informational content—so also
may artworks similarly be regarded as being distinct from their physical vehi-
cles, and as being structured packages of informational content, which in
their case consists of medium content plus representational content.[32]

But how exactly should this view be theoretically articulated, given that
the artwork in question has to itself represent its subject matter? There is
really only one possibility, namely that it is the medium content of an art-
work that represents the subject matter—because there is nothing else that
could do the job, on this "informational package" approach.

Returning to perception of a van Gogh cornfield picture, this claim—that
medium content does the representing—does seem psychologically realistic,

31. Wollheim defends this common assumption in his book *The Art of Painting*,
arguing that one simultaneously sees both the physical painting and what it repre-
sents. I argue against this view in the upcoming chapter 6.

32. This view is most explicitly defended in chapter 6.

in that it is clearly the perceived vigorous brushstrokes (fluent perception of which, it will be recalled, on the present view is simply perception of the relevant items of medium content, including stylistic and expressive features such as their vigorous quality) that can be seen to represent the cornfield.

But how is this view of medium content, as representing subject matter, to be rendered consistent with the earlier arguments of this chapter to the effect that medium content is itself indicated or symbolized by the artwork that results from the artist's actions? To achieve consistency, all that is necessary is to distinguish the physical artifact that results from the artist's actions from the resulting artwork, which must now be identified with the relevant medium content itself, since as before there is nothing else available that could take on that role on this "informational package" view of artworks. Thus a more complete statement of the resulting theory is that it claims that the physical artifact indicates the medium content—which is the artwork—and which medium content (or artwork) in turn represents its subject matter.

Thus the key to achieving a consistent theory is to regard representational artworks as involving not one but two distinct stages of signification or symbolization. In the first stage, a physical artifact of some kind (whether a painting, printed page, length of film, musical or theatrical event, and so on) signifies an artwork, which is an (organized) collection[33] of medium content of the appropriate, medium-specific kind. And in the second, more conventional stage, that artwork represents its subject matter.

As to the kind of signification involved in each stage, it might seem clear enough from this chapter that each stage must involve a distinct kind of signification (which kinds I have described as "indication" and "representation" respectively in this chapter). However, this issue remains unsettled, since the very different functional roles of medium content and representational content in understanding artworks do not necessarily imply that each must be signified in a different manner or mode. (This matter will be finally resolved in sections 12.1–12.3, with help from material in chapter 9.)[34]

Thus, to sum up this concluding section, I have discussed the perception of medium content and also outlined one possible way in which the results of this chapter could be naturally extended to support a more comprehensive double content (DC) account of the nature of artworks.

33. In a fuller account one would regard particular elements of intention, style, and expression as individual "items" of medium content, which in an appropriately organized manner make up the collection in question. I discuss some such issues in chapter 6.

34. Chapter 12 will also show how one basic idea of the current chapter—that the *subject matter* content of an artwork can be distinguished from the *medium* content that provides an artistic commentary on it—is closely related to some important "orientational" ideas that will be introduced in part 3 of the book.

6

A Defense of
Three Depictive Views

\mathbf{T}his chapter will build on the results of chapter 5 by relating them to some influential but controversial views of two major theorists of representation, Richard Wollheim and Ernst Gombrich.

Among other things, I shall defend a *twofoldness* thesis as to the inseparability of perception of a picture and of its subject matter, making use of the recently articulated "interpretive" form of the double content (DC) theory of pictorial representation, according to which a picture is *represented by* its physical vehicle—so that a picture is itself part of the *representational content* of the vehicle—which picture in turn *interpretively* represents its subject matter. I shall also show how Richard Wollheim's own twofoldness thesis, along with related views of his, might be vindicated by reinterpretation along similar lines, and conclude by showing that Ernst Gombrich too may be protected from some standard criticisms of his views—which views are also consistent with those of Wollheim as thus reinterpreted.

6.1. THREE DEPICTIVE VIEWS

Ernst Gombrich and Richard Wollheim have what seem to be diametrically opposed views on some central issues concerning pictorial representation or depiction. Also, it is commonly thought that both of their views are vulnerable to various damaging criticisms—or at least that their views are significantly incomplete as they stand.[1]

1. E. H. Gombrich, *Art and Illusion; A Study in the Psychology of Pictorial Representation*, 2nd ed. (London, UK: Phaidon Press, 1962); Richard Wollheim, *Painting as an Art* (Princeton, NJ: Princeton University Press, 1987).

In such a theoretical situation, an optimum solution for all concerned might involve coming up with a more comprehensive theory that would preserve some of the most central insights of each writer; show that their views are, after appropriate adjustments, compatible with each other after all; and also show that the (appropriately amended or reinterpreted) versions are no longer vulnerable to the usual criticisms. In such a way one might hope both to vindicate some central insights of Gombrich and Wollheim on depiction, and also in so doing help to defend in turn the more comprehensive theory, which thus attempts, among other things, to reinterpret or reinvigorate some of the work of these two important theorists.

I believe that this admittedly optimistic-sounding scenario is in fact actually realizable. In this chapter I shall make a start on realizing it in the following way. I shall make use of the double content (DC) theory in its *interpretive* form as developed in chapter 5, which has the stronger conceptual resources required for a more comprehensive theory of depiction, and then I shall carry out, to the extent that space permits, the outlined vindications.

6.2. WOLLHEIM AND TWOFOLDNESS

I shall now begin to relate the theoretical results of chapter 5 to some closely connected issues in the literature on depiction. As a useful point of entry into the relevant literature on this topic, there are a series of contentious issues arising in the work of Richard Wollheim on pictorial depiction. As is well known, Richard Wollheim uses a distinction between the "configurational" and "recognitional" aspects of a picture to give an analysis of pictorial depiction in terms of "seeing-in," which in his view entails "twofoldness," or a conscious attention on the part of a viewer, in a single act of seeing, to both configurational (or object-related) and recognitional (content- or subject matter–related) aspects of a picture.[2]

However, Wollheim's claims regarding "seeing-in" and twofoldness have been much criticized.[3] Nevertheless, Wollheim's distinction of "configura-

2. Thus in Wollheim's later account of twofoldness, as found in his *Painting as an Art*, p. 46, he says, "The two things that happen . . . are, it must be stressed, two aspects of a single experience that I have, and the two aspects are distinguishable but also inseparable." Wollheim also summarizes his earlier, different account of twofoldness, and his reasons for changing it, in ibid., p. 360, n. 6.

3. For example, by Malcom Budd in "On Looking at a Picture," in *Psychoanalysis, Mind and Art: Perspectives on Richard Wollheim*, ed. Jim Hopkins and Anthony Savile (Oxford, UK: Blackwell, 1992), and Dominic Lopes, *Understanding Pictures* (Oxford, UK: Oxford University Press, 1996), pp. 43–51. Patrick Maynard provides a useful summary of many different points of view on these topics in his paper "Seeing

tional" from "recognitional" *objects* of seeing, in terms of which he articulates his claim of twofoldness, is widely accepted, including by those who reject or significantly modify his claims concerning twofoldness.[4]

However, I shall argue that Wollheim's critics have, in effect, picked on the wrong target—in criticizing twofoldness rather than the configurational/recognitional distinction, that is. For in my view, a suitably modified and rehabilitated twofoldness thesis is indeed a central feature of a good theory of pictorial depiction; but at the same time, the widely accepted configurational versus recognitional distinction itself, understood as a distinction between "objects" of sight rather than between two aspects of the *phenomenology* of seeing such "objects," should be abandoned, or, at least, significantly supplemented by the introduction of a third fundamental element or factor.

Let me explain. I shall claim that, instead of a configurational (or material object) versus recognitional (or subject matter) distinction, we in fact need a *tripartite* distinction between configuration, *medium*, and subject matter—and that twofoldness involves not *configuration* and subject matter, but instead *medium* and subject matter.

Furthermore, I claim that a relevant concept of "medium" as distinguished from "configuration" is itself available, in embryo form, in Wollheim's own writings, so that the seeds for restoration of an adequate concept of twofoldness are available to him within his own overall theoretical framework.[5]

For Wollheim himself distinguishes the configuration (or materials) of painting from the *medium* of painting, in discussing what he calls "thematization,"[6] as follows: "Thematization belongs to an instrumental, or means-end, way of using the materials of painting, and it is this imposition of an end upon the materials that converts them into a medium."[7]

Then a little later he says, regarding the general ends of thematization, that ". . . the broadest obtainable formula is this: the acquisition of *content* or

Double," *Journal of Aesthetics and Art Criticism* 52, no. 2 (1994): 155–67. See also the symposium on Wollheim's work with contributions by Richard Wollheim, "On Pictorial Representation," *Journal of Aesthetics and Art Criticism* 56, no. 3 (1998): 217–26; Jerrold Levinson, "Wollheim on Pictorial Representation," *Journal of Aesthetics and Art Criticism* 56, no. 3 (Summer 1998): 227–33; and Susan Feagin, "Presentation and Representation," *Journal of Aesthetics and Art Criticism* 56, no. 3 (1998): 234–40.

4. For example, by Lopes, *Understanding Pictures*, pp. 43–51, who makes a similar distinction of (physical) design properties from representational content.

5. Which is not to say that I regard his "seeing-in" theory itself as ultimately being defensible, given the many effective criticisms of it such as are noted above.

6. Which he defines as follows: "For this process by which the agent abstracts some hitherto unconsidered, hence unintentional, aspect of what he is doing or what he is working on, and makes the thought of this feature contribute to guiding his future activity, I use the term *thematization*" (*Painting as an Art*, p. 20).

7. Ibid., p. 21.

meaning. Thematization is by and large pursued so as to endow the resultant surface with meaning."[8]

Thus there is already the germ of an idea here that thematization, by imposing ends on the *materials* of painting, converts them into a *medium* that, unlike the materials themselves, acquires, or is endowed with, *content* or *meaning.*

However, he also says, in describing the major two parts of his work in the book, that

> One part is dedicated to the medium of painting, the other part to meaning in painting. There must be an account of how the brute materials of painting are converted into a medium, and there must be an account of how the medium is used to generate meaning and of the different varieties of meaning in which this can issue.[9]

And also:

> Thematization arises out of the agent's attempt to organize an inherently inert material so that it will become serviceable for the carriage of meaning.[10]

The first of these two quotations says that a medium, unlike the "brute materials" of painting, can be used to *generate* meaning, while the second implies that a medium—unlike the "inherently inert material" from which it is organized—will, after "organization," become capable of *carrying* meaning.

Thus overall, three related claims regarding the meaning-relatedness of a medium can be extracted from these passages: that a medium in some way *has* meaning or content, or that it *generates* meaning, or that it is capable of *carrying* meaning. And second, all three quotations distinguish a meaning-related *medium* from the "inert" or "brute" *materials* of painting, which by implication are not meaning-related in any way (and hence are neither meaningful themselves, nor capable of generating or carrying meaning).[11]

I think that these little-noticed passages are remarkable in their implications. For if we assume that by "configurational" objects Wollheim is indeed referring to the *materials* rather than the *medium* of painting, as seems clear

8. Ibid., p. 22.

9. Ibid., p. 23.

10. Ibid., p. 25.

11. Michael Podro has made similar points more emphatically, e.g., in Michael Podro, "Review of Wollheim, *Art and Its Objects*, 2nd Ed.," *Burlington Magazine* 124, no. 947 (February 1982): 100–102, and Michael Podro, "Depiction and the Golden Calf," in *Philosophy and the Visual Arts: Seeing and Abstracting*, ed. Andrew Harrison (Dordrecht, Holland: D. Reidel, 1987).

from some of his descriptions of configurational items as "marks," "differentiated surfaces," and so on,[12] then these very passages seem to doom his own "configurational plus recognitional" account of twofoldness to incoherence and failure. For if configurations or configurational objects—as "inert" or "brute" *materials*—are inherently unable to have, generate, or carry meaning, then how can they be an inseparable part of a twofold whole, whose only other part is itself a recognizable content or meaning, which could only (*per impossibile*) be had, generated, or carried by those same meaningless configurational objects?

However, at the same time Wollheim clearly also wants to use his configurational versus recognitional distinction as a distinction between two *aspects* of a single, special twofold *visual phenomenology*, each aspect of which experience is such that it is incommensurate with a "face-to-face" visual experience of its corresponding object or subject matter.[13]

I suggest that the best way to make sense of this is to postulate that the relevant "objects of sight" are *different* in each case, so that a *reformed* "configurational" aspect would have as its seen "object" some *medium content*—for example, some wall-like content—that is distinct from the *physical* wall that is the "object of sight" when it is seen "face-to-face."[14]

Thus it seems clear that a rehabilitation program for Wollheim's twofoldness claim must adopt as its necessary initial goal the replacement of *configurational materials* with *medium* (or *medium-related*) items, since they, and only they, are capable of appropriately supporting or carrying recognitional contents or meanings so as to restore the twofoldness claim to at least a minimal logical health.

I shall carry out the rehabilitation plan, and hence vindicate a form of Wollheim's twofoldness claim, after integrating my discussions of "medium content" in chapter 5 with Wollheim's views on the "material versus medium" distinction.

12. Also see his discussion of Gombrich in *Art and Illusion*. p. 360, n. 6, where he likens his recognitional/configurational distinction to Gombrich's nature/canvas dichotomy.

13. For example, he says, "We get lost once we start comparing the phenomenology of our perception of the boy when we see him in the wall, or the phenomenology of our perception of the wall when we see the boy in it, with that of our perception of boy or wall seen face-to-face" (Wollheim, *Painting as an Art*, p. 46).

14. For as Budd points out in "On Looking at a Picture," p. 272, because of the claimed incommensurability, the configurational aspect cannot simply be seeing of the "face-to-face" physical surface—so it is either nothing (his suggestion), or it requires reinterpretation along some such lines as mine.

6.3. MEDIUM CONTENT AND "A MEDIUM"

To summarize where we have arrived at, it seems clear from the discussion of Wollheim in the previous section that the concept of the *medium* of painting, as embryonically used by Wollheim, is itself one that in some way involves meaning or content, and which concept is to be distinguished from concepts applying only to the corresponding physical configurational materials, which are not content involving.

I shall now, as promised, provide some integration of that point with my chapter 5 points regarding the materials and medium of painting, and their connections with what I called *medium content* (or medium-related content), and the issue of picture identity.

First, I argued that medium content is *represented* by a physical painting, and that content could also be described as *expressive content*, since in typical cases the physical painting represents, as part of its medium content, the expressive activities of its artist, including her intentions and style with respect to the subject matter.

Compare that view with my initial summary of Wollheim's view, namely that thematization, by imposing ends on the *materials* of painting, converts them into a *medium* that, unlike the materials themselves, acquires, or is endowed with, *content* or *meaning*.[15]

It seems clear that our ideas are fairly closely related, and therefore suitable candidates for inclusion in a more integrated view. Wollheim's "thematization" is arguably already included in my broad concept of an artist's intentions.[16]

The main difference between our views seems to be that my concept of "medium content" is specifically tailored to define the (medium-related) represented content of *a particular painting* as created by a given artist, whereas Wollheim's invocation of *a medium* of painting is a much more generalized concept, more tailored to explaining how an *indefinite number* of works in a given medium acquired their meaning.

I can make this connection more precise as follows. I have argued that a picture or artwork, as distinguished from a physical painting, is itself a contentlike entity, which is entirely made up of the medium content associated with a given physical painting. On this view, a painterly artwork is an *organized collection of medium content*. However, Wollheim's concept of "a medium" is a much more indefinite concept, in that it, in my view, deals with all of the possible ways in which any of the physical materials associated with painting could be used so as to represent any *medium content* whatsoever.

15. See the previous section.
16. As seems clear from its definition (see fn. 6).

Thus in my view Wollheim's concept is about how any (in themselves meaningless) physical painterly materials could be used so as to represent *some* meaningful medium content—whether or not that content is sufficiently organized so as to define a specific artwork—and thereby render meaningful *a medium*, viewed as the sum total of all possible such representational uses of physical painterly materials.

Now recall my view of picture identity (as summarized in section 5.9), according to which a picture[17] is not a physical object, such as a physical stretched canvas, but instead it is itself one kind of *representational content* associated with such a stretched canvas. On this view, pictorial representation[18] involves not one but *two* stages of representation—in the first of which a physical vehicle represents a picture, and in the second of which that picture in turn represents its own subject matter or subject content.

Thus, on this depictive theory there are not just *two* distinct items—a physical object, and the subject matter or subject content it represents—but instead *three* distinct items involved in cases of depiction or pictorial representation, namely a physical object, the picture represented by it, and the subject matter represented in turn by the picture. And it is for this reason, among others, that I would claim that Wollheim's two-item configurational versus recognitional distinction is inadequate.

Since, however, a picture is itself an organized collection of medium content on my view, another way to make the threefold distinction is to distinguish material object, from medium content, from subject matter.

However, there are some complexities unaccounted for by that simple distinction, due to the differences between "a picture" (a substantive or objectlike concept) and medium content on the one hand, and between a physical object and configurational items on the other hand, which will now be discussed.

To begin with, both the concept of a physical object, and of a picture, are sortal or entity-like concepts that have a class of objects as their extensions. However, the concept of the "material" or configuration associated with a physical object is instead either a *qualitative* term (in that an object *has* a shape or configuration, rather than itself *being* [identical with] a shape), or alternatively it functions as picking out various salient physical *parts* of an object (such as the physical clumps of paint or charcoal that physically *constitute* the marks on the surface of a some particular physical canvas). Thus "configurational" information covers both qualitative configurations, and also physical parts or "materials" such as marks or clumps of paint—the pres-

17. I use the term "picture" rather than "painting" so as not to confuse a physical painting with the picture that (on my view) is represented by the physical painting.

18. As opposed to other kinds, as distinguished in chapter 9. See also the discussion of trompe l'oeil representations in section 6.5.

ence of which marks, it should be remarked, is also what most directly makes it true that the object *has* a certain shape or configuration in the qualitative sense. Thus qualitative and partlike configurational aspects or items in a particular case will typically be integrally related.

Given these qualitative or partlike features of the materials or configuration of a physical painting, an appropriately adjusted term (or phrase) is also required in the case of the picture itself, so that we have some similar way in which to refer to either qualities or parts of a picture.

Now the term "medium" by itself, as an abstract sortal term, is not well suited to this purpose, hence providing yet another reason[19] as to why the phrase *medium content* is an appropriate one to use to refer to the pictorial analog of configurational items.

Let me explain. Since on my theory a picture is itself a kind of representational content, any *parts* or *qualities* of the picture will themselves be contentlike—hence the term "content" in the phrase "medium content." Also, as already seen, the content in question is indeed *medium*-related rather than *configuration*-related; that is, it is related to painting considered as a *medium* rather than just to painting considered as a collection of configurations or materials.[20]

To expand on this point, since a picture is (on my account) itself a *representational content* of its corresponding physical object or vehicle (rather than being itself a physical entity), then only some *correspondingly contentlike entity* (or contentlike *factors*) can serve in giving an account of the parts and qualities that make up a picture. Hence the physical materials or qualitative configuration associated with a given physical vehicle cannot serve that purpose. For at best they would figure in an account of how a physical object is able to *represent* a picture—but, as with any representation, that would tell us little about the *nature* of what is thus represented.

6.4. AN INTERPRETIVE TWOFOLDNESS THESIS

Now I shall present my own twofoldness thesis. In the first place, my thesis (as with Wollheim's later version) is a thesis about a single act of seeing that

19. In addition to the reason given in chapter 5, namely that the kind of content in question is integrally related to the medium used by a picture's creator.

20. Also, I should explain why I do not simply use the phrase "pictorial content" to refer to the content-parts or qualities associated with the content that (on my account) comprises a picture. My concern is that that phrase is already too wedded to the "content" of a picture as conventionally understood, that is, to (what I have been calling) the *subject matter* or subject content of a picture.

is both of representational subject matter, and of a picture or artwork which represents that subject matter, and which elements are *inseparably linked* to each other—and perceived to be thus—in a manner to be explained.

As a preamble, it will be useful to briefly discuss what it is for a picture to be a *representational* one, since I am only discussing representational pictures in the current account. Minimally, a representational picture is a picture that *has* or *represents* a subject matter.

Now I claim that, since the concept of pictorial representation is a broadly empirical or perceptual one, it must at least be *possible* that (in some instances) one can *see* that *a picture represents its subject matter*, or, in other words, see something that simultaneously visually involves both a picture and its subject matter as represented by the picture. For in the absence of at least *some* such representational experiences of pictures, it is hard to see how we could have ever acquired the empirical concept of a representational picture.

Now this minimal claim of possible representational seeing is not yet a full-blown twofoldness thesis, for that will require—in my version—that *all* instances of seeing a picture, or some pictorial subject matter, are of this twofold representational kind. Nevertheless, I believe that it is important that a twofold thesis should maintain its roots in the concept of a representational picture, and so my twofoldness thesis will not merely be about pictures and subject matters, but about pictures insofar as they *represent* some subject matter.

Now I shall proceed with my main twofoldness thesis. To begin with, recall that on my view, one paradigm type of medium content is *expressive* content, which expresses an artist's intentions and style with respect to some subject matter. Another way of putting this point is to say that medium content involves a visual *interpretation, construal,* or *commentary* on some subject matter. This *interpretive* element plays a central role in the twofoldness thesis to be outlined.

Consider next an analogous case of a *literary* commentary, such as a newspaper editorial. Three features of such a commentary are relevant. In the first place, a commentary by its very nature is a commentary *on* or *about* some subject matter, and in that sense any given commentary is *inseparably linked* to the subject matter about which it is a commentary. For it would not be *a* commentary unless it was about *some* particular subject matter, and it could not be identified as *the particular commentary that it is* independent of the one particular subject matter that it is about.

In the second place, it is notoriously the case that editorial commentaries do not simply *objectively describe* their subject matter, but instead they *interpret* or *construe* the subject matter in whatever way best fits with the intentions and editorial style of the writer in question. If an ideal of objective description is *transparency*—in which the pure subject matter itself is presented, with no overlaid editorial biases or construals—then any commentary

must *fail* to be transparent, in that it would not be a commentary at all if it did not present some *construal* of its subject matter, rather than merely a transparent objective description of it.

Thus the contents of editorial construals or commentaries are inevitably *non*transparent, or *opaque*, with respect to their commentaries, in that there is no possibility of disentangling the relevant *editorial construal* of the subject matter from some hypothetical corresponding "pure" or objective subject matter.

In the third place, consider a reader of such an editorial commentary, and her experience of the subject matter of the commentary as she encounters it in the context of actually reading the commentary. I would claim that, because of the opacity of the commentary,[21]any experience she has of the subject matter of the commentary is actually an experience of the *construed*, rather than the hypothetical "pure," subject matter. And what is more, that experience of hers, of construed subject matter, is *inseparably linked* to the very commentary that she is currently reading, since it is the subject matter *as construed by that very commentary* that constitutes the "subject matter" as experienced by her.

To conclude this linguistic analogy, I propose an *interpretive* twofoldness thesis for *editorial commentaries* on the basis of this demonstrated "editorial opacity," namely that a reader's experience of a commentary, and of its construed subject matter, are inseparably linked in exactly the ways that have just been described.

Here is a brief clarification of the kinds of inseparability involved, which will apply to pictures also. Point one above is about how a commentary is "inseparable" from its subject matter in the dual sense that (a) that commentary *could not* occur without *a* subject matter, and (b) it *could not* occur with any subject matter other than its actual one. Now point one by itself does not exclude the possibility that its subject matter S might either occur by itself, or be the subject matter of some other commentary (or both). However, point three excludes both possibilities, so that commentary and subject are *mutually inseparable*, on this account, in that neither could correctly or veridically be experienced as occurring without the other.

As for opacity, logically speaking B is *opaque* relative to A just in case B's relation to A provides a necessary condition of the identity of B—so that opacity is one form of *logical dependence*.[22] Thus cases of *transparency* of B rel-

21. A commentary is "opaque" in a derived sense, if it induces opacity in the subject matter that it construes. See also the clarification on opacity in the text below.

22. On this definition not only is *the subject matter* of a commentary opaque relative to its *commentary*, but the converse relation holds as well. However, the intuitive picture of an interpretive mode of access to a subject matter inducing the subject matter to become "clouded" or "opaque"—relative to some supposed "transparent" but logically distinct form of the subject matter—works better *as an easily accessible intuitive picture* than does an attempted intuitive picture for the converse relation.

ative to A are instead cases in which the identity of B is logically *independent* of its relation to A.

Returning to pictures, my pictorial twofoldness thesis can be summed up as a claim that pictures are *pictorially opaque*, in precisely the same ways as those in which editorial commentaries have been shown to be "editorially opaque." Thus on my account both are species of (what could be called) *interpretive opacity*.

I shall now describe the corresponding points about pictures, retaining as far as possible the same descriptive forms as in the literary case.

In the first place, a picture—that is, an organized collection of medium content—is by its very nature a visual construal or commentary *on* or *about* some subject matter, which subject matter it represents; and in that sense any given visual construal is *inseparably linked* to the subject matter about which it is a construal. For it would not be *a* visual construal unless it was about (or, represents) *some* particular subject matter, and it could not be identified as *the particular visual construal that it is* independently of the one particular subject matter that it represents.

In the second place, it is notoriously the case that pictures, and particularly artistic pictures, do not simply *objectively represent* their subject matter, but instead they *interpret* or *construe* the subject matter in whatever way best fits with the intentions and pictorial style of the artist in question. If an ideal of objective visual representation is *transparency*—in which the pure subject matter itself is visually represented, with no overlaid artistic biases or construals—then any visual construal must *fail* to be transparent, in that it would not be a visual commentary at all if it did not present some *construal* of its subject matter, rather than merely a transparent objective representation of it.[23]

Thus the contents of artistic construals or visual commentaries are inevitably *non*transparent, or *opaque*, with respect to their pictorial commentaries, in that there is no possibility of disentangling the relevant *pictorial construal* of the subject matter from some hypothetical corresponding "pure" or objective visual subject matter.

In the third place, consider a perceiver of such a picture, and her experience of the subject matter of the picture as she encounters it in the context of actually seeing the picture. I would claim that, because of the opacity of the picture, any seeing by her of the subject matter of the picture is actually a seeing of the *construed*, rather than the hypothetical "pure," subject matter. And what is more, that seeing of hers, of visually construed subject matter, is *inseparably linked* to

This is doubtless related to the fact that we intuitively view commentaries as in some sense *acting upon* or *changing* subject matters, but not vice versa.

23. See chapter 9 for an account of "simple" or transparent, noninterpretive ("delineative") representations, in which a physical object directly represents its subject matter. See also the discussion of trompe l'oeil representations in the next section.

the very picture that she is currently seeing, since it is the subject matter *as construed by that very picture* that constitutes the "subject matter" as seen by her. (Thus ends the pictorial analogue of the "editorial commentary" points.)

Thus my *interpretive twofoldness thesis* for pictures is that a viewer's seeing of a picture, and of its construed subject matter, are inseparably linked in exactly the ways that have just been described. And the clarification of the kinds of inseparability involved for a commentary and its subject matter applies equally well to pictures and their subject matters: in particular, a picture and its subject matter are *mutually inseparable*, in that neither could (correctly) be seen to occur without the other.

The foregoing perceptual or experiential thesis can also be captured in a logical formulation, as follows.

As an initial, but inadequate formulation, the fact might be cited that a perceptual statement such as

1. Person X sees that picture P represents subject matter S^{24}

is *logically opaque*, in that inferential exportations to

2. Person X sees picture P

and

3. Person X sees subject matter S

are *invalid*.[25]

However, this does not capture even part of my inseparability thesis, since it merely shows that statement 1 describes a case of (what could be called) *propositional* or *factual* seeing—of seeing that *P is R-related to* S^{26}—for which, since it is a distinctive kind of seeing, one would not expect a simple analysis as two combined cases of simple seeing (of *seeing P*, and *seeing S*).

24. Statement 1 is to be read as implying that "picture P represents subject matter S" is *in fact* what person X sees, but that X may not herself *realize* (with full explicitness) exactly what she has thus seen. This point is needed so as to allow statement 1 to be true even for unsophisticated perceivers, who may only marginally possess the concepts of "representation," "picture," and "subject matter."

25. This logical sense of opacity is the familiar one that is applicable to other perceptual contexts as well. For example, the statement "Bill saw that his car was not in the parking lot" is also opaque, in that one cannot validly infer from it that "Bill saw his car."

26. But this is not to deny that propositional seeing may be an integral part of twofold seeing; it is just that it is not a *characteristic* or *distinguishing* part of it.

Hence it is to be expected that statement 1, concerning propositional seeing, would not entail either of the "simple seeing" statements 2 and 3.

What is instead needed, as a legitimate part of my twofoldness thesis, is the stronger thesis that

4. Statement 1 entails ~(X sees P).~(X sees S).

That is, that if statement 1 is true, then neither of the simple seeing statements 2 and 3 can be true. Point 4 also captures, I believe, a logical core of Wollheim's own later twofoldness thesis as applied to representations,[27] though not the twofoldness of *all* "seeing-in" cases, some of which do not, on his view, involve representations.

To complete the logical analysis of (my interpretive brand of) twofoldness, we need two more axioms, the first of which is

5. There are no cases of simple seeing of pictures or subject matters.

Point 5 is justified by the relevant inseparability results presented above. In the case of a picture, because a picture is on my account essentially *a visual construal of a subject matter*, it follows that, if the picture is considered simply "by itself," independently of a subject matter, it would be an *incomplete* or *unsaturated* entity that is not the kind of thing that could be perceived. Hence "X sees picture P" must be false for all values of X and P.

And similarly, because on my account a subject matter is essentially a *construed* subject matter, which is thus construed by the very same picture that represents it, it follows that, if the subject matter is considered simply "by itself"—independently of its thus being construed by the picture that represents it—it also would be an incomplete or unsaturated entity that is not the kind of thing that could be perceived. Hence "X sees subject matter S" must be false for all values of X and S. Of course, on my view common claims that someone "sees a picture," or "sees some subject matter," are to be interpreted as *twofold* claims, rather than in the technical "simple" senses here introduced.

And finally, we also need the *mutual inseparability* axiom, that

6. Neither a picture nor its subject matter could (correctly or veridically) be seen as occurring without the other.[28]

27. At least, if his concept of a physical representation is reinterpreted as my concept of a picture.

28. This axiom could also be given a perception-independent formulation as: any picture or subject matter occurs in at most one picture-subject matter combination. However, since the subject matter in question is *opaque* subject matter, which arguably has integral perceptual or experiential connections, this would be a less basic formulation.

6.5. QUESTIONING INTERPRETIVE TWOFOLDNESS

Now that an interpretive twofoldness thesis is available, what kind of evidence, if any, is required in order to defend it?

In answering this question I shall take my cue from the corresponding literary example of a newspaper commentary. Properly understood, there is nothing particularly controversial about the corresponding twofoldness thesis for literary commentaries, since the thesis simply involves a drawing out of some (perhaps unexpected) logical implications of assumptions about commentaries, and their subject matters, that are universally accepted. That opinionated commentaries and their commentary-construed subject matters are inseparably twofold requires proof, if any is required, only in the sense of a *logical* proof or demonstration that the universally held assumptions do indeed have those (inseparably twofold) logical implications—which demonstration I have already provided.

And the same goes, I hold, for the twofoldness of pictures. Once it is conceded that pictures are, in some suitably broad sense, *visual commentaries or construals* of their subject matters, then it follows *as a matter of logic* that pictures are inseparably twofold. Thus, unlike Wollheim's later twofoldness view, which he presents as an exciting and mysterious thesis about the visual phenomenology of twofold seeing, my view is rather a *normative conclusion* about *what we are logically required to say or hold* about cases involving the seeing of pictures and their subject matters, given only certain fairly minimal and generally accepted assumptions about the nature of pictures.[29]

Thus in my view it would simply be a misunderstanding if critics were to directly question my twofoldness conclusion itself. Instead, they should raise issues about one or more of three things: (a) The premises, including their applicability to pictures, from which I *logically derive* the twofoldness conclusion or conclusions; (b) the adequacy of my theory of pictures itself, in which a picture is identified with medium-related content that is, in typical cases, an expressive construal of its subject matter, and which theory hence has enough conceptual resources to *model* the relevant premises and twofold conclusions; or (c) *empirical application questions* regarding how various miscella-

29. Or, put another way, it provides a basis for a regulative theory as to which cases of seeing should *count* as being cases of pictorial seeing. However, it should be noted that Wollheim's earlier account of twofoldness, as found in Richard Wollheim, *Art and Its Objects: With Six Supplementary Essays*, 2nd ed. (Cambridge, UK, and New York: Cambridge University Press, 1980), in his essay entitled "Seeing-as, Seeing-in, and Pictorial Representation," also regards twofoldness as ". . . a normative constraint upon anyone who tries to appreciate works of those arts [painting and poetry]" (p. 216).

neous pictorial cases or intuitions relate to twofoldness itself, or to any theory of pictures, including the present one, that can model twofoldness-related phenomena.

A prominent nexus of issues falling under category (c) is (what could be called) an *error theory of pictures*, which would attempt to explain, or explain away, apparent *deviations* from twofoldness premises or conclusions, whether or not they are modeled in some appropriate pictorial theory. I shall now give some examples of likely fragments of such an error theory of pictures, using as an example a van Gogh picture of a cornfield, executed using the painter's characteristic large and vigorous brushstrokes. The theory will attempt to identify *characteristic error conditions* under which deviations from expected results occur, or seem to occur. All of the examples given will concern apparent cases in which a picture is seen, but its subject matter is not.

The first error condition occurs if, rather than seeing a picture itself, one instead only sees the corresponding *physical painting*. Of course it is possible to do this, on my theory, without seeing the subject matter of the picture, and hence it does not constitute a counterexample to twofoldness.

The second error condition concerns the seeing of medium content, and comes in at least two versions. First, on my view, one does not see *the picture itself* unless one sees the *relevant organized collection* of medium content that is identical with the picture. Now one way in which this can fail to happen is if one perceives some *part* of that medium content, but without perceiving it *as* being part of that organized collection. For example, one might become so interested in some of van Gogh's vigorous brushstrokes "in their own right" that one fails to perceive them *as part of* the picture in question, and hence for that reason one does not thereby also perceive the relevant part of the subject matter of the picture.

A somewhat more radical failure in perception of the medium content of a picture might occur as follows. An art student might approach a van Gogh picture, not in order to appreciate the picture and its subject matter for their own aesthetic sake, but instead to learn about—perhaps in order to borrow—some of the painter's *stylistic methods*. In such a case, the student might reinterpret the physical painting as representing not the original organized collection of pictorial content which constitutes the picture, but instead a more "unsaturated" or *indeterminate* kind of medium content—none of which is identical to any of the relevant pictorial medium content—that might be made determinate in many different pictorial ways, and with many different corresponding subject matters. Obviously one could see such indeterminate medium content, and evaluate its worth as a stylistic method relative to many possible pictures and subject matters, without seeing any of the subject matter of the relevant picture.[30]

30. This would be an analysis in line with my explication of Wollheim's nascent concept of "a medium," or of the possibilities of a medium, as discussed in section 6.3.

A third error condition concerns a "flip-flop" situation in which some of the medium content of a picture is reinterpreted as *subject* matter—or more precisely, a situation in which the physical painting itself is reinterpreted as representing *another* picture, some of whose predominant subject matter occurs in areas which formerly were predominantly areas of medium content in the original picture. Obviously in such a case there is a risk that one will no longer be able to perceive the subject matter of the picture in its precise original form, after one has engaged in such a perceptual "flip-flop."[31]

A fourth error condition involves the case of trompe l'oeil representations, which (when successful) seem to involve no twofold awareness of medium content and subject content. I handle this case by denying that they are *pictures*.[32]

Briefly, on my view a trompe l'oeil painting is a *simple* representation, in that the physical painting *directly* represents its subject matter, with no intervening pictorial or medium content of any kind. Hence it is only to be expected that they are unable to provide twofold visual experiences, since they lack the expressive means to do so.[33]

A fifth error condition, or syndrome of conditions, concerns the absence of any critical "normal observer" factors such as full alertness, requisite pictorial or artistic prior experience, an unbiased and sympathetic determination to visually appreciate a picture in its own terms, and so on. Clearly the absence of one or more such factors could lead to various perceptual failures, including a failure to see relevant parts of the subject matter of a picture that one is, on the basis of such reasons, more or less *imperfectly* seeing.

To conclude this section, I shall make the (perhaps obvious) point that my interpretive twofoldness thesis, as interpreted within the current theory of depiction, is inherently easier to defend than Wollheim's own version in

31. For example, it seems likely that many of Ray Lichtenstein's well-known blown-up versions of traditional pictures and cartoons, in which what were originally medium-content features of some other artist's intention and style are transformed into deadpan Lichtenstein subject matter, may have originated in perceptions of this kind. A simpler example would be the section 5.4 example of a misinterpretation of a steel engraving of a woman (which includes medium-related cross-hatching and repeated lines) in which it is wrongly seen as a picture of a woman with lines, or a net, all over her face. (The example was from Andrew Harrison, "Dimensions of Meaning," in *Philosophy and the Visual Arts: Seeing and Abstracting*, ed. Andrew Harrison [Boston, MA: Kluwer Academic Publishers, 1987], p. 63, but who used it for another purpose.)

32. On which also see chapter 9.

33. Related views that treat trompe l'oeil cases as in some way failing to be fully pictorial are provided by Susan Feagin and Jerrold Levinson in the previously mentioned symposium on Wollheim: Feagin, "Presentation and Representation," and Levinson, "Wollheim on Pictorial Representation." Of course this is also Wollheim's own view of trompe l'oeil cases: see Wollheim, *Painting as an Art*, p. 62.

that on my account *both* a picture *and* its subject matter are different varieties of *representational content*. Wollheim was engaged in the quixotic task of trying to show how what are in fact *logically distinct items*—namely configurational materials and subject matters—could nevertheless *correctly be perceived* as being *logically inseparable* in certain situations. But my entirely content-based DC theory of pictures provides an ideal model or realization for the interpretive twofoldness thesis, for I can claim that a picture (speaking informally) *just is* such a single package of visual information, as represented by some physical object, that may be discussed in the two complementary but inseparable ways that have been outlined.[34]

6.6. GOMBRICH VINDICATED

Ernst Gombrich has a view according to which it is impossible simultaneously to see both a physical painting and its subject matter or content.[35]

In his view this impossibility is analogous to the impossibility of seeing, as one looks at a "duck-rabbit" (a well-known visual design, interpretable either as a duck or as a rabbit), both the duck and the rabbit at the same time. In such a case, each interpretation conflicts with the other, so that at most one of them can be seen at a given time.

Now it is usually assumed that Gombrich is doubly wrong in this case, both for thinking that the duck-rabbit case is genuinely analogous to the painting-subject matter case,[36] and for thinking that in any case there must be a conflict between seeing a painting and simultaneously seeing its subject matter.[37]

What is more, it is also generally assumed that Gombrich's view is *inconsistent* with Wollheim's twofoldness thesis. For Gombrich asserts the *impossibility* of simultaneous painting-subject matter seeing, while Wollheim instead seems to assert the *necessity* of such simultaneous painting-subject matter seeing.

34. A Kantian view of twofoldness as providing a synthetic a priori "law of thought" regarding pictures might also be appropriate.

35. Gombrich, *Art and Illusion*. Arguably this point is of central strategic importance to Gombrich in supporting his general illusion theory of depiction, in that an illusion as of seeing a real thing could hardly be produced if one was at the same time aware of the physical surface of a painting. See Budd, "On Looking at a Picture," and Lopes, *Understanding Pictures*, p. 40.

36. Wollheim argues against the analogy in Wollheim, *Painting as an Art*, p. 360, n. 6.

37. For example, see Lopes, *Understanding Pictures*, pp. 40–42, who claims that "It is a grave mistake to suppose that no picture may be experienced simultaneously as a marked, coloured, textured surface and as what it represents." See also Wollheim's own comments in Wollheim, *Painting as an Art*, p. 360, n. 6.

However, I claim that, just as it was possible to vindicate a form of Wollheim's twofoldness thesis, so also is it possible to vindicate *both* of Gombrich's views—on the relevance of the duck-rabbit analogy, and the impossibility of simultaneous painting-subject matter seeing—and also show them to be entirely consistent with the reinterpreted Wollheim twofoldness thesis.

What is more, in the case of Gombrich no reinterpretation of his views is needed at all. It is rather, I would claim, that the general failure to distinguish the *physical* or *configurational materials* of painting, such as a physical painting itself, from *medium-related content*—such as a represented picture—has led to a systematic confusion of cases, and hence produced spurious or merely apparent evidence for one view or another, including the appearance of conflict between the views of Gombrich and (a properly reinterpreted) Wollheim, and the general impression that Gombrich's evidence for his views is weak or nonexistent.

First, Gombrich's claims concern the relations between a *physical painting* and its subject matter, whereas in my view a proper reinterpretation of Wollheim's twofoldness thesis instead has it as concerning the relations between a *picture* and its subject matter. Thus logically at least there cannot be any conflict between Gombrich's impossibility thesis and Wollheim's twofold necessity thesis, since Gombrich's thesis is about a *physical painting*, whereas Wollheim's is instead about a *picture*.

This already is a significant result, since it means that even if Gombrich's claims are most probably true (as I shall argue), they no longer threaten to impugn the reinterpreted twofold thesis. Here then is my brief vindication of Gombrich.[38]

I shall argue that it has not been realized that acceptance of the impossibility of simultaneously seeing a duck-rabbit as a duck and as a rabbit immediately gives strong support to his thesis of the impossibility of simultaneous painting-subject matter seeing.

The following concepts and points will be useful during the discussion. Consider a given region of the visual field of a perceiver that contains a painting, such as a duck-rabbit painting. First, it is clearly the case that visual information concerning the given region of the visual field is initially processed at a low or subdoxastic level. Consider then a higher-level interpretation of the lower-level visual data that is *comprehensive*, in the sense that it *uses all of the available lower-level data* in a single consistent high-level interpretation of that data.

Now any such *comprehensive interpretation* precisely defines the exact limits of "visually compossible seeing"—that is, of items that can simultane-

38. Perhaps I should make it clear that in general it makes no difference to my own view of pictures, including the interpretive twofoldness thesis, as to whether or not Gombrich can be vindicated.

ously be seen—for the given region during a given perceptual episode. And any comprehensive interpretation distinct from the previous one will doubly be in conflict with it, first because each must occur nonsimultaneously, and second because each interpretation will make—because they are distinct—*conflicting* uses of at least some of the available low-level visual data.

The intuition that is at work here is this: that one cannot have one's visual cake, and eat it too. The visual cake (the low-level data) gets *used up* by a given comprehensive interpretation, and hence one cannot *simultaneously* visually experience some *different* high-level interpretation of that same visual cake. Of course a given set of visual data can be reinterpreted, but my point is that it would indeed be a *re*-interpretation, a second and distinct comprehensive interpretation that would doubly visually conflict with the first comprehensive interpretation.[39]

Here is the relevance of this point to the Gombrich case. To begin with, the duck-rabbit case perfectly illustrates the point. The reason why one cannot simultaneously see the duck-rabbit *as a duck* and *as a rabbit* is because each interpretation is itself a *comprehensive* interpretation of all the low-level relevant data, so that there is *no data left over* to allow a simultaneous different interpretation, because the content in question covers the whole of the visual region from which the data is obtained.[40]

However, it has not been realized that if one accepts this point, or some similar point expressed in different terminology, then one has *already* made it very difficult for oneself not to accept Gombrich's other claim concerning the conflict between seeing a physical painting and seeing the subject matter of the associated picture. Critics of Gombrich such as Wollheim focus on the fact that the duck versus rabbit case is *symmetrical* (both are subject matters), whereas a corresponding "physical painting versus rabbit" case is an *asymmetrical* pair.[41]

But all that is necessary to prove his asymmetrical thesis is that *one* member of the pair—namely, the subject matter—should be a *visually comprehensive interpretation* of all the relevant data. But has one not already conceded that, in conceding that Gombrich is correct about the duck-rabbit conflict, a point that everyone accepts as valid?

39. Maynard in "Seeing Double," p. 156, argues that ". . . there is no general question about people simultaneously processing sense inputs in alternative ways." I could agree, but my point is rather about a *comprehensive, high-level* interpretation, of which a person is *visually aware at a given moment.*

40. My interpretive twofoldness thesis could be used to strengthen this point. Because picture perception has that kind of double interpretive complexity, it is even more likely that a *pictorial* interpretation of data is indeed a "comprehensive" interpretation, in the relevant sense.

41. For example, Wollheim, *Painting as an Art*, p. 360, n. 6.

As far as I can see, there are only two ways to attempt to avoid this conclusion. One way would involve engaging in some suspicious-sounding revisionist backtracking, such as by saying that after all a given interpretation of the duck-rabbit (such as: as a rabbit) has not been *proven* to be a fully comprehensive interpretation of the data by itself; so that for instance it has not been ruled out that one could *either* simultaneously see "a physical painting and a duck," *or* instead simultaneously see "a physical painting and a rabbit."

However, I doubt that I am alone in finding that interpretation tortuous in the extreme, and one that no one would ever have thought of simply on the basis of any actual visual experiments with a duck-rabbit painting.

The other possible attempt to avoid the conclusion that subject matter provides a *visually comprehensive interpretation* of all the relevant data would involve an attempt to cast doubt on "duck" content (or "rabbit" content) as somehow not being suitably representative of content in general.

However, my argument for, for example, a "rabbit" interpretation being a *comprehensive* or "data-exhausting" interpretation—of all the low-level visual data from the visual region in question, with which the content is coextensive—does not depend on the contingent fact that, as it happens, the low-level content comprehensively interpretable as a rabbit is *also* susceptible of an alternate and distinct high-level content interpretation as a duck. The argument applies equally to *any* case in which a region of content, because it is coextensive with the visual region from which low-level visual data is obtained, thereby exhausts that data in the process of its being defined as a comprehensive high-level interpretation of that data. The duck-rabbit case serves merely to dramatize this internal or logical feature of any comprehensive high-level cognitive interpretation.

Thus, to summarize, I conclude that Gombrich is very likely correct,[42] both in holding that a visual experience of a given visual region as a certain kind of subject matter precludes also experiencing that same region as being part of a physical object, and in holding that the duck-rabbit case is relevant to deciding that issue.

42. Only "very likely," because the question is a broadly scientific one, whereas factors such as the logical inseparability involved in my corresponding twofoldness result give me appropriately greater confidence in its truth.

Part 3

Artworks, Designs, and Orientation

Artworks and Designs

I n this chapter I show that *artworks* must be distinguished from *designs*, where designs are a special category of *humanly meaningful types*—not previously defined in this way—that have physical artifacts as their tokens. Thus I propose a distinction between *design* intentions, activities, and products, as opposed to *artistic* intentions, activities, and artworks. Examples of *design products* would include a specific type of car (or any other invention or device) as well as closer relatives of art such as decorative wall designs.

In order to distinguish *artistic* from *design* intentions, an example is presented in which two sculptors independently work on a single object to produce two sculptures, which are distinct *just because* the artistic intentions of the sculptors are distinct. This case is then contrasted with an attempted parallel example for design intentions, which fails to produce two correspondingly distinct design products in spite of the different design intentions of its designers. It is argued that this failure occurs because designs are *types*, for which any single token of a given type could not simultaneously be a token of some other type of the same general kind; whereas the possibility of my sculptural "double artwork" example shows that such artworks cannot be types. I then further investigate the concept of a design, and conclude by arguing that an extension of the sculptural example could show that literary artworks also cannot be types.

7.1. ART, DESIGN, AND INTENTIONS

The distinction of art from craft is a familiar one. Artistic intentions and activities produce artworks, while, it is sometimes held, (exclusively) craft-

based intentions and activities produce instead only "craft objects," which are not artworks.[1]

But there is another, arguably more significant distinction between artistic and more mundane intentions, activities, and products—bearing some resemblance to artistic ones but yet being distinct from them—which (strangely enough) seems not to have been clearly proposed or investigated yet (or at least, not in the specific way in which I shall make the distinction).

The distinction I have in mind is that between genuine artistic intentions (or activities) and artworks, versus what could be called *design* intentions (or activities) and *design* products. Examples of *design products* would include a specific type of car or motor vehicle, such as a Rolls-Royce, or any other invention or device, as well as closer relatives of art such as decorative wall or furnishing designs. Correspondingly, *design* intentions or activities are any of the intentions, or activities, which go into designing and actually producing some design product.

It might be thought that the class of design products is coextensive with that of artifacts, and hence that I am merely discussing the more familiar distinction of artworks from artifacts.[2]

However, though a good case can be made that any artifact must be *made* (rather than, for instance, just naturally occurring, or becoming so simply in virtue of someone *declaring* it to be thus),[3] it seems clear enough that not every artifact need be *designed* prior to its being made. For example, even birds and monkeys can make tool-like artifacts, but few would claim that they *intentionally design* the tools that they make. Thus issues concerning the intentions of designers play a significant part in discussing design products, just as a consideration of artistic intentions is integral to discussions of artworks.[4]

Returning briefly to the art-craft versus the art-design contrast, a summary point showing their distinctness is as follows. If we accept R. G. Collingwood's account of the art-craft distinction, a critical difference between art and craft is that artistic activities are creative, whereas craft activities are not, since (on Collingwood's account) they merely follow preestablished rules or recipes. However, the art-design contrast cannot be made in

1. The *locus classicus* for a distinction of art from craft is R. G. Collingwood, *The Principles of Art* (New York: Oxford University Press, 1945). There is a useful recent discussion of the distinction in M. A. Boden, "Crafts, Perception, and the Possibilities of the Body," *British Journal of Aesthetics* 40, no. 3 (July 2000): 289–301.

2. Stephen Davies in his book *Definitions of Art* (Ithaca, NY: Cornell University Press, 1991) provides a useful overview of various positions on artifacts and artworks.

3. George Dickie in his later works such as *The Art Circle: A Theory of Art* (New York: Haven, 1984) argues for this view.

4. A fuller discussion of the distinction is given in section 7.4, including cases of designs that do not result from any design intentions or activities.

those terms, since it is clear enough that some design intentions and activities can be just as creative and original (in their own ways, of course) as paradigm cases of creative artistic activities. Museums that celebrate the originality and creativity of car and furniture designers, or of the work of significant inventors, are celebrating genuine creative achievements, whereas no amount of excellence of craftsmanship can (by itself) achieve any creative results at all.

Thus, designers can be creative, but (I claim) their design intentions, activities, and products are not, as such,[5] *artistic* intentions, activities, or artworks.

But then in what does the difference between art and design consist? As a first approximation to the solution I shall propose, Arthur Danto's account of the difference between artworks and (what he calls) "mere real things" may be invoked. It will turn out that design products are indeed "mere real things," whereas artworks are not, but my account of artworks will rely even more heavily on the role of an artist's intentions than does Danto's account.[6] I shall also draw attention to the differing roles played by the intentions of the artist versus those of the designer.

With respect to the intentions of an artist, a further element of Danto's approach to artworks may usefully be invoked, namely his "method of indiscernibles," by which he argues that, of two perceptually indiscernible objects, one might be a work of art while the other is not, or (in another case) each might be a different artwork. In the second case, the differing intentions of each artist seem relevant in some way to distinguishing the two artworks from their corresponding indiscernible objects.[7]

However, since the objects in question are distinct objects with different causal histories, it is always open to objectors to claim that it is the distinct causal histories (or some other factors connected with the distinctness of the objects), rather than the distinct intentions in question, which are actually what differentiates the two artworks.[8]

Hence it would be very desirable, if possible, to find a case in which a *single* object (with a single causal history) is worked on by two different artists, each with different intentions, in which it is plausible to claim that two distinct artworks result from their artistic efforts. If such a case were possible, one would have a "pure" case of distinct artistic intentions providing

5. I would not deny that a design object might come to be *regarded* or *used* as an art object, but (for example) even if a rock is used as a hammer, or regarded as such by its user, it does not thereby become a hammer.

6. For example, as in A. C. Danto, *The Transfiguration of the Commonplace: A Philosophy of Art* (Cambridge, MA: Harvard University Press, 1981).

7. Ibid., chap. 1.

8. For various criticisms of Danto's view see M. Rollins, *Danto and His Critics* (Oxford, UK, and Cambridge, MA: Blackwell, 1993).

both a necessary and sufficient condition for the distinctness of the corresponding two artworks. I shall shortly provide such a case.

On the other hand (to return to the main theme of this chapter) if it turns out that similarly distinct *design* intentions on the part of two designers as applied to a single object could result in only *one* finished design object, then a critical difference between the role of intentions in art versus design activities and products would have been identified, and hence a critical difference between art and design generally. (I shall show this after providing the promised artistic example.)

Another advantage of the artistic case to be provided will be that it will also show that neither artwork in question could be a type or universal,[9] since distinct types of the same general kind could not be coinstantiated by a single concrete object (example: no particular car can be both a Ford and a Pontiac, since each is a distinct kind of car). This will be described as the *disjointedness of distinct types* principle.

This principle holds for the following reason. Types that are *not* of the same general kind (such as warmth and hardness) have their distinctness as types determined by the categorical differences of their general kinds rather than by their extensions, so that an object can be both warm and hard, for example. However, types that *are* of the same general kind instead have their distinctness as types determined by their relations as subsets of the extension of the general kind in question. Thus, if their extensions are disjoint then the types are indeed distinct; but any overlap in extension (so that there would be objects to which both types apply) would merely show that after all the types were not distinct. A biological example is provided by two species of the same genus: the species count only as distinct if there is no animal belonging to both species.[10]

But since cars and other "type" objects provide paradigm cases of *design* objects, another critical difference between artworks and design objects will have been uncovered.

9. Support for a "type" view as applied to at least some works of art is provided by (among others) N. Carroll, *A Philosophy of Mass Art* (Oxford, UK: Clarendon Press; New York: Oxford University Press, 1998); G. Currie, *An Ontology of Art* (Houndmills, Basingstoke, Hampshire, UK: Macmillan in association with the Scots Philosophical Club, 1989); J. Margolis, *Art and Philosophy* (Brighton, Sussex, UK: Harvester, 1980); and R. Wollheim, *Art and Its Objects: With Six Supplementary Essays*, 2nd ed. (Cambridge, UK, and New York: Cambridge University Press, 1980).

10. A potentially more contentious example concerns the possibility of items of furniture such as "sofa beds," specimens of which are both sofas and beds. However, such a case does not provide a counterexample to the present *disjointedness of distinct types* principle, but instead merely shows that beds and sofas are overlapping rather than distinct types. (My thanks to Peter Lamarque for the putative counterexample.)

7.2. TWO SCULPTURES, ONE OBJECT

Here is the promised artistic example. Natalia and Seamus are sculptors who gradually become acquainted with each other via occasional random meetings at the bronze foundry whose services both make use of. Each works in a modernistic, abstract style. Some of Natalia's works are similar to those of Seamus, but others are not.

Seamus and Natalia have great difficulty in communicating, partly because Natalia is an expatriate Russian with a very limited command of English. But even so, even when Seamus is reasonably satisfied that he understands what Natalia is trying to tell him, he can make little or no sense of the ways in which she describes both her own works and his too. What is more, apparently she has similar problems with Seamus's attempts to explain his own works to her, or to describe how hers affect him. It is as if their divergent cultural origins have given them fundamentally different outlooks on art, in spite of the occasional, superficial similarities in some of their works.

One day when they run into each other, they discover that a striking coincidence has occurred: each has been promised that one of their works will be included in an important exhibition in their respective countries. But what is also striking is that each also faces a major roadblock in acceptance of his or her opportunity. Each is required to submit a major, large-size bronze sculpture to their respective exhibitions, but neither of them can afford more than half of the tremendous costs associated with having such a large work cast at the foundry where they meet.

Each of them is rapidly becoming desperate, because for each the tremendous opportunity to advance his or her own career makes rejection of their respective offers unthinkable. Yet at the same time acceptance seems impossible because no one will extend either of them individually enough financial credit to go ahead with their respective opportunities—as mentioned, each has only about half of the financing that would be required to complete their projects.

Well, desperate situations lead to desperate solutions. One of them (it doesn't matter who) has a flash of inspiration. As sculptors working with industrial materials such as bronze, each is comfortable with their everyday artistic working conditions, in which it is commonplace for industry professionals to assist the artist at every stage of an artwork, from the conception in sketches and clay models right through to the final casting of a work.

Thus as professional sculptors, each knows that his or her exclusive artistic control over their own work is completely compatible with other people having played some part in its production. What is important for such exclusive, complete artistic control by an artist is that at every stage the artist him- or herself has complete freedom of decision as to whether or not to accept any

changes in his/her work from its previous state, whether those changes are the result of her/his own work or of the actions of a professional assistant.

The flash of inspiration in question could be expressed as follows. Its first stage involves the realization by Natalia and Seamus that each of them could use the other as their professional assistant—that Natalia could work on her sculpture, using Seamus as her assistant, while at the same time Seamus could work on his sculpture while using Natalia as his assistant.

But the second and most critical part of the flash of inspiration is still to be expressed. It starts with the realization that the idea of some changes in a work being artistic changes made by an artist (those changes made by an artist after assessment of any "assistive" changes made by an assistant in a work) is an idea that is relative to the perspectives and intentions of the person who is making the changes.

In the usual situation, an artist views his or her changes in a work as artistic changes, while his or her assistant views their changes as "assistive" changes. However, of course as far as the object itself being worked on is concerned, it merely undergoes changes due to the actions of each person— there is nothing in the changes themselves which provide physical evidence of whether or not they are artistic or assistive changes.

The final stage of the flash of inspiration occurs when Seamus and Natalia realize that there is an additional kind of relativity involved in the ideas of artistic and assistive changes. It is that one of them could regard a given change as artistic (as a change made by her in her capacity as an artist), while the other could legitimately regard the very same change as assistive.

Natalia and Seamus thus realize that this makes it possible for each of them to work upon and make changes in the very same object. Each of them can regard that object as their own personal art object, and view their own changes to it as artistic changes, while at the same time viewing any changes made by the other in that object as assistive changes. At the completion of the project, each will have produced his or her own work of art. But by each working upon the very same object in this way, they will have halved their individual costs and made it possible for each of them to complete their project within their individual budget limitations.

Of course, actually carrying out this project involves many difficulties for Natalia and Seamus. First of all, neither has any desire to collaborate with the other in producing a single work of art for which they would jointly be the artists. Their fundamental lack of comprehension of each other's artistic outlook and point of view would make this impossible in any case.

Second, they realize that in order for each to achieve a work of art that is legitimately his or hers alone, they will have to enforce a mutual noncommunication policy. Each will have to make any desired changes in the object with no information at all about why the other made his/her changes (if any).

This likely means that there will be various false starts and blind alleys, that is, cases where one of them modifies it in a certain direction, but the result of which proves to be impossible for the other to modify it in a way that is artistically satisfying to him/her. Nevertheless, each knows that since some of their previous works are similar, it should be possible for them to proceed in this manner.

Third, each must agree that the other has an unrestricted right to make changes in the object until satisfied that his/her own artwork is completed. In particular this means that the project is not finished until both simultaneously regard their works as completed. Thus, each has an unrestricted right to modify or destroy (by making changes in it) even a finished work by the other, if its existence is incompatible with his/her own work achieving completion.

These conditions are certainly draconian. However, once embarked on this difficult enterprise, Seamus and Natalia do find an unexpected benefit from their unusual working procedure. At each stage, novel creative possibilities are suggested to each of them by the unexpected changes made in his/her own work by the other. Thus the experience turns out to be artistically liberating for each, in spite of their uniquely constrictive working conditions.

As expected, the project of each artist takes longer than their usual time for completion of a work, due to various false starts and unusual turns in their projects. But eventually their works are completed to the satisfaction of each. Seamus calls his work *Epiphyte II*, while Natalia entitles hers *Homage to Malevich*.

Fortunately, the exhibition of Natalia's work is scheduled during a period that does not overlap with that for Seamus's later exhibition, so each is able to exhibit his/her own sculpture as desired without any practical difficulties arising.

After the exhibitions, the two artists work out an arrangement according to which each loans the sculptural object to the other for a specified period. Each artist is also successful at finding a buyer for their respective works, in one case a devoted collector of Natalia's art, in the other an enthusiast of Seamus's bronzes. Of course, the buyers too have to agree to the unusual loan conditions in order for either's purchase request to be accepted.

Subsequently Natalia's work begins to gain international recognition, so that one buyer after another is able to resell *Homage to Malevich* at great profit to another eager collector (who must, of course, agree to abide by the same loan conditions as before). However, Seamus's work *Epiphyte II* enjoys only a somewhat more modest success, and so his work remains comparatively inexpensive as it passes through the hands of a succession of collectors. Thus ends the example.

As should be clear, I have tried to construct the example in such a way that there can be little doubt concerning the artistic distinctness and independence of the two sculptures *Homage to Malevich* and *Epiphyte II*, in spite of the fact that each is associated with only a single sculptural object.

I think that this sculptural example shows at least the following. First, since there are two distinct sculptures, but only one sculptural object, neither can be identical with it, so neither is a concrete particular or (in Danto's terminology) a "mere real thing."[11]

What is more, the example gives this result without any (initial) need to bring in considerations of the role of the Artworld, or of the role of interpretations of artworks, as does Danto's theory (which is not to deny that a deeper analysis of what underlies the possibility of such an example might invoke such concepts).

Second, the example does, as promised, provide a "pure" case of distinct artistic intentions providing both a necessary and sufficient condition for the distinctness of the corresponding two artworks, since the only difference between the sculptures is provided by the distinct intentions with which Natalia and Seamus worked upon the corresponding single sculptural object.

And third, the example also shows (as pointed out in the previous section) that neither sculpture could be a type or universal (nor a token or instance of such), since the "disjointedness of distinct types" principle applies,[12] namely that distinct types or universals of the same general kind could not be coinstantiated by a single concrete object, and hence to that extent it distinguishes artworks from design objects, which in paradigm cases *are* types (or tokens thereof).

But it should be pointed out that the same conclusion could be drawn from Danto's case of *two* indistinguishable objects which are different artworks, since presumably identical tokens of a type could not also be tokens of any distinct types of the same general kind, any more than could a single token. Thus if Danto's account is acceptable, there is already a conclusive argument available against paintings or sculptures being types.

7.3. TWO DESIGNERS, ONE DESIGN

Now I shall raise the question as to whether the above case of two distinct sculptures—produced by different artists, yet being associated with a single sculptural object—could be matched with a parallel example, in which two *designers* with differing design intentions each produces his or her own distinct design product, and do so under the same restrictive conditions as before, namely that each works upon a single shared physical object, and does so without any discussion or collaboration with the other designer.

I claim that it is impossible to construct such a parallel example for the

11. Danto, *The Transfiguration of the Commonplace.*
12. See section 7.2.

design case, and indeed that it is *conceptually* impossible to do so. One reason why this is so is because (as pointed out in the first section) paradigm cases of design objects are provided by cars and other type-based objects (for which individual cases are tokens of an appropriate type). Hence, given that design products are tokens of a design type, as before the "disjointedness of distinct types" principle applies (any single token of a given type could not simultaneously be a token of some other type of the same general kind). Thus, for instance, a token of one particular type of car, produced by one designer, could not simultaneously be a token of another distinct type of car produced by another designer.

However, it will still be useful to attempt to construct a design example that is as closely analogous as possible to the artistic case, as a way of showing how intentions play a very different role in design, as opposed to artistic, cases.

In the first place, any case in which an employer hires two designers for a project is one in which it is presupposed from the start that they are to produce a *single* resultant design product, no matter how different are the design intentions of the two designers. (This is the practical presupposition that corresponds to the logical point about design products being types.)

Also, the restrictive working conditions (each working independently and alternately, with no communications between them) would be just as draconian as in the artistic case, but one can imagine real-life cases where such a method might be used as a last resort, such as in a case of two brilliant but very argumentative designers, Jane and Enzo, who find it impossible to cooperate in a conventional way on a design project, since their design views and intentions are so different, but who could be persuaded or forced by their employers to work thus upon a single object.

There might even be some practical point or justification to the employer requiring Jane and Enzo to work in this manner, in that the employer might hope to achieve the best possible design result, in that it would be the result of *two* independent sets of design intentions, rather than just one set. For, even though it is impossible for two distinct design products to result from Jane and Enzo's efforts, it is possible (even if unlikely or very difficult) for the single resultant design to simultaneously realize the distinct intentions of each designer.

To see how this is possible, suppose that the design project for Jane and Enzo involves a futuristic car. Now of course in a real-life case there will be many design parameters (such as engine size, materials to be used, and cost) to which each designer must conform, but there could still be room for very different stylistic approaches by each designer.

The root cause of this possibility is that (whether in artistic or design cases) a given intention may be a sufficient condition, but it is never a *necessary* condition of whatever features of a physical result counts as a successful

carrying out of it, because there are (in general) many ways in which an intention can be realized. For if instead there was a one to one correlation between intentions and results, then no result could simultaneously be the product of another intention as well; but since this is not so, a given resultant state of a physical object can correspond to the successful carrying out of more than one different intention, which hence would be *overdetermined* by such intentions (which thus provide sufficient but nonnecessary conditions for the resultant state).

For example, a particular shape of the roof of a car could be intended or accepted by Enzo as being a kind of design flourish, expressing an unusual futuristic feeling, whereas Jane may have accepted or produced that shape of the roof (as part of her conception of the design) for quite different reasons, such as that it is aerodynamically efficient, or that it accords well with other parts of her intended design, and so on.

Another way of expressing the possibility of overdetermination of a result by multiple intentions is in terms of reasons: there could be many reasons for producing a given design product feature (such as a roof with a particular shape), and each of these could be incorporated in an intention to produce that feature, which intention is justified by the reason in question.

Because of overdetermination, no design product feature (such as a particular roof shape) can be *individuated* purely by any one specific intention to produce it, and hence the different design intentions of Jane and Enzo are at best each merely a *causally* sufficient condition of the roof shape being what it finally ends up being. On the other hand, in the artistic case, the different intentions of Seamus and Natalia do serve to individuate their distinct works of art, and any specific features of them. Hence there is a fundamental difference, as claimed, between the role of intentions in the work of artists versus designers.

7.4. MORE ON THE CONCEPT OF A DESIGN

The concept of a design will now be investigated more fully. So far designs have been claimed to be types (unlike artworks), and to be such that their tokens are distinct from artifacts in that there are artifacts (such as tools produced by birds or monkeys) that are not designed. (However, this last point will require some further discussion, to be provided shortly.)

One fundamental difference between artifacts and designs is, of course, that artifacts are particular physical objects, whereas designs are types. Hence it is the class of *tokens* of designs to which the class of artifacts most directly requires comparison.

Something should also be said about the relations between the *process* of designing something, and the finished design *product*. On my account, it is the finished design product that is, properly speaking, a legitimate token of the "design" in question. Admittedly, it is common to also speak about such things as plans or diagrams for a design product as being, or providing, "the design" for the finished design product, but on my account such plans or diagrams are *representations* of the design (or of some possible token of the design) in question, rather than themselves constituting or being tokens of the design. Thus on my account *designing* activities are part of a planning or representing phase which is prior to the actual production of a design (or some token thereof).

It is also necessary to consider perhaps unusual cases in which something may arguably be *recognized* as a (token of a) design without any prior designing activities having occurred in the causal history of the object in question. For example, a piece of driftwood, or some configuration in the sand on a beach, could be recognized as being (or having) an interesting design, in spite of the fact that no one designed (or even made) the item in question (so that the item does not even qualify as being an artifact).[13]

Thus I claim that suitable natural or "found" objects could (in addition to intentionally designed objects) also qualify as (tokens of) designs, so that neither artifactuality nor having been produced by some design process is a necessary condition of something's being a token of a design, or of its having a design.

To this extent, I would claim that designs are comparable to artworks in that there are cases in which an object may be recognized as an artwork even if no artistic intent or activities were involved in its causal history (for example, if the object is from some culture which had no concept of art), and also in that there are cases in which an artwork is not an artifact, such as those when a piece of driftwood is legitimately exhibited as an artwork.[14]

Dickie and others have given a procedural account of how such objects as pieces of driftwood, which otherwise are not artworks, nevertheless acquire the status of being artworks,[15] but I claim that in the case of designs, there is in general no comparable procedural stage which is required in order that an object should become a design:[16] designs can, I claim, in many cases simply be recognized as such by competent individuals.

13. S. Knapp and W. Michaels discuss a sand-configuration case in G. Iseminger, *Intention and Interpretation* (Philadelphia: Temple University Press, 1992), chap. 4, "The Impossibility of Intentionless Meaning."

14. Davies discusses such cases in chapter 5 of his *Definitions of Art*.

15. For example, in Dickie, *The Art Circle*, chap. 4.

16. This is not to deny that there might be some cases in which an object may become a design in a procedural manner; for example, see section 7.5, where such a case is discussed.

Nevertheless, it is important to limit the extension of the concept of a design in some way, so that not any object whatsoever qualifies as being (or having) a design. I propose to do so by characterizing designs as a certain proper *subclass* of mere configurations or structures (which arguably are possessed by any object whatsoever).

On my account, a design is some configuration that (to competent observers) can be *regarded as if* a designer might have intentionally produced it, whether or not it was so produced. Or, to put the matter another way, a design is some *humanly interesting* configuration in an object, as opposed to configurations or structures in general which need not have any particular humanly interesting factors as part of their configuration.

Thus, on my account a design is any configuration that may be recognized (by suitably competent observers) to have at least some minimally striking or noticeable culturally significant component, of a kind that could plausibly be regarded *as if* it had been intentionally produced, whether or not it was so produced.

We should also distinguish two different *ways* in which a design can be recognized, and hence two different categories of design types. First, there are those designs whose tokens can be identified simply by *direct perceptual inspection* of their intrinsic properties, independent of knowledge of the perceiver of any relational properties that the tokens may have. Call these designs *purely perceptual* designs—or simply *perceptual* designs for short. While second, there are those designs whose tokens are also dependent in some way on *non*directly perceivable factors, such as the *functions* or *standard uses* of their tokens, or on other relational, nonintrinsic properties of theirs. This is the class of *functional* designs.

For example, an object might be recognizable as a hammer in two different ways: one might either recognize it as being hammer-*shaped*—as being a token of the *perceptual* design type of hammer-shaped objects, not all of whose tokens are necessarily functional hammers—or recognize it as as a token of the corresponding *functional* design type, as an object whose standard use is to hammer things, but not all of whose tokens are necessarily of exactly the same *perceptual* hammer-shaped design type.

However, in practice these perceptual and functional categories of design types are usually closely associated, in that typically a designer will be aiming at *both* a specific function *and* a specific perceptual design for her intended product. Thus my initial characterization of designs as involving *meaningful* configurations or structures covers both purely perceptual designs, and the much more miscellaneous category of functional designs, which involve at least some element of functionality or relatedness in their definition.[17]

17. See section 7.5 and chapter 8 for more on perceptual versus functional types.

On a broader issue, an implication of the general view of designs as being humanly meaningful is that there could be artifacts that are *not* designs (in addition to the above cases of designs which are not artifacts). For example, a device could be constructed to produce objects having random configurations of shape, surface texture, and so forth. Each of these objects would be an artifact, but most of them would not be recognizable as designs, and hence would not qualify as designs.

Also, on the issue of there being artifacts (such as tools produced by birds or monkeys) which are not designed, it is still possible that in some cases such items would nevertheless qualify as being designs because they are recognizable as such. However, there could still be other cases where such recognizability is absent. For example, a case could be made that, strictly speaking, birds or monkeys do not make *tools* (since being a tool plausibly entails being or having a design), but rather that they make *artifacts* (such as a broken-off twig) which they *use* as tools, but which objects do not (usually) have a tool-related design because they are not recognizable as having such a design.

Two logical kinds of design should also be distinguished, namely (what could be called) *sortal* versus *qualitative* designs. *Sortal* designs are those designs in which the relevant term or description picks out a sort or kind of object, such as the design of a (particular model of) Rolls-Royce car. *Qualitative* designs, on the other hand, are those in which the relevant design term or description picks out some property or quality of an object. For example, a wineglass might be designed to be tulip-shaped, so that one would say that it *has* a tulip-shaped design (rather than that it *is* a tulip-shaped design, as would be appropriate if it were a case of a sortal design instead). Qualitative designs could also be described as *design features* rather than as designs, to emphasize their nonsortal nature.

The possibility of qualitative designs provides another potential disanalogy between artworks and designs, in that visual artworks are often taken to be objects or particulars, rather than some of them (as with qualitative designs) being properties or qualities of objects.

Thus, though each visual artwork is associated with a corresponding sortal design, design features would correspond not to visual artworks themselves, but instead to artistic *features* or *qualities* of visual artworks.

7.5. PIGGYBACK SORTAL DESIGNS

I now want to raise two potential problems for my account of designs, and show how they might be resolved. Consider a heap of garbage, which normally would not be considered to be, or be recognizable as, a sortal design

because of its cultural lack of interest, its fairly random specific configuration, and so on.[18]

Suppose that an established artist moves that heap of garbage into an art gallery, and declares it to be an artwork, in a legitimate enough way so that (on a procedural account of arthood such as that of Dickie) it thereby acquires the status of being a work of art. The first problem for my account is that there now seems to be an artwork (though admittedly a freshly minted one) without there being any corresponding sortal design. This is a potential problem because implicit in my discussion of the concept of "design," and of how it should be distinguished from that of "art," is a requirement that to each artwork there should correspond exactly one sortal design token.

My solution for this potential problem is to claim that in such a case the configuration of the garbage heap has *become* of sufficient cultural interest (because of the procedural success of the heap's becoming an artwork) so that the heap *does* now qualify as a sortal design. Thus the heap has become a sortal design by virtue of a kind of implicit procedure, which piggybacks on the more explicit procedure by means of which the heap acquires its status as an artwork.

The second potential problem for my account concerns my claim that designs (whether sortal or qualitative) are *types*. To begin with, consider those *perceptual* types, as discussed in section 7.4, whose tokens can be identified by *direct perceptual inspection*, so that they are not dependent on nonperceivable factors such as their *functions* or uses, or other relational properties. Presumably it is true of such perceptual types that, for any two perceptually indiscernible objects A and B, if A is a token of type X, then B is also a token of type X.[19]

However, in the case of artworks which are particulars (such as paintings, or newly promoted garbage heaps), it is not the case that perceptually indistinguishable objects A and B are both artworks if one is; indeed, a major reason for invoking a procedural theory of art is to explain how it is possible for one such object (such as the heap of garbage in an art gallery) to be an artwork even though an identical heap found elsewhere would not be an artwork.[20]

The potential problem (or what some might think of as a potential problem) for my account is that again there seems to be a mismatch between the concepts of art and design, in that my account has the implication that any identical heap of garbage outside the art gallery has, by virtue of the in-

18. Though photographers or others might be able to find a qualitative design or designs in various visual aspects of it.

19. To be sure, those same objects might nevertheless be of different *functional* types; see the discussion below, and chapter 8, for more on the distinction between perceptual and functional types.

20. In G. Dickie, "Art: Function or Procedure—Nature or Culture?" *Journal of Aesthetics and Art Criticism* 55, no. 1 (Winter 1997): 19–28, Dickie argues that both his theory and that of Danto are of such a procedural type.

gallery "procedural promotion" of the heap to sortal designhood, *also* become a sortal token of the same type as the heap inside the gallery, whereas there is no such "procedural promotion" with respect to the outside heap's *arthood* status, since it remains as a nonartwork.

My solution to this potential problem is to deny that the mismatch is a genuine problem, and indeed to assert that the mismatch in actuality provides a good illustration of one way in which a type-concept such as that of a design is logically different from a particular-object concept such as that of a visual artwork. Thus a mismatch should be expected on my view—and on views such as that of Danto, who would also deny that indiscernible tokens of a given perceptual type must have the same artistic status.[21]

A general solution to the problem could also be described as follows. One must distinguish, as already noted, between *perceptual* and *functional* types. Tokens of the same *perceptual* type are not necessarily also tokens of the same *functional* type. On the current view, a given token of a *perceptual* type, such as the garbage heap in the gallery, may also have the *function* of serving as the artifact associated with the relevant artwork. However, it does not follow from this that a *perceptually* identical heap outside the gallery is also a token of that same *functional* type, namely that type whose token serves as the artifact associated with the relevant artwork.

Parenthetically, this solution could also easily be generalized to apply to the multiple original prints of a given artwork in a medium such as etching (see chapter 8). All the original prints are tokens both of the same perceptual type, and of the distinct functional type just mentioned, namely that type whose tokens serve as artifacts associated with the relevant artwork. But any further perceptually indiscernible but nonoriginal *copies* of those prints, though they would be tokens of the same *perceptual* type, would nevertheless not be tokens of the relevant, and distinct, *functional* type.

Nevertheless, a more specific form of the potential problem for my account might go as follows: that since I claim that sortal designs in general are *recognizable* as such, how can I account for the fact that various people who might happen to have identical garbage heaps in their backyards, but who have no knowledge of the identical "promoted" garbage heap in the art gallery, will still be unable to recognize their own heaps as being sortal designs of the relevant type?

My reply involves a clarification of the relevant sense of "being able to recognize" a sortal type. For example, in scientific cases it is common for recognitional abilities to be very narrowly distributed among scientists, so that an ability to recognize a token of a certain fossil type may be possessed by very few of them. Also, new discoveries can allow a previously unrecog-

21. Danto, *The Transfiguration of the Commonplace*. Also see the comments on Danto's "method of indiscernibles" in section 7.1.

nizable fossil type to become recognizable, but again, only by suitably informed scientists (or other enthusiasts). My claim that sortal designs must be "recognizable" as such does not deny that the possession of certain relevant kinds of knowledge may be necessary in order for a person to acquire the relevant recognitional ability. Thus in my account "recognizable" means "can be recognized by suitably informed or suitably competent persons," as implied by my initial recognizability claims.

7.6. LITERARY VERSUS VISUAL DESIGNS

Now that some initial clarity has been achieved on artwork versus design issues with respect to visual artworks such as sculptures or paintings, it will be useful to briefly compare and contrast such cases with those of literary artworks and designs.

Jorge-Luis Borges has a well-known example in which he suggests that sections of the text of Cervantes' work *Don Quixote* could reappear in word-for-word identical form as a distinct literary work by another author, the fictional Pierre Menard.[22]

According to Borges, the very same text would, in Menard's version, serve as the basis for a work in a somewhat affected, archaic style, in spite of the fact that Cervantes' own literary work had no such archaic stylistic features. As a result, since each work sharing the same text has its own distinctive features of this or other kinds, each must be a different literary work and also be distinct from the text that they have in common.

Now linguistic texts are types, as are designs. However, not any text is a design, since on my view only texts with at least a minimal level of meaning or comprehensibility would normally count as designs (for instance, a random sequence of words would not usually be a design).[23]

Thus on my view the text of a literary work is a (sortal) design type which, with the aid of Borges's argument, can (where applicable) be distinguished from various different corresponding literary artworks.

Given such distinctness arguments for literary designs versus literary artworks, enough resources are already available to mount an argument that literary artworks themselves cannot be types, any more than could visual artworks.

22. Borges, "Pierre Menard, Author of the *Quixote*," in J. L. Borges, *Labyrinths* (Harmondsworth, Middlesex, UK: Penguin, 1985).

23. Not, that is, unless it happened to be promoted to designhood via piggybacking on an artistic procedural creation of some corresponding literary artwork, which employed that exact sequence of words—or unless the random sequence had some practical *function* which thereby endowed it with meaning.

For as noted at the end of section 7.2 and elsewhere, by the "disjointed-ness of distinct types" principle several identical tokens of a type could not also be tokens of any distinct types of the same general kind, any more than could a single token be of distinct but generally similar types (as in my sculptural double artwork example).[24]

The applicability of this type principle to the present case is as follows. If the literary artworks of Menard and Cervantes *were* each regarded as distinct literary types, each of whose tokens were (presumably) tokens of the identical textual passages in question, then those same tokens would be tokens of two distinct types of the same general kind. But since this is impossible, such literary artworks cannot be types.

An attempt to avoid this conclusion might be made using (what could be called) a *token segregation* strategy. Instead of assuming that any identical tokens of the textual design in question are of the same type, an attempt might be made to segregate tokens into *Cervantes-tokens* and *Menard-tokens*, for example, on the ground that only tokens printed in a volume with Cervantes' name on the cover should count as Cervantes tokens, and similarly for Menard. Thus on this approach, Menard-artwork tokens are not simultaneously Cervantes-artwork tokens, and vice versa, so that the previous type problem does not arise.

However, this attempt initially seems to fall foul of another previously invoked general principle about types, namely, that for any two perceptually indistinguishable objects A and B, if A is a token of type X, then B is also a token of type X. Nevertheless, as noted in the previous section, that principle holds true only for *non*relational types, so if it can be argued that "token segregation" of the kind in question could produce *relational* or *functional* types, this strategy has not yet been defeated.

Here is an attempt to explain in relatively neutral terms what might be involved in such a "token segregation" strategy. The idea seems to be that, with respect to Cervantes' creation, there is a class of (what could be called) *legitimate associated artifacts* or LAAs, each of which is a token of the textual design in question, but which are also differentiated from a distinct class of Menard-related LAAs (which are also tokens of the same textual design) by *relational* features peculiar to each artifact, such as that the Cervantes LAAs are included only in volumes with Cervantes' name on the title page, and similarly for those of Menard.

The question then becomes whether membership in such a set, by an appropriate artifact which is a token of the relevant textual design, is suffi-

24. Compare the independent arguments in chapter 3 as to why plays, whose scripts are also literary designs, could not be types.

cient for that artifact to be also a token of some relevant *artistic* type which *constitutes* Menard's or Cervantes' literary work.[25]

How might this issue be resolved? I believe that possibly the only definitive way to do so is to invoke concepts and methods similar to those used in my sculptural double artwork example, and thus to defeat the effort to achieve token segregation by finding cases in which at least one such supposed artwork token would (*per impossibile*) simultaneously have to be a token of another *distinct* artwork, without any possibility of segregation.

Here is how this would work. As a preliminary, imagine that in my sculptural double artwork example—the original single sculptural object which provided the physical basis of both Natalia's work *Homage to Malevich* and Seamus's work *Epiphyte II*—is, with the agreement of both artists, itself *duplicated*. Since the work in question was a bronze cast, this would simply require another cast to be prepared using the same original mold, so that each cast is artistically on an equal footing with the other. Thus, if one embodies the work of both sculptors, then so does the other. Hence the result of this process would be two distinct sculptural artifacts, each of which has full claim to embodying both Natalia's and Seamus's work. And of course more legitimate copies could also be made if both artists gave their approval to such a procedure.

Perhaps it is clear enough that a type-theoretic explanation of such artifacts, which would seek to regard them as tokens of an artistic type, must fail because each such artifact would (*per impossibile*) simultaneously have to be a token of two distinct types (one for each artist's work) of the same general kind. For in this case a token segregation strategy is not possible, since each individual artifact, viewed as a putative token, already has full claim to be a legitimate token of both putative types.

A possible objection to this argument should be considered, which involves changing the example somewhat. Suppose that Natalia and Seamus agreed, as a matter of practical convenience, to split the initial two artifacts between them so that Natalia would exhibit copy number one as her work, and Seamus would exhibit copy number two as his work. Then, the objection would run, has not a de facto token segregation been achieved, in which Natalia's copy is her work but no longer Seamus's work, and vice versa for Seamus's copy, so that after all a type-token explanation of such artworks remains an open possibility?

My reply to this objection is that it conflates two different senses of ownership. All that Natalia and Seamus have agreed to (as a matter of practical convenience) is that each should have *legal* ownership or custody of a given copy of their work. Thus Natalia's copy is "her copy," and it fails to be

25. This question must of course be distinguished from the trivial one of whether, for example, each Menard LAA is a token of the type "being a member of the Menard LAA set."

"Seamus's copy," only in the legal sense that Natalia but not Seamus has legal title to copy number one, by virtue of their contractual agreement to split the copies between them. But this contract has no bearing on the issue of the *artistic status* of each copy, which remains as before, such that each copy embodies both artworks simultaneously. Hence the objection on behalf of a type-approach fails.

Now that a sculptural double artwork case involving multiple artifacts has been discussed, it only remains to extend the procedure used to linguistic cases. Without constructing an example in detail, what is required is a hypothetical case in which two authors with very different backgrounds and intentions independently work upon producing a single text or textual design. (As with the sculptural case, different intentions and independent working conditions are required so as to avoid the case collapsing into one of joint authorship of a single artwork.)

In a successful case the resultant text would embody two distinct literary artworks, one for each author, and thus any tokens of it would also simultaneously embody both artworks, thus making token segregation impossible and hence showing that literary artworks cannot be types any more than could sculptures.[26]

Thus in literary cases too the suggested distinctions between artworks and designs can be maintained, and hence we now have some additional reasons in support of some *non*-type-based theory of art, such as the double content (DC) theory.[27] Also, the artwork versus design distinction will play an important part in chapters 8 through 10.

26. It should be noted that this kind of double artwork counterexample is potentially effective against *any* type-based theory of art, including sophisticated versions such as that of Jerrold Levinson as applied to music in his essay "What a Musical Work Is," in J. Levinson, *Music, Art, and Metaphysics: Essays in Philosophical Aesthetics* (Ithaca, NY: Cornell University Press, 1990), in that double artwork counterexamples specifically undermine the type-based logical status of a theory, no matter how (otherwise) successfully the types in question might be characterized. See also the section 3.6 use of a similar logical argument as applied to distinct plays.

27. For related arguments against films being types, see my papers "Ariadne at the Movies," *Contemporary Aesthetics* 1 (2003), online at http://www.contempaesthetics.org/pages/article.php?articleID=203, and "Ariadne Revisited," *Contemporary Aesthetics* 1 (2003), online at http://www.contempaesthetics.org/pages/article.php?articleID=211.

Reorienting
Artistic Printmaking

In this chapter I extend the results of chapter 7 by exploring some further aspects of the nature and relations of *artworks* and *designs*, in particular with respect to a relatively neglected artistic concept, that of the *spatial orientation* of a design token or artwork. It will turn out that orientational concepts and factors can (among other things) help to clarify ways in which pictures are distinct from design tokens.

The investigation will also raise some significant but neglected issues concerning *artistic printmaking*, and strongly suggest in addition that two new concepts of interpretation—of *identifying* and *constitutive* interpretation—are required to adequately explain the artistic phenomena that will be uncovered.

One important question not considered in chapter 7 concerns the relations between an *artwork*, and the *concrete object* that (in some way) embodies, or provides a physical substratum for, the artwork in question (such as a stretched and painted canvas in the case of a painting).[1]

Such an object (which is typically but not always an artifact of some kind) is itself a design token. I shall describe the concrete design token, which thus corresponds to a given artwork, as its *corresponding design token* (or CDT).

As for the design itself, of which that object T is a token, it may be identified as that *perceptual* design type which has as its tokens the class of objects (including T itself) which are *perceptually indistinguishable* from T under normal viewing conditions.

The reason for this choice is as follows. Since any change in any normally perceptible feature of the CDT might aesthetically change the corre-

1. Of course on the RC theory one such relation is that of representation, but currently we are investigating other significant relations.

sponding artwork, all and only the actually perceptible features of the CDT must be the features of the artwork's corresponding design, so that all of its tokens must be perceptually indistinguishable.

To be sure, this is a specialized, *perceptual* design concept that is independent of *functional* design types,[2] which might classify as functionally distinct certain perceptually indistinguishable items, or functionally identify perceptually distinguishable items. More broadly, the distinction, and my concentration on the perceptual cases, is defensible in terms of the galaxy of reasons that distinguish the aesthetic, disinterested perception of pictures from more practical or functional concerns with them.

However, for reasons given in chapter 7, an artwork itself cannot be *identified* with a token of any type (including any design type),[3] so in particular an artwork cannot be identified with its CDT. Indeed, in chapter 7 I argued (in effect) that a single sculptural object could serve as the CDT for two *distinct* sculptural artworks.

8.1. INTRINSIC AND FIELD ORIENTATION

Now I shall introduce two related concepts of *spatial orientation*, both of which concern the orientation of the front surface of an object (such as an artwork) that is perpendicular to a horizontal axis through its center, which axis is the normal viewing line of sight for the work in question. Relative to such an axis, the artwork may be rotated through 360 degrees; for rectangular artworks, there are four salient positions, in which the work is (perceived as) respectively upright, on its right side (turned ninety degrees clockwise from the upright position), upside down or inverted, and on its left side.[4]

However, further analysis is required in order to capture the full meaning of a term such as "upright." Intuitively, in order to be "upright" something must both have a "top side" or *top* (which is identifiable as such, no matter how the object may be rotated), and also be oriented so that its top is currently aligned with the top of the natural environment in which it is located. Thus two related orientational concepts are needed, as follows.

2. See the previous discussions of that distinction in sections 7.4 and 7.5.

3. On which see also section 8.8.

4. One could further investigate smaller increments of rotation of forty-five degrees, so that the four square pictures considered would be interspersed with four diamond-shaped pictures. But that would unnecessarily complicate the discussion, as would any consideration of three-dimensional cases. Also distinguish the current kind of orientation from (what could be called) "compass orientation," which concerns instead rotations of an object around a vertical axis. (I discuss other such orientational issues in chapter 9.)

The first concept concerns things that have their own *intrinsic orientation*, criteria for which includes having a (reasonably) well-defined unique top[5]—an "intrinsic top"—sides and bottom (in the case of roughly rectangular objects), or (in the case of roughly circular or spherical entities) as having corresponding unique points or areas (a topmost point or area, and so on) rather than sides.

There are two species of intrinsically oriented things. First, a general category of *objects*, that includes such things as human beings, flowerbeds, and buildings, as well as (I shall argue) two main topics of this chapter, namely pictures and works of art.[6] (But not all objects have an intrinsic orientation.)

The other species of intrinsically oriented things is that of (what could be called) *environmental fields*. An environmental field is some area in space which is aligned with some culturally standard axes (such as the flat surface of the world for a horizontal axis, and the gravitational field of the earth for a vertical axis) in such a manner that everyday judgments about objects being horizontal, vertical, above or below others, upright, and so on are made with reference to such an environmental field that contains the objects in question. An environmental field will itself have a top (or topmost area), and so on, and hence qualifies as having an intrinsic orientation.

The second concept of orientation is that of (what I shall call) *field* orientation, which concerns the *alignment* of an object—whether or not it has an intrinsic orientation—with respect to an *environmental field*.[7]

Thus, an object is generally (perceived as being) *upright* just in case it has

5. I shall interpret this characterization in a weak, culturally realistic sense as implying only that if an object has an intrinsic orientation at a given time, then it has exactly one top at that time, rather than as more stringently implying that whenever an object has an intrinsic orientation, then there is some unique side which always serves as its top. Thus the concept allows both that having an intrinsic orientation might be a contingent property of an object, and that an object might have different tops at different times during those periods in its history (if any) when it has an intrinsic orientation.

6. Clearly intrinsic orientation for objects is generally relative (in various ways) to human interests and purposes—in the case of pictures, artistic intentions or cultural norms play a primary role in determining which side of a picture counts as the top. Or in the case of a home, if it were on its side it would be very difficult to live in, and so in such a case the orientation that best fits our needs (and hence is most commonly found) is such that its top serves to define the home's intrinsic orientation. See section 8.10 for more on such functional considerations.

7. In scientific studies of perceptual orientation a distinction is commonly made between intrinsic orientation and "deictic" or indexical orientation, for example, George A. Miller and P. N. Johnson-Laird, *Language and Perception* (Cambridge, MA: Belknap Press, Harvard University Press, 1976), chap. 6. But my concept of field orientation is not observer-relative as is their "indexical orientation."

an intrinsic orientation,[8] and is such that its intrinsic top is *aligned with* the top of its environmental field.[9]

An object is *upside-down* or *inverted* if its intrinsic top is instead aligned with the bottom of its environmental field; and so on.

The above points provide the outlines of (one part of) a *perceptual logic of spatial orientation*, whose claims, as with any logical principles, may be hoped to have a high degree of "obviousness" about them. (But the general neglect of such issues seems to have left these points previously unformulated, at least in the field of aesthetics.)

8.2. AN EXAMPLE: ANNA'S PRINTMAKING

I shall now give a printmaking example showing the relevance of orientational issues to issues of pictorial identity. I shall make use of the diagrams shown in figure 1, so as to have a definite case to consider.

One way (but not the only way) to describe the relations of the diagrams in figure 1 is as follows. If diagram 1 is regarded as showing a picture in its upright orientation, whose intrinsic top is aligned with side W, then diagram 2 shows the same picture when rotated clockwise through ninety degrees, with diagrams 3 and 4 showing the same picture after further ninety-degree increments of rotation. Thus all four diagrams could be considered as showing or representing a single pictorial object or design token in various orientations.

The example initially concerns a case of a picture or visual artwork produced by an artist—Anna—in a multiple edition (with the artist's medium being any one of etching, lithography, photography, serigraphy, and so on). Suppose that the resulting original prints all exactly resemble diagram 1 in figure 1 (when both figure 1 and the prints are in their standard or upright orientation). Then each such original print is, by usual standards, a print or copy of *the same* pictorial artwork, or picture, as are all the others—which picture may conveniently be labeled as picture 1A, both because of its association with diagram 1, and because the picture was created by Anna.

Next, suppose that Anna is walking by the right side of a horizontal pile of prints of her picture 1A, and, looking down on it, happens to notice that (relative to her current viewing position) the top print of her picture looks

8. I oversimplify here in the interests of brevity. A brick standing on end might be perceived as being "upright" even though it has no unique top. An intermediate category of "semi-intrinsic orientation," allowing for objects with more than one top, is probably needed to deal with such cases.

9. Miller and Johnson-Laird, *Language and Perception*, chaps. 4 and 6, refers to this as the "characteristic" orientation of an object.

FIGURE 1

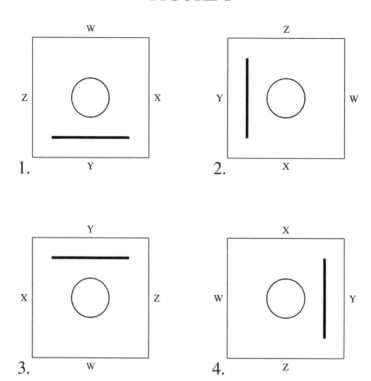

like diagram 2 rather than diagram 1. This happens because Anna has in effect rotated herself through ninety degrees counterclockwise relative to the print; an equivalent effect could of course be achieved if Anna, when viewing the print in its normal orientation with side W at the top, were instead to rotate the print itself through ninety degrees in a clockwise direction, so that side Z is at the top.

Anna could easily be struck by the fact that her picture 1A, when seen in this nonstandard orientation, in some ways *looks aesthetically different* than it did when seen in its standard orientation, with side W at the top. For example, on one natural interpretation, the aesthetic effect of her picture 1A is of repose and harmony, with a circle centered above a firm horizontal line. But when picture 1A is seen in its "sideways" orientation as in diagram 2, it instead "looks" more asymmetric, aggressive, and "sequential."

However, of course the notoriously slippery concept of what something "looks like" aesthetically must be used with care, since Anna is also quite capable (as are we) of perceptually *compensating* for the sideways orientation

of picture 1A, and hence (via an appropriate perceptual adjustment) of seeing it as looking aesthetically *exactly like it looks* in its more standard orientation as in diagram 1.[10]

This point could be summed up by saying that any sense in which picture 1A "looks aesthetically different" when seen sideways is at best of very questionable relevance as a point about a legitimate perception of *picture 1A itself*.

Nevertheless, Anna might surmise that even if the sense in which a diagram 2-looking picture "looks aesthetically different" from picture 1A is not relevant to *picture 1A itself*, surely there must be *some* "object of sight" in this case, which is such that *it* is what she saw, and which object had aesthetic characteristics such as looking asymmetric, aggressive, and "sequential," and as looking "aesthetically different from" picture 1A.

I suggest that what Anna saw was actually *another* picture, whose intrinsic top is aligned with side Z, and which exactly resembles diagram 2 in figure 1, when each is in an upright orientation. But of course at this stage this "picture 2," as it could be called, has a somewhat tenuous status, in that it is not an "artist-approved" picture as is picture 1A. Nevertheless, picture 2 at least is logically or formally distinct from picture 1A, in that the intrinsic top of each picture is *aligned with a different side*—side W for picture 1, and side Z for picture 2.[11]

However, Anna herself is, as the artist in question, in a position to do more than merely surmise or hypothesize about this matter. She can (if she wishes) decide that she wants picture 2 to be a picture *of hers;*[12] and there are various ways in which she can then *make it the case* that there is indeed an *artist-approved* picture 2A of hers,[13] whose intrinsic top is aligned with side Z, which picture is just as legitimate as picture 1A, and which is at the same time distinct from picture 1A in the way just discussed.

Here is one such method.[14] Anna runs off more prints, using the same printing setup as she originally used for picture 1. Then she turns each resultant print sideways so that it exactly resembles diagram 2, and then has them mounted and framed in that orientation. I should add that in Anna's view, this is a perfectly legitimate way for her to produce original prints of her new picture 2A.

Now of course other artists, and perhaps some aestheticians too, might disagree with Anna on this point. But my point is that Anna as a creative

10. Such perceptual compensation cases are discussed further in section 12.1.

11. In chapter 10 I defend the legitimacy of such a noticed but artist-unapproved picture.

12. For example, perhaps because picture 2 resembles other works of hers, so that it would be an appropriate addition to her corpus.

13. I argue later that this picture 2A is distinct from picture 2: see section 8.5.

14. I discuss some other ways in section 8.9.

artist has an unchallengeable authority to decide on the *methods* by which *she herself* shall produce original prints of *her artworks*, including in the case of picture 2A.[15]

Now the example so far has tacitly assumed that prints respectively for pictures 1A and 2A were separately produced by Anna in *different printing runs*,[16] even though the same printing procedure was used in each case. However, there is nothing to stop Anna deciding to move to an even more simplified process, in which she simply prints many copies of the *design* in question (that is, of the design that figure 1 shows in four different field orientations), and when the need arises for a print of picture 1A or picture 2A, she simply takes one of these prints and mounts and frames it in an orientation appropriate for its role as a print either of picture 1A or of picture 2A. Again, I would claim that Anna's use of this method is *her prerogative*, and after all (unlike some Andy Warhol cases) she still does personally decide, for each and every print, which of her pictures 1A or 2A it shall be.[17]

The example is not quite ended yet, for we need to assume (for reasons that will become clear: see section 8.6) that Anna repeats the whole process for a *further* picture 3, which, in its upright orientation (with intrinsic top side Y), exactly resembles diagram 3 in its upright orientation. Thus the example concludes with Anna having a choice between three different orientations for any given print, each of which serves to identify a *different picture* of hers.

As a preliminary point about this "printmaking" example, it surely demonstrates that in *some* way orientational factors are integrally involved in characterizing the nature and identity of Anna's three pictures. I shall offer my own diagnosis as to exactly how orientational factors are involved, but I think that the example has some independent value as a test case, or challenge, for those who have simply assumed the general irrelevance of orientational issues to the aesthetics and ontology of visual artworks, but who find my specific diagnosis of it to be questionable for some reason.

15. Many of Andy Warhol's silkscreen pictures were actually almost entirely produced by artistic assistants and technicians; but since *he*, as the artist in question, chose those methods of producing his prints, their integrity and authenticity as distinctive original works by him is assured.

16. Much traditional artistic printmaking uses the attribute of *having been produced from a given printing run* (as part of a limited edition, after which the printing plates and the like might be destroyed) as a criterion of authenticity for an original print. However, this procedure arguably is primarily a means of assuring potential buyers that a given print is indeed approved by the artist. Anna could use different methods to reassure her potential buyers.

17. See section 8.7 for further justification of Anna's procedure.

8.3. DIAGNOSIS

Here, then, is my diagnosis of the "printmaking" example (the general outlines of which diagnosis are probably already clear from my way of describing the example). First, the example as given preserves the traditional view that any given physical print produced by an artist is (after any appropriate review stages as decided by the artist) a print of *at most one unique artwork* by that artist.[18]

As it happens, artist Anna decides *which* artwork this should be in a given case at a much later stage than is customary—in that usually this is decided *prior* to anything being printed on the relevant media—but that fact is simply a reflection of the integral role of orientational factors in her decision.

Second, as to what happens when Anna first notices that one of the prints of her picture 1A "looks aesthetically different" when she sees it in a sideways orientation (in which orientation it exactly resembles diagram 2). As noted in the example, there is a clear sense in which, if Anna were to interpret what she sees as being her original picture 1A (with intrinsic top aligned with side W), then it would *not* "look *aesthetically* different"—in spite of its different "sideways" field orientation which, of course, would also cause what she sees to look "field orientationally" different.

But since what Anna sees *does* look aesthetically different to her, my diagnosis is that what Anna is actually seeing is *picture 2* (whose intrinsic top is aligned with side Z) rather than *picture 1*A (whose intrinsic top is aligned with side W). For the distinctive aesthetic effects noticed by Anna (such as "what she sees" looking asymmetric, aggressive, and "sequential") apply to it only insofar as it is seen *as* having side Z aligned with its intrinsic top—or, to put the same point another way, if the current field orientation of the print, with side Z at the top, is seen *as* providing the *upright* orientation of the picture in question.

Next, pictures 1A and 2 must be distinguished from their *corresponding design token* (CDT), namely the relevant physical print on which Anna's gaze is directed. All three entities must be nonidentical, because pictures 1A and 2 are distinct (having intrinsic tops aligned with different sides), plus the fact that presumably the physical print that is their common CDT must have the same relation to each of them, so that the relation in question could not be the identity relation. And, as an independent proof of the distinctness of the pictures from their CDT, arguably tokens of the (relatively abstract) design in question (such as the relevant CDT) have no intrinsic orientation *of their own*, whereas both pictures 1A and 2 do have intrinsic orientations.

However, more conceptual analysis is still required, with respect both to

18. I could have changed the example so that this was not so, but that might weaken the intuition that each such print, after the artist's decision, is indeed a genuine print of its respective single artwork by her. See also section 8.9 on related examples.

Anna's seeing, and to the correlative "objects" that she sees. Three concepts of visual interpretation will be needed in the discussion, two of which are discussed in the next section.

8.4. IDENTIFYING AND CONSEQUENT INTERPRETATIONS

The first of these visual interpretive concepts is that of an *identifying interpretation*, which occurs when some visual data is *interpreted as being* some object or property by a person. This concept covers both normal or "basic" kinds of seeing of objects or qualities, as well as cases such as Anna's seeing of one of her pictures when she looks at one of her prints. In more precise cognitive science terms, the idea is that an *identifying interpretation* is any processing of *low-level visual information* from some relevant region of the visual field that results in a *high-level sortal* or *entity-related* (including properties when they are conceived of as entities) classification of that information.

The second interpretive concept is that of (for want of a better term) a *consequent interpretation*, which occurs when some item, *previously identified through an identifying interpretation*, is *itself interpreted* in some way.[19]

For example, when Anna first saw picture 2, she did so (on my view) by *identifyingly interpreting* the visual information from the "print"-representing region of her visual field *as being picture 2* (which interpretation, in my view, includes as a necessary element interpreting the picture *as having its intrinsic top aligned with side Z*). But, having thus visually identified picture 2, she was then able to carry out several *consequent interpretations* of *picture 2 itself*, including interpreting *it* as having various aesthetic qualities such as its looking asymmetric, aggressive, and "sequential."[20]

As to the subset of identifying interpretations that thereby identify *pictures* or *artworks* (such as pictures 1A and 2), perhaps I should briefly indicate why I regard them as being interpretations of *low-level visual data*, rather than

19. This concept may simply be an explicit, generalized form of the usual concept of "interpretation" of an artwork, which (when properly used) similarly presupposes prior identification of the artwork in question. I shall assume that this is the case.

20. My distinction here between these two kinds of visual interpretation roughly corresponds to the distinction in the philosophy of language between *identifying reference* to entities, as carried out by referring expressions, and *predications of* those entities as thus identified. It is perhaps surprising that there seems not to be any corresponding standard concepts or terminology for cases of visual interpretations, since the need for *some* such distinction is, I take it, hard to deny.

as interpretations of *physical objects* or events such as the relevant common CDT for both pictures 1A and 2.[21]

One reason is systematic: since a general concept of an identifying interpretation of low-level visual data is needed anyway, as part of a cognitive science explanation of how we are able to perceive such physical objects in the first place, it would merely complicate theory to assume that artistic identifying interpretation must involve an *additional* layer of interpretation of such already interpreted physical objects—prior to a demonstration (which I have yet to see) that such complications are absolutely necessary.[22]

Yet another class of reasons concerns the conceptual swamp that results from attempts such as that of Danto to regard artworks as being interpretations *of such* mere real things *themselves*.[23]

My alternate low-level concept of identifying interpretation allows me to agree with Margolis, against Danto, that at least all "identificatory" seeing involves interpreting (with the complementary concept of *consequent interpretation* being available to explain any remaining nonidentificatory cases), while yet enabling me to side with Danto against Margolis in claiming that there are some "basic" things and qualities, as identified through visual perception, which are independent of cultural factors.[24]

21. Arthur Danto's general view regards artworks as interpretations of such "mere real things." See, e.g., his book *The Transfiguration of the Commonplace: A Philosophy of Art* (Cambridge, MA: Harvard University Press, 1981).

22. The point is a significant but apparently generally unrecognized one; for example, in section 6.6 I defended Gombrich's thesis that one cannot simultaneously perceive a physical painting and the relevant picture by appeal to the idea of a *comprehensive* interpretation of low-level visual data. The general assumption that artistic interpretation must start with *physical objects* rather than with visual data may have led previous commentators to overlook such possibilities.

23. As illustrated by his ongoing debate with Margolis: see J. Margolis, "Farewell to Danto and Goodman," *British Journal of Aesthetics* 38, no. 4 (October 1998): 353–74; A. Danto, "Indiscernibility and Perception: A Reply to Joseph Margolis," *British Journal of Aesthetics* 39, no. 4 (October 1999): 321–29; and J. Margolis, "A Closer Look at Danto's Account of Art and Perception," *British Journal of Aesthetics* 40, no. 3 (July 2000): 326–39.

24. On which issue see the two contributions by Danto to a symposium on his views, Arthur Danto, "Seeing and Showing," *Journal of Aesthetics and Art Criticism* 59, no. 1 (2001): 1–9, and "The Pigeon within Us All: A Reply to Three Critics," *Journal of Aesthetics and Art Criticism* 59, no. 1 (2001): 39–44. I offer some criticism of related views of Danto in chapter 4.

8.5. CONSTITUTIVE INTERPRETATION

Next, as to what happens when Anna decides that she likes the newly identified picture 2 enough (in view of her *consequent* interpretations of it) that she wishes to make that picture her *own*, that is, into an artwork of *hers*. Now since the resultant picture is *Anna's* picture rather than simply *a* picture, it must inevitably have properties (including its relations to other works in her corpus) that are not possessed by picture 2 itself. Hence, strictly speaking, Anna's "picture 2" must be *distinct from* picture 2 itself. One way of characterizing their relation is to say that picture 2 is an anonymous or "found" *version* of picture 2A (where picture 2A is Anna's picture), rather than itself *being* Anna's picture 2A. (Picture 2 is a "found" picture in a sense analogous to that in which a piece of driftwood could be a "found sculpture.")

But exactly how does Anna achieve the feat of "converting" picture 2 into her own distinct picture 2A? It seems unavoidable that she must do so by (in some way) providing her own unique *artistic interpretation* of picture 2: Anna finds a way in which to *interpret* picture 2 as *a picture of her own*. But the idea of interpretation at work here requires yet a third distinct concept of interpretation: Anna carries out (what I shall call) a *constitutive* interpretation[25] of picture 2, which constructively or productively[26] converts or transforms picture 2 into her own picture 2A.

25. This is a very different concept than Peg and Myles Brand's thus-described concept which Danto accepts as relevant to his own view in the following way: "Constitutive interpretations just are what I had in mind by surface interpretations: it is what the audience grasps when it understands the work, and, so far as this interpretation answers to the artist's intention, to understand the work is to know what the intention was" (Mark Rollins, *Danto and His Critics* [Oxford, UK; Cambridge, MA: Blackwell, 1993], p. 201). This Dantoesque concept is much closer to my concept of an *identifying* interpretation (apart from the differences as noted in section 8.4).

26. In that the object after interpretation has acquired properties it did not have prior to being thus interpreted. But such constitutive interpretation by *artists* should be sharply distinguished from more controversial issues as to whether *critical* interpretation is ever genuinely productive; for example, Margolis claims that it can be in "Reinterpreting Interpretation," *Journal of Aesthetics and Art Criticism* 43 (1989): 237–51, while Robert Stecker denies it in his "The Constructivist's Dilemma," *Journal of Aesthetics and Art Criticism* 55, no. 1 (1997): 43–52.

8.6. DIFFERENCES AND SIMILARITIES IN THE PICTURES

It will be recalled that in the initial example Anna did not stop after her constitutive interpretation of picture 2 as her new picture 2A, but instead she repeated the whole process (of identifying a new picture, and then adopting it as one of her own) for a *further* picture 3, which, in its upright orientation (with intrinsic top aligned with side Y) exactly resembles diagram 3 in its upright orientation.

Now one consequent kind of interpretation of that picture, identifyingly interpreted as picture 3, might find aesthetic qualities of "domination" or "constriction" in the relations of the line with respect to the circle in this orientation. Of course, other clusters of consequent interpretations could be provided for picture 3, such as a cluster depending on a consequent interpretation of the circle as a pool close to the viewer, with the line being a dark horizon beyond it.

However, as before, I would claim that any such consequent interpretations depend upon a *prior* identification of the relevant picture as one *whose intrinsic top is aligned with side Y*. For it is only as thus identified that picture 3 may be said both to have a *horizontal* line in it, and a horizontal line that is *above* the relevant circle (for in no other orientation of the design token are both of those statements true), which "basic facts" about picture 3 provide the "factual basis" of any such clusters of consequent interpretations of it.

The reason for including this third picture (or more precisely, the pair of pictures 3 and 3A) is as follows. Both pictures 2 and 3 are examples of (what I have called) "found pictures," and so they are appropriately similar for comparison with respect to the integral orientational factors that serve to distinguish them (as are indeed Anna's own corresponding pictures 2A and 3A as well). Also, Anna identified each of pictures 2 and 3 in the same way (by an *identifying interpretation*), and her own corresponding pictures 2A and 3A resulted in each case from acts, similar to each other, of *constitutive* interpretation on her part.

However, Anna's original picture 1A is in some ways a special case, in that (I shall assume) it was created by her in some more *usual* artistic way, without any "found picture" acting as an intermediary. Thus Anna's creation of *it* cannot be assumed to have involved either any identifying interpretation of something, or any constitutive interpretation of some appropriate intermediate entity or stage.

Nevertheless, as far as any *audience members* for Anna's pictures are concerned (including Anna herself, insofar as she can take up the perspective of a viewer of her works), her pictures 1A, 2A, and 3A presumably have precisely the *same* status as artworks, in spite of the differing creative stages involved in

picture 1A versus pictures 2A and 3A. For unless Anna were to deliberately relate the three pictures (such as by stipulating that they should be exhibited together, along with informative captions relating the history of their genesis), there would be nothing in the *finished* pictures to reveal that history.

Now an experienced artist's intentions about how she wishes a work to be received or understood by viewers would typically (and should) be *realistic*, in the sense that, not only would she *want* viewers to understand her work in a certain way, but she would present it to them in such a way that it is *substantially possible* for them to understand it in the desired way.[27]

Indeed, arguably it is part of the meaning of a claim that someone genuinely *intends* a communication of theirs to be understood in a certain way (as opposed merely to their idly *wishing* or hoping for that, or *pretending* to intend it, when they know that such hopes are actually *unrealistic*, that is, very unlikely to be fulfilled) that they have adequate grounds for believing that a reasonable number of viewers could and would understand the work in that way.

In sum, then, Anna's intentions with respect to her three works must be understood as intentions regarding how all three *finished* works should be regarded by their viewers, if she supplies them with no information other than the finished works themselves. (For any other supposed "intentions" of hers would be no more than pretense, or idle or irrational wishes.)

Thus the upshot of this discussion is that, as far as any legitimate or reasonable artistic intentions of Anna's go, she must intend the intrinsic orientation of picture 1A (with intrinsic top W) to play a *similar* "identificatory" kind of role in her picture 1A as the (differing) intrinsic orientations of her other pictures 2A and 3A play in their respective pictures.

Hence I claim that the unusual examples provided by each set of pictures 2 and 2A, and 3 and 3A, which serve to draw attention to a necessary orientational factor in the identity of *those* pictures, may also reasonably be extrapolated to apply to picture 1A *itself*—and hence (since the example provided in figure 1 is only an example of what could be *any* design whatever) to pictures in general as created by artists.

8.7. A DEFENSE OF ANNA'S METHOD

A diagnosis still needs to be given of the simplified process by which Anna chooses a final artwork status (as picture 1A, 2A, or 3A) for each of the extra

27. That is, not merely "empirically possible" in some minimal sense such as "not inconsistent with any known scientific laws," but rather that there is a reasonably high probability that reasonably informed viewers *would* be able to understand the work in the desired way.

prints that she made, using the same printing setup as she had originally used for picture 1. Her method is, in effect, to assign a given artistic identity to any one of the prints by simply rotating the print into the *correct field orientation* in which it should be displayed, which choice of orientation she then makes manifest or public (so as to make her intentions clear) by the manner in which she mounts and frames the relevant picture.

My diagnosis of Anna's procedure, which I believe to be defensible, is as follows. To begin with, it is perhaps obvious that visual artworks such as pictures have a well-defined *upright* orientation—which is that orientation in which the picture is normally displayed—and which they possess because of the intentions of the artist, or because of various cultural norms, such as that if a person is painted in a standing posture, then the side of the picture nearest to her head should be displayed so that it is visually higher than the other sides. Also, it will be recalled from section 8.1 that an object cannot *have* such an upright position unless it also has an *intrinsic* orientation, in that an "upright" orientation of a picture *just is* that field orientation in which the intrinsic top of the picture is aligned with the field top. So for pictures in general it is taken for granted that they have an intrinsic orientation, and are normally intended to be exhibited in their upright orientation.[28]

The relevance of these two points (that pictures have an intrinsic top, and that they are normally exhibited in an upright orientation) to Anna's methods is as follows. Because of those two points, artists such as Anna can be sure that, if they make it clear (such as by the manner in which they mount and frame their works) that their picture is to be exhibited with a *given side X of the picture as the field top* (so that side X will be seen as being both the highest side, and as being horizontal, in the environment in which the picture is exhibited) then, because of the convention that pictures are to be exhibited *upright*, that side X will also be perceived by viewers as being aligned with the *intrinsic top* of the picture.

But this point is all that Anna needs to justify her unusual method of creating a print of a given one of her three pictures. For I have argued that a necessary factor in the identity of each picture, and of their distinctness from each other, is that each has a different intrinsic top (with, respectively, sides W, Z, and Y being aligned with the intrinsic tops of pictures 1A, 2A, and 3A). But Anna knows that (because of the "upright" convention) she can ensure that a normal viewer (who makes the usual orientational assumptions) will, in viewing a given print, make an *identifying interpretation* of it as a given picture, based on whichever side Anna has (in effect) *prearranged* to be included in that identifying interpretation *as being aligned with the relevant intrinsic top*.

28. I discuss pictures exhibited in *non*upright positions in chapter 10, which also discusses various competing theories regarding the role of orientational factors in defining the identity of pictures.

Thus, for example, if Anna mounts and frames her print with side Y as the *field* top, that is all that she needs to do in order to (reasonably) guarantee that a normal viewer will *identifyingly interpret* the exhibited physical print[29] as that picture (with the given printed design) which has *side Y aligned with its intrinsic top*, and thus which viewer will have identifyingly interpreted the print as being *picture 3A* (rather than some other picture which also uses that same printed design). Thus Anna's procedure is justified, and does succeed as a method of creating distinct artworks that are distinct at least partly because of the distinctness of the sides with which their intrinsic tops are aligned.

8.8. PICTURES ARE NOT TYPES

One further issue should be clarified, with respect to the relations of the four pictures 2, 2A, 3, and 3A. Recall that I set up the example in such a way that any print resulting from Anna's decisions was a print of at most *one artist-intended* picture, since, prior to Anna's decision about which of her pictorial artworks a particular print should be, that print is not (yet) a print *of* any artist-intended picture at all.

However, the same point does not hold true for the "found" pictures 2 and 3 themselves. Part of the reason for calling them "found" pictures is to suggest that they are in some sense "there" to be found or viewed; that is, that they have some objective status (at least to the extent of being *potentially* "findable" by viewers or artists, prior to anyone actually finding them).

But more importantly, once two such distinct pictures *have been* found for a given design token (which serves as the CDT for both pictures), then there are two distinct *actual* pictures associated with that CDT, in spite of the fact that one can legitimately deny that these pictures are themselves artist-intended visual *artworks*.

One consequence of this fact is that such pictures, even though they are of the multiple, printmaking kind, such as in the present example, *cannot be types*; for the only plausible candidate to be a token of the two distinct (supposed) type-artworks 2 and 3 in the present case would be the single physical print which is the unique CDT associated with each of them. However, types of the same general kind which are *distinct* types cannot (by definition) have a token in common.[30]

29. Or more precisely, as I argued in section 8.4, identifyingly interpret *the visual data* from the print-related area of her visual field.

30. For example, two species of *animal* can only be *distinct species* if there is no animal that is simultaneously an instance of both species. See chapter 7 for more discussion on this "disjointness of distinct types" point.

Moreover, this antitype theory point may be generalized to cover the artist-intended visual artworks 1A, 2A, and 3A as well. For since all of the relevant prints of the three distinct artworks are *qualitatively identical* design tokens, which presumably could not be tokens of distinct *visual* types any more than could a single token,[31] then artworks such as 1A, 2A, and 3A could not be types either.

8.9. JUSTIFYING THE EXAMPLE

Now I shall explain further why I selected this particular kind of multiple artwork example. The fundamental reason is to try to achieve an example in which, to the greatest extent possible, it becomes clear that it is specifically *orientational* factors that distinguish different artworks. For orientational factors are normally unnoticed in the artworld,[32] and it is all too easy to confuse their effects with those of other factors.

For example, suppose that a painter were to produce four unique, individual paintings employing the same design as figure 1, each of which is exhibited in a different one of the four orientations as shown in that figure 1. I think that it would generally be agreed that these are four distinct pictures; but it would be all too easy for orientational critics to say that the distinctness of the objects *as artworks* has nothing to do with their *orientational* differences, for example, on the grounds that the four pictures would still be *distinct* pictures or artworks even if they were all intended to be exhibited in the *same* field orientation.[33]

Also, simply moving to a more usual case of a comparison of three multiply-produced artworks,[34] in which prints of each artwork were produced in separate printing runs using distinct printing plates (embodying the same design) individually created for each artwork 1A, 2A, and 3A, would also be questionable in a similar way. For critics could contend that the resulting

31. I assume here, as before, that the types in question are visually rather than functionally defined types: see section 8.0.

32. As is well illustrated by the near total lack of discussion of such issues in the literature. But Richard Wollheim does briefly discuss the process by which an artist chooses an orientation in Wollheim, *Painting as an Art* (Princeton, NJ: Princeton University Press, 1987), p. 20.

33. For example, because of Danto's well-known arguments to the effect that qualitatively indistinguishable objects can nevertheless be distinct artworks, for example, in Danto, *The Transfiguration of the Commonplace.*

34. Of course I could have compared four rather than three such artworks, but that would not have advanced the discussion in any substantive way.

three sets of prints, from the three separate printing processes, would be distinct *as multiple artworks* simply because of the numerically distinct creative processes that produced them, *whether or not* the artist intended them to be exhibited in differing orientations.

My actual example and discussion seeks to avoid such (what are in my view) "red herring" criticisms in two ways. First, my arguments for the existence of the "found" pictures 2 and 3 do not depend on prior distinct *creative acts* by an artist, so that there is less room for critics to explain away such distinct pictures in ways independent of orientational factors. And second, my postulation of a simplified *joint* productive phase, during which prints for all three of Anna's pictures 1A, 2A, and 3A are produced *prior* to a decision about the individual pictorial status of any given print, also serves to short-circuit such criticisms.

8.10. THE FUNCTIONAL NATURE OF INTRINSIC ORIENTATION OF CONCRETE OBJECTS

To conclude, my diagnosis of the example can be supported further by a (necessarily brief and initial) analysis of (what could be called) *the functional nature of intrinsic orientation of concrete objects*, in that (as was initially pointed out) clearly intrinsic orientation for such concrete objects is generally relative (in various ways) to human interests and purposes.

For though the *field* orientation of such an object is simply a (relational) fact about the item that holds whatever our interests or purposes are (such as the fact that a given, ostensively identified side of an object is aligned with the top of its environment), this is not in general true for any *intrinsic* orientation that an object may be interpreted as having, assignment of which does depend in various ways on the functions that an object can perform for us in furthering our ends.

In particular, I would claim that, insofar as types and their concrete-object tokens are considered, it is only *functionally* defined types that are relevant to determining the intrinsic orientation of a token, and *not* any of the perceptually defined *visual* types, tokens of which on my account make up the *corresponding design tokens* (CDTs) that embody any pictures. (Which is not, of course, to deny that those same objects may also be tokens of functional types, as in the following example.)

As an example illustrating this point, consider an object that is both a token of a *functional* design type, such as a particular type of car, all of whose tokens are actual cars of that type, and also—commonly, since many objects

have a visual design[35]—a token of a *visual* design type, all of whose tokens are visually indistinguishable from the current token.[36]

My claim is that the object considered as a (token of a) *functional* design type—of a vehicle used for certain purposes or functions—may be capable of determining an intrinsic orientation,[37] namely of determining that the *roof* of the car is its intrinsic top (for we standardly use cars to drive around in, and this is best achieved by regarding the *upright* orientation of the vehicle as being that orientation in which its roof is topmost).

However, that same object when considered simply as a token of a *visual* design has no power to determine an intrinsic orientation—and what is more, this is arguably a *necessary* feature of purely visual designs, for it could not suit our overall purposes to have possibly *conflicting* intrinsic orientations assigned to the same object based on differing functional versus visual considerations.[38]

Next, suppose that a sculptor Bob decided to use that car as the raw material for a sculpture of his. I claim that the functionally defined intrinsic top of the car is irrelevant to whatever intrinsic orientation is possessed by any *sculpture* that Bob might produce using the car as his raw material.

For if Bob were to weld the back bumper of the car to a horizontal base, so that the car is in a vertical orientation with its radiator at the top, then surely it is undeniable that this orientation constitutes the *upright* orientation *of the relevant sculpture*, with the car's radiator aligned with the sculpture's intrinsic top (or equivalently, of course, with the horizontal base aligned with its "intrinsic bottom").

The example is of some independent interest, because arguably Bob has transformed the visual design of a *real*, particular upended car into an effective, ironic *representation* of *an* upended car. But still, the intrinsic orientation of Bob's *sculpture* itself is distinct from the (functionally defined) intrinsic orientation both of the physical car that is its raw material, and from that of the sculpture's *subject matter*—namely, the represented car.

35. I argued in chapter 7 that only *meaningful* configurations are designs, so that, for instance, some random pieces of rock may not be tokens of any design.

36. The problem described earlier in section 8.8 about conflicting distinct types, which prevents pictures from being types, does not apply in the present case, since visual and functional types are *not* types of the same general kind.

37. Though not all functional types need do so; my claim is only that any types that *do* determine the intrinsic orientation of their tokens are functional types.

38. This is not to deny, of course, that a given *picture* (such as a representational picture of some buildings) has an intrinsic orientation—which would normally be that orientation in which the buildings look upright when one looks at the picture. But as always it is necessary to distinguish the relevant *intrinsically oriented picture* from its concrete CDT, which is the particular visual design token in question.

But how then do pictures *themselves* acquire their independent intrinsic orientation? As an initial answer to this question, there are various ways in which a given, *non*functionally defined visual design token can nevertheless be *used* for certain *pictorial* functions or purposes[39]—more specifically, used *as a vehicle for displaying* various pictures, with the particular picture displayed depending both on the current field orientation of the CDT, and on the *identifying interpretation* of it by its viewer.

Thus I would claim that it is in this way that artist Anna *used* any given individual printed design token (when mounted and framed in an appropriate orientation) *as* a print of one of her pictures, having its own corresponding intrinsic orientation. And then any viewer of Anna's picture is able to make an *appropriately similar pictorial use* of the relevant CDT,[40] in carrying out her *identifying interpretation*, that identifies the relevant picture when her gaze is directed upon that appropriately oriented CDT.

39. An analogy may be helpful. A piece of wood could be *used* as a hammer, or a support, or a barrier, and so forth, without it being the case that it actually *is* a hammer, or a token of any other such functionally defined type.

For a related account of how pictures acquire an intrinsic orientation, see chapter 9. Section 12.5 gives a more fundamental functional account in terms of the achievement of determinate subject matter by an artwork.

40. As noted previously, in my view the likely cognitive mechanism by which this is done involves the interpretive processing of *low-level visual information* from that CDT-related region of the visual field: see section 8.5.

9

Varieties of Visual Representation

I n this chapter I argue that, once orientational factors are recognized, then it must also be acknowledged that specifically *pictorial* representation cannot be the *only* kind of visual representation. It is argued that there are no less than *three* additional, *"delineative"* kinds—which involve only a *single* kind of content—and that pictorial representation is distinguished from them by its conforming to a principle of *oriented subject matter invariance* (the *OSMI* principle).

The double content (DC) view has a natural explanation of this difference, in that "delineative" kinds of representation are *simple* or *single-stage* kinds of representation, whereas *pictorial* representation instead has the same double content or *two*-stage representational structure as argued for in the earlier chapters. (Later, in chapter 12, it will be argued that the first stage of pictorial representation is itself such a "delineative" kind of representation.)

As before, by a "visual representation" I mean roughly an item that is both visible itself, and which purports to represent some actual subject (that in paradigm cases is also visible) in such a way that the representing item is in some way similar to, or recognizable as, the purported actual subject; and which item has a representational *content* or *subject matter* that may or may not accurately characterize any actual subject.[1] *Pictorial* representation is one species of visual representation.[2]

1. Thus as before I shall use the terms "subject matter" and "representational content" interchangeably in this chapter, as having no implications as to whether there actually is some subject (namely, some actual object, event, or state of affairs) that might serve as a standard of correctness or appropriateness in each case of visual representation.

2. To be sure, there is much argument as to exactly how the relations between a pictorial representation, its subject matter, and its actual subject (if any) should be

However, one of my main concerns in this chapter will be to argue that there are no less than three *additional* varieties or species of visual representation, none of which are currently adequately recognized, and which together comprise a category of visual representation distinct from that of pictorial representation.

Thus we shall be discussing two main categories of visual representation. The first category is the familiar kind, comprising the category of paintings, drawings, photographs, and other pictures that visually depict things. I shall refer to this category as that of *pictures* (or *depictions*), which pictures or depictions function by *depicting* some subject or subject matter.

The second category of visual representation, however, seems to be (as noted) a currently unfamiliar and undefined one—at least in conceptual terms. Thus some discussion is required prior to any succinct characterization of it. I shall refer to this category by means of the (correspondingly unused) term *delineation*, which "delineations" function by *delineating* some subject or subject matter.

Delineations come in three different varieties, to be called *structural*, *aspect*, and *integrative* delineations (for reasons that will become clear), so that overall, when pictures also are considered, there are four distinct varieties of visual representation. It will turn out that a primary difference between pictures and the three kinds of delineations is a difference in *orientational* characteristics of each.[3] Thus I shall begin with some further discussion of spatial orientational factors, as a necessary preamble to the introduction of the category of delineations.

9.1. PICTURES AND ORIENTATION

Recall that two complementary spatial orientation concepts may be defined—*intrinsic* and *field* orientation, as initially presented in section 8.1. To begin, here is a brief summary of that material.

As a preliminary, there are two necessary conditions for something to be in an *upright* orientation. First, it must have a *top* or *top side*, which is identifiable as such, no matter how the object may be rotated or currently oriented; such an object has an *intrinsic orientation*, and its top is an *intrinsic top*. And second, such an intrinsically oriented object must currently be oriented so that its intrinsic top is *aligned with* the top of the natural environment, or environmental field, in which it is located.

characterized, in such works as Nelson Goodman, *Languages of Art* (1968) and Richard Wollheim, *Painting as an Art* (1987). But my current concerns lie elsewhere.

3. They also have differing identity conditions, as discussed in section 9.2.

The concept of alignment can be generalized to apply to *whichever* side of an object is aligned with the top of the environmental field—whether or not the object has an intrinsic orientation: such an alignment constitutes the *field orientation* of an object. Thus any rotation of an object changes its *field orientation*; whereas on the other hand, if an object has an *intrinsic orientation*, then it possesses an intrinsic or inherent top (no matter what field orientation the object currently may have, or be rotated to).

Now I shall discuss the relevance of intrinsic orientation to pictures. To begin with, pictures standardly have a well-defined *upright* orientation, in which the picture is normally displayed, and which they possess for various reasons such as the intentions of the artist, photographer, and so on, or because of various cultural norms, such as that if a person is painted in a standing posture, then the side of the artwork nearest to her head is to be displayed so that it is visually higher than the other sides.[4]

Also, as will be clear from the initial definitions in this section, an object cannot *have* such an upright position unless it also has an *intrinsic* orientation, in that an "upright" orientation of an artwork *just is* that field orientation in which the intrinsic top of the artwork is aligned with the field top. So for pictures in general it may be taken for granted that they have an intrinsic orientation, and that they are normally intended to be seen or shown in their upright orientation.[5]

However, it seems not to have been noticed that the intrinsic orientation of a representational picture also confers on it an additional property, namely that the *field orientation* of its *subject matter* may be *determined from* that intrinsic orientation of the picture[6]—no matter what the field orientation of the picture may be—in the following manner. Since the derivation is to be carried out in several stages, I shall state and illustrate the result to be arrived at before deriving it.

The result I shall arrive at is that the *oriented subject matter* of a picture

4. Recall also from section 8.10 that a physical artifact in a suitable orientation may be *used* by a viewer to *identify* a picture in its upright orientation.

5. As a *non*-normal example, it is possible that an artist might clearly indicate which side of a given picture would *normally* be considered as its intrinsic top (such as by the orientation of her signature, or a title placed below the picture, and so forth), yet nevertheless deliberately arrange to have the picture hung in a position *inverted* from that "normal" orientation—thus acting within the avant-garde tradition of mocking or subverting "normal" artistic conventions. I discuss such cases in chapter 10.

6. This is not to deny that, from the differing epistemic perspective of a picture's creator, her desire to represent the subject matter as having a given field orientation determines which side of her painting—assuming that the subject matter has already been painted there—she should count as defining the intrinsic top of the corresponding picture. Thus the actual relation in question is one of codetermination, in that knowledge of either enables the other to be fixed.

remains *invariant* through rotation; or in other words, that the field orientation of its subject matter does not change even if the field orientation of the picture does change. I shall call this principle the *oriented subject matter invariance* or *OSMI* principle. For example, if an (upright) picture of an upright building is inverted (that is, rotated to an upside-down position), then what results is an *inverted* picture of an *upright* building (rather than an inverted picture of an *inverted* building).[7]

Here then is the derivation. First, the subject matter of a picture always has some particular field orientation of its own, as in the case of a picture of an *upright building*.[8]

Second, the question must be asked of how we *know* that the subject matter of such a picture is indeed that of an *upright* building, rather than of a building in some other field orientation. An initial answer might go as follows: we know it is upright, because when the picture itself is viewed in its own natural upright orientation, the depicted building can be *seen to be* upright. Or in other words, we determine the field orientation of the subject matter by "normalizing" the field orientation of the picture itself to its upright position—in which its field top is aligned with its intrinsic top—and then we can see that the field top of the *subject matter* has the same field orientation as do both the intrinsic top and current field top of the picture.

However, this initial result does not yet enable us to claim that the field top of the subject matter is always aligned with the *intrinsic* top of the picture. For there is at least an abstract possibility that the field orientation of the subject matter might itself covary with the *field* orientation of the picture when the picture is rotated, rather than remaining fixed as does the intrinsic top of the picture. But this possibility will now be ruled out.

Third, the field orientation of a picture A's subject matter is surely one of the *necessary characteristics* of picture A, in the sense that any picture B, whose own subject matter had a different orientation from that of picture A, for that reason could not be identical with picture A. For example, just as a picture of a *person* could not be identical with a picture of a *cat*, because each picture has a different subject matter, so is it equally clear that a picture of an *upright* or standing person could not be identical with a picture of a *horizontal* or reclining person, because each picture has a differently (field) *oriented* subject matter. Thus having a given *field orientation* for its subject is just as much necessary to the identity of a picture as is its having a certain *kind* of subject matter.

7. Sections 12.4 and 12.6 relate the OSMI principle to the distinction of medium content from subject matter.

8. However, choosing such an example, in which the subject matter itself has an intrinsic orientation, is not necessary to the point being made; I do it only because it is easier to describe the field orientation of a subject using a term such as "upright" that implies an intrinsic orientation for any object that it describes.

However, since this is so, it follows that the field orientation of the subject matter of a picture cannot itself change as the picture is rotated, on pain of the picture itself losing its identity during this process. Or in other words, just as the particular *kind* of subject matter that a picture has must remain invariant during its rotation, so also must the specific *field orientation* of the subject remain invariant during any such rotation—and hence, as announced, the *oriented subject matter invariance* or *OSMI* principle holds for pictures.[9]

Given this account, the characteristic kind of representation associated with pictures could appropriately be called *intrinsic* representation, in that the field orientation it represents its subject matter as having depends solely on the "alignment status" of that subject matter—as upright, inverted, and so on—with respect to the *intrinsic top* of the picture. Thus, pictorial or intrinsic representation is on this view *independent* of whatever actual field orientation a picture might happen to have—which view also exactly fits the very common intuition that both a picture, and what it represents, cannot be changed merely by changing the field orientation of a picture.

Thus I would claim that my concept of pictorial or intrinsic representation captures at least a large central core of cases that have traditionally been regarded as being pictures. Nevertheless, the concept is still flexible enough to allow for the possibility of other cases of visual representation that do *not* conform to its oriented subject matter invariance (OSMI) principle, and which hence require additional visual representation concepts for their adequate description, such as the three new "delineative" concepts that I shall introduce.

9.2. PICTORIAL VERSUS DELINEATIVE REPRESENTATION

In this section I shall briefly draw out an important implication of the above account of pictures that will also serve to make it intuitively clear why *pictorial* representation cannot be the only kind of visual representation. The implication to be discussed is that pictures must be distinct from the physical

9. One caveat should be mentioned. In chapter 10 I shall discuss various theories of pictorial *inversion*, including theories that would *deny* that a picture retains its identity through rotation. However, a modified form of the OSMI principle would still apply in such cases: the *family* of distinct pictures (namely, those corresponding to various rotational stages of what we normally consider to be the *same* picture through rotation) would still be such that their subject matters each have the same invariant field orientation.

Section 10.3 also provides an explanation of the holding of the OSMI principle as being due to the differing kinds of *structure-preserving invariances* characteristic of inversion cases.

artifacts that are their vehicles, because it is possible for *more than one* picture to be associated with a given physical vehicle, so that such objects are (at least potentially) pictorially *ambiguous*.[10] Thus it will be necessary to distinguish orientational facts about pictures from those about their physical vehicle.

Consider a rectangular physical painting A, whose subject matter is a car, with the roof of the car being closest to its field top W, and its wheels closest to the bottom, opposite side Y of the painting. Most likely the artist had intended to depict the car in its own upright orientation, so that side W of the *painting*, which is its field top, would be aligned with the intrinsic top T of the *picture*. Call this picture—whose intrinsic top T is aligned with side W of the painting—picture P1. Thus if painting A is rotated to an inverted position, with side Y at the top and side W at the bottom, and with picture P1's top T being similarly inverted by the rotation, what results is an *inverted* picture P1 of an *upright* car, because of the previously discussed OSMI principle for pictures.

However, artists are of course free to depict cars (or any other objects) in any field orientation that they please, and to change their minds about such matters at any time prior to exhibiting the resulting picture. Suppose that the artist in question, after inverting picture P1 (and hence painting A) in the manner just discussed, decided to *reinterpret* her physical painting A as a picture, not of an *upright* car as with picture P1, but instead as a picture of an *inverted* car.

In so doing, she would be deciding that side Y (and not side W) would be aligned with the intrinsic top of the resulting picture. But then that resulting picture P2 must be a picture *distinct* from the original picture P1, because each picture has an intrinsic top[11] that is aligned with a *distinct* side— side Y for picture P2, and side W for picture P1. Also each picture has a different *oriented subject matter*, with picture P1 showing an upright car, while instead picture P2 shows an inverted car.

Thus in sum, a pictorial *ambiguity* results: the inverted physical painting A, with side Y as its field top, could be interpreted either as an *inverted* picture of an *upright* car (picture P1), or as an *upright* picture of an *inverted* car (picture P2). And also neither picture, strictly speaking, can be identical with the physical painting A, given that P1 and P2 are distinct from each other.

Now both pictures P1 and P2 are subject to the OSMI principle, since as usual field rotations of either picture would not affect their intrinsic orientations, relative to which the field orientation of their respective subject matters is defined. Also, P1 and P2 are distinguishable from each other, and hence from A, because they obey the OSMI principle.

10. The first part of this section could be thought of as a convenient summary of some of the main implications of chapter 8.

11. In section 12.5.4 I argue that each has the same intrinsic top, in spite of their differing field orientations.

However, what about the distinct, physical painting A itself? Since it is distinct from both pictures P1 and P2, surely there must be some legitimate sense, or senses, in which *that physical painting itself* represents a car, independently of the specifically *pictorial* way in which P1 and P2 represent a car. For in seeing the physical painting, one can see *car-related subject matter* even if one does *not*—as we normally do—proceed to interpret what one is seeing as a picture having a certain intrinsic top.

My claim is that here is where the possibility of *nonpictorial* or *delineative* forms of representation becomes operative. If one regards the painting A simply as *a rectangular physical object*, which represents an upright car when side W is A's field top, then when A is inverted—so that side Y becomes its field top—it will be seen as representing an *inverted* car. Thus the representational capacities of *the painting A itself* do *not* obey the OSMI principle—which is just what one would expect, since conformity to the OSMI principle is what distinguished pictures P1 and P2 from A in the first place.

Further, I shall argue, as previously mentioned, that there are in fact *three* different characteristic ways in which a physical object such as A could delineatively or nonpictorially represent some subject matter, which could briefly be summarized as follows:

1. *Structural* delineation: the object, in any field orientation, represents the subject matter *without* representing its field orientation.
2. *Aspect* delineation: the object, in a particular field orientation, represents the subject matter in the same particular field orientation.
3. *Integrative* delineation: an integrative concept covering all possible cases of aspect delineation for a given object. (Thus, if one wishes, aspect and integrative delineation could be regarded as related subspecies of a single kind of delineation.)

One outcome of the discussion in this section is that pictorial versus delineative kinds of representation are closely associated with different kinds of *uses* or *social functions* of objects such as paintings, maps, diagrams, and so on. We naturally refer to physical paintings and photographs as *pictures* because the predominant or most common *use* of such objects is in a pictorial way. However, as has just been illustrated, the relevant physical objects could also function in some delineative representational way as well.

On the other hand, other kinds of objects, such as maps or diagrams, instead predominantly function in *delineative* ways—see the next section—even though they too may function pictorially in less common cases. (A further discussion of the contrasting representational uses of objects in general is provided in section 9.9.)

To conclude this section, here are brief replies to two possible objections to my account.

The first objection is that there are many objects that have *no* field orientation—such as planets or city streets—but surely there can nevertheless be pictures of such objects, so that the OSMI principle would fail to apply to pictures of such subject matters. Answer: this objection confuses the *subject matter* of a picture, that is, its visible representational content, with whatever actual objects or scenes might have *inspired* (in a painting) or *causally produced* (in a photograph) that representational content.

The second objection is that there are pictures, such as Escher's well-known lithograph *Relativity* (1953), which show a scene with parts that apparently each have *different* field orientations, so that the subject matter of the picture as a whole either has multiple orientations or *no* field orientation. Again, does not such a picture violate the OSMI principle?

My answer is in two parts. First, the subject matter of any picture may be composed of several parts or objects. For simplicity I have assumed that one may characterize the field orientation of a picture's subject matter as a single unit, but one could equally well describe it distributively, in terms of a geometric *orientation matrix*, in which each distinguishable part, object, or area of the subject matter has its own individual field orientation description specified, relative to the intrinsic top of the relevant picture. Then my OSMI thesis would be that the relevant *matrix* of field orientations remains invariant through rotation of the picture.

On the other hand, the objector's concern might be more that some areas of the subject matter of the lithograph could equally well be assigned *differing* or *inconsistent* field orientations, because of the overall *ambiguity* of field orientation of Escher's lithograph taken as a whole. However, this kind of objection mainly serves to show the necessity of distinguishing individual *pictures*—each with its own distinctive intrinsic top—both from each other and from their physical vehicle, as discussed in this section. Indeed, the overt ambiguities of Escher's *Relativity*, which positively require an account such as mine for their resolution, provide convincing evidence that the current approach, which finds potential ambiguities of pictorial interpretation in *any* physical pictorial vehicle, is fundamentally on the right track.

9.3. MAPS

Now I shall proceed to discuss delineations. To begin with, as already mentioned, the concept of a delineation is an unfamiliar one. Nevertheless, there are some familiar examples of the extension of this unfamiliar concept of a

delineation, among which geographical *maps* and technical *diagrams* provide some prominent examples, as well as *trompe l'oeil* paintings.[12]

I shall start by discussing maps. Dominic Lopes treats maps as a subclass of pictures, saying of them that they ". . . are clear examples of informative pictures."[13]

But Richard Wollheim is more wary of maps. In his view, a map is not a "representation"[14] because maps are (in his terms) excluded by virtue of the connection between representation and "seeing-in." It will be useful to quote his remarks:

> . . . the connection allows to exclude from representationality signs like maps that are not of whatever it is that they are of because we can see this in them. We may or may not be able to see in them what they are of but, if we can, it is not this fact that secures their meaning. A map of Holland is not of Holland for the reason that the land mass of Holland can be seen in it—even if to a modern traveller a map reminds him of what he can see, looking down upon the earth, at the flying altitude of a plane. No: what makes the map be of Holland is what we might summarily call a convention.
>
> This fact about maps and what they map is confirmed by the way we extract from them such information as they contain. To do so we do not rely on a natural perceptual capacity, such as I hold seeing-in to be. We rely on a skill we learn. It is called, significantly, "map-reading": "map-*reading*."[15]

Thus, according to Wollheim, a map is not (in my terms) a picture, for example, because we do not see what a map is *of* when we look at it; instead, on his view, a map is rather a conventional sign, that needs to be read rather than seen.

However, I believe that Wollheim has not considered a sufficient variety of visual phenomena in his account. In particular, a map does show or visually represent (in my broader sense) various spatial relationships between places, in that one can *see* those relationships in looking at a map. Thus, even if a map has a higher degree of conventionality than most pictures, it would be wrong to deny that it does in *some* way visually represent geographical features. A map is much closer to a picture than it is to a conventional linguistic

12. Trompe l'oeil paintings will be discussed in section 9.7.

13. Dominic Lopes, *Understanding Pictures* (Oxford, UK: Clarendon Press; New York: Oxford University Press, 1996), p. 94.

14. By which he means roughly a picture or depiction in the above sense, minus any trompe l'oeil paintings, minus any (in his view) nonrepresentational abstract pictures. See Richard Wollheim, *Painting as an Art* (Princeton, NJ: Princeton University Press, 1987), p. 62.

15. Ibid., pp. 60–61.

sentence, but Wollheim's summary dismissal of maps as conventional does not adequately explain this proximity.[16]

Nevertheless, I shall side with Wollheim in denying picturehood to maps, but for other reasons than his—reasons which will both explain why maps are not pictures, and why maps and pictures are nevertheless species of a common genus of *visual representation*, which genus is distinct from other more distant categories of representation such as that of linguistic representation.

9.4. STRUCTURAL REPRESENTATION

In order to explain what it is about maps that makes them nonpictorial in various ways, I shall, as previously announced, bring in the neglected concept of the *spatial orientation* of a visual representation. It will turn out that there are critical orientational differences between pictures on the one hand, and maps (or other "delineations") on the other (as well as other significant differences).

As already implied, there are three possible nonpictorial or "delineative" kinds of visual representations associated with maps, all of which make no use of the "pictorial" concept of intrinsic orientation[17] (in terms of which, as explained in section 9.1, a picture *intrinsically* represents its content or subject matter, in a manner that satisfies the *oriented subject matter invariance* or *OSMI* principle).

The first of these kinds I shall label as a *structural* delineation. In a *structural* delineative interpretation of a map, it is viewed or visually interpreted as giving *purely structural or relational visual information* about its subject matter, which information does not depend on any kind of *orientational* information (whether of a field or intrinsic kind, and whether pertaining to the map or to its subject matter).

It is important to distinguish relevant versus irrelevant kinds of orientational information. Obviously any map will include "compass orientation" information (with one side being north-facing, the opposite side being south-facing, and so on), which provides, in effect, an *intrinsic* orientation for the map (with its north-facing side being its intrinsic top).[18]

16. Indeed, an aircraft or satellite *photograph* of an area of terrain (which, as a photograph, is surely a picture, if anything is) could be *used as* a map, and it would *become* one with only minor visible alterations (such as suppressing irrelevant details, or adding captions). Thus for me, the burden of proof regarding maps lies with those who would *deny* (as shall I) that they are pictures.

17. I discuss *pictorial* interpretations of maps in section 9.9.

18. This is so because, if the map were placed horizontally, and its north-facing side were aligned with a (north-pointing) compass needle, then this would count as being the "upright" or "standardly aligned" orientation of the map. However, it

And, equally obvious, any particular viewing of the map (in a location within the terrain of which it is a map) will be a case in which the map has some particular field orientation relative to the surrounding terrain, of which it is a map.

But my claim is that a *structural* map interpretation makes no *use* of any such orientational information—that since it is purely *structural* (including broadly geometric) visual information that is seen to be represented, it would make no difference how the map itself might be field aligned with respect to an actual landscape, and nor would it make any difference whether or not the map had an intrinsic orientation.[19]

And what is more, the same points hold for the seen represented content too: it also is interpreted structurally, with no attention being paid to any intrinsic or field orientational factors.

This is a good point at which to bring in another example of a delineative representation, namely a *diagram* or blueprint. For example, a schematic diagram of a car engine under a typical interpretation does not *picture* or *depict* a car engine, but instead it merely *visually represents* its parts and their positions relative to each other, without depicting any particular orientation of the engine—and hence it (structurally) *delineates* rather than depicts the engine.

As evidence for the presence of such a structural interpretation of maps or diagrams as a normal (or at least common) case, consider Wollheim's own negative evaluation of maps as requiring *reading* rather than genuine visual interpretation. (There is also a natural sense in which one may have to learn to interpret or "read" a car schematic diagram, or an architectural blueprint.) I suggest that the so-called reading in question is simply a consequence of the fact that extracting invariant, orientation-independent visual information from an object such as a map requires extra *conceptual work*, over and above

should be pointed out that the geographical or geometric *relationships* made possible by a compass grid (such as that one place A is southeast of another place B) constitute invariant or *structural* information, of the kind I am claiming to be involved in a structural map interpretation (see the next footnote).

19. To be sure, some structural information may *indirectly* depend on intrinsic orientation, in that it is in some sense "part of the meaning" of a claim that place A is southeast of place B that there is also some method of standardly aligning the map with an actual compass needle (hence determining an *upright* position for the map, with its north-facing side thereby counting as its *intrinsic top*), so that the map content may correspond or be aligned with actual geographical relationships. Nevertheless, A's being southeast of B is of a piece with A's being twice as far from B as is some other place C—all of it is invariant, structural, or geometric information that takes no direct account either of a map's current field alignment relative to an actual landscape or of any additional ways in which that purely structural information may be linked to an intrinsic top so as to maximize the representational utility of the map.

that required simply to visually interpret it as an object, or as an object *depicting* something.[20]

Or in other words, the so-called reading is instead a further, more abstractive phase of (what is nevertheless) genuine *visual* processing of information from a map or diagram. The visual appearances of things naturally come in many specific situational (lighting and the like) and orientational forms. Abstracting what visually is in common or invariant among many such particular appearances is not necessarily easy or automatic as is the seeing of such aspects themselves. Yet what is thus abstracted is still genuinely visual information, so that, for instance, one who has learned how to do this for a given map or diagram can actually *see* that same invariant visual information in the map or diagram before her, no matter what particular orientational conditions may prevail.[21]

And finally in this section, another, more a priori kind of argument for the existence of structural delineative visual processing[22] is that, since *structural* visual information about a represented object is a legitimate and knowable category of visual information about the object (having cognitive value complementary to that of pictorial representations of it), then there has to be some empirical way in which such information can actually be collected through our visual perceptual mechanisms—hence there must *be* actual mechanisms of structural delineative visual processing, which involve concepts that suffice to define a class of objects as the contents of structural delineations.

9.5. ASPECT REPRESENTATION

In the previous section one particular variety of delineation (namely, a *structural* delineation) was defined and distinguished from a picture. Now I shall

20. Also, it should not be overlooked that many diagrams or blueprints may themselves include symbols or words that do indeed require literal reading, so the effects of such linguistic parts should not be allowed to confuse the issue of the status of the *non*linguistic parts of a map or diagram.

21. To be sure, with some diagrams such as an electrical circuit diagram, there is less reason to say that it delineates any specifically *visual* subject matter. However, as Wollheim points out in another connection, it is possible to hold that an item may visually represent *non*visual aspects of a subject matter—so that, for instance, a painting of Laocoön can represent him as about to cry out in agony, which is a future sonic event (Wollheim, *Painting as an Art*, p. 67). But in any case, clearly there can be genuinely visual representations which at least *attempt* to delineate nonvisual subject matters, so that the diagram itself may still be interpreted visually as a delineation in such a case, no matter how little specifically visual subject matter information it gives.

22. Which is the cognitive side of a claim that some objects are structural delineations.

introduce another variety of delineation to be called *aspect* delineation. It will be helpful again to go back to first principles, as in the case of structural delineations.

Thus, recall the principle of *oriented subject matter invariance* (OSMI) that applies to pictures, so that (for example) an (upright) picture of an upright dog will, upon rotation to an inverted position, become an *inverted* picture of an *upright* dog (rather than an *inverted* picture of an *inverted* dog). As before, I claim that satisfaction of this invariance principle is a necessary condition of something's being a picture (or, of its being a case of specifically *pictorial* visual representation). Recall also that the OSMI principle holds for a picture because *the field orientation of its subject matter* is determined by *the intrinsic orientation of the picture itself*, rather than by the *actual field orientation* of the picture.

This being so for pictures, all that is needed to find further distinctive *non*pictorial modes of visual representation is to find distinctive ways in which an object can visually represent something *without* its being the case that the way in which it does so satisfies the OSMI principle. So far, one such mode has been found, that of *structural* visual representation, which fails to satisfy the OSMI principle because an object (such as a map) in this mode fails to have an *oriented* subject matter of *any* kind (no matter what orientation it itself may be placed in).

Thus in particular, non-OSMI-satisfying cases will include those in which the field orientation of the subject matter of the representing object *is* determined by its actual field orientation. Hence we are looking for cases in which, for example, an actual field *inversion* of the object itself also produces an *inversion* in the field orientation of its subject matter.

Intuitively speaking, these are cases in which one regards the subject matter as being *closely associated with* the actual physical object in question—so that if the object is inverted, then so also must be the subject matter. (See also the initial example of this in section 9.2.) Thus in the case of a map, which typically has a geographical region or landscape as its subject matter, when the field orientation of the map itself is inverted, the field orientation of the represented landscape, that is, of *the subject matter* of the map, will be inverted too.

Here is an attempt to make that intuitive characterization more precise. As a preliminary, it is useful to take as an initial point of reference a map held upright so that its due north direction is vertically upward. Its *top* is then the *north* side, in the sense that, for any point X on that north side, a line drawn perpendicularly through X and the map will identify points which are such that point X is *due north* of all of them. (With similar definitions for the corresponding east, south, and west sides). For convenience label the four sides as N, E, S, and W respectively.

Next, it will be useful to define a sense in which a given side of an aligned

rectangular geographical area of the subject matter, whose sides are parallel with sides N, E, S, and W of the map (such as a roughly rectangular city thus aligned) on the map is "north-facing." A side is *north-facing* just in case it is closer to the north side of the map than are the other three sides of the area (with similar definitions for the corresponding east-, south-, and west-facing sides).

As a further step in these definitional preliminaries, an *aligned area* is *itself* north-facing just in case its north-facing side is also its current field top. Thus in the case of the map's initial upright orientation, with the north side at the top, any aligned rectangular area will be such that it is north-facing (that is, with its north-facing side being the *current field top* of that area). And finally, the subject matter as a whole of the map is north-facing just in case any exhaustive division of all of its content into contiguous aligned areas is such that all of those areas are north-facing.

Next, suppose that the map is inverted. This will have the result that all of the previously *north*-facing aligned rectangular areas of the map's subject matter will now have become *south*-facing subject matter areas—because the new field top of each area will be its *south*-facing side rather than (as previously) its north-facing side. Hence the subject matter as a whole will have become south-facing too, so that as desired, we now have a more precise characterization of a sense in which a field inversion of the map itself has produced an inversion in the field orientation of the subject matter of the map.

These two cases—of a map in two distinct field orientations—provide examples of what I shall call *aspect* or *aspectual* visual representation, in which an object (such as a map) in a particular field orientation visually represents a subject matter that has *the same* field orientation as does the object representing it.

To summarize and generalize from the example given, aspect representations or delineations have two logical features that should be remarked on. First, they are *internally consistent*, in the sense that, for instance, if the content as a whole of a maplike delineation is north-facing, then each of the regions making up that content is also north-facing. Also, their field orientation is of course consistent with that of corresponding physical regions of the map itself, since each has an identical field orientation.

In addition to internal consistency, a principle of (what could be called) *external consistency* of oriented representational content also applies to aspect representations, in that—as shown above—if a map is inverted then the oriented content of the map is *also* inverted from its previous field orientation. Thus if the original map content was north-facing, an inverted map *aspectually represents* an inverted, south-facing content, which oriented content is (as was the north-facing content previously) also doubly consistent—both internally and externally—with its corresponding map.

Hence, in the case of internal consistency, for a *given* orientation of the

map, each map element aspectually represents some oriented map content *in the same way* as every other map element; while for external consistency, each *different* orientation of the map itself aspectually represents *in the same way* a *correspondingly different* orientation of the content of the map.[23]

Turning now to the wider context in which this notion of aspect representation was introduced, it is apparent that the external consistency principle holding for aspect representations is *inconsistent* with the oriented subject matter invariance (OSMI) principle for pictures. Or in terms of an example, in the case of a picture of a dog, if an upright picture of an (upright) dog is inverted, then it becomes an inverted picture of a (still) upright dog. But in the case of a map, if an upright map that aspectually represents an "upright" or north-facing content is inverted, then the map becomes an inverted aspect representation of an *inverted, south-facing* content. Hence it follows that cases of aspectual representation are *not* also cases of pictorial representation. I conclude, then, that aspect representation is indeed a *delineative* rather than *depictive* representational concept.

9.6. ASPECTUAL VERSUS "CONTRA-ASPECTUAL" DELINEATIONS

In the previous section I gave two consistency principles (internal and external) for aspect representations. However, a further principle is required to complete the definition of a desired kind of close correspondence obtaining in cases of aspectual representation, as the following thought experiment will show.

As is well known, because of the laws of optics the human eye produces an inverted image on the retina for any object that is seen. Now normally we somehow perceptually compensate or adjust for this, so that objects are nevertheless seen in their actual upright orientations (so that we are "perceptual compensators"). However, it is easy to imagine that some other people might be (what could be called) "perceptual literalists," who see things only in the same inverted form as that produced by their eyes as images on their retinas.

Imagine, then, such a person seeing what is actually an inverted map (labeled as in the previous section), with actual side S at top, and with its actual inverted content being south-facing. However, a "perceptual literalist" will not see it that way; for him, it will look exactly how an upright map with north-facing content looks to us "perceptual compensators."

For such a person, it is unavoidably true that it is actual side *S*, rather

23. In the next section I shall argue that an additional principle (concerning the identification of a perceived top with an actual top) is needed to complete the characterization of aspectual representation.

than actual side *N*, which seems to him to be the north-facing side on the map. For it is only when side S is actually at the top that he is able to see the map as representing north-facing content.

Now clearly this view of things is profoundly unintuitive for us "perceptual compensators," and we have right on our side, too, because we see side N as being at the top when it actually is at the top. However, this thought experiment does show that our way of seeing things (or more importantly, the usual way in which objects such as a map nonpictorially and nonstructurally represent things) is not the only logically possible way.

Thus our kind of "aspectual seeing," which links a perceived top to the same actual top of the physical map, should be viewed as providing an additional principle or necessary condition for aspectual representation (in addition to the two consistency principles already discussed). And hence what "perceptual literalists" see could instead be described as *contra-aspectual seeing*, since it inverts a necessary condition of aspectual seeing properly so considered. However, because of the fatally flawed epistemic status of a "contra-aspectual representation," I shall not consider this as amounting to a legitimate extra kind of visual representation, and so no addition to the three varieties already considered is needed.

9.7. INTEGRATIVE REPRESENTATION

In discussing the external consistency of cases of aspectual representation, I said that it holds when each *different* orientation of a map itself aspectually represents *in the same way* a *correspondingly different* orientation of the content of the map. However, it should be clear from this that external consistency holds between multiple cases of aspect representation. Yet at the same time, all of these cases are represented by the same single physical map (in its various possible different orientations). Thus one is led to inquire as to whether another more *integrative* or *summative* concept of representation could be applied so as to unify these disparate cases of aspect representation.

In a more mathematically precise form, the suggestion is that a new concept could be defined, of an *integrative* delineative representation, it being a *summation* or *integration* of a continuous series of all of the *aspect* representations of a given content, each of which represents that content in some particular orientation. Or, put more simply, the concept of integrative representation generalizes the concept of aspect representation (which applies only to one particular orientation of a map, and of its content) so as to apply to all possible cases of the orientation of a map. And hence integrative representations are themselves delineative or nonpictorial for the same reasons as for aspect representations themselves.

As an initial example of integrative representation using a map (which also brings in cases of aspect representation), recall that on a road trip it is often helpful to turn a map to an angle at which the road as represented on the map is parallel with the actual road on which one is traveling, and with a specific orientation so that what looks like the road ahead on the map corresponds to the actual road ahead of oneself. (In this way it becomes easier to find visual correspondences between the map and the actual landscape.) This activity may involve many turnings of the map (including to any possible specific orientation within the 360-degree compass of the map), so that the particular orientation of the map depends on one's specific direction of travel at any given moment.

In such a case it seems intuitively natural both to think of this use of the map as comprising a *single* representational function of the map (in which case the map would be regarded as being used in an *integrative* representational way), yet also as its use being made up of many particular episodes of the map in a particular orientation representing its content in a particular orientation (in which case each episode is being regarded as a case of *aspectual* representation).

The close relation of the concepts is also shown by the fact that one cannot distinguish the content of aspect and integrative representation cases as being respectively orientationally dependent versus independent, because independent cases would instead count as cases of *structural* representation (that is, as having the same content whatever their orientation).

Turning to another kind of example, I would claim that *trompe l'oeil* paintings should also be regarded as integrative or aspect delineations, rather than as pictures. Thus I agree with Wollheim's view that similarly denies picturehood to such trompe l'oeil paintings—but, as with maps, for different reasons than his.[24]

For insofar as (by definition) such paintings seek to "trick the eye" into regarding their representational content as being real, then it immediately follows that any rotation of the trompe l'oeil painting must be perceived as also being a rotation of (what is in fact) its representational content, on pain of the illusion failing to work. Thus, successful trompe l'oeil works *must* function delineatively rather than pictorially. This account also has the advantage that it explains successful trompe l'oeil cases as being genuine cases of *visual representation*, in spite of the fact that no (specifically) *pictorial* representation is involved.[25]

24. See Wollheim, *Painting as an Art*, p. 62.

25. Thus my account may have some advantages over that of Susan Feagin in "Presentation and Representation," *Journal of Aesthetics and Art Criticism* 56, no. 3 (Summer 1998): 234–40, who argues that trompe l'oeil paintings "present" rather than "represent" things.

In concluding this section, I shall summarize some deeper reasons for the noted orientational differences between structural, integrative, and aspect delineations on the one hand, and pictures on the other. (See also section 9.2 for some related points.)

First, it is clear that, since a single physical map can be involved in three different kinds of delineative representation, therefore the sortal or object-referring concept of a "delineation" itself must refer to the *same* physical object in each case, so that delineations are physical objects. What distinguishes the three classes of delineations is not the referent of the term "delineation," but rather the characteristic orientational differences between the representational *contents* in each case. Thus delineative kinds are kinds of representational content, each of which, however, is also associated with a characteristically different kind of orientational *use* of the (single) physical object in question so as to achieve the desired kind of representational content.

Given that delineations are physical objects (such as a particular map or diagram), it follows that when that physical object changes its orientation, then so inevitably does each area that represents the subject matter of that object (when it is interpreted as an integrative or aspect delineation). Thus in this (perhaps relatively simple or basic) *delineative* mode of visual representation, changes in orientation *in various areas of the object* are naturally seen or interpreted as changes in orientation *of its subject matter*. For example, a formerly upright line on a map is rotated to a horizontal position, in which case it is naturally delineatively interpreted as (what is now) a *horizontal* road, rather than as (what was formerly) a *vertical* road.

However, with pictures on the other hand, a picture of a vertical road does *not* become a picture of a horizontal road merely because the picture is rotated from a vertical to a horizontal position. Thus in this (perhaps less basic or more sophisticated) *pictorial* mode of visual representation, in some cognitive way a pictorial entity is defined that has an *intrinsic* orientation, so that its rotation makes no difference to the orientation of the picture's subject matter, which orientation is invariant because it is defined *relative to the intrinsic top* of the picture, rather than relative to *its current field orientation*, as is the case with an integrative or aspect delineation. Thus at bottom the distinction between pictorial and (integrative or aspect) delineative representation is as basic as the distinction between intrinsic orientation and field orientation itself.

9.8. POSSIBLE PICTURES
VERSUS DELINEATIONS

Here now is another example illustrating ways in which pictorial concepts are distinct from delineative ones. One might encounter a picturelike object (that may or may not actually be a picture), but initially be unable to *visually understand* it as a picture. One might be able to see that it has *some* representational content in some areas, but nevertheless one does not (yet) see how those areas of content could be integrated together into a single picture. Thus, in an important sense, one cannot (yet) perceive this object *pictorially*, or *as a picture*.

In such a case, it is necessary to distinguish two concepts or phases of specifically *pictorial* perception: first, an *exploratory* one, in which one mobilizes one's *picture-related* conceptual and perceptual resources in an *attempt* to discover a picture, and second, an achievement or *occurrent* concept, which would apply only if one is currently actually perceiving a picture. The case in question is admittedly a case of *exploratory* pictorial perception, but it is not (or not yet) a case of *occurrent* pictorial perception.

However, surely, in one's (so far failing) attempts to see the object *as* a picture, there are *some* perceptual activities going on that must *already* qualify as achieved or occurrent perception of the object *as a visual representation* in some respect or respects (or at least, as occurrent perception of parts of the object *as* having representational content). I claim, therefore, that there has to be some more permissive or less demanding concept (or concepts) of occurrent visual perception of a representation, to supplement the (currently inapplicable and more sophisticated) concept of *occurrent pictorial* perception—and that an occurrent form of the concept of *integrative delineative perception* can supply what is required here.

Thus what is needed is an account that acknowledges that, in a case such as this, there is both an *exploratory* pictorial perceptual activity occurring, and also some *already achieved perceptual recognition of some representational content* (or content fragments), which fragments are (presumably) used in a trying out of various different "perceptual hypotheses" concerning the relations of those representational fragments; and this is a role tailor-made for (a more generalized concept of) *integrative delineative* perception, in which content elements are viewed as in various ways *changeable* or *rearrangeable* relative to each other, until one best interpretation is fixed on.[26]

Now to be sure, the hypotheses in question are indeed (exploratory) *pic-*

26. To be sure, this is a more abstract sense of "changeable views of content," or of changeable orientation with respect to content, but it is one that befits the exploratory context.

torial hypotheses; but my point is that such hypotheses would have nothing to work on without a supply of already perceived *non*pictorial (integrative delineative) content elements.

There is also a significant role for *structural* delineative perception in this case, that is revealed by inquiring as to what should convince a reasonable person that she had *failed* in her attempt to perceive a picture in such a case. I claim that the only reasonable ground on which to give up and admit failure is if one is reasonably sure that one has *succeeded* in *another* perceptual task, namely that of grasping as a whole the structure of whatever actual (visual) representational content one has succeeded in perceiving. For it is only if one is (reasonably) sure both that one has indeed perceived that whole structure (that is, perceived the *structural delineation* associated with the object), and that the thus-perceived structure is *visually chaotic* (or insufficiently coherent to be interpretable instead as a genuine pictorial content) that one has any good reason to give up one's attempt at pictorial interpretation.[27]

A possible objection to my view should also be considered, arising from an opposite case in which exploratory picture perception were instead *successful*. Would this be a case where my structural delineative test would prove the representational content to be visually coherent, and hence pictorial in nature, so that a supposed nonpictorial, structural delineation turned out to be pictorial after all?

My answer is that this objection confuses nonoriented, structural delineative content with oriented pictorial content. It is indeed the case (I would claim) that the visual coherence (or otherwise) of the nonoriented structure of the representational content can provide a sufficient condition or test of whether the object in question *could* be perceived as a picture, or not. However, the coherence (or otherwise) that provides the evidence in these cases is not an oriented *pictorial* coherence, but instead just a delineative or nonoriented *structural* coherence. There is all the difference in the world between an object's qualifying as a *potentially perceivable* picture in virtue of some minimal structural coherence of content, versus its having a corresponding *pictorial* coherence in its content, and particularly one of an *aesthetically interesting* kind—as any failed painter with little or no artistic talent (but who nevertheless succeeded in applying the lessons of his art theory courses, regarding coherent painterly structure, to his paintings) could attest to.

27. The issue here should be distinguished from that of aesthetic evaluations of the "pictorial unity" of a picture, which evaluations arguably presuppose that an object is indeed a picture (even if a poor one because of its relative disunity).

9.9. USES OF DELINEATIONS AND DEPICTIONS

Now that some basic distinctions have been made between delineations and depictions, I shall conclude with some brief further (see section 9.2) discussion of a perhaps ancillary, but nevertheless significant, issue concerning the relations of these two categories of visual representation.

This issue is as follows. It seems quite possible that a *delineation* (such as a map or diagram) could itself also be interpreted or used in some *pictorial* manner. While on the other hand, it seems that *pictures* themselves could be used in *delineative* ways, such as in the case of an aerial photograph that is readily usable as a map. How are such cases to be accounted for?

One basic point in reply is that an object that normally represents in delineative ways (such as a map or diagram) may nevertheless be *usable* pictorially, and vice versa. Thus, a map remains a *map* (that delineatively represents in the three ways discussed) even if ways are found to use it pictorially. And similarly, a picture is still a picture, even if ways are found to *use* it delineatively.

Here are two other examples, one of each kind. As a further example of a picture used delineatively, a specially prepared representational painting (which would normally be regarded as a picture) might be *used* by a spy to convey geographical information, in which case the painting is *used* in delineative ways as if it were a map or diagram.

Or, on the other hand, a normally delineative map might be exhibited as a fine specimen of the engraver's art, in which case the intentions of the exhibitors give prominence to one specific orientation (the normal, upright one) over other possible orientations, so that the map as a whole is regarded as a picture having its own intrinsic orientation. Thus from this point of view, if the pictorially used map were inverted, then its oriented content would remain the same as before, instead of changing as in its integrative or aspectual uses.

A deeper explanation of this case is as follows. Clearly one could take a map and photograph it, so that one ends up with a *picture* of the map. Since this picture is a picture *of the map*, its content or subject matter (namely, the map) will remain orientationally invariant if the picture is inverted. However, *any* map could be thus regarded or used *as* a picture of a map—and with good reason, since most likely any commercially produced map started off *as* a photograph (that is, a picture) of some original hand or computer-drafted map. Hence it is possible to satisfactorily explain pictorial uses of such delineations.

As for delineative uses of pictures, these too may be readily explained in more basic terms. On my account, any picture is *associated with*, but is not strictly identical with, a physical object (see section 9.2). But then it will always be possible to consider that object simply as a physical object *in its own right* (ignoring its pictorial connections), and then go on to consider ways in

which that same physical object might delineatively represent (in various ways) some content. So here, too, "crossover" uses of pictures and delineations pose no fundamental problems for my account of them.

Thus, in sum, I hope to have provided in this chapter a useful framework for further investigations into the many interesting issues associated with the various kinds of visual representation.

Four Theories of
Inversion in Art and Music

T his chapter integrates the recent issues concerning pictorial orienta-
tion with some of the broader issues discussed elsewhere in the book.
It also extends the orientational points to apply to the *structure* of *musical
themes*—of a theme, versus its musical *inversion*—and finds close parallels
with cases of *spatial* inversion for paintings, as well as investigating four pos-
sible specific theories as to the nature of all of these cases. Noteworthy also
is that the focus on the specific concept of *inversion* enables the discussion to
dispense with any explicit introduction of the concepts of intrinsic and field
orientation, since the concepts of uprightness and inversion already presup-
pose those concepts.

To begin, recall that a visual artwork such as a picture or drawing is an
autographic work, in that it seems to be closely identified with a particular
physical object, so that even an exact copy of it does not count as being gen-
uinely the same work of art. While on the other hand, other artworks such
as musical or literary works are *allographic*, in that they are copyable without
any such limitations: for example, two identical copies of a novel could each
equally be a genuine instance of that novel.[1]

Nevertheless, in spite of this very basic distinction between autographic
versus allographic artworks, it seems clear enough that a deeper under-
standing of both kinds of artworks requires the pursuit of *analogies* or *similar-
ities* between them, in spite of their differences. For any such analogies that
may be found will provide critical tests for more general theories about the
nature of artworks, such as the current double content theory.

For example, Arthur Danto famously argued that there could be several,

1. See section 4.0 for an initial discussion of the autographic/allographic distinction.

physically distinct but qualitatively indistinguishable red rectangles, some of which were *distinct* artworks, while others were not artworks at all,[2] from which he concluded that autographic artworks could not merely be *physical objects*, but that instead they must be partly constituted by the intentions and actions of their respective artists.[3]

Others have argued for a similar point as applied to *allographic* works such as novels or musical pieces: mere textual or sonic qualitative identity is also not sufficient for artistic identity. For example, as Jorge Luis Borges in effect showed with his well-known example of a fictitious work by one "Pierre Menard," the text of which was word for word identical with the text of a section of Cervantes' *Don Quixote*, but whose aesthetic qualities were quite different, we must distinguish the identity of a *literary artwork* from mere *textual* identity.[4]

And Jerrold Levinson has argued that similar points apply to musical scores and performances: two different composers might produce *textually identical musical scores*, which nevertheless would provide the textual basis for two *distinct* pieces of music—both because of the fact that there are two different composers involved, and because of their differing artistic intentions concerning their respective musical works.[5]

Thus, in spite of the differences between autographic and allographic artworks, the pursuit of analogies between them can clearly produce powerfully convergent requirements or constraints on acceptable theories of the nature of artworks.

In this chapter I shall propose and argue for a novel analogy between autographic pictures and allographic musical pieces, which potentially could provide an even stronger set of constraints on acceptable theories of art. Whereas Danto, Borges, and Levinson used cases of *indistinguishable*—but nevertheless physically distinct—paintings, texts, and scores, I shall instead work with cases that stand in the relation of *inversion* to each other. More specifically, I shall be concerned with the question of how spatially inverted and uninverted paintings or *pictures* relate to each other, and of how nonspatially inverted and uninverted *themes* in music relate to each other as well.[6]

2. Arthur Danto, *The Transfiguration of the Commonplace* (Cambridge, MA: Harvard University Press, 1981), chap. 1.

3. Others arguing against the "physical object" assumption include Richard Wollheim, *Art and Its Objects: With Six Supplementary Essays*, 2nd ed. (Cambridge, UK, and New York: Cambridge University Press, 1980); Joseph Margolis, *Art and Philosophy* (Brighton, Sussex, UK: Harvester, 1980); and of course the current book.

4. Sections 3.6 and 7.6 also used this well-known example.

5. Jerrold Levinson, *Music, Art, and Metaphysics: Essays in Philosophical Aesthetics* (Ithaca, NY: Cornell University Press, 1990), chaps. 4–5.

6. However, in the case of art, the points to be made would be applicable also to

I should emphasize that this approach to inversion seems not to have been investigated prior to the current work, so that most of this chapter is breaking new ground—hence there are no writings by others on the approach, to which references could be given or comparisons made. However, I do discuss the general implications of this approach with respect to other views in sections 10.7 and 10.10.

Inversion is an example of a *structure-preserving* transformation. For example, no matter how a square or rectangle is rotated about a perpendicular horizontal axis through its midpoint, that transformation preserves the same square or rectangular shape intact. And on the face of it, the same applies to paintings or other pictures too—a painting has the same structure, including both geometrical and other formal elements, as well as color or textural relationships, no matter how it is rotated, and no matter how complicated its design structure may be.

In the case of music, a theme is "inverted" when, in mirror-image style, the previous high notes are replaced with inverse low notes, and vice versa. Here, too, arguably the operation is structure preserving, in that the same *configuration* or *pattern* of notes is preserved, in spite of the different particular notes that result when a theme is inverted.

The basic issue in each case, of pictures or music, is whether these inherent *structure*-preserving features of inversions are sufficient for the *identity* of the relevant inverted and uninverted artworks—or whether, as with Danto's rectangles or Levinson's scores, one must insist that artistically they are distinct.

Now in the case of pictures, the matter might seem obvious, for if a picture were simply a *physical object*, then of course it would remain the same, identical object through spatial inversion. But as Danto's "indistinguishable red rectangles" case showed,[7] we already have good reason to deny that assumption.

In chapters 7 and 8 I have proposed a more specific way in which to distinguish an artwork or picture from its associated physical object or substratum, which substratum is on my account a *design token*—where the design or structure is the class of perceptually indistinguishable objects which are tokens of the design in question. Then the unique object that physically embodies a given picture is its *corresponding design token* or *CDT*. On this

wider cases of any 90-degree spatial rotations of pictures (about a horizontal axis through their midpoint, perpendicular to the line of sight), which includes rotations through 90 and 270 degrees, as well as to the specific inverse or inverted case of rotation through 180 degrees. But all of the significant issues to be dealt with can be discussed by considering the inversion case alone. So both for that reason, and to preserve parity with the musical case (in which there is no ready analogy to "sideways" rotations through 90 or 270 degrees of an upright or uninverted picture), I shall restrict discussion to cases of inverted versus uninverted pictures and musical themes.

7. Danto, *The Transfiguration of the Commonplace*.

approach, one or more pictures may be conceptually distinguished from its, or their, physical CDT.

Here is how this distinction may be used in cases of spatial inversion. First, the *structural invariance* required for genuine cases of spatial inversion may be accounted for in terms of the *invariant design structure* provided by the design of the CDT—which design, of course, remains the same through any spatial rotation or inversion of the unique design token being discussed, which itself remains numerically identical through inversion.[8]

Second, the issue can then be raised of how the one or more pictures *associated with a given CDT* is itself, or are themselves, affected in inversion-related ways by any spatial inversion applied to the CDT. This is a nontrivial issue, in spite of the triviality of the issue as applied merely to the physical CDT itself, about which much discussion is possible.[9]

Indeed, there are no less than *four* different kinds of possible theories about the relationships of the respective pictorial or artistic inverted and uninverted items, along with ancillary issues about their relations to their CDTs, which I shall explore in this chapter. And I shall also show that there are a corresponding variety of theories about musical cases of inversion as well. I shall conclude by picking a provisional leading candidate from among our four theories,[10] and also briefly point out how my results provide significant *further* constraints on acceptable theories of the nature of artworks—in addition to those already provided by writers such as Danto and Levinson.

10.1. A PICTORIAL EXAMPLE

Before saying any more about the relations of a picture, or pictures, to its, or their, CDT, it will be useful at this stage to "jump in the deep end" with a particular example of spatial inversion, and see what can be made of it.

Here is the example. Harold, who is a traditional representational painter, had partly rearranged his paintings the previous night in his studio. But on entering the studio next morning, his eye is immediately caught by what looks

8. However, as will become clear, this is not so in the case of music inversion: this is one of the differences between "autographic" pictures and "allographic" musical themes. For an absorbing account of inversion issues, see Douglas Hofstadter, *Gödel, Escher, Bach* (New York: Vintage Books, 1980).

9. See also chapter 8, which includes a complementary discussion (with examples) of multiple pictures associated with a single CDT.

10. In this preliminary investigation I shall concentrate on similarities between pictorial and musical cases, in the hope of discovering a uniform theoretical treatment for both. But I do not doubt that there may be some value in the exploration of different theoretical treatments for each in some cases.

to him like a picture of an upside-down or inverted building. It takes a moment before he realizes that what he is seeing is not actually a picture of an inverted building, but that instead it is one of his paintings—which in fact is a picture of a right-side-up or upright building—which painting he must have inadvertently turned upside down the previous night during his rearrangements.[11]

My initial question is as to what kind of mistake, if any, had Harold made in this case. Harold himself, if asked to perspicuously describe what had happened, might naturally describe it thus: "Initially, I thought I was seeing an upright picture of an inverted building, but then I realized that what I was actually seeing was an inverted picture of an upright building."

For reasons of brevity and convenience, I shall abbreviate the relevant terms as follows: "U" for Upright or right side up, "I" for Inverted, "P" for Picture, and "S" for Subject or subject matter of a picture. Then the two views above can be abbreviated as the UP-IS view (upright picture, inverted subject) and the IP-US view (inverted picture, upright subject).[12]

First, then, if Harold did make an initial mistake, it cannot be located in the "objective visual appearance" of his picture. For the *appearance* of what Harold was looking at did not change during the events in question; instead, he merely changed his *interpretation* of what he was seeing, in changing from his initial UP-IS to his final IP-US view. Or to put it another way, such a supposed UP-IS case is *visually indistinguishable* from such an IP-US case, in some basic sense of perceptual indistinguishability, in spite of Harold's differing interpretations.

I take it, however, that we may agree with Harold that he did initially make a mistake of *some* kind, and that, as suggested above, the mistake in question may naturally be described in terms of his having correct or incorrect *visual interpretations* of his painting. Thus in some more sophisticated or interpretive sense of perception, the picture did *look different* to Harold when he was interpreting it on the UP-IS model, versus when he changed his interpretation to that of the IP-US model, and the second way it looked to him was correct whereas the first was not.[13]

Furthermore, what makes Harold's IP-US visual interpretation correct,

11. The example itself has obvious similarities with the printmaking examples in chapter 8, and with the pictorial ambiguity case discussed in section 9.2. But here I shall raise some new and distinctive issues about such cases.

12. In section 12.1 a third *perceptual compensation* interpretation of what is thus seen, as a *UP-US* picture, is discussed, but it is not germane to the current discussion.

13. A recent debate between Arthur Danto and Joseph Margolis usefully draws attention to various issues concerning "basic" versus "interpretive" perception: see Joseph Margolis, "Farewell to Danto and Goodman," *British Journal of Aesthetics* 38, no. 4 (October 1998): 353–74; Arthur Danto, "Indiscernibility and Perception: A Reply to Joseph Margolis," *British Journal of Aesthetics* 39, no. 4 (October 1999): 321–29; and Joseph Margolis, "A Closer Look at Danto's Account of Art and Perception," *British Journal of Aesthetics* 40, no. 3 (July 2000): 326–39.

as opposed to the incorrectness of his UP-IS interpretation, is something *about his painting itself*: specifically, that it is because his painting is indeed *a picture of an upright building*—and not of an inverted building—that his IP-US interpretation thereby counts as correct, and his UP-IS interpretation as incorrect. To be sure, it may be that the main reason why his picture is of an upright building is because Harold, in painting it, intended its subject to be—or interpreted it as being—an upright building (rather than an inverted one); so the location of the correctness in the picture itself, rather than in Harold's current interpretations of it, does not preclude that the picture itself acquired its normative status as a standard of interpretive correctness in virtue of prior intentions or interpretations on Harold's part.

Another conclusion that can be drawn is that a picture A of an upright building cannot be *identical* with a picture B of an inverted building, because each has at least one description true of it that is false of the other—namely, that A but not B is a picture of an upright building, and that B but not A is a picture of an inverted building.

10.2. MORE INVERSION THEORY

I shall now define, with the aid of the just-presented Harold example, various inversion-related concepts needed for subsequent discussion of the four theories to be presented. Here too we are breaking new ground.

To begin with, the introductory discussion of the structure-preserving concept of inversion applied that concept not to pictures themselves, but only to their *corresponding design tokens* (CDTs), whose design serves as the appropriate invariant structure in cases of spatial inversion of a CDT. However, once pictures have been distinguished from CDTs, it also becomes necessary to consider issues of inversion as applied to pictures themselves.

The example of Harold's accidentally inverted picture in section 10.1 provides a potentially rich structure of inversion concepts as applied to pictures, as may already be apparent from the discussion in that section, which structure seems not to have been previously investigated.

As an initial step, three different kinds of inversion need to be distinguished. The first kind could be called an *identity inversion*, which, as the name suggests, covers cases in which an item *retains its identity* through inversion, so that the item and its inverse are one and the same object. The initial case of a CDT and its (spatial) inversion is of this kind. Identity inversions will also be referred to as *cross-inversions* (X-inversions) for reasons of terminological distinctiveness—suggested by the fact that in such a case an item survives *through* or *across* the inversion process. Also, an *X* looks like both an upright and an inverted version of the same letter *v*.

The second and third kinds require some discussion before being defined. Recall that Harold distinguished between his initial but mistaken interpretation of his accidentally inverted picture—as an upright picture of an inverted building (a UP-IS picture)—and his subsequent correct interpretation of it as an inverted picture of an upright building (an IP-US picture).

Now each of those putative pictures has *some* claim to be regarded as "an" inversion of Harold's original uninverted or upright picture (the UP-US picture), in that each is associated with the same physically inverted state of the CDT—which CDT is the same for each picture, of course. Hence there is room for a *generic* concept of inversion, which allows that both the UP-IS and the IP-US pictures are *generic inversions* of the UP-US picture.

However, clearly there is also room for a more specific concept of inversion, which is such that only the *IP-US* picture, and not the UP-IS picture, qualifies as the legitimate *specific inversion* of the UP-US picture, since—among other reasons, and in Harold's view—only that IP-US picture, and not the UP-IS picture, qualifies as the *correct* pictorial reading or interpretation of the inverted painting. Thus, in sum, we have three kinds of inversion: identity or cross-inversions, and both generic and specific inversions—X-inversion, G-inversion, and S-inversion.

A desirable principle concerning inversions of any one of the three kinds considered is that if item A has as its inversion item (or items) B, C . . . , then A and items B, C, . . . are *symmetrically related*, in that A itself will (in turn) count as an inversion (of the relevant kind) of items B, C. . . . In the case of spatial inversion this principle is perhaps obvious, in that a single inversion (or rotation by 180 degrees) will produce inverted item(s), which may in turn themselves be inverted (or rotated by 180 degrees) to restore the original item(s) and orientation. In the case of music, it is also perhaps obvious that any theme is itself the inversion (of some kind) of whichever theme (or themes) serves as its own inversion. This principle could be called the *inversion symmetry* principle.

As to the relations among cases of X-, G-, and S-inversion, a plausible initial view is that the S-inversion cases are a proper subset of the G-inversion cases, and that it is an open question, requiring further argument in a given case, as to whether or not any S- or G-inversion is also an X-inversion.

There is one further element required to round out the discussion of Harold's painting. It may have been noticed that so far there has been an asymmetry in the discussion of the painting, in that only *one* putative picture has been discussed in connection with the original upright state of the painting—namely the UP-US picture—whereas *two* (putative) pictures have been discussed in connection with the inverted state of the painting, namely the UP-IS and IP-US pictures. This asymmetry will now be rectified.

Recall that Harold initially saw—what looked to him like—an *upright*

picture of an *inverted* building, namely the UP-IS picture. But so far no *specific inversion* of this picture has been identified—unlike the case of the IP-US picture, which is the specific inversion of the UP-US picture, and which UP-US picture correspondingly itself counts as the specific inversion of the IP-US picture, by virtue of the above inversion symmetry principle.

What is wanted as the specific inverse of the UP-IS picture is a picture that shares the same specific subject matter as it has, namely that of being an inverted building, while it also counts as being *an* inversion of the UP-IS picture—for when both elements are combined, the result will be a specific inversion of the UP-IS picture. Hence the desired picture must be an *inverted picture* with an *inverted building* as its subject matter: an IP-IS picture. And intuitively that result is correct, in that if Harold initially saw his—actually inverted—painting as *an upright picture of an inverted building*, then he would expect *that upright picture* to be inverted, and hence to become an IP picture, if his painting were *again* inverted, yet to nevertheless retain *its inverted subject matter* (IS), hence producing the IP-IS picture.

10.3. THE FOUR THEORIES

I shall now (as announced) use the discussion so far as a basis for articulating four possible theories concerning the relations of inverted and uninverted pictures. The theories will subsequently be extended to musical cases as well.

First, recall the distinction in the Introduction between a picture and its associated painting or other physical basis, which I called its *corresponding design token* or CDT. An initial need for such a distinction has already been demonstrated, in effect, in that Harold interpreted a single *painting* of his—initially and incorrectly—as being a picture of an *inverted* building, and then correctly as a picture of an *upright* building—so that, in effect, *two* distinct potential pictures were being considered with respect to whether either of them was connected in some appropriately integral way with the painting or CDT in question.

Given the distinctions, both between different pictures, and between a picture and its CDT, it is now possible to describe the issues and theories connected with any possible inversions of them.

First, if any of Harold's "interpreted" pictures can be inverted in space, then each such picture itself can exist or occur in more than one orientation in space. Now for a CDT, which is a physical object, this is a completely trivial issue, since in general one and the same physical object can exist or occur in any spatial orientation, as can any token of its corresponding design.

However, the matter is not so trivial for pictures, as distinct from their

CDTs, as will become clear. In fact it will turn out that there are *two* ways in which a picture might fail to be spatially invertible: either what seems to be an *X-inverted* picture is really *not a picture at all* (the subject of theory 3), or, as in theory 4, it is instead a *different* picture (so that again, a picture *itself* is not [X-] invertible without loss of its identity). I shall refer to such a non-X-invertible picture as being *fixed*—in that, since it is unable to survive through any orientation change such as inversion, it therefore has a *fixed* or unchangeable orientation.

Another related issue to be considered is that of *how many* pictures might correspond to a given CDT. In the present chapter I shall consider this question only with respect to inversion issues.[14]

To begin with, all four theories to be considered share a common feature. It is that, whatever inversion or inversions a picture (and its CDT) may have or undergo, the *subject matter* of the picture (or pictures) does not undergo any corresponding inversion. For example, as already seen, if a picture is of an *upright building*, then it has the same uninverted subject matter—in this case, of an *upright* rather than *inverted* building—even if the picture itself is inverted. The reason for this common feature was explained in the previous section, in that it is based on the differing kinds of *structure-preserving invariances* characteristic of inversion cases.

Thus it will be unnecessary to explicitly mention this general assumption—of the invariance of some level of specificity of subject matter under inversion—when discussing each of the four theories to be presented.[15]

The first theory (theory 1) to be discussed has two parts. Part 1 involves an initial claim that, for a given design token T, *at most one picture* is associated with it (so that T acts as the CDT for at most one picture). From this claim it follows that at most one picture is (X-) inverted when its CDT is inverted.

Part 2 of theory 1 claims that the (at most) one picture in question is indeed X-inverted when its CDT is inverted. As already noted, this identity-preserving coinversion claim may seem too obvious to mention, but, as we shall see, theories 3 and 4 will deny it.

Thus, symbolically theory 1 could be referred to as the OX theory, in that it postulates that there is at most One picture P associated with a token T, and that that picture P itself is X-inverted if its CDT is inverted. I take it that this is the usual, or traditional, view of paintings and other visual artworks. For reasons of space I shall omit discussion of a possible variant on

14. See chapter 7 for a sculptural example of a single object that—because of the differing intentions of two artists—embodies two separate sculptures, each in the *same* uninverted orientation. A similar example could easily be constructed featuring one physical painting embodying two distinct pictures in the same orientation.

15. In chapter 9 this feature was described as the *oriented subject matter invariance* (OSMI) principle.

theory 1, which would say that the one picture in question is *fixed* (that is, not X-invertible). This seems likely to be a minority view, since the one-to-one correspondence of a picture and its CDT according to theory 1 gives less reason to distinguish features of a picture (such as X-invertibility) from those of its corresponding CDT.

Theory 2 differs from theory 1 only in its first part. According to theory 2, there could be *Many* (or More than one) picture associated with a given CDT T, rather than at most one as with theory 1, and *at least one of them* will itself be (X-) inverted if its CDT is inverted. Thus symbolically this could be described as the MX theory (Many pictures, at least one of which is X-inverted if the CDT is inverted).

As for theories 3 and 4, they share a common structure and hence will be considered together. But, as will become clear, each realizes that structure in fundamentally different ways, so it is appropriate to consider them as distinct theories.

Theories 3 and 4 each differ from theory 2 only in their second part. Thus both theories agree with theory 2 in holding that there could be *many* pictures associated with a given CDT T, but differ from theory 2 in that they deny that any of those pictures are X-inverted when T is inverted. Hence theories 3 and 4 hold that pictures are *fixed* rather than (X-) invertible. Thus symbolically theories 3 and 4 could be described as MF theories (*many* pictures, all of which are *Fixed* [or not themselves X-inverted] if the CDT is inverted).

However, this specification leaves many issues unresolved, and, most significantly, as will become clear, the issue of the *ontological status* of inverted pictures. There are two fundamentally different ways of handling such pictures.

The first of these MF approaches to inverted pictures could be called the *eliminative* approach. It would deny that (strictly speaking) there are any inverted pictures, and would seek to explain away apparent references to such pictures. This approach defines theory 3 (the MFE theory: *Many Fixed* pictures, *Eliminating* any inverted ones).

The second MF approach (the *inclusive* or *all-accepting* approach) would instead accept such references at face value. Thus, on this inclusive approach, there are inverted pictures, but none of them are identical with any upright pictures. This approach defines theory 4 (the MFA theory: *Many Fixed* pictures, inclusive or *All-accepting* of inverted ones).

10.4. A MUSICAL EXAMPLE

Given the complexity of the issues concerning theories 1–4, all that can be achieved in the remainder of this chapter is the provision of some initial evi-

dence, suggesting that theories 2, 3, and 4 are indeed live options to theory 1 in the case of visual artworks. I shall also introduce a *musical* example—closely analogous to the Harold painting example—both as supportive evidence for the pictorial cases, and as raising interesting musical aesthetics issues in its own right.

Here then is a musical example that is structurally similar to the Harold UP-IS and IP-US pictures case as first described in section 10.1. Anne is a composer who likes to compose using computer software that enables her to directly type her compositions into the computer. Her software allows the use of various "shortcut" keys (including one key which inverts a given theme). Anne had been working on a new, original theme for her current composition the previous night. But on starting up her computer the next morning, and replaying her original theme for the first time, she is mystified to hear (what initially sounds like) an entirely different theme, which embodies an apparently "falling" subject in place of the "rising" subject that characterized her original theme. It takes a moment before she realizes that what she is hearing is not actually a theme with a falling subject, but that instead she is hearing *an inversion of her original theme* (with its rising subject), which inversion she must have entered into the computer by accidentally pressing the "invert" key the night before, subsequent to her entering of her original theme.

As in the Harold inverted-picture case, my initial question is as to what kind of mistake, if any, had Anne made in this case. Anne herself, if asked to perspicuously describe what had happened, might naturally describe it thus: "Initially, I thought I was hearing an uninverted theme embodying an inverted, 'falling' subject, but then I realized that what I was actually hearing was an inverted theme embodying an uninverted, rising subject."

A comparison with the Harold painting case will show that their respective structures are identical. Harold confused a UP-IS picture with an IP-US picture, while Anne confused a "UT-IS" theme (uninverted theme, inverted subject) with a "IT-US" theme (inverted theme, uninverted subject).

However, due allowance must also be made for the fact that in music (unlike painting), a theme and its inversion (or inversions: see section 10.2) will be embodied in *numerically distinct* CDTs, in that the CDT for a theme—consisting most probably of a physical sound sequence token, whose design is specified by a particular printed sequence of notes in a score—will be a *different sound sequence token* from the corresponding CDT for any *inversion* of that theme, which would be another sound sequence token, whose design is instead specified by a differently printed passage in the score.[16]

16. However, the two (generic) inverses of the original UT-US theme, namely IT-US and UT-IS, will nevertheless have a single common sound sequence token as their CDT, which sound sequence token was interpreted by Anne first as an IT-US theme and then as a UT-IS theme.

Thus, for example, the appropriately modified theory 1 issue as applied to music is that of whether *at most one theme* corresponds to those distinct CDTs embodying the theme and any inversions of it.

10.5. THEORY 1 (THE OX THEORY)

Now I shall start to draw on both examples in discussing theory 1 (the OX theory). In the case of pictures, it seems to have been generally taken for granted that theory 1 is true—even by those, such as Danto, who deny that pictures are identical with physical objects.

First, recall a point made in section 10.1 concerning Harold's UP-IS and IP-US pictures, that a picture A of an upright building cannot be identical with a picture B of an inverted building, because each has at least one description true of it that is false of the other—namely, that A but not B is a picture of an upright building, and that B but not A is a picture of an inverted building. Thus if both of the UP-IS and IP-US pictures are genuine, then they must be *distinct* pictures because of their differing subject matter. And a similar point would apply to the musical example: if both of the UT-IS and IT-US themes are genuine, then they must be distinct musical themes.

However, both the picture UP-IS and the music UT-IS case turned out to be mistaken interpretations of another picture (IP-US) or theme (IT-US). Is this sufficient to impugn their status as legitimate pictures or themes in their own right?

I suggest not, because, in the case of Harold's initial mistake, it seems reasonable to say that in *some* sense Harold was "seeing a picture"—when he interpreted the painting as a UP-IS picture—even though his interpretation was *wrong* with respect to the actual artist-created picture or artwork, which was in fact associated with the *IP-US* picture. Or, to put the matter in another way, *something* was presented to Harold in a pictorial way, even though that "something" came with no official artistic license, and failed to be identical with the single pictorial item—Harold's original intended UP-US picture—associated with its CDT, which *did* have an official artistic license. And similarly, Anne heard *something* that sounded like a musical theme when she heard the putative UT-IS theme.

Another way of shoring up the integrity of the "mistaken" pictorial and musical cases is as follows. As the original artists of the original works, either Harold or Anne could have decided to *adopt* the objects of their mistaken interpretations as new, legitimate artworks. Thus, Harold could have decided that he *preferred* to interpret his previous UP-US work as a new work—as an upright painting of an inverted building (UP-IS)—and so it would turn out

that the object of his previous mistaken interpretation (the UP-IS picture) was now a legitimate, artist-intended picture after all.[17]

But surely this could only happen if the UP-IS picture *was* indeed a picture prior to its promotion to legitimacy. Harold could hardly decide that he liked the UP-IS picture more than his original UP-US picture unless the UP-IS picture was, indeed, *a picture*. And similarly in Anne's case: her preferring the accidental UT-IS theme to her original UT-US theme could not happen unless the UT-IS theme was indeed heard by her as *a theme* in its own right prior to her deciding that she preferred it to her original theme. Thus I conclude that these examples do indeed demonstrate the distinctness of the UP-IS and IP-US pictures, and of the UT-IS and IT-US musical themes.

Thus it is already possible to conclude that theory 1 (the OX theory) must be *wrong* in its assumption that at most one picture (or theme) is involved in any given inversion case of the relevant pictorial and musical kinds. Other reasons for the wrongness of the OX theory will emerge as the chapter proceeds.

This result is particularly striking for pictures, since it emphasizes their nonphysical nature in a novel and perhaps unexpected way, while at the same time the corresponding musical result seems also not to have been argued for previously. Thus attention now shifts to the remaining theories 2, 3, and 4.

However, before ending this section I should mention what might be thought to be an additional form of the OX theory: that there is only one picture in such cases, that it is identical with the single common CDT for each such (supposed) picture, and which CDT represents (as its subject matter) an upright building in the upright orientation of the CDT, and an inverted building in the inverted orientation of the CDT (so that in some generic sense the CDT itself is a picture both of an upright and of an inverted building).

One problem with this approach is that it would enforce a disanalogy between the pictorial and musical cases, which would require some defense. Also, an initial impression is that it cannot handle the issue of the distinctness of the UP-IS and IP-US pictures, which have differing, apparently incompatible subjects even though they are visible only in the *same* inverted state of the CDT in question. Furthermore, this approach seems unable to explain the sense in which the UP-IS picture is both an *upright picture* (since the supposed CDT-identical "picture" is *inverted* rather than upright when the UP-IS picture is visible), and yet also has an *inverted* subject matter.

But the most fundamental diagnosis of the wrongness of this alternate theory is that it is arguably not about *pictorial* representation at all, but instead it is about an (integrative) *delineative* kind of representation (see chapter 9). Or, in terms of the double content (DC) theory, it attempts to

17. In chapter 8 I gave a related series of examples of distinct pictures based on such changed artistic intentions.

explain pictorial *double* content cases merely in terms of the *single* level of content provided by delineative representation.[18]

10.6. THEORY 2 (THE MX THEORY)

The next question to be addressed concerning our Harold and Anne examples is as follows. Given the distinctness of the UP-IS and IP-US pictures, and of the UT-IS and IT-US musical themes, what are the implications, if any, for the issue of whether or not the original UP-US picture and UT-US theme are themselves *cross-invertible*—that is, invertible with their identity preserved intact?

This issue is now important, because a choice from the remaining theories 2, 3, and 4 depends on this issue. Theory 2 (the MX theory) claims that there is *more than one* picture or theme, *at least one of which* is X-invertible, whereas theories 3 and 4 (the MFE and MFA theories) *deny* that any items are X-invertible.

In the case of pictures, I assume that the most initially intuitive assumption would be that the original UP-US picture *is* X-invertible (identical with the IP-US picture). In this way the correctness of Harold's second interpretation of his painting—as an IP-US picture—would be explained as a case of his having correctly seen his original UP-US picture itself—even though, in thus seeing it, he was seeing it in an inverted position, and hence seeing it as an IP-US picture. Thus this interpretation would support theory 2 over theories 3 and 4.

Things are not so intuitively clear, however, in the musical case. Recall the description of Anne's listening:

> It took a moment before she realized that what she was hearing was not actually a theme with a falling subject, but that instead she was hearing an inversion of her original theme (with its rising subject), which inversion she must have entered into the computer by accidentally pressing the "invert" key the night before, subsequent to her entering of her original theme.

It is not obvious at all that Anne's hearing "an inversion of her original theme (with its rising subject)" could count as a case of Anne hearing *the original theme itself*, which is what is required if the original UT-US theme is to be X-invertible, and hence identical with the IT-US theme that she indisputably does hear.

18. See chapter 9 on delineation, and chapter 12 for more on these general connections.

Now someone might object that, because of the intentionality or interpretive nature of perception, the IT-US theme might *be* identical with the original UT-US theme, but that Anne might nevertheless fail to *perceive* the IT-US theme *as* being identical with that original theme. I have two replies. First, it should at least be *possible* for Anne to perceive the two as being identical, if they are indeed identical, even if theme perception is intentional; but that possibility is part of what I am attempting to cast doubt upon.

Second, on my view both theme and picture perception are themselves the *result* of interpretive activities involving intentionality, in which one (or more) CDTs are interpreted in various ways *as* various pictures or themes. It would be a confusion (and the start of an infinite regress) to think that the resulting pictures or themes are themselves open to a further layer of varying perceptual interpretations. Hence on my view, if the IT-US theme actually were identical with the original UT-US theme, then one's hearing of the IT-US theme would *be* a hearing of it *as* (one contingent state of) the original UT-US theme. Thus, to the extent that one's actual perceptual experience is different, or unclear on this issue, then to that same extent it is doubtful whether the UT-US and IT-US forms are actually identical.

Almost certainly, if Anne were asked herself, she would insist that there is all the difference in the world between hearing a theme (and its subject) on the one hand, and hearing an *inversion* of that theme (and its subject) on the other hand. What is more, Anne would likely insist that the difference between those two hearings—of the UT-US and IT-US themes—was much greater than the difference between hearings of the (provably non-identical) UT-IS and IT-US themes, where the difference is based solely on a difference in *interpretation* of (a token of) the *same* sound sequence, whereas in the UT-US and IT-US comparison, the sound sequences are entirely different. Hence I conclude that, initially at least, such musical cases seem to count strongly against the theory 2 assumption of the existence of X-inversion for themes.

Perhaps a music professor (in a music theory class) might be tempted to say, of such a case, that in some "deep" sense the themes or passages are "the same music," but surely this can be understood as a claim concerning the essential equivalence or invariance of the underlying structural or formal qualities of each piece, given a (relatively trivial) musical, or mathematical, transformation from one to the other, rather than a claim that in some full (aurally sensuous or aesthetic) sense, the pieces are identical as *heard music*—even though one can be heard as a transformed version of the other.[19]

It is also relevant that any inversion requires some degree of structural invariance between an item and its inversion (see section 10.2), so such evi-

19. Stephen Davies discusses versions of themes in his *Musical Works and Performances*, pp. 54–58.

dence by itself, without further clarification, offers no support for the musical identity claim in question. And in any case, the principle of subject matter invariance—that an item and an inverse of it are (in this case) generically about the same subject matter (see section 10.2)—is only a *necessary* condition of musical identity, not a sufficient one.

Now switching back to *visual* cases, there, too, evidence can be found which seems to count against theory 2's X-inversion assumption. Consider a head-and-shoulders portrait or photograph of a loved one. That same portrait when viewed in an inverted position as an IT-US picture will have virtually none of the personal, affective, and aesthetic qualities possessed by the portrait when viewed right side up. Indeed, the qualitative differences between the two could be just as undeniably significant as those qualities which a composer such as Anne is likely to find significantly different in hearing a music theme and its inversion (as just discussed).

In sum, then, there are examples, drawn both from art and music, which strongly suggest that theory 2's *X-inversion assumption* must be wrong, so that the remaining theories 3 and 4, which deny the existence of X-inversion cases, have gained some significant initial credibility as live theoretical options.

10.7. TAKING STOCK: ISSUES OF INTERPRETATION

There are potentially far-reaching implications of our rejection of theories 1 and 2. In this section I shall briefly discuss the implications for issues of *interpretation*, reserving broader implications as to allowable theories of art until after discussion of theories 3 and 4.

To begin, the Danto-Margolis debate on the nature of "basic" perception of objects versus "interpretive" perception of their associated artworks has already been noted.[20] But from the perspective of the current results, that debate has operated with an overly limited concept of artistic interpretation, that has taken no account of the *differing* ways in which a given physical object or event might be artistically interpreted as involving *distinct* artworks—including both veridical and nonveridical cases, such as Harold's initially incorrect interpretation of his inverted picture.

My basic arguments have been of two kinds. First, if an artwork is distinct from its physical substratum or CDT, and if that artwork is a broadly *representational* one that has a *subject matter,* that can in turn be *distinguished from* that artwork, then inevitably a *duality* of possible interpretation of that

20. See fn. 13.

physical CDT results—for example, a CDT can be interpreted *either* as a UP-IS *or* as a IP-US picture (or a UT-IS or IT-US theme).

These novel interpretive possibilities are easy not to notice, because usually only one of those pictures or themes was initially intended or officially approved by the artist; however, as I have shown, the artist could decide to *adopt* the other picture or theme as her own, hence showing their legitimate status at least as "found" or proto-artworks.[21]

My second argument has been that actual inversion of a CDT, whether in pictorial or musical cases, produces results that are, aesthetically or interpretively, typically so strikingly different from the corresponding uninverted forms that, again, it seems hard to deny that distinct artworks must be involved. Thus in this way too, a novel group of interpretive cases has been found.[22]

Also, there seems to have been no previous commentary on the close, specific parallels between related *pictorial* and *musical* cases of interpretive perception, as established in the present work, in spite of their logical differences as autographic versus allographic art forms (see the Introduction). The Danto-Margolis debate has primarily been focused on visual, *autographic* artworks, and so in that way too it is much too limited in its assumptions about the range of interpretive possibilities for artworks, whether they are autographic or allographic.

Potentially, then, the present discoveries might be as significant for aesthetic theory as have been some *already* recognized interpretively ambiguous cases, such as a *duck-rabbit* picture (that can be seen either as a duck, or as a rabbit), which Ernst Gombrich used as one of the cornerstones of his theory of pictorial perception and ambiguity,[23] and which others such as Richard Wollheim have criticized.[24]

Such interpretive ambiguity cases have typically proved to be catalysts for provoking interesting aesthetic theorizing of a wide variety of kinds, and it seems reasonable to suppose that the present cases might also be fruitful in similar ways.

21. In a similar manner to that in which an artist might use a "found" piece of driftwood as a sculpture.

22. The kinds of interpretation involved were specified in chapter 8 in connection with the printmaking examples.

23. Gombrich, *Art and Illusion; a Study in the Psychology of Pictorial Representation*, 2nd ed. (London: Phaidon Press, 1962).

24. Richard Wollheim, *Painting as an Art* (Princeton, NJ: Princeton University Press, 1987). See also chapter 6 for one aspect of the Gombrich-Wollheim debate.

10.8. THEORIES 3 AND 4
(THE MFE AND MFA THEORIES)

At this stage we have reached a theoretical crossroad. In the previous section serious doubt was cast on theory 2's assumption that there are X-inversions, so that the common hypothesis of theories 3 and 4 (the MF hypothesis) is preferable to that of theory 2 (the MX theory). However, this decision leaves many issues unresolved, and, most pressingly, the issue of the status of inverted items such as the IT-US theme or the IP-US picture previously discussed.

To see why this is a pressing issue, recall that Harold's UP-IS picture and Anne's UT-IS theme, though they were initially viewed as incorrect perceptions of something else, were nevertheless capable of subsequent adoption by their respective artists as new, legitimate art or musical items in their own right. Thus their prior status as a legitimate picture or theme, independent of their respective UP-US picture and UT-US theme, is relatively secure.

However, once the X-inversion assumption is questioned, the status of the other inverse forms—the IP-US picture and IT-US theme—becomes not so secure. As long as they could count as being identical with their respective UP-US and UT-US forms, their status was as secure as those original UP-US and UT-US works themselves—but now that support, we are assuming, is gone.

The "theoretical crossroad" mentioned occurs because there are two fundamentally different potential ways of handling inverted pictures and themes, each of which would have deep and pervasive effects upon the present theory of inversion in art and music. For reasons of brevity, I shall primarily concentrate on discussing pictures for the remainder of this section, but similar points would apply to musical themes as well.

The first of these approaches to inverted pictures could be called the *eliminative* approach. It would deny that, strictly speaking, there are *any* nonupright pictures, and would seek to explain away apparent references to such pictures. This approach defines theory 3 (the MFE theory: many Fixed pictures, Eliminating any inverted or nonupright ones).

The second approach (the *inclusive* or *all-accepting* approach) would instead accept such references at face value. Thus, on this inclusive approach, there are inverted pictures, but none of them are identical with any upright pictures. This approach defines theory 4 (the MFA theory: many Fixed pictures, inclusive or All-accepting of nonupright ones).

As before, it will be useful to begin discussion of these alternative MFE and MFA approaches through consideration of Harold's two pictures, namely the UP-IS (upright picture, inverted subject) and IP-US (inverted picture, upright subject) pictures. According to the eliminative approach,

only the UP-IS picture is genuine, and hence the other apparent IP-US picture must be explained away, since it involves an apparent reference to a nonupright picture. On the other hand, on the inclusive or noneliminative approach, both pictures may be accepted as genuine—and, of course, neither is identical with the more usually seen UP-US (upright picture, upright subject) picture.

An immediate problem for the eliminative approach is how to preserve the initial intuition that the UP-IS and IP-US pictures are indeed *distinct pictures*—or at least, under an alternative description, to find a sense in which Harold's seeing of the IP-US picture is *veridical*, whereas his seeing of the other UP-IS picture is not.

I think that a plausible initial strategy for an eliminative approach is to try to analyze any references to apparent nonupright pictures as involving concealed references to (or some other use of) their corresponding upright pictures. Thus in the initial description above, its working strategy could be to argue that the sense in which the UP-IS and IP-US are distinct pictures is really just the sense in which the UP-IS and UP-US pictures are (indeed) distinct pictures.

Thus, for example, an eliminativist might argue that Harold's apparent seeing of an IP-US picture is not really a seeing of *any picture at all*, but instead it is an amalgam of (roughly) the following elements. First, Harold does see the inverted CDT that corresponds to the original UP-US picture. Second, on the basis of visual information he gathers while *identifying* that CDT as being inverted, he is able to deduce *which* original (upright) picture it *would* show if it *were* instead in an uninverted orientation. And third, having thus identified the appropriate upright picture, he is able to recall (roughly) what that original UP-US picture *looked like* (or would look like) when it was (or if it were) displayed by the uninverted CDT.

Or in brief, on the eliminativist view, to see an (apparently) inverted picture is to see an inverted CDT, and to think of, or imagine oneself perceiving, the corresponding uninverted picture. Or, to put the matter yet another way, on the eliminativist view "seeing a nonupright picture" is a matter of decoding a kind of *visual puzzle*, which does not make sense by itself as a picture, but which may—through appropriate inferences or conceptual rotations—be transformed into a more familiar and legitimate upright picture. Or, on this view the viewer *perceptually compensates* for the unusual orientation of the picture.

It remains to find a sense in which, on an eliminative theory, Harold's seeing of the IP-US picture is veridical. Here the eliminativist can apply the same transformation as previously, and argue that apparent talk about the IP-US picture is really about the *UP-US* picture instead, so that on this account Harold is indeed led, through perceptual means, to identify the correct pic-

ture—which was of course the UP-US picture that was intended by the artist to be associated with the painting which is its CDT.

Thus, to initially summarize the virtues of the eliminative approach, it is able at least to handle two initial, fairly demanding tests, and, as with any eliminative theory, it is more parsimonious than its noneliminative competitor.

However, there is a serious question about whether the eliminative approach can adequately handle the central claim of both theories 3 and 4, as MF theories, that a picture in an upright or uninverted posture (the UP-US picture) is *not the same picture* as the "inverted picture" (the IP-US picture) which becomes visible when the CDT of the original picture is inverted. The problem is that what seems to be the only available, viable strategy for an eliminative approach—that of analyzing any references to inverted pictures in terms of the corresponding upright pictures—seems to be in direct conflict with theory 3's "distinct pictures" thesis, since the eliminative strategy basically *is* trying to identify those pictures which theory 3 itself claims to be distinct.

Perhaps there is a sense in which the eliminative approach scrapes through on a technicality, in that, since on the eliminative account there is *no* inverted IP-US picture at all, then the issue of the identity or otherwise of *two* supposed pictures cannot arise on this account. Also congenial to the eliminative approach is a possible reinterpretation of theory 3's noninvertive or "fixed" thesis as claiming merely that no picture occurs in more than one orientation, hence avoiding the troublesome issue of comparison of pictures altogether—but this formulation is too generic, in that theory 4 would make the same claim.

However, as long as it seems reasonable to retain the formulation of theory 3 in terms of *distinct pictures*—for instance on grounds such as that claims to perceive the upright (UP-US) and inverted (IP-US) pictures are justified to exactly the same extent as each other, so that each kind has an equally legitimate claim to being a genuine picture, and to be capable of comparison with other pictures—then to that extent the eliminative approach will remain a significantly flawed competitor.

Turning now to the all-inclusive or noneliminative approach to Harold's pictures—defining theory 4, the MFA theory—according to that approach, as already noted, both the UP-IS and IP-US pictures may be accepted as genuine, and neither is identical with the more commonly seen UP-US picture. Thus, unlike the eliminative approach, there is no need for elaborate paraphrases to explain the supposed seeing of certain pictures as opposed to others, and all picture perception can be given a uniform account.

However, the main comparative strength of the inclusive approach is that it can account for visual aesthetic phenomena that necessarily must be dismissed, or reinterpreted in an arguably unsatisfactory way by an eliminative approach.

For example, the eliminative approach is forced to regard any (IP-US

type) inverse pictorial information as merely being a set of clues to—or as a mere means to the end of—deciding which *non*inverse picture is the relevant one, rather than being able to treat that aesthetic information, as can the noneliminative approach, as an aesthetically interesting pictorial end in itself. For the IP-US picture which Harold saw, after realizing his mistake in initially seeing a UP-IS picture, itself has its own integral visual appearance and aesthetic effects *as* an IP-US picture, which are different both from those of the UP-IS picture *and* of the UP-US picture, of which it is a nonidentical inverted version.

Thus, for example, an artist could deliberately choose to exhibit one of her paintings *as* an IP-US picture, by including suitable indications to the viewer that this was her intended interpretation—such as by including visibly unused inverted picture-hanging hardware items (or an inverted title) at the bottom of the exhibited painting, signaling that her picture was meant to be seen as an inversion of a (now rejected) prior picture. And the other inverted picture (the IP-IS picture) could be exhibited using similar visual cues.

To strengthen the force of these points, consider again the corresponding musical example. It is hard to deny that an inverted IT-US theme has some auditory aesthetic qualities that are quite different from those of the original uninverted UT-US theme, while yet it is still true that one, in hearing it, can hear it *as* an inversion of the original theme, rather than its simply being the case that one hears (what happens to be) an inverted theme as a theme in its own right—that is, a hearing of the UT-IS theme—which would *not* involve hearing the sounds *as* an inverted version of the original theme.

Hence it seems that, on this very preliminary survey of the evidence for each theory, the MFA theory 4 emerges as the most plausible initial candidate for an adequate account of inversion in art and music.[25]

10.9. CONCLUSION

To conclude this chapter, I shall, as promised, discuss the implications of our results for allowable or defensible theories of art. Currently, the most common theory of the nature of allographic art forms such as music or literature, as noted in previous chapters, involves a claim that such artworks are *types*, which have physical texts, scores, or performances as their *tokens*.

But the cases given in the present paper show that there can be *more than one* picture or musical theme associated with a given physical item, from which it follows that such pictures or themes *cannot* be types.[26]

25. Section 12.5 gives further arguments in favor of theory 4.
26. See the various previous arguments to that effect, e.g., in chapters 7 and 8.

In the case of themes, it is arguable that any complete musical work is made up of a *sequence* of such themes, so that if individual themes cannot be types, then neither can the *sequence* of themes that makes up the musical work.[27]

Furthermore, this result arguably applies even to sophisticated type theories such as that of Levinson, who views a musical type as mediated by the intentions of its composer.[28]

For a composer could, I would argue, *intend* that a given thematic passage in her composition should be musically *ambiguous*, or *equally well* be interpretable as either a UT-IS theme or an IT-US theme. On Levinson's type theory, such a compositional intention would be impossible to carry out—which is surely an intuitively unacceptable result.

Thus, in sum, the evidence presented here shows, as before, the need to find a different, *nontype* theory of the nature of artworks, such as the double content (DC) theory. On the other hand, as noted before, the DC view does seem at least potentially to provide a workable explanation of the inversion cases discussed here, for there is no theoretical bar to a physical object having *multiple* sets of representational properties, so that the various kinds of *interpretation* of an object, or sound-sequence, as one artwork or another, would involve the activation of one or another such set of representational properties of the object. Thus this chapter has served to reinforce and sharpen the findings of the previous chapters in this third part of the book.

27. Which is not to deny that there may be additional necessary conditions for the identity of a work, such as its having been created by a particular artist with specific intentions, as in the "Menard" example of section 3.6.

28. Levinson, *Music, Art, and Metaphysics*.

Part 4

Representation

External and Internal
Representation

This chapter will investigate the logical structure of the concept of representation itself. Throughout the book the concept of representation has been used in discussions of representation of artworks or of subject matters, both of which are kinds of representational *content*. Also, the novel *delineative* kinds of content postulated in chapter 9 were also kinds of *content*, so that overall the focus has been almost entirely on representation of content.

However, the concept of representation is clearly also usable in cases where *what* is represented is not some kind of content, but instead is some *actual* physical entity, state, or process—for example, a picture of Napoleon represents the (formerly) *actual person* Napoleon.

But exactly how are these two kinds of representation—of content versus of some actual entity—related to each other? Perhaps surprisingly, there is currently no generally agreed-on theory of representation that gives proper recognition to both kinds. Indeed, the prevailing orthodoxy, insofar as there is one, is that only representation of *actual* entities—to be called *external* representation here—is genuinely relational, that is, in relating a physical, representing artifact to some genuine distinct item that it represents. Or, otherwise put, it is assumed that representation involves genuine *reference* to some object represented only when the object in question is actual or concrete, and hence *not* an item of content such as an artwork—for as argued in chapter 2, at least some artworks such as plays are purely fictional entities that have no actual existence.

Thus my task in this chapter is to show at a more theoretical level how cases of representation of *content*—here called *internal* representation—can also be genuinely relational or referential, and hence that it is a mistake to

try to deny or explain away such natural or apparent cases of referential representation of content.[1]

As a nonrigorous but at least suggestive argument for that thesis, the material in the book so far has surely showed that a view of artworks as themselves being the *content* of representations is an eminently plausible, or at least a theoretically *possible* or *defensible*, view of their nature. But no one can doubt that we are able to refer to individual artworks. It follows that it is at least theoretically *possible*, or not ruled out on reasonable theoretical grounds, that some putative content items such as artworks *could* be referred to. But if *some* content could be referred to, then it becomes an urgent task to develop a basic theory of representation that allows for that theoretical possibility. This chapter will provide that basic theory and undermine some standard objections to viewing content referentially.

Since this chapter provides a basic investigation of the *concept* of representation, it does not specifically address issues concerning the differences between various *kinds* of representation, such as delineative versus intrinsic representation as discussed in chapter 9. Also, the discussion does not address the double content (DC) claim that pictorial representation involves *two* distinct stages or kinds of representation (identified specifically as aspect representation plus intrinsic representation in section 12.5), nor the inseparability claim in chapter 6 that one cannot "simply" see the subject matter of a picture independently of also seeing the relevant medium content associated with the picture. Thus strictly the discussion is most directly applicable to single-stage, delineative kinds of representation such as aspect representation, though for the purposes of this chapter those additional issues and distinctions may be set aside.

11.1. INTERNAL VERSUS EXTERNAL REPRESENTATION

I shall argue that there are two kinds of representation, whose differential features are closely linked to the logical intensional/extensional distinction, and whose joint recognition promises, among other things, to provide a relatively clear and unified account of fictional reference.

To begin, I shall show that the concept of representation has two distinct aspects by demonstrating an apparent ambiguity in the concept. One standard test for ambiguity of a concept C is to find a case in which C both is, and is not, applicable to some object or objects; then one may proceed to repair the

1. See also related points in section 2.3 on the integrity of the surface structure of ordinary discourse about fictions.

damage by distinguishing different senses, aspects, or varieties of the concept "C." Here is a pictorial test case of this kind for the concept of representation.

First, it is surely true that a picture P might *represent* a man, even if there is no *actual* man about whom it is true that *he* is the man thus represented by picture P. For the person who painted A might have intended merely to represent "*a* man," without having any particular actual man in mind.

However, if there is no *actual* man represented by picture P, then there is a clear sense in which P does *not* represent "a man"—at least, not in the sense in which it *would* represent "a man" if there were some *actual* man whom it represented.

At the same time, though, to repeat, clearly picture P might still represent "a man" in the first sense above, in that, if the artist's painting is successful, then it *will* "represent a man," in spite of the fact that it does not represent "a man" in the sense of: an *actual* man.

Now to be sure, the ambiguity here might be argued to be located primarily in the whole phrase "representation of a man," or in different senses of "a man" in each case, rather than in the concept of representation itself. Nevertheless, the case at least shows the need to distinguish two fundamentally different *aspects* or *categories* of representation—each generically describable as: representation by a picture P *of some thing X*—that we confuse at our peril. Thus the label "ambiguous" will remain descriptively convenient for such phrases as "P is a representation of a man," and thus derivatively as applied to the concept of representation itself, even if it is only (very) different kinds of use, or different aspects, of that concept that are actually involved.

As for the evidence I have used to establish the ambiguity in question, it itself is arguably not controversial at all, since it is recognized already. For example, Richard Wollheim distinguishes representations of *particular* objects, or events, from representations of objects or events ". . . that are *merely* of a particular kind," and thus of *a* man, and so forth, rather than of some particular man;[2] while Kendall Walton uses the fact that a picture can represent a man, even though there is no actual man thus represented, as part of his case that the concept of representation is primarily to be understood not in object-centered ways, but rather in terms of his own "props used in imaginative games" approach.[3] And Nelson Goodman, in the face of such examples, distinguishes a *picture* of a man from a *man-picture*, in cases where no actual man is represented.[4]

2. Richard Wollheim, *Painting as an Art* (Princeton, NJ: Princeton University Press, 1987), pp. 67–71.

3. Kendall L. Walton, *Mimesis as Make-Believe: On the Foundations of the Representational Arts* (Cambridge, MA: Harvard University Press, 1990), chap. 3, "Objects of Representation."

4. Nelson Goodman, *Languages of Art; An Approach to a Theory of Symbols* (Indianapolis: Bobbs-Merrill, 1968), chap. 1.

However, by focusing on the fact that examples such as the above show that there is an apparent, or at least formal, *ambiguity* in the concept of representation, I hope to facilitate the raising of issues and approaches that have not yet been adequately investigated.

First, I shall distinguish the relevant distinct concepts or aspects of representation as *external* versus *internal* (or outer versus inner) representation. *External* or outer representation by a picture P is about cases where there is some actual object X, normally *external* to the representing object P,[5] which is represented by P. Thus, for example, picture P externally represents *a man* just in case there is some actual man, distinct from P, who is represented or portrayed by P.[6]

However, the formulation of a corresponding characterization of *internal* representation is inevitably more controversial. Here is an initial attempt: internal representation is about whether there is *an object* X', that is *internal* to the object P, and which is represented by P.

That this characterization is inevitably controversial can be seen by giving a substitution-instance of it: picture P internally represents a man just in case there is a man, who is internal to P, and who is represented by P.

This instance is likely to raise logical and metaphysical hackles on at least two grounds: first, that it clearly involves *reference* to, and *reidentification* of, "the man" in question (since it seems to be said both that there is such a man, and who—that is, that same man—is both internal to P, and represented by P), and second, metaphysical worries about how "a man" could possibly be "internal" to a picture P. (See section 11.6 for a discussion of these issues.)

Indeed, it seems likely that these, or related, logical and metaphysical obstacles have proved formidable enough to dissuade previous attempts at distinguishing an internal aspect, or kind, of representation from its more conventionally accepted external aspect or kind.

Nevertheless, as already noted, at least the *unanalyzed* ambiguity, and the evidence on which it rests, is not controversial: that a picture can represent a man, without there actually being such a man, cannot be denied. Thus the initial issue is, of course, as to how linguistic contexts such as "picture P represents a man" should be *analyzed*, in cases when there is not any actual corresponding man represented by P.

I take it that it would usually be assumed that this initial case just shows that there is a *unitary* concept of representation, which, among other things,

5. Though there may be special cases of an object externally representing *itself*, or parts of itself, that straddle the distinction being made here, such as the section 5.6 example of an artwork made of materials that easily deteriorate, which might be intended to represent its own impermanence. I shall ignore such cases in what follows.

6. Thus I shall not consider more generic kinds of representation in which, for instance, a picture of a man in an encyclopedia might be considered as making plural reference to men, or to *any* actual man, rather than to a particular actual man.

is such that "P represents X" does not entail "there is an actual X represented by P." However, that nonentailment can equally well be explained by postulating two *distinct* concepts of representation, on one of which, namely internal representation, the entailment does not hold, while on the other (external representation) the entailment does hold. For it is clear that standard examples of the nonentailment in question would, on my account, be cases of internal rather than external representation, and hence could be adequately explained by that concept of internal representation.

Moreover, the issue of ambiguity is not so easy to evade, because, for instance, one could *see* or *recognize* that a picture P represented "a man," whether or not there was, independently of one's act of perception, some actual man who was represented by picture P. Thus it is hard to deny that one could, on the one hand, have conclusive perceptual evidence that a picture P represents *someone*—which "someone" one would describe or recognize as "a man"—quite independently of whether one *also* has any evidence that something else, an actual man, is represented by picture P. Thus from an epistemic perspective the relevance or applicability of two *distinct* concepts of representation—or of two distinct kinds of "object" of the concept—seems to be an inescapable part of the joint evidentiary situation in such a case.

Hence I would claim that, in spite of any initial difficulties or obstacles in characterizing internal representation, some analysis should be attempted of that concept, that adequately captures or allows for such epistemic differences, as well as being acceptable on logical and metaphysical grounds.

11.2. POSSIBLE OBJECTIONS

Before giving my account of internal representation, there is a major issue that needs to be discussed, namely the function or purpose of a concept of internal representation in cases where there *is* an external representation by picture P of object X. I shall argue in section 11.5 that in such cases internal representation still has an important *epistemic* role to play, in that it is at least partly in virtue of seeing what a picture P internally represents—its object X'—that one can *justify* a claim that P externally represents object X.

But there is a potential basic objection to such an approach, namely that when external representation obtains, there would be no such theoretical need, or room, for a concept of internal representation in addition to that of external representation, so that its general postulation for all cases of representation is ad hoc.[7]

7. However, arguably the standard view of representation, based as it is on external representation, is itself ad hoc in a different way, in that it cannot be generalized to cover cases when there is no externally represented object.

This objection could take two forms. First, that in cases of external representation of an object X by picture P, the object X' that one sees when looking at P is *X itself*, so that there is no distinct object X' available, which could serve as the object of an independent kind of "internal" representation. I shall call this the "seeing through" objection, in that on this account one "sees through" an external representation P of object X to its actual object X.

Second, it might be argued that whether or not the "seeing through" view is correct in some or all cases, epistemic claims that picture P externally represents object X can be justified on other, nonreferential grounds, such as by claiming that P has a group of properties which are its *representational content*—those properties it represents X as having—which explain P's ability to externally represent X without introducing any independent *object* X' that is internally represented.[8] I take it that this second, more general objection— the "nonreferential" objection—embodies a view that is the common core of most extant views of representation, whatever else they disagree on.

Since my purpose in this chapter is not primarily polemical, I shall address such nonreferential views only indirectly, via the above-mentioned epistemic justification argument, which at least will show that nonreferential views could not provide a complete account of representation. But I shall attempt to refute the first, "seeing through" view of external representation, both below and in succeeding sections, since versions of it—holding that any genuine representational reference could only be to an external object of reference—constitute a more immediate threat to my approach.

11.3. THE IMPOSSIBILITY OF SEEING THROUGH

I shall show that perceptual access to a picture P of actual object X does not give the perceiver perceptual access to *X itself*—so that, even if there is *something* X-related that one sees when looking at picture P, that something cannot be X itself. Call this the *no seeing through*, or NST thesis.

To begin, the obvious point should be made that a picture P of some actual object X is not itself *identical with* that object X.[9]

Thus there is a straightforward, veridical perceptual sense in which, if one sees picture P of an actual person X, one does not *thereby*—that is, simply in virtue of seeing picture P itself—also see person X, because of course P is

8. This is not to attack the concept of representational content itself, but only an appeal to it as supposedly preempting the postulation of such an object X'.

9. And in general, a picture of *an* X is not itself an X: representations are not instances of the things they represent.

not X, and therefore it could not correctly be seen to be X. And this point remains valid whether or not object P is a picture or representation of X.

Second, I want to extend this point to cover not just direct seeing of P itself, but any kind of *perceptual access to*, or perceptual *involvement with* P in which a viewer's gaze is directed upon picture P, including cases in which the viewer's interpretation of what she sees is primarily *X-related* rather than *P-related*, so that on some analyses she would, strictly speaking, no longer be seeing P itself. Thus if the general formula "Viewer A sees picture P of object X" is considered, I wish to also consider cases in which substitution-instances of that formula do not entail "Viewer A sees picture P."

For example, a trompe l'oeil picture P of object X is such that, when a viewer's gaze is directed upon that picture P under normal conditions, the viewer is perceptually aware *only* of something X-related, rather than of picture P itself, so that in some sense she does *not* perceive picture P itself, as such.

Nevertheless, I want to claim for these extended cases too that, since picture P is not itself identical with object X, then viewer A, *merely* by virtue of having perceptual access to P, does not *thereby* gain perceptual access to X itself. Thus I would claim that the conjunction of

(1) Viewer A sees picture P of object X,

and

(2) Viewer A does not see object X independently of her perceptual access to P

entails

(3) Viewer A does not see object X.

Statement (2) is needed so as to rule out a case in which, for instance, viewer A's perceptual field includes both a picture P of X, and, independently of that picture, *X itself*—because of course our interest is only in what is entailed by perceptual access solely to picture P itself.

More informally or intuitively, my point is this: that there is no magical way in which, merely by looking at a picture P of some actual object X—which picture is not identical with X—one can thereby get to see *X itself*, no matter how one explains or analyzes what is involved in having perceptual access to picture P, and of what is involved in P's having representational qualities such that it represents X. For perceptual claims are veridical, no matter what interpretive juggling or rearranging goes on with respect to

"what one sees" in such a case; so that if P is not X, then one cannot *correctly* be said to see X, solely in virtue of one's looking at P, whether or not P is a representation of X, and whatever is the correct analysis of "P is a representation of X."

Next, I shall discuss an attempt to escape this conclusion via a claim that some pictures are *visual prostheses*, that is, that they are like devices such as eyeglasses or binoculars, *through* which one is indeed able to see actual objects such as X.[10] However, I shall show that, insofar as it is true that one is able to see X itself while looking at or through such a device, it follows that the device in question is not a *representation* of X.[11]

Some who argue for the "visual prosthesis" view, such as Walton and Lopes, do so by invoking the concept of *counterfactual dependence*—that if some visual properties of the actual object X had been different, then the corresponding properties of the prosthesis would have been different.[12]

However, that backward-looking, past tense concept is arguably irrelevant to issues about actually seeing X through a genuine prosthetic device. What is instead needed for genuine seeing of X is a *forward-looking* counterfactual dependence, or FCD concept: that if some visual properties of the object X *were to become* different, then the corresponding properties of the prosthesis *would* become different. For it is characteristic of actually seeing an object X through such a device that changes in the object itself result in changes in the properties one sees it to have *in real time* (in the future or the continuous present).

But if one were to record such changes on videotape, that recording itself would no longer be able to change its properties to reflect any current and continuing changes in X. Thus in viewing or seeing that videotape, one would no longer be seeing *X itself*, but only a *picture* of X, since that picture is *not forward counterfactually dependent* on X. Thus on this analysis, genuine seeing of X through a prosthesis simply is a seeing of X itself rather than of some representation of X; whereas when one does see a *representation* of X, it does not have the FCD relation to X itself, and hence does not count as an actual seeing of X.

10. Kendall Walton holds such a view for photographs in "Transparent Pictures: On the Nature of Photographic Realism," *Critical Inquiry* 11 (1984): 246–77, while Dominic Lopes extends it to pictures generally in his book *Understanding Pictures* (Oxford, UK: Clarendon Press; New York: Oxford University Press, 1996), chap. 9. For a critique of such views independent of mine see Nigel Warburton, "Seeing through 'Seeing through Photographs,'" *Ratio* 1 (June 1988): 64–74.

11. Or more precisely, under these conditions it is not *functioning as* a representation of X: there might, for instance, be cleverly constructed binoculars which both externally represent X when one looks *at* rather than *through* them, but which nevertheless enable one to see X itself when one does look through them.

12. Walton, "Transparent Pictures," and Lopes, *Understanding Pictures*.

Because of the importance of the current issue, I shall also provide another, noncounterfactual analysis of the differences between prosthetic and representational seeing, which in addition involves only changes in relational rather than inherent properties. A useful bridge concept in the discussion is that of (what could be called) environmental stability. A representation R of object X is *environmentally stable* (hereafter: stable) in the sense that R will continue to be a representation of X through *normal changes in its position or environment*, such as its being moved from room to room, or if other objects or persons change their position relative to the current position of representation R. Or, in more usual metaphysical terms, to say that an object R is an external representation of X is to attribute some *non*relational properties to it, *in virtue of which* it is able to externally represent X, and which nonrelational properties are independent of its other relational properties such as its position relative to other objects in its environment.

However, visual prostheses are instead *environmentally unstable*, in that, obviously, what one sees through eyeglasses or binoculars will *change* as the seen objects are moved around, or if other objects are moved around relative to them. Thus the price of being able to *actually see the object X itself* through a visual prosthesis is that one's doing so depends on complex *relational* properties of the prosthesis, such as its having the right kind of visual alignment to one's eyes and to the actual object X. Hence, prostheses have a property, namely *instability*, which stable representations necessarily lack, and so representations cannot be prostheses.

In more intuitive terms, the reason why a prosthesis cannot be a representation of X is because it could not *stably* represent X, as opposed to any other things: it would "represent" whatever objects were appropriately aligned with it, and in thus "representing" anything, it would actually represent nothing.

Thus I conclude, on the basis of both of these analyses, that the "prosthesis" defense of the claim that some pictures both represent some actual X, and are such that in looking at them one can see X itself, must fail, and hence that it is never true that perceptual involvement with a representation of X involves a perceiving of X itself. Thus the *no seeing through*, or NST thesis, is true for external representations.[13]

11.4. A WIDER CONTEXT

The argument of this chapter has been primarily focused on pictorial representation, but before continuing it will be useful to situate the discussion in

13. Other arguments against the "seeing through" view are given in sections 11.6 and 11.7.

a wider context. I would claim that any kind of external representation, including conventional linguistic kinds of signification, also involves an appropriate case of internal representation. Thus broadly speaking, internal representation is concerned with internal referential aspects of meaning, intension, or content,[14] whereas external representation is instead concerned with extension, or external, worldly reference.

In the arts, the internal representation thesis is primarily relevant to topics such as that of pictorial representation, and of fictional reference, and my announced epistemic argument for internal representation is primarily relevant to pictorial representation cases. But nevertheless it is still useful to examine such cases in the broader context both of representational conventions, and of artistic intentions to represent actual subjects, even when such attempts end in failure, that is, with no external pictorial representation or depiction having occurred.[15]

I shall consider three putative kinds of representation, to be labeled *signification*, which is a bare reference to a subject, as in baptizing someone with a name; *description*, which characterizes something in some way, even if incorrectly; and *standard* or unqualified representation, our primary topic of interest. The three examples to be used all concern cases of putative portraiture of a subject B by artist A, so that our primary interest will be in the species of standard representation referred to as pictorial representation, or depiction. (The examples are brief—fully adequate discussion of them would of course require much more space.)

Case 1. Subject B has paid artist A to paint his portrait. At the end of the session she hands him her painting P, which consists of an apparently random collection of blobs of paint. Does painting P externally represent or portray B, and if so, in what sense?

Arguably this is a case of signification only (no description or picturing)—P is *of* B, or *about* B, only in the sense in which a name is of or about its bearer. Interestingly enough, this would count as a case of signification of B, even if artist A had had no concurrent *intentions* to portray B at all while painting the picture, because the social conventions regarding portraiture, as with naming baptisms, are performative in nature: if one performs the requisite actions (painting) in the right social setting of agreed-on portraiture, the resultant artifact (the painting P) thereby conventionally counts as signifying the subject. (The internally represented item in such a case would presumably be a pure, nondescriptive pointer to the relevant individual B.)

14. A thesis that *all* aspects of content or meaning may be explained in terms of internal representation will not be defended here, though this book as a whole strongly supports it.

15. My thanks to the JAAC editor, Susan Feagin, for suggesting the relevance of such cases, and of analogous cases in the philosophy of language such as the one discussed below.

Case 2. Same initial situation, in which A has been hired to paint B's portrait. This time, A's resultant picture P resembles a slim, short woman—quite unlike the tall, heavy male sitter B. Again, does painting P externally represent or portray B, and if so, in what sense or senses?

As before, P does signify B for the previous reasons. In addition, some appropriate concept of *descriptive* representation *might* now become applicable as well. Intuitively speaking, "slim short woman" is a possible description—albeit a significant *mis*description—of a heavy, tall man, whereas "random blobs of paint," as in case 1, is not a possible misdescription of B.

However, in this case, unlike case 1, the intentions of painter A are of crucial importance. Unless she *intended* her picture P to pictorially represent B, there would be no *point* in saying that picture P descriptively represents or misrepresents B; it would not provide any kind of painterly description of B itself—as opposed to some other object, or no object at all—no matter how closely the two descriptively resemble each other. The significant degree of misrepresentation in the present case tends to show that artist A did *not* have the requisite intention—failing special pleading on her part, such as a claim perhaps that the painting metaphorically depicts the inner feminine side of her thickset subject B.

But then exactly what is descriptive representation? I would claim that (a) no genuine external representation of any kind is involved in such cases, and hence that (b) the relevant internally represented object, namely the slim short woman in this case, is just an internal representation of *a* woman, rather than of any particular actual woman or man. Also, the characteristics of the internally represented woman are only descriptively relevant to B at all if picture P's contents include an intention by painter A to depict B.

Thus presumably the main utility of a concept of descriptive representation, in cases where depiction has not occurred, would be to duly acknowledge the existence of "near-miss" cases in which both appropriate intentions to depict an object, plus a reasonably good descriptive match, may be inferred or seen to have been achieved. But even so, such cases strictly speaking are not *failed depictions* of B, since they do not depict (pictorially represent) B in any sense, though they must involve an intention to depict B.

A related case is as follows. In the philosophy of language, "referential" uses of definite descriptions are acknowledged, which achieve reference in spite of incorrect descriptions—such as someone saying "that man over there is smoking" when the smoker is in fact a woman.[16]

However, there are at least two reasons as to why there are no analogous referential descriptive misrepresentations among putative pictures. First, there is no close pictorial analogue of the demonstrative linguistic element

16. See, e.g., Keith Donnellan, "Reference and Definite Descriptions," *Philosophical Review* 75 (1966): 281–304.

"that man," supplemented by contextual factors such as a gesture or head turning, which can establish reference *independently* of the description. And second, descriptive terms in language can function either to identify (as in a definite description) or to predicate a property of a thus-identified item. But in the case of putative pictures, there is not enough structure to distinguish those semantic functions, which lack would also thwart attempts to establish that there are misrepresenting referential pictures of this specific kind.

The closest quasi-pictorial analogy to referential linguistic misdescriptions would be a distorting mirror, which does establish contextual reference to the objects it shows, and does "misdescribe" the characteristics of the relevant objects. However, because of the forward counterfactual dependence of such images on their actual subjects (see section 4), the relevant objects are not *represented* at all in such cases; instead, the viewer simply sees the actual objects through the mirror, as distorted by its optical characteristics.

Case 3. A paints B's portrait, with the intention of depicting him. But this time, both A and B are happy with the result, in that each can *recognize* B in the finished portrait. This finally, I would argue, is a genuine case of pictorial or depictive external representation. It would also qualify as a case both of significative and of descriptive representation of B. However, depiction, unlike descriptive representation, is compatible with fairly radical mismatches in descriptive characteristics between picture and subject—that is, with genuinely *depictive* misrepresentation—as long as recognizability is preserved.[17]

Thus I claim that a necessary condition of P's externally depicting an actual object X is that P be *recognizable* as X,[18] with that locution itself being explained in terms of recognizing or seeing the relevant internally represented item X'. While at the same time, "near-miss" cases where recognition is not achieved can be acknowledged to have some representational status—but nevertheless be explained away as cases of descriptive, nondepictive representation.

However, recognition by itself does not provide a sufficient condition of external depiction, because "false positives" are possible—pictures that would be generally recognized as X, but which were not intended to externally depict X. Thus both recognition and intention to depict are required to achieve a sufficient condition of external depiction.

Now recognition can be achieved simply from perception of a picture

17. Antonia Phillips provides a convincing account of the centrality of recognition in portraiture in her paper "The Limits of Portrayal," in *Philosophy and the Visual Arts*, ed. A. Harrison (Dordrecht, Holland: Reidel, 1987), pp. 317–41.

18. Arguments for this view are given in my paper "Representation and Resemblance," *Philosophical Forum* 12, no. 2 (Winter 1980–81): 139–58, while Lopes (*Understanding Pictures*) and Phillips ("The Limits of Portrayal") provide other arguments for recognitional views of representation. The following section also provides relevant arguments.

itself—but can knowledge of the relevant intention to depict be acquired in the same intrinsic manner, or is external or contextual information also required?

To be sure, contextual information is often available in the forms of titles of paintings, catalog descriptions, and so on, rendering the issue moot in those cases. But in the absence of such aids, here is a brief suggestion as to how knowledge of relevant intrinsic artist intentions might be achieved in a central class of cases. There are stereotypical characteristics associated with well-known people, such as Lincoln's tall, gaunt, and bearded profile. Anyone making publicly available a picture having such characteristics is prima facie implying that his intentions were to depict Lincoln, in the absence of any contextual evidence to the contrary. Thus in such cases, the same factors that enable one to *recognize* that Lincoln is internally represented by the picture also establish artistic *intentions* to depict Lincoln, which factors taken together are a sufficient condition of the picture's externally depicting Lincoln.

In the next section I shall use this analysis of pictorial representation in the presentation of the previously sketched (in section 11.2) epistemic argument for the referential status of the concept of internal representation.

11.5. INTERNAL REPRESENTATION

My strategy with regard to defining and defending internal representation will be threefold: (1) to accept my initial, tentative definition of the concept as a working model, in spite of its apparent difficulties; (2) to use the veridicality of seeing and recognition to justify its referential logic; and (3) to use the briefly sketched epistemic approach to it to justify its conceptual indispensability. Then in succeeding sections I shall disarm any associated ontological anxieties (section 11.6), and situate the inner/outer distinction in a wider symbolic framework, in which internal representation to an entity X is a form of intensional or *de dicto* reference to X, while external representation is a form of extensional or *de re* reference to X (section 11.7).

To begin, my initial attempt at a definition of internal representation was this: internal or inner representation is about whether there is an object X', that is internal to the object P, and which is represented by P. For example, picture P internally represents a man just in case there is a man, who is internal to P, and who is represented by P.

As announced, I shall accept this characterization and justify it as follows. If a person with average perceptual abilities, under normal lighting conditions, sees a picture of a man, he will be able to *see a man* when he looks at it, or equivalently, he will be able to *recognize* what he sees as a man—assuming that the picture is successful in representing a man, that is, that

similar average people under normal conditions can see or recognize a man when they look at it.[19]

Thus one's *primary evidence* as to whether a picture A is *successful* in representing a man (whether or not it externally represents a particular man) is derived from evidence as to general abilities of people to *see* or *recognize* a man when perceiving that picture A. For whatever the intentions of the person making the representation, she will only have *succeeded* in representing X if those general recognitional conditions are satisfied.

However, the concepts of seeing and recognition are *veridical* concepts, such that a claim to see or recognize X is true only if there *is* an X that one sees or recognizes. Thus if it is true that one sees a man X when perceiving picture A, then there must *be* a man X whom one sees—or one did not, after all, *see* or *recognize* such a man X when perceiving the picture.

Hence, short of a massive "error theory" of ordinary reports of seeing or recognizing pictures, which would deny that we ever really do see or recognize items when seeing pictures, our ordinary epistemic claims to see or recognize X when perceiving A should be respected, as requiring us to accept that there is an *internal* X that is thereby seen or recognized—and hence to accept the current *referential* characterization of internal represention being argued for.

Now it might be thought that this conclusion is premature, on the ground that seeing or recognizing X when perceiving a picture might be a case of *external* rather than internal representation. However, it has already been established that, strictly speaking, one cannot see the *actual* object X, in seeing a picture of X that externally represents X.[20] Hence all one can do instead is to see or recognize the *internal* object X'—a case of *internal* representation.

Now, as already pointed out, the ability to see a man while looking at a picture, or the recognition of what one sees as a man, is a skill independent of whether or not the picture also externally represents some particular actual man. Nevertheless, there is an important connection of such "internal" abilities with external representation as well, in that, I shall briefly argue, it is in virtue of seeing what a picture P *internally* represents (its object X') that one can *justify* a claim that P externally represents object X[21]—given the failure of justifications in terms of "seeing-through" approaches.

The basic reason as to why external representation claims are epistemically dependent on internal representation claims is because of the con-

19. Lopes, *Understanding Pictures*, gives a useful account of some relations between recognition and representation, though he assumes a unitary concept of representation. See also Flint Schier, *Deeper into Pictures* (Cambridge, UK: Cambridge University Press, 1986).

20. See the arguments against the "seeing through" thesis in section 11.3.

21. Lopes, *Understanding Pictures*, provides a survey of various factors possibly relevant to a more complete justification.

junction of the following three points that have already been presented separately, namely: (1) claims of successful representation require perceptual or recognitional evidence, since mere evidence of artistic intentions to represent X does not demonstrate success in doing so; (2) the only perceptual or recognitional evidence available is of *internal* representational kinds, since strictly speaking one cannot see or recognize a picture as *externally* representing X; (3) as claimed in the previous section, recognition of an internally represented object is a necessary condition of external representation of its actual counterpart, and it becomes a sufficient condition when reinforced by intent to externally represent X, which normally follows as a matter of course via the primia facie intentions of those making their pictures publicly available.

To be sure, one might *believe* that one sees that a picture *externally* represents Napoleon, but one cannot *actually* see it thus even if the picture *is* an external representation of Napoleon, for the reasons already given (because of "no seeing through" plus the veridicality of the concept of seeing). Hence such claims of perception or recognition of external representation need to be reworked as objective, perception-independent claims about what a picture itself externally represents—but the only perceptual or evidential *support* available for such objective claims is from *internal* representational sources.

Now a full justification of a claim that picture P externally represents an actual man X would presumably require much more evidence than merely that one can internally see picture P as a man, or see a man when one looks at it—presumably one also must be able to see it as a man of a certain sort, or as a man having further, sufficient identifying characteristics. But the ability to internally see a man when one looks at the picture remains as an indispensable part of those evidential necessary conditions for external representation of the actual man X.

I take these points as showing that the epistemic foundations of internal representation are *at least* as secure as those of external representation, so that any potential attacks on my account of internal representation as somehow being "unfounded" or "subjectivist" have already been defused to a significant extent.

Next, I claim that the overt or intuitively natural *logical form* of statements of internal representation—that there is an object T', that is internal to the object P, and which is represented by P—can itself be given an epistemic defense, in that the evidential chain justifying claims of external representation itself requires that the internal epistemic evidence *have such a logical form*, that is, a logical form in which a particular "internal" entity is referred to and reidentified as being represented by P.

To begin with, it has already been established that a claim to see a man when looking at picture P is, on the face of it, unavoidably referential—that

is, implying a claim that there is a man whom one sees.[22] An additional reason for accepting that point is because statements reidentifying that same man play an essential role in the epistemic justification of claims of external representation by a picture.

This is so, as before, because justification has a *social* dimension: in order to justify a claim that picture P externally represents an actual man X, there must be intersubjective agreement on the evidence for that claim. This requires that different persons must each be able to see picture P as internally representing the *same* man X', since otherwise the evidentiary basis for the external representation claim—the fact that a man X', that is, the same man X' in each case, can be seen by qualified observers when looking at picture P—will fail to be established.

For example, suppose that two people A and B look at the same picture P, and that each claims, on the basis of what he sees, that the picture externally represents Napoleon. If asked for the evidentiary basis of his claim, A replies that he can see, recognize, or identify *the man in the picture* as Napoleon—that is, that the man internally represented by the picture is recognized by him as being Napoleon. And suppose that person B gives the same reply to the question.

Now my claim is that, in order for B to be *corroborating* A's claim, it must be assumed or presupposed that each is talking about the *same* man in the picture. For if A were to recognize one man X in a picture, and B were to recognize another man Y in the same picture, then there would be no single man Z such that both A and B recognize *him* as being Napoleon, and hence no secure ground for social agreement that the picture therefore externally represents Napoleon.

Indeed, so basic is this point that one can hardly even make sense of the claim that A and B might be recognizing different men in the picture—other than in the everyday sense that the picture multiply represents *two* distinct men, so that A and B might be talking at cross-purposes about those different men, that are visible in different areas of the picture.

To be sure, nonreferential analyses of what I am calling "internal representation" might attempt to deny all of this; but my point is that the possibility of reidentification of the same object of reference is a cornerstone of an *epistemically* defensible account of representation.

Hence, I would claim, the overt or intuitive logical form of statements of internal representation cannot be overturned without at the same time overturning our whole present scheme of justification of claims that some pictures do indeed externally represent certain actual things (again, given the inadequacy of nonreferential or "seeing through" views for this task). Thus

22. I shall argue in the next section that this "there is" need not be construed as having existential import.

the referential logical form of statements of internal representation is arguably at least as secure as is the referential logical form of statements of external representation, under our present scheme of justification.

11.6. ALLAYING ONTOLOGICAL ANXIETIES

Next I shall seek to allay any initial ontological anxieties about the status of objects of internal representation, of the kind raised in section 11.1.

In the previous section I provided an epistemic justification of the referential logical form of the definition of internal representation as: there is an object X', that is internal to the object P, and which is represented by P, along with examples such as: picture P internally represents a man just in case there is a man, who is internal to P, and who is represented by P.

Now I shall address the status of the phrase "there is" in the definition. I claim that this phrase is merely part of a claim that "there is" *an object of reference* X' that is represented by a picture; or in other words, this "there is" has no specifically *ontological* implications as to the status of any given such object of reference, but instead it functions to indicate that statements of inner representation are indeed *referential*, in that they involve a reference to some object.[23]

A more specifically ontological anxiety is a concern that an account of internal representation might be committed to the *existence* of such internal objects, since of course the idea of an actually existing man as somehow being internal to a picture of him seems confused or even self-contradictory. However, my reply is that a general account of internal representation must inevitably include cases of internal objects that do not exist, since they are *fictional* in a broad sense—such as with pictures of unicorns, or Santa Claus, or of a character in some fictional novel or play (as discussed in chapters 1 and 2). This again shows that the referential form of statements of internal representation does not in itself have any ontological implications as to the status of any particular objects that are thus referred to.[24]

I shall further discuss the validity and ontological harmlessness of reference to fictional entities in sections 11.10 and 11.11.

23. I distinguish my account from a Meinongian account of reference to nonexistent objects in section 11.11.

24. Thus my account has some affinities with Brentano's concept of the "intentional inexistence" of intentional objects, though such connections will have to be explored elsewhere.

11.7. REPRESENTATION AND THE INTENSIONAL/EXTENSIONAL DISTINCTION

I shall now locate the discussion of internal and external representation in a broader linguistic and symbolic context.

So far, it might seem as if my attempts to clearly distinguish internal from external representation are in a certain sense quixotic—an attempt to swim upstream against an established theoretical current—in that our usual ways of regarding representation, as involving only actual objects if they involve objects at all, seem to work well enough without any such theoretical interference or innovation being needed. And I suppose that even my epistemic arguments for the centrality of internal representation, in the justification of cases of external representation, might be regarded as theoretically overscrupulous or unnecessary, in the absence of any further considerations in their favor.

However, I shall now show (in outline form) that the internal-external distinction for visual kinds of representation is just one part of a much broader and more pervasive contrastive feature of any broadly linguistic symbolic system, that is, one capable of representing, characterizing, and referring to an indefinitely wide range of objects or events, as in the case of natural languages.

To begin, Frege familiarized us with a distinction between different ways in which linguistic referring terms might function in identity statements.[25] In a statement such as

(1) "The Morning Star is the Evening Star,"

he pointed out that the statement would normally be taken as an informative, contingent identity statement, and hence as having a different informative content from a related logically necessary statement such as

(2) "The Morning Star is the Morning Star."

However, if the referring terms in each of those statements (1) and (2) had the same reference in each case, then each statement would express the same proposition, since one could substitute, for the referring phrase "the Evening

25. Gottlob Frege, "On Sense and Reference," in *Translations from the Philosophical Writings of Gottlob Frege*, 2nd ed., ed. Peter Geach and Max Black (Oxford, UK: Blackwell, 1960).

Star" in (1), the coreferring phrase "the Morning Star," hence making explicit that it, too, on this interpretation, would express a necessary rather than a contingent proposition.

However, Frege reasoned that this could not be correct, and hence that one must postulate that the referring phrases "The Morning Star" and "the Evening Star" in statement (1) refer not to their usual references, but rather instead to *distinct* entities, which he called the "senses" of those referring phrases. Thus the sense "The Morning Star" is distinct both from the usual reference of that expression, and from the sense of "the Evening Star," hence explaining how the identity statement (1) could be contingent and informative.

Now I shall not endorse Frege's specific solution to this problem, but it is at least now generally recognized that singular referring terms can be intensional or opaque, in that inferences based on substitution of coreferring terms in contexts containing the terms can fail, so that *some* such solution is needed.

Another way of making the relevant distinction of purely referential, transparent, or extensional uses of terms, versus intensional or opaque uses of them, is in terms of the *de re*/*de dicto* distinction: purely referential uses of terms are *de re*, referring to an object no matter how it is characterized; whereas *de dicto* uses instead refer in a way that *does* depend on how the relevant object is characterized. Again, I shall not endorse this particular approach to the relevant issues, but it is at least of instrumental value in making the connection to our current topic of external versus internal kinds of representation, as follows.

In the case of external representation of an actual object X by a picture P, it seems undeniable that P externally represents X, no matter how X is described. For example, if picture P externally represents Napoleon, and if Napoleon happened to be the best friend of one Jacques Ebert, then it follows that P externally represents the best friend of Jacques Ebert.

I take it that there should be nothing surprising about this result, since after all, external representation is representation of actual, concrete individuals or events, which remain the same entities no matter how they are characterized. Thus it seems undeniable that external representation of some object X involves *de re* reference to X, that is, to X no matter how it is characterized.

On the other hand, it perhaps should be equally unsurprising that internal representation *does* critically depend on how its internal referent X' is characterized. This point is sometimes expressed, I shall argue, by the slogan "all representation is representation as,"[26] to indicate that a painter cannot, for instance, represent Napoleon without representing him *as* having a certain limited group of characteristics.

26. E.g., see Walton, *Mimesis as Make-Believe*, pp. 106–107, and the concluding comment in this section.

It follows that there will be, for any given picture P that represents Napoleon *as* having a certain set of characteristics A, another set of characteristics B, truly applying to Napoleon, that P will *not* represent Napoleon as having.

Thus for most, and perhaps even all extant representations of Napoleon, it would be false to say that they represented Napoleon *as the best friend of Jacques Ebert*, in spite of the fact that, in externally representing Napoleon, they thereby represent the best friend of Jacques Ebert. Hence I conclude that cases of "representation as" involve reference *de dicto*, rather than *de re*, to the object that is thus represented *as* having certain characteristics. For the reference is clearly to the object as characterized in some specific way, rather than to the object independently of how it is characterized.

It remains to show that the relevant kind of "representation as" involves cases of *internal* rather than external representation. Two arguments should suffice. First, it seems undeniable that external representation is always *de re*; but since all representation is either external or internal, any cases of *de dicto* representation, such as the one just illustrated, must be cases of internal representation. (But of course, none of this is to deny that a given *picture* can both internally and externally represent something.)

Second, talk of "representation as" is always talk about features that an artist incorporates into her own way of representing her subject, rather than being talk about that actual subject itself. Suppose that it was never true that Napoleon was the most mean-minded bureaucrat. Then, in representing Napoleon *as* the most mean-minded bureaucrat, the artist must be *internally* representing him, because no external representation of the most mean-minded bureaucrat could count as a representation of the actual Napoleon himself, because of the inapplicability of the referring phrase "the most mean-minded bureaucrat" to Napoleon himself.

Or, otherwise put, because of the natural connection between representing *as*, and ways of *imagining* something, if one imagines Napoleon to be the most mean-minded bureaucrat, then it is Napoleon *as thus imagined* by oneself, or *as represented* by oneself, who satisfies that description, rather than its being the actual person Napoleon himself who satisfies that description.[27]

Thus I conclude that the distinction of internal from external representation is as theoretically basic, or unavoidable, as is the distinction between intensional versus extensional or purely referential singular terms or expressions, whether explained in Fregean "sense versus reference" terms, in terms of a *de dicto/de re* distinction, or in some other way. And indeed, given the fact that linguistic reference is itself a broadly representational activity, it perhaps

27. Compare this account with that of Walton, *Mimesis as Make-Believe*, who would analyze this as a case where the artist or imaginer generates fictional truths about Napoleon himself.

should come as no surprise that nonlinguistic kinds of representation should exhibit similar logical behavior.

As a footnote to this section, it is interesting that the slogan discussed above, "all representation is representation as," is strictly speaking false on the present view, in that "representation as" has been argued to be exclusively concerned with internal representation, so that any cases of external representation would falsify the slogan. Indeed, the slogan could be regarded as, strictly speaking, being logically incoherent, in equivocating between the two different senses or kinds of representation: the initial "all representation" naturally evokes the usual picture of external representation of actual entities, whereas I have argued that "representation as" must rather be understood as *internal* representation.

11.8. THE NONIDENTITY OF INTERNAL AND EXTERNAL OBJECTS OF REPRESENTATION

An important implication of the current identification of the objects of internal/external representation distinction as being a species of the intensional/extensional reference distinction is that strictly speaking, for any given external representation P of an actual object X, the actual entity X in question cannot be regarded as being *identical* with the related entity X' that is internally represented by P. For of course the whole point of the intensional/extensional contrast is that an entity X' *under a description* cannot be regarded as being identical—as an object of reference—with the related entity X that is not "under a description"; or, in Fregean terms, that a reference to a sense must be to an entity distinct from the entity referred to by a normal, nonintensional reference.

Now this view might perhaps initially seem somewhat disconcerting, or unexpected, as applied to nonlinguistic cases of representation, but it nevertheless at least serves to legitimate the distinction of internal from external representation, in that, if distinct entities are indeed involved in each kind of representational reference, no one can maintain that the distinction itself is frivolous or theoretically unnecessary—as I have also shown in section 11.2 with respect to the falsity of the "seeing through" or "visual prosthesis" view which would identify X' with X.

Fortunately, however, an additional, clinching argument is available for the nonidentity of objects of internal and external representation, independently of their claimed connection with the intensional/extensional objects distinction. It is straightforward: if internal and external objects were iden-

tical, then for each internal object of reference there would *necessarily* be a corresponding external object—since each would be identically the same object in each case, on this hypothesis. But then there would be, for every internal object, an *existing* external object, since all objects of external representation actually exist.

However, there are two conclusive arguments against that supposed state of affairs. First, clearly some internally represented objects have no corresponding externally represented, and hence existing, objects, as in the case of fictional entities. And second, it is indubitable that most, if not all, existing physical objects only *contingently* exist—that is, that each of them, in spite of its being internally representable, might not have existed, while other currently nonexistent objects might have existed. Hence, to sum up, the hypothesis that internal and corresponding external objects of representation are identical has been conclusively shown to be false, independent of intensional/extensional considerations.

Hence I would argue that the case for identification of the objects of internal/external representation distinction as being a species of the intensional/extensional reference distinction has been significantly strengthened by the above, independent nonidentity argument for internal and external objects.

11.9. NONIDENTITY, AND ACTUAL VERSUS REPRESENTATIONAL TRUTH

I mentioned in the previous section that the thesis of the nonidentity of the corresponding objects of internal and external representation might initially seem somewhat disconcerting, or unexpected, as applied to nonlinguistic cases of representation. Here is some intuitive motivation for such a reaction: surely, for example, if one sees a picture of Napoleon, is it not a picture of *Napoleon himself* that one is seeing, that is, is not the depicted individual that one is seeing identical with Napoleon? For if the man that one sees was not identical with Napoleon, why would one be so sure that it is Napoleon himself that one is seeing, when looking at the man in the picture?

I suspect that these and other such intuitive considerations provide a significant part of the support for the more traditional view of representation as being analyzable purely in terms of external representation. For to begin, of course everyone can agree that a picture of Napoleon must be a picture of Napoleon himself: that fact is simply part of the logic of external representation. But then it is assumed that, when looking at such a picture, the *evidential basis* for one's claim that it externally represents Napoleon himself is provided by the fact that one can *see Napoleon himself* while looking at the picture.

But strictly speaking, that view must be wrong, as was established in section 11.2. Also discussed has been the fact that we need a uniform account of internal reference, whether or not there actually is any externally represented person. So accounts of representation that uniformly explain recognition of entities in pictures in terms of transparent seeing of *externally* represented entities are fundamentally inadequate for this general, existence-independent task.

And second, as the section 11.6 discussion on the connection of representation with the intensional/extensional distinction showed, it is necessary to distinguish extensional or transparent references to a person from intensional or description-relative references to "him," which strictly speaking are to "him as characterized or pictured in a certain way" rather than *transparently* to he himself.

Thus, when seeing a picture of Napoleon, one's evidential basis for one's claim that one thereby "sees Napoleon" is, strictly speaking, that one can see the man in the picture *as* Napoleon—or that one sees him *depicted as* Napoleon—and hence it is not true that one sees that he *is* Napoleon, in the sense of veridically seeing that *he is identical with* the actual person Napoleon.

Now to be sure, this point does not discredit or undermine one's claim to "see Napoleon" when looking at the picture; it merely shows the need for a different kind of analysis of the sense in which such locutions might be true.

For as might be expected, an account which distinguishes externally from internally represented objects will also need to distinguish *actual* truths from *internally represented* or *representational* truths, which are specifically about internal objects as such.

Thus for instance, it is true of the person as internally represented in the picture that he is Napoleon, and hence he can be seen to be Napoleon by anyone looking at the picture, so that "he is Napoleon" is a *representational truth* about the person thus seen. But this representational truth about the object that can be seen in the picture should not be confused with an *actual* truth about it—for, as shown above, it is *actually false* that the person thus seen in the picture is identical with the actual person Napoleon.[28]

Nevertheless, there can be actual truths about internally represented objects, of a broadly extrinsic kind concerning the relations of internally represented objects to the real world. For example, it is actually true of the object seen in the picture as Napoleon that it is represented by the picture *as being* Napoleon, and that it is not identical with the real person Napoleon.

The distinction between representational versus actual truths is in part already a familiar one, for there is an important proper subset of representational truths, namely *fictional* truths, that have been widely discussed in the

28. These cases may be compared with the section 2.7 cases of fictional existence versus actual nonexistence of characters such as Hamlet.

literature.[29] For, though the category of representational truths in general applies to any kind of internally represented object, whether or not there are any corresponding externally represented entities, the subcategory of *fictional* truths applies only to internal objects that have no corresponding actual object that is externally represented.

I shall discuss the status of such "fictional objects," and of fictional truths about them, in the following two sections.

11.10. THE LOGICAL STATUS OF FICTIONAL ENTITIES

Now I shall show how the current view enables a fresh, and arguably improved, account to be given of the logical status of discourse involving talk about *fictional* entities. The basic idea is this. First, there are, of course, no such actual entities, so that their ontological status, as things that do not exist, is already established. However, an account is still possible of the sense in which it is true that Hamlet exists in the fictional world of the play *Hamlet*, as given in section 2.7.

Second, since none of these entities actually exist, there are no legitimate cases of *external* representation of them. Third, consequently any apparent references to such entities should be construed as being cases of *internal* representations of such entities—whether of linguistic, pictorial, or other representational kinds—in which some representing object internally represents, and thus refers to, an internal object.[30]

And fourth, an account of fictional truth—as opposed to actual truth—for such internal fictional entities is then potentially available, along the lines sketched in the previous section for the broader concept of representational truth.

This treatment has several related advantages over more conventional accounts. First, in support of its account of fictional truth, a corresponding distinction between "internal" versus "external" statements—and between differing kinds of truth-conditions for each—is often made in discussions of fictional characters. For example, an *internal* statement such as "Hamlet is the prince of Denmark" is *fictionally* true, while an *external* statement such as "Hamlet is one of Shakespeare's most complex characters" is *externally* or *actually* true.[31] But recall that on my account is it possible to construe both

29. See, e.g., Walton, *Mimesis as Make-Believe*, and the references therein, as well as chapter 2 here.

30. As in the chapters 1 and 2 discussions of plays and characters.

31. Again see chapter 2, and the included references.

kinds of statement as being about the *same* fictional character: internal statements describe its intrinsic characteristics, while external statements describe its extrinsic characteristics that link it to the actual world.

Second, this account is able to preserve the genuinely referential form of such fictional discourse, since, as argued in section 11.1, internal representation not only is, but arguably also must be, logically referential.

Also, the possibility of genuine reference to specifically fictional entities is guaranteed by the necessity of our being able to genuinely refer to (internal versions of) any kinds of entities whatsoever. Thus no "special pleading" is required to legitimate cases of fictional reference, which, as referents of the ontologically neutral kind of reference involved in internal representation, are in no way anomalous, or in need of special explanation.

A related point is that what characterizes fictional entities as specifically or essentially fictional is something about their *external* representational status, namely that there are no external representations of them. But their internal representational status, as just noted, is one they share with every other kind of entity.

11.11. MORE ON THE STATUS OF FICTIONAL ENTITIES

As noted in the previous section, it is generally agreed that fictional entities do not exist. But this basic fact is often held to be fatal, or at least theoretically intractable, for a broadly referential account of fictional entities such as mine. For on a conventional theory of representation, according to which all representation is external representation, there are only two possibilities if there are no objects to externally represent: either one must give a nonreferential account of the representation of such objects—which would be fatal to my theory—or one must appeal to a special class of "fictional objects" that would serve as the referents of *external* representations of them, in spite of the fact that such objects are agreed not to exist.

Such theories could be described as broadly Meinongian,[32] in that they hold that some objects, in spite of not existing, can nevertheless "subsist," or have "being," and so on. But, though other such theories have been constructed,[33] it is unclear to me at least that the theoretical complexities involved in such theories have any decisive payoff in terms of increased theoretical

32. Alexius Meinong, "On the Theory of Objects," in *Realism and the Background of Phenomenology*, ed. Roderick Chisholm (Glencoe, IL: Free Press, 1960), pp. 76–117.

33. E.g., Terence Parsons, *Nonexistent Objects* (New Haven, CT: Yale University Press, 1980).

understanding, or explanation, of the nature of fictional entities—hence my comment that this kind of approach is theoretically intractable or unrewarding.

Now I shall introduce another basic feature of the distinction between external and internal representation. In the external case, the object represented is of course both logically and ontologically *independent* of the object that is externally representing it. It is this fact which, I would argue, is the basic reason why Meinongian theories are so theoretically elusive or unrewarding, because such entities are freestanding, independent entities whose status as objects of reference, or as objects having an ontology of a certain kind, has no obvious support of any kind beyond the need to postulate such entities, if this approach is to be adopted.

On the other hand, in the case of internal representation a case can be made that the relevant objects of reference are in some appropriate sense referentially—but not ontologically—*dependent* on the actual objects that internally represent them, in that the actual existence of those representing objects in some way underwrites or guarantees the *availability* as objects of reference of appropriate internally represented objects.

As evidence for this claim, it is perhaps obvious that one cannot see a man, as internally represented by a picture P, without directing one's gaze upon that same physical picture P, so that one's epistemic access to an object that P internally represents is *epistemically* dependent on one's having access to P itself [34]—from which epistemic dependence one may make appropriate inferences to a corresponding, appropriate kind of *internal referential dependence*. Or, as a related point, one may appeal to the representational powers of a given physical object, as provided by its physical design or configuration, as an explanation of how it is possible for it to internally represent some appropriate object of reference.

This approach may also be used to explain apparent cases of artistic *creation* of fictional characters and events in fictional works. First, it would seem to be true in *some* sense that Shakespeare "created" the character Desdemona in his play *Othello*. But, if Desdemona was *created*, then how do we avoid the conclusion that therefore Desdemona *exists*—or at least has some kind of Meinongian "being"?

On the current approach, we can instead say that what Shakespeare actually created, and what does indeed exist, is a *textual representation* of Desdemona—as part of his original manuscript of his play *Othello*—rather than the character herself. But that representation nevertheless made Desdemona available as an *object of internal reference* of that created representation.[35]

34. In chapter 2 I provide related discussions concerning the epistemic authority of representations in helping to determine the internal truth conditions for fictional statements.

35. See section 2.7.

This account is not yet complete, for the possibility of there being many distinct physical representations of the play, each being able to make reference to the *same* internal character Desdemona, still needs to be explained. In this connection I have introduced the concept of an *originative representation*,[36] which is one that is intended by its author both to be a definitive representation of the play and its characters, and to be usable by him or others to make *authorized copies* of that representation, which are, in turn, intended to represent the same characters.

Thus on this account there is an irreducibly *intentional* element involved in any reidentification of the same character, as internally represented by distinct representations of her—and this is a necessary feature of a satisfactory account, for it is generally acknowledged that mere qualitative identity of representing objects, as in cases of two texts being word for word identical, is not sufficient for the identity of any associated characters or artworks.[37]

At the same time, this possibility of reidentification of an internal object across different representing objects is arguably itself a necessary feature of any genuinely referential account of fictional or other objects—since without the kind of objective, or at least inter-subjective, status of internal objects made possible by this account, talk of "reference" to, or "reidentification" of, such entities by various people in different situations would be a mere sham.[38]

There are at least two other ways of arguing that reference to fictional characters is possible. An "ordinary language" approach would argue that, since references to, and reidentifications of, fictional characters are common in everyday linguistic practices, such uses need no additional justification beyond their bedrock linguistic status.

A related but more sophisticated approach would distinguish a "surface" level or theory of fictional reference from possible deeper theories, which might or might not maintain genuine reference to fictional entities. (I argued for such a "surface" approach as one form of legitimate theorizing about reference to fictional entities in section 2.3).

Intuitively the idea is that such a surface theory could be genuinely true, and explanatory, as applied to *surface* phenomena, such as everyday linguistic references to fictional characters, whether or not a deeper or more reductive theory might explain—or explain away—such apparent references in other terms. On such a surface view one can both acknowledge what is valid in "ordinary language" approaches, yet also allow the possibility of more fundamental levels of theorizing.

But now that the current account of reference to fictional entities in terms of internal representation is available, I would claim that it provides

36. In chapter 2 and section 4.3.
37. As in the case of the previously discussed Borges "Menard" example.
38. See also section 11.4 on that point.

the only necessary *deep* theory of fictional entities—to complement, underlie, and explain the just-discussed surface theory. Thus on my account, fictional reference is genuine both in surface and more fundamental theoretical ways.

Part 5

Further Developments

Issues Resolved

Т he previous chapters have left several significant theoretical issues in a partly undeveloped or unresolved state, a situation that this concluding chapter will rectify.

One primary issue is that of the precise nature of the two main kinds of representation—*concrete artifact-artwork* (CA) and *artwork-subject matter* (AS) representation—involved in a double content (DC) theory of art. Another issue is that of the connections between the part 3 chapters 8, 9, and 10 that raise spatial orientation issues about artworks, and the basic structure of the DC theory itself.

Fortunately, it will turn out that both of these issues can be resolved together, in that a broadly *orientational* account can be given of the respective structures of CA and AS representation, along the lines of the chapter 9 distinction between aspect representation and intrinsic representation.

This orientational analysis will also provide some significant independent justification for the postulated double content structure of artworks, in that arguably it is also needed to account for the nature of more miscellaneous kinds of ordinary, nonartistic representations such as "record" photographs, documentary films, and instruction manuals.

Indeed, the investigation will result in a general *eight-factor* theory of DC representation, in section 12.9, which will substantially enhance the analysis of the concept of representation introduced in chapter 11, in ways that are both theoretically defensible and cognitively realistic. Thus overall the resulting theory may claim to be justified both as a theory of the nature of art and as a general theory of the nature of representation.

For simplicity of exposition, it will be convenient to use examples and concepts most directly applicable to the visual arts, but the results are intended to apply to any kinds of artworks—and in many cases to more general kinds of representation as well.

12.1. THE TWO KINDS OF REPRESENTATION (CA AND AS) IN A DC THEORY

There is an important issue concerning the precise nature of the two main kinds of representation—*concrete artifact-artwork* (CA) and *artwork-subject matter* (AS) representation—involved in a double content (DC) theory of art, which issue the current and next two sections will attempt to clarify using the orientational concepts introduced in part 3.

As to the nature of CA representation, chapter 9 provides one main basis for a solution to the issue. Recall that three *delineative* forms of representation were introduced there, in which some concrete artifact such as a physical map could structurally, aspectually, or integratively represent its subject matter, independent of issues concerning pictorial representation. My claim will be that all cases of CA representation are cases of an appropriately broadened concept of *aspect* representation—broadened to cover any kinds of concrete artifacts and artworks, not just visual cases.

As a preliminary point, it is clearly desirable on grounds of economy and simplicity to identify CA representation with one of the previously identified kinds of representation, if at all possible. And since the delineative kinds are independent of the way in which a picture represents its subject matter, and already linked specifically to cases of representation by concrete artifacts, one or more of their members provide an attractive initial theoretical option as an analysis of CA representation.

Chapters 8 and 9 also made it clear that under normal conditions a physical painting exhibited in its upright orientation will, because of social norms and conventional expectations, be taken to be associated with an *upright picture* having the same field orientation as the physical painting. Thus aspect or aspectual representation, in which a physical artifact in a given field orientation represents or delineates some content that has the *same* field orientation, is a natural initial choice as an analysis of CA representation—while structural delineation, which takes no account of orientational factors, may be ruled out from the start.

However, the choice between aspect and *integrative* representation as an analysis of CA representation is not so straightforward or easy. Insofar as the concept of integrative representation (see section 9.7) is distinct from that of aspect representation, it concerns a kind of delineative representation in which various rotational field orientations of a concrete artifact represent various particular field orientations of the same summed underlying content (such as some geographical terrain delineated by a map), with each particular orientation representing one part of that summed content. Nevertheless, as discussed in chapter 10, the most plausible two theories concerning pictures—the MFE

and MFA theories of section 10.8—would both *deny* that pictures themselves can retain their identity through such rotation (with corresponding arguments for musical themes), hence emphasizing the aspectual partness at the expense of the summed wholeness of the relevant integrative content.

Thus if we accept the theoretical arguments of chapter 10, it seems that integrative representation must also be ruled out as an alternative to aspect representation in the analysis of CA representation. But the issue is hardly a trivial or obvious one, since it requires detailed argumentation rather than just reliance on initial intuitions, which may tend to be misleading in this case, as was also illustrated in chapter 10.

One such initial intuition remains to be addressed, namely that a physical artifact, such as a painting or drawing, may be freely rotated without its having any effect on the identity of the relevant picture. But how can this be possible, if the artifact *aspectually* represents the relevant visual artwork? Would not the relevant oriented pictorial content become unavailable to perception after any such rotation?

Here is where the "perceptual compensation" arguments presented in the course of initially defending the third MFE theory (many fixed pictures, eliminating nonupright ones) in section 10.8 become independently useful. In the case of a picture that is intended by its creator to be an upright picture, arguably viewers can *perceptually compensate* for any nonupright orientation of the relevant artifact, in the various ways described there.[1]

Thus the relevant initial intuition concerning free rotation is, after all, consistent with holding that all visual artworks are aspectually represented by their corresponding concrete artifacts—which point, it will turn out, may also be extended to cover artworks in general.

12.2. ASPECT REPRESENTATION GENERALIZED

As noted in the previous section, if the concept of aspect representation is to be usable as part of a general analysis of *concrete artifact-artwork* (CA) representation, it is necessary to *generalize* it, so that it will apply not just to purely visual artworks, but also to cases of nonvisual artworks such as music or literature, as well as to hybrid or mixed cases such as film or video arts that have

1. The utility of these arguments for this purpose does not undercut the final choice of the alternate MFA theory—of many fixed pictures, all-accepting of nonupright ones—as being preferable to the MFE theory: again see section 10.8. Also, this perceptual compensation interpretation means that there are now *three* possible interpretations of an inverted picture: IP-US, UP-IS, and UP-US (see section 10.1).

both a temporal or narrative structure, as well as music, speech, or other sounds, in addition to the relevant visual aspects.

A key to broadening the concept of aspect representation involves broadening the associated concept of *spatial orientation*, so as to cover other kinds of characteristics of concrete artifacts and artworks, that are also naturally conceived of as being concerned with *some* kind of orientation, as opposed to some relevant nonorientational underlying structure. Recall that aspect representation as currently defined is specifically concerned with spatial *field* orientation (rather than *intrinsic* orientation, of which more in the next section), which concerns the *alignment* of an item with a spatial *environmental field*; thus, for example, an artifact in a given spatial field alignment will aspectually represent some content that has the *same* spatial field alignment or orientation.

Turning now to a new example, a piece of music as normally played has a *forward temporal* orientation, such that the beginning of the piece is played at a time temporally prior to the middle and end sections of the music. In this case the relevant environmental field is that of *time* rather than space, and the *temporal* field orientation of the relevant concrete artifact—the sequence of sonic events—is that its start is aligned with the start of the temporal sequence, and its end is aligned with the end of the temporal sequence. However, if a recording of a piece were played *backward*, from finish to start, it would have, in that playing, an *inverted* temporal field orientation, such that its *end* was field-aligned with the *start* of the temporal sequence, and its start with the end of the temporal sequence.

Presumably the underlying nonorientational *structure* of the music would be the same in either case, whether temporally "upright" or temporally inverted. But intuitively, only the temporally "upright," *forward*-moving performance would count as a performance of the *musical piece* itself, as opposed to a mere demonstration of its underlying structure, and hence both the relevant concrete artifact—the forward-moving sequence of sonic events—and the musical piece that it represents have the *same temporal field orientation*. Thus the broadened concept of aspect representation may appropriately be applied to this musical case.

It also follows that for music too, as for visual artworks, it is possible to distinguish aspectual versus structural delineative uses of the relevant concrete artifact. Presumably a use of a musical event sequence as a *structural* representation would seek to emphasize the *structure* of the music[2] rather than the relevant oriented progression of the music, just as a map or diagram in a particular spatial orientation might nevertheless be used to emphasize *invariant topographic structure* rather than to aspectually represent a particular field orientation of the relevant landscape.

2. Such as in a teaching situation: see the section 10.6 discussion of such a case.

As another, more familiar example of broadly orientational concepts applied to music, the chapter 10 discussion of inversion of musical themes dealt with not *temporal* inversion of a whole musical piece, but instead with *pitch* inversion of individual notes in a theme. Here too it is possible to distinguish the normal "upright" or uninverted form of a theme from its inverted form, and to regard the piece of music itself as having the same pitch-uninverted characteristics as does the relevant concrete artifact, namely the relevant pitch-uninverted sequence of sonic events that constitutes the playing of the theme. Thus here too a generalized concept of aspect representation is applicable.[3]

To sum up this part of the discussion, once the concept of orientation is broadened in such ways as these, so as to cover more miscellaneous perspectival or directional aspects of artifacts and artworks—defined relative to an appropriate environmental field—as opposed to more invariant underlying structures associated with *various* field orientations of some relevant orientational kind, it becomes clearer how a suitably generalized concept of aspect representation could indeed provide a basic analysis of concrete artifact-artwork (CA) representation.

The two musical examples also together provide evidence that a generalized aspect representation concept must allow for simultaneous *multiple* field orientational factors—perhaps of disparate kinds—being the same in both concrete artifact and artwork. For if the two examples are combined, they show that a piece of music, and its associated artifact, must simultaneously be noninverted both in temporal *and* pitch characteristics—and presumably also in any other relevant orientational characteristics as well.[4]

Thus the desired generalization of aspect representation is one in which *all* of the relevant field orientational or perspectival factors, of whatever kind, are the same in both artifact and artwork.

Parenthetically, from a cognitive science perspective it is not surprising at all that concrete artifact-artwork (CA) representation should be thus explicable

3. In this example the relevant environmental field is a "pitch space" which is symmetrical around a horizontal temporal axis, representing some appropriately chosen invariant pitch, relative to which pitches above that axis are mapped into pitches an equal distance below the axis, and vice versa, if a *pitch inversion* is in effect for the relevant notes.

4. As a further, more exotic example, if the score of a musical piece were laid out on a horizontal axis, and then it was "rotated" around its temporal midpoint in another kind of "pitch space" generated by a vertical axis representing increase in pitch in the upward direction, and decrease in pitch in the negative direction, then all notes except for those at the midpoint would change their pitch, depending on the angle of rotation. But of course normal performances have none of those exotic changes, and hence this is yet another kind of way in which both the musical artifact and the music itself have the same, in this case specialized "pitch-space," orientation.

in terms of this specific generalized concept of aspect representation. For the concept guarantees that concrete representations can be cognitively processed with a *minimum amount of unnecessary data transformations* in the extraction of the desired representational contents, namely the relevant artworks.

To be sure, a world in which persons heard a musical piece played in one temporal direction, but interpreted it as a musical piece having the opposite temporal direction, is a logically *possible* world, but the extra cognitive burden of the required data transformations would be vanishingly unlikely to emerge in, or to survive, an evolutionary process of cognitive development. Thus aspect representation, as here defined, is the simplest and most efficient way in which an organism could process any kind of concrete representational information, whether concerning artworks or anything else.

To continue, spatial orientation itself provides a widespread, though almost universally ignored—or taken for granted—factor in any *linguistic* or *notational* representations of completely or partially nonvisual artworks, whether of performing arts such as music, theater, and dance, or nonper-forming arts such as literary novels or poems. All of these arts use concrete artifacts such as musical scores, manuscripts including dance notation, the-atrical scripts, and other natural-language representations of artworks, including poems and novels, all of which linguistic or notational artifacts are intended to be viewed or read in a normal spatially *upright* orientation. Of course this is so obvious as to hardly require mention, but it does become sig-nificant in tandem with other orientational factors, as will now be shown.

In the English language, it is a standard convention that a page of text should be viewed in an upright orientation, and that one should read the text of each sentence from left to right (unlike Hebrew and Arabic, for example) starting with the top sentence and progressing down each page. Thus the *ori-ented narrative progression* of the text, and correspondingly of the narrative progression of the represented novel or poem, etcetera, depends on *all* of these orientational conventions being satisfied or observed by the reader, including the apparently superficial one of a normal spatial orientation.

To be sure, it is possible to learn to read a text correctly when it is posi-tioned in a spatially inverted position, by simultaneously also altering the other two rules of English reading as well—hence reading from right to left and up rather than down the inverted page—but such triply complex percep-tual adjustments merely serve to show that *there normally are* at least three standard orientational requirements for correct cognitive processing of non-pictorial linguistic or notational representations.

However, this example does also show that a clarification is needed in the definition of aspect representation, of the sense in which all *relevant* orienta-tional factors are the same in both artifact and artwork. For clearly the spa-tial field orientation of a text could not itself be such a relevant factor, in that

there is no obvious sense in which a novel or poem as such could have a spatial orientation.

Thus a further degree of abstraction is required in understanding the role of concrete orientational factors. The spatial orientation is not itself a salient or relevant factor, but instead it is a necessary condition, or enabling factor, which enables the left-to-right plus top-to-bottom orientational rules together to define an *oriented narrative direction* both in the physical text itself and in the represented artwork—and it is that oriented narrative direction itself which is the relevant common orientational factor in both artifact and artwork.

As for cases of hybrid artworks such as film or video works, these present no special problems for the present view, since they are just cases in which a disparate or heterogeneous range of orientational factors make up the range of *relevant* factors for aspect representation. For example, a film typically will have *spatial* orientation (for its images) and *narrative* orientational direction for both its images (since they are moving ones) and spoken dialogue, as well as a more purely *temporal* direction for its accompanying music. Thus overall it may be concluded, at least on a preliminary basis, that the generalized concept of aspect representation does provide a satisfactory analysis of the first stage of concrete artifact-artwork (CA) representation, in the current double content (DC) theory of art.

12.3. THE INTEGRATION OF AS AND INTRINSIC REPRESENTATION

In the previous two sections, concrete artifact-artwork (CA) representation, whose content—*artwork* content—is the initial kind of content in the current double content (DC) theory, has been explained in terms of a generalized concept of *aspect* representation. That explanation is an important addition to the current DC theory, since previous discussions of CA representation in the book have instead concentrated on proving that indeed artworks *are* represented by concrete artifacts, but without specifying exactly what kind of representation was involved. But now, that theoretical gap has been closed with the specification of *aspect* representation as the relevant kind of representation.

On the other hand, in the case of *artwork-subject matter* (AS) representation, a much more detailed explanation of its nature—in terms of factors such as the inseparability of artwork and subject matter, and the nature of medium content with respect to its complementary subject matter content—is already available, so that the remaining explanatory gap is a relatively minor one. Nevertheless it is still important to integrate the broadly orien-

tational considerations introduced in the last three chapters of part 3 of the book, which led to the current generalized definition of aspect representation, with the already existing explanations of AS representation.

In particular, section 9.1 introduced a concept of *intrinsic* representation for pictures. Unlike *aspect* representation, in which the spatial field orientation of a concrete artifact represents a content having the *same* field orientation, in the case of a picture it has an *intrinsic* orientation that is *independent* of whatever actual field orientation its corresponding concrete artifact might happen to have. Thus for pictures, the spatial field orientation a picture represents its subject matter as having depends solely on the "alignment status" of that subject matter—as upright, inverted, and so on—with respect to the relevant *intrinsic top* of the picture, so that in this manner the picture *intrinsically represents* its subject matter, independently of the field alignment of its corresponding artifact.

This account of intrinsic representation for pictures needs to be generalized so as to apply to any kinds of artworks, as does the *field* versus *intrinsic* orientation distinction itself. To be sure, to some extent these generalizations are already underway, at least as regards *field* orientation, since the previous section provided examples of appropriate kinds of field orientation—of temporal, narrative, and "pitch-space" kinds—associated with generalized cases of aspect representation. Also the chapter 10 discussion has already shown the close relations between visual spatial orientation and musical "pitch orientation" (inverted musical themes and the like) cases, so that insofar as the field/intrinsic orientation contrast is already established for pictures, it is also established for musical pitch orientation cases. Nevertheless it will be useful to go back to basic principles to further the discussion, as follows.

To begin, though every case of *aspect* representation produces some content that has the same relevant field orientation as its representing concrete artifact, not all of those resulting "aspect contents" necessarily have their own *intrinsic* orientation. For example, the contents produced by the aspect representations resulting from various rotations of a map typically would not have any intrinsic orientation.

Under what conditions, then, do aspect contents have an intrinsic orientation? For present purposes, one important class of cases is provided by those contents that in turn represent a *further* content, namely their own subject matter, which class of cases includes artworks.[5]

The crucial reason as to why artworks *must* have an intrinsic orientation of the relevant kinds—corresponding to each relevant kind of field orientation involved in the relevant aspect representation—is because without it,

5. Along with more utilitarian, nonartistic items such as record photographs, documentary films, and instruction manuals.

they could not specify or define the relevant kind of field orientation of their *own* contents or subject matters.[6]

For example, a picture could not depict a person as being horizontal, or a film present a scene as being in the normal temporal "forwards" direction, unless the relevant artwork had an appropriate *intrinsic* orientation, relative to which the relevant field orientations of the subject matters could be defined. Thus the possession by an artwork of an intrinsic orientation in some basic respect is a necessary condition of the *determinacy* of its subject matter in that orientational respect.

This also means that the field orientation of a subject matter is *fixed* by the intrinsic orientation of its corresponding artwork, no matter what field orientation the artwork itself may have. Thus, since the *intrinsic* orientation of an artwork is independent of its current *field* orientation, any changes in its current field orientation will leave the field orientation of its subject matter unchanged —hence leading to the *oriented subject matter invariance* or OSMI principle.[7]

To continue, other narrative or temporal examples would include "flashbacks" in plays, novels, or films, when the normal forward narrative direction of the subject matter, as defined by the intrinsic forward temporal orientation of the relevant artwork, is interrupted by backward-jumping elements of content that return to some earlier temporal period. The inverted temporal direction of those backward movements of subject matter can only be defined or recognized as such *relative to* the intrinsic forward orientation of the narrative artwork itself.

Thus, to summarize, artwork-subject matter (AS) representation may be explained in terms of *intrinsic representation*, which is such that some relevant kind of *intrinsic* orientation of an artwork defines and fixes the corresponding kind of *field* orientation of its subject matter, independently of whatever the relevant field orientation of the *artwork itself* may be. That summary also serves to concisely summarize the relations, with respect to orientational considerations, of concrete object-artwork (CA) representation and AS representation as well.

As to orientational considerations themselves, they may either be of some broad categorial kind, such as spatial or temporal factors, including close relatives of temporal orientation such as narrative direction, or of more miscellaneous specific kinds, including various pitch-space orientations in music.

Other miscellaneous cases would include "light-value orientation" in photography, in which light-values (light versus dark) might be inverted or otherwise altered, as in an original negative from which a black-and-white

6. Thus for artworks, too, intrinsic orientation may be functionally defined in terms of the purpose that it serves—as was shown in the case of the intrinsic orientation of concrete artifacts in section 8.10.

7. Introduced in section 9.1.

photograph is printed, and also "color orientation," in which normal versus complementary colors occur in a color print versus a color negative, respectively. Or a play might be performed using inverted *gender* orientations, with men playing women's parts and vice versa. Or in general, *any* kind of property or factor that can be organized into a *field* of *related* properties may usefully be analyzed in orientational terms in double content (DC) cases, as will be further shown in the following sections.

12.4. THE INTEGRATION OF ORIENTATION AND MEDIUM CONTENT

Section 12.3 showed how artwork-subject matter (AS) representation could be explained in terms of the orientational concept of intrinsic representation. However, it is also very desirable to find some way in which to integrally connect those orientational considerations and results with one of the other central issues about the nature of AS representation, namely that an artwork is made up of *medium content*, that provides an *expressive stylistic commentary* on the relevant subject matter.[8]

Initially, issues of orientational structure and expressive commentary issues might seem entirely foreign to each other. However, this is perhaps mainly because the prior discussions of orientation have focused on its broadly categorial or logical features, and mainly in connection with the special case of spatial orientation, rather than on specific or subtle ways in which artists might use the full possible range of orientational factors to achieve expressive or stylistic effects. Though a full account of the relevant relations would require a book-length discussion in itself, a brief introduction follows, that should at least serve to show that the topics are intimately connected, and hence that a single kind of AS representation is being discussed in both cases.

Here is an initial way to connect the two topics. Consider the boundary conditions, or necessary limits, of expressive artistic commentary. If an artist is to be genuinely expressive, she must somehow be expressive in a modulated and responsive way about *a given subject matter X*, since if her expressive devices were *too* powerful or unsubtle, they would merely overwhelm or destroy the desired subject matter X, hence turning it into some other subject matter Y—so that after all she would *fail* to be expressive about *X* itself. Thus the artist's chosen modes of expression—as explained in terms of the concept of *medium content*—with respect to a given subject matter X must nevertheless leave that subject matter X itself invariant through any of her possible expressive transformations of it.

8. See chapters 5 and 6 for more details on medium content.

But this just enunciated "principle of expressive nondestructiveness," as it might be called, is none other than the *oriented subject matter invariance* (OSMI) principle in another guise—hence showing the integral connection of orientational issues with medium content issues. Recall that the OSMI principle holds for artworks having the same intrinsic orientation in some respect. Then stylistic or expressive commentary that produces medium content with respect to a given subject matter X can be thought of as concerning a possible *range* of artworks A1, A2, . . . An, each of which shares the same intrinsic orientation in all relevant respects—and hence all of which determine the *same* relative field-oriented subject matter content X.

But at the same time, each of those artworks is different from the others, in that each has at least one field orientational difference in its medium content, in some respect, from all of the others, and which hence provides its own distinctive commentary on the relevant invariant subject matter.[9]

Thus the medium content in each case is made up of various field-oriented items (as aspectually represented by some concrete artifact), which have particular values of intensity, color, shape, and so on, but whose field orientation is *independent* of that of the relevant invariant subject matter. Thus in this manner the artist or viewer may, having made appropriate assumptions about the relevant intrinsic orientations of various elements of an artwork, cognitively separate the invariant *subject matter* of the work from the independent commentaries concerning it that make up a work's *medium content*.

1. Artistic Realism

But how exactly does the artist or viewer decide on what are *appropriate* assumptions about the relevant intrinsic orientations of various elements of an artwork? As an initial approximation, the idea of *artistic realism* provides a useful guide.[10]

Artists may rely on viewer assumptions that, unless there is evidence to the contrary, figurative artworks—those that purport to represent real persons, landscapes, and so on—are to be interpreted as having a subject matter that is a *reasonably faithful* or *realistic* representation of some corresponding actual persons and subjects—for example, as having approximately the same colors as the actual colors of blue sky, green leaves, and pink or brown skin, the same normal shapes of the corresponding objects, and so on.

9. This point ties in with the section 10.8 selection of theory 4, the MFA theory, as best, according to which, in a similar manner, any orientational differences will define a different artwork.

10. The idea of a medium will modify this: see section 12.6. Also see the next section for a more detailed account of how an artistic realism assumption may work.

2. Orientational Summary, and the Nature of Fields

As a preliminary point, all of the orientational concepts apply in the first place to conceptual, logical, or mathematical structures, which may be realized or concretely instantiated in the world in cases of aspect representation by concrete entities, or be true of some kind of content (medium content or subject matter) in other cases. The concepts might be applied to the whole of the subject matter of an artwork, or instead primarily to *parts* of it, such as particular regions of a picture, or to *aspects* of it, such as shapes, colors, or textures, so that the complete analysis of the subject matter of an artwork might require an integration of many such more specialized analyses of parts or aspects of the subject matter.

The most basic concept is that of a *subject matter* S of a representational artwork, such as a kind of entity, or qualities such as a specific shape or color, or relational qualities such as some specific spatial orientation. Thus a subject matter is any part or aspect of what is intuitively the complete relevant subject matter of an artwork.[11]

A second basic concept is that of a field. A *field* F is defined relative to, or with respect to, some particular subject matter S, and it is an ordered collection of determinate values Fa, Fb, . . . Fi, which typically are of the same general or determinable kind as is S.[12]

S itself serves as the *intrinsic top* of field F, in virtue, it will turn out, of its functional role as a cognitive guess or hypothesis about the likely subject matter of a representation. Then the other elements of F deviate, in one or more dimensions, from its top element S in characteristic ways.

The particular kind of oriented structure of field F thus produced by these deviations or transformations would depend on what kinds of deviations from, or contrasts with, its subject matter S would be most *useful* to artists creating works having S as part of their subject matter—whether for expressive purposes, or because of the limitations of a particular medium or style, and so on. Hence potentially there might be a whole range of specialized fields, each of which is most appropriate or useful for a given medium, style, or even individual artist, so that full understanding of an artwork in the relevant medium or style would require a grasp of the relevant specific field F.

With color, some form of "color wheel" or *circular* organization of values—as with spatial orientation cases—might be most useful, and hence might be the one actually cognitively used by most artists and their audi-

11. Or in the epistemic terms of actual cognitive processing—see the following section—a subject matter S is only a *hypothetical* subject matter until either it or one of its orientational values have been identified.

12. But atypically, some fields might need to include "interdeterminable" items, on which see fn. 14.

ences. Other cases might use noncircular linear or nonlinear divergences, as with the nonrealistic rough paper and intermittent coverage of some uses of the pastel medium,[13] or loudness or softness divergences from a given realistic sound level in a musical case.[14]

As applied to representations, the current orientational theory postulates at least one further field F2, which is qualitatively identical with F1, and whose orientational alignment with the initial, environmental field F1—and in particular the alignment of F2's top F2a with some element F1i of F1—defines the field orientation both of some relevant concrete artifact A, and of its subject matter S, which subject matter is thus *aspectually* represented by artifact A. Thus if just two (rather than three) identical fields F1 and F2 are involved in the analysis, this would be a case of artifact A being a *delineative* aspectual representation of a *single* content, namely the subject matter S, which case would therefore not count as a double content case.[15]

But in double content cases there are *three* identical fields F1, F2, and F3; in this familiar case the field orientation of F2, with respect to F1 provides sufficient information to define the formal orientational characteristics of the medium content of the relevant artwork, while the relative field orientation of F3 with respect to F2 similarly defines the orientational characteristics of the subject matter S.

13. The nature of a medium is further discussed in section 12.6.

14. Also, some "interdeterminable" fields are to be expected in the works of at least some artists, for example, because the overall *color* impression of a region of a picture could depend both on the actual color applied to it plus the *texture* of the resultant surface, so that in addition to three color dimensions (for example, for hue, intensity, and brightness), several more dimensions of textural information might be needed as well.

To be sure, in theory the color dimensions alone could capture this information, since the texture partly determines the color-dimension values. But the possibility of synaesthesia, or intermodal artistic linkages, cannot be discounted: the exact meaningful "flavor" of a color might thus depend on its *textural context* in the case of a particular artist. Another more radical example would be the interaction of color with *tactile* qualities, such as the ridges and valleys of thick impasto paint, which arguably involve tactile as well as visual information.

15. Strictly speaking, only the *top* element of F3—and of F2 in a delineative two field case—is needed to provide orientational information, via its alignment with an appropriate element of F2 or F1 respectively. But the possibility of iterated or nested representation cases (see section 12.5.8), with further lower-level subject matters, means that it is theoretically simpler and more uniform to discuss the orientations of complete fields.

3. Modifications of Artistic Realism

Returning to the artistic realism assumption, in the default or paradigm case of a completely realistic, transparent artwork, such as an accurate color photograph, *all three* factors (as represented in the orientational analysis by the three identical fields) of environmental field, artwork intrinsic orientation, and subject matter will be the same. This is because both artwork and subject matter fields are in an "identity alignment" with each other (with each pair of aligned values being identical), hence producing an upright picture-upright subject matter (UP-US case), since the same subject matter S is the top element in both fields.[16]

However, an artist might choose instead to provide a medium-specific *commentary* on her subject matter, which is not so realistic. Consider, for example, a picture such as one of Andy Warhol's 1967 silkscreen prints of Marilyn Monroe, in which the pink color of her face is replaced with a strong red color.[17] How could the meaning of such a change be explained?

One implausible hypothesis is that Warhol intended to represent her *incorrectly*, as having a *red face*.[18] But that would be as if he were saying through his work, "See, I'm deliberately making a mistake," which would at best provide a puzzling commentary on the *artist* rather than on his subject. Instead, it seems clear that, insofar as the color change is meaningful at all,[19] it provides a medium-specific commentary on its *unchanged*, and hence *pink*-skinned, subject matter—for example, as linguistically translated, that this is how the normal, pink-skinned Marilyn might sometimes look through the garish and dangerous light of fame and media publicity.

An orientational analysis can explain this medium content interpretation in a very economical way. The default realistic assumption concerning the intrinsic orientation of the picture in the relevant respect (with the realistic pink being the upright value) remains in place, as does the picture's corresponding pink subject matter with which it is identically aligned. But the one factor that has changed is the *field orientation* of the picture in the relevant respect: the strong red color shows that the pink top of the picture is field-aligned with that relevant *red* in the environmental field, instead of with its salient pink top, and hence the picture is *inverted*[20] relative to the environ-

16. Which also serves to explain why it is so easy to overlook the role of orientational factors in understanding artworks.

17. Along with blue shadows, and a lighter red background.

18. Such misrepresentations are further discussed in the following section.

19. Which, to be sure, some might doubt in Warhol's case, since he was notoriously uncommunicative about his artistic intentions. But for present purposes its meaningfulness will be assumed.

20. In a conveniently broad sense of "inverted," meaning any displacement from the top position.

mental field. Thus this is an *inverted picture/upright subject matter* (IP-US) case, and thus analogous to a spatially inverted picture whose intrinsic top and oriented subject matter remain the same through a spatial field inversion.

In more intuitive terms, the point is that any *nonrealistic* elements in a picture may be explained in terms of a *changed field orientation of the picture itself* (or of such orientational change/s in some particular element or elements of the picture, as in the present case), rather than having to invoke the implausible assumption that the *subject matter* itself has changed. Or, in medium content terms, the artist is free to comment on the unchanged subject matter by making implicit use of the IP-US orientational mechanism discussed.

Thus, to briefly summarize and generalize this section, there is an integral connection between issues concerning the expressive artistic commentary provided by medium content, and the orientational issues which, it turns out, provide the "cognitive mechanics" by means of which the double content (DC) structure of artworks is actually realized.

12.5. DC THEORY IN DEPTH: ARTISTIC REALISM, MISREPRESENTATION AND THE IP-US/UP-IS DUALITY, AND MORE

The generalized orientational analysis of concrete artifact-artwork (CA) representation and (AS) representation in this chapter has not yet come to grips with the full range of possible cases and theoretical issues. In particular, the important topic of how an artwork could *mis*represent—yet nevertheless still represent—its subject matter requires more discussion.[21] That issue is also integrally related to the orientationally dual cases of inverted picture-upright subject matter (IP-US) and upright picture-inverted subject matter (UP-IS), as will become clear.[22] But first, some prior issues need to be discussed, along with a more basic analysis of the likely cognitive stages of representational processing.

1. A Conflict of Information Problem

To begin by putting the issue in a broader context, the general double content (DC) theory of artworks assumes that concrete artifacts are capable of

21. In addition to the brief comments in the previous section, in discussing a possible misrepresentation of Marilyn Monroe as having a red face.

22. As discussed in sections 9.2 and 10.1. As usual, specific examples will involve *visual* artworks, but the results are generalizable to artworks in general.

conveying enough information about an artwork so that *both* the artwork *and* its subject matter can be cognitively grasped on the basis of perception of the relevant artifact. Thus any given area of a relevant artifact has to be capable of somehow conveying information both about the relevant medium content—that defines the artwork—and about its subject matter.

However, there is a potential problem, if a given such area has to simultaneously represent both medium content and subject matter content of the *same* specific kind S—as in the case of the Marilyn picture discussed in the previous section, a single area of which could be interpreted either (correctly) as a reddish commentary on a pink-faced Marilyn, or (incorrectly) as a commentatively neutral *mis*representation of Marilyn as having a red face. And the problem is a pervasive one, as shown by the initial spatial examples of the IP-US versus UP-IS duality in sections 9.2 and 10.1, where similarly any given area of a picture could be interpreted either as part of the *spatial* "commentary" (the IP-US case) or as part of the *spatial* subject matter (the UP-IS case).

One natural approach to this problem, as to how information about *two* similar or S-related components of pictorial meaning can be derived from a *single*, aspectually oriented concrete artifact A, is to postulate a working assumption of *artistic realism* with respect to S, as discussed in the previous section. Thus pictorial perception can fill in the inevitable gaps in the specific aspectual information provided by artifact A, by making *default assumptions* about any missing S-related information that is not specifically aspectually represented by the artifact. As previously discussed, in orientational terms this is an initial assumption that one is dealing with a completely realistic, transparent artwork, such as an accurate color photograph, for which *all three* factors of environmental field, artwork intrinsic orientation, and subject matter are in an identity alignment, with their respective fields in their upright position, hence producing an upright picture-upright subject matter (UP-US) case.

2. Stages in Cognitive Processing of Artworks, and Misrepresentation

Here is a more detailed account of how the artistic realism assumption might work, that will also provide some lower-level further justification for the current orientational analysis. Initially at stage 1, a viewer would perceive some concrete feature of artifact A, such as a certain face-shaped configuration, and hypothesize that it was intended to represent *a face*—that is, a certain schematic, projected, or *hypothetical* subject matter HS. In terms of cognitive processing, this might be a matter of matching the visual shape to one of a

cognitively stored series of *stereotypical* normal face shapes for various races, ages, sexes, and so on). Or if the initial hypothesis was that it was intended to represent the face of a particular, well-known person, then more specific stereotypes would be relevant.[23]

Now if all pictures were *completely* realistic in all respects, including being completely devoid of all artistic commentary, this initial hypothetical matching stage might be all that was required to explain pictorial representation, hence making an orientational double content theory unnecessary. However, a viewer's cognitive pictorial *competence* (and in general, cognitive artistic competence) requires that she be able to deal with normal or characteristic kinds of *failures* of matching in this initial stage—and not only for a particular facelike configuration in a given picture-artifact, but for a whole potential range of pictorial ways in which subject matter matching failures, with respect to the given facelike hypothesized subject matter as compared with a range of possible facelike configurations in different pictures, might occur.

It is at this point that the concept of an *environmental field* becomes relevant. Recall that such a field F is an oriented structure whose top element is an appropriate initial, stereotypical realistic element HS, but whose other elements *deviate*, in one or more dimensions, from that top realistic element HS in likely or characteristic ways—such as in medium-specific ways, as discussed in the next section.

Thus the next or *second* stage of cognitive processing would attempt to match the original, concrete facelike configuration perceived in artifact A with one of these *environmental field* elements in field F—other than with its field top HS, that is, since if a field top match had been achieved in the first stage, then this second stage of processing would be unnecessary. If the matching succeeds, then the *oriented position* of the matched element in field F would serve to define the *field orientation* O, with respect to hypothetical subject matter HS, of the concrete artifact in question.

On the other hand, if a match is still not possible in this second stage, then the viewer would have *failed* to understand the relevant concrete shape

23. To be sure, stage 1 subject matter guessing or recognition may itself be facilitated by information relevant to stage 2 (see below). Thus there is a familiar "chicken versus egg" issue—every chicken is hatched from an egg, but every egg is laid by a chicken—of (in this case epistemic) priority in such cases, because arguably in some cases the cognitive ability to *initially* recognize a subject matter S itself depends on assumptions about the likely field contents and structure of the subject matter. For example, if one is looking at a drawing, then one's perceptual expectations will have already been adjusted for likely fields that are *appropriate* for perception of drawings. Thus some stage 2 processing concerning field structure may "prime" or enable a viewer's stage one subject matter guess. Hence the three stages of cognitive processing laid out here are somewhat oversimplified as a general account.

in artifact A as a representation of hypothetical subject matter HS, and so consideration of some alternative hypothesis about its hypothetical subject matter would become appropriate.

However, in a case where this second stage of the analysis is successful, there is not yet any separation of aspect representation of HS-related *medium content* from that of HS-related *subject matter*. Thus at this stage artifact A is, in effect, perceived as only *generically* aspectually representing the relevant artwork having subject matter HS, and no decision has yet been made as to the relevant field orientation of either the artwork, or of its specific subject matter.

Hence a further, *third* stage of processing is required, in which there would be a *disambiguation* or *separating out* of medium content from subject matter elements in the relevant artwork. In usual or normal cases, any deviations from realism with respect to HS—and hence a nonupright field orientation O of artifact A with respect to HS—would be entirely explained in terms of an aspectually corresponding, *non*upright field orientation O of some item in the relevant medium content, in which case the *actual* subject matter S of the picture would be identical with the *hypothetical* subject matter HS. Or, in orientational terms, the initial default presumption of identity alignments for all three elements of environmental field, picture, and subject matter would have been maintained for the picture-subject matter alignment, but would have failed for the environmental field-picture alignment, hence producing overall an IP-US case.

However, in *unusual* cases this third stage of processing could produce a different, dual result—for example, if one had independent evidence that *no* artistic commentary on the hypothetical subject matter HS was intended by the artist. In that case, the nonupright field orientation of artifact A with respect to hypothetical subject matter HS would have to be explained instead in terms of a corresponding nonupright relative field orientation of the *subject matter* with the *picture*—so that the *actual* subject matter S would not after all correspond with the hypothetical subject matter HS, hence producing an orientational UP-IS case (in place of the previous IP-US case).

But this UP-IS kind of case is precisely what is needed to explain the general possibility of *mis*representation, which concept similarly requires both that there be representation of a subject matter HS, while yet the actual or specific value of the subject matter should be a divergent value S—as in the case where the possibility was considered that Warhol represented Marilyn's pink face as being red. It is a strength of the orientational analysis that it can naturally capture both elements, in that the intrinsic top HS (pink) of the subject matter is in a (broadly) inverse alignment with the relevant divergent value S (red) in the picture field.

Also, since this explanation of misrepresentation depends, in more

abstract terms, simply on a nonupright alignment of one item with another that acts as a field for it, this explanation will also explain misrepresentation in cases of purely *delineative* (see chapter 9), *single*-stage aspect representation, such as that of an inaccurate map of a region. (See 5 below for further points about misrepresentation.)

3. Representation Stages Are Not Completely Separate

But there remains an aspect of double content misrepresentation cases that needs further explanation. These UP-IS cases are cases where it is determined, as a result of stage three of the analysis, that the concrete artifact A aspectually represents not the relevant artistic *artwork* as in IP-US cases, but instead its *subject matter* S. But then, strictly speaking, the overall double content account of two completely separate stages of representation—of concrete object-*artwork* (CA) representation, followed by artwork-subject matter (AS) representation—has been shown to be an oversimplification.

However, in all such cases, the artwork will still *itself* intrinsically represent the relevant subject matter element S that the artifact aspectually represents. Thus in such cases the artifact provides explicit *evidence* as to which subject matter element S is represented by the artwork, so that it has only an epistemic rather than an ontological role in determining the subject matter of the artwork. Second, as just discussed, the main cases of aspectual representation of subject matter by an artifact are *mis*representation cases, so that correct representation cases are untouched by this anomaly. Third, it is still true that, at the second stage of analysis, all aspectual representation by concrete artifacts is of undifferentiated or generic *artworks*, rather than of any actual subject matter.

And fourth, in every actual case, there will be *some* respects in which a given artwork-related artifact does aspectually represent *some* medium content elements, so that there are no "free-floating" artworks, *none* of whose medium content elements are aspectually represented by an artifact. Thus overall the DC two-stage model of representation for artworks has only been minimally oversimplified in previous discussions of it.

4. Duality Cases Involve Common Tops

Another more technical matter that needs to be clarified concerns the IP-US, UP-IS duality cases and the precise orientational differences between them. Though such simultaneous inverted and upright *pictures* cannot be identical with each other, any more than can their simultaneous upright and inverted *subject matters*,[24] nevertheless it does not follow that the intrinsic *tops* of the pictures

24. See the initial discussion of these matters in section 9.2.

are different from each other, nor that the intrinsic tops of their subject matters are different from each other. Instead, in each case both pictures have the *same* intrinsic top as each other, with a similar point applying to their subject matters. Indeed, these points could be viewed as intuitively *necessary* requirements, given the artistic realism initial assumption of three identical aligned intrinsic tops, divergence from which is created *solely* by a change in alignment of one or more of those *same* tops relative to the environmental field top.

In order to see how this would work, consider again the section 9.2 example of a painting A of a car. This time it is necessary to go over the example in more exhaustive detail. The orientational relations of *ten* items— one environmental field F, one physical artifact A and two of its sides (W and Z), two pictures (P1 and P2) and their common intrinsic top T(P), plus the two respective subject matters (S1 and S2) having a common intrinsic top T(S)—have to be considered.

Initially the field top of physical painting A, as aligned with environmental field F, is a side W, which side is initially aligned with the intrinsic top T(P) of picture P1, which picture depicts a car in an upright orientation, so that its subject matter S1 (the upright car) has an intrinsic top T(S) that is also initially aligned both with top T(P) and with side W of painting A.

When the physical *painting* A is inverted, the result may be interpreted either as an inverted picture P1 of an upright car (the IP-US case), or as a distinct, upright picture P2 of an inverted car (the UP-IS case).

The first IP-US interpretation assumes that the inversion of the physical painting A also results in an inversion of the *intrinsic top T(P)* of picture P1. Thus on this interpretation, the intrinsic top T(P) of picture P1 remains *aligned with* side W of the physical painting as W is rotated to an inverted position. While at the same time, the intrinsic top T(S) of subject matter S1 must, because of the OSMI principle, also remain aligned with the rotated intrinsic top T(P) of P1, so as to maintain subject matter S1's *same relative field alignment* with picture P1, so that as a result T(P) will also end up still aligned with side W of painting A. Thus, in sum, on the IP-US interpretation, inversion of the painting-artifact A is interpreted as resulting in an aligned field inversion of *all three* of side W plus intrinsic tops T(P) and T(S).

However, in the alternative, upright picture-inverted subject matter (UP-IS) interpretation, the inversion of A, and hence of side W does *not* also result in the inversion of the common intrinsic top T(P) of pictures P1 and P2—as one might expect, since this is an *upright* picture interpretation. But the inversion of A does still result in the inversion of the intrinsic top T(S) of the *subject matter* S1, so that as a result its top T(S) ends up still aligned with side W of A. However, in that position T(S) is now in an *inverted* relative field alignment with the intrinsic top T(P) of its picture—hence, in sum, making this a UP-IS case.

To summarize both cases together, on the first IP-US interpretation, inversion of the artifact A also inverts top T(P) of picture P1, which top inversion must also invert T(S) so as to maintain the relative alignment of T(P) and T(S). However, on the alternative UP-IS interpretation, inversion of A also inverts *only* T(S), and *not* T(P)—hence altering the *relative* alignment of T(S) with T(P) to an inversion relation, resulting in an inverted subject matter (IS).

Thus, in sum, it is possible to explain the orientational changes in each alternative interpretation on the assumption that pictures P1 and P2 share a *common intrinsic top* T(P), and that subject matters S1 and S2 share a common intrinsic top T(S)—which is also the simplest way in which to interpret the intuitive IP-US versus UP-IS duality of the two pictures.[25]

However, it should be stressed that such duality cases are primarily of theoretical interest, in that normally only *one* of them is a plausible *artistic* interpretation of the relevant concrete artifact—because one function of medium content is to represent the intentions and artistic actions of the artist in creating a work,[26] and normally those artistic *intentions* will unequivocally determine which orientational interpretation is correct, for the whole range of relevant orientational factors in an artwork. Thus the current orientational DC theory should not be viewed as leading to a pervasive skepticism concerning the possibility of correct or univocal interpretations of artworks.

5. Common Fields and Misrepresentation

Given the above explanation of the IP-US versus UP-IS duality, it should also now be clear why both the *environmental field* and the *artwork* orienta-

25. For completeness some related forms should be mentioned. Recall from section 10.2 that a UP-US form can also be interpreted as an IP-IS form (since their relations are an inverted form of the IP-US/UP-IS duality). But this means that the issue of whether inversion of an artifact produces inversion of one, or both, of the picture and subject matter is itself dependent on the interpretation given to the initial form—whether as UP-US or IP-IS. For UP-US to IP-US requires a triple inversion (of artifact, picture, and subject matter), but IP-IS to IP-US requires only a double inversion (of artifact and subject matter). Also UP-US to UP-IS requires only a double inversion (of artifact and subject matter), but IP-IS to UP-IS requires a triple inversion (of artifact, picture, and subject matter).

The point should also be made that the upright/inverse descriptions used in these forms are relative to an *initial interpretation* of the *hypothetical* subject matter of an artwork. Thus, for an example, if a painting is initially interpreted as a picture of an *inverted* car, then that interpretation will nevertheless define the *UP-US* labeling instead of the UP-IS labeling of the relevant orientational forms. Thus "upright" and "inverted" in these formulas are defined relative to such an initial interpretation.

26. See chapter 5.

tional field must be identical. For that duality can hold in *all* cases only if *identical* field elements are available in all cases, both for an artwork and for a (hypothetical) subject matter to be aligned with.

But that result also offers an important insight into the nature and limits of *misrepresentation* of a subject matter (on which see also 3 above). On the current account, the limits of possible misrepresentation of subject matter HS are set by the limits of possible *commentary* on HS, for a given medium, style, and artist—for both depend on the same common *field*.

Or in cognitive processing terms, as discussed in 3 above, a hypothesized or guessed subject matter HS can only be confirmed as relevant or *applicable* to a concrete artifact if a *match* with some element of the common field is achieved at stage 2 of the cognitive processing. But this initial match occurs *prior* to a stage 3 determination of whether the match should be interpreted as relevant to the artwork, or to its subject matter. Thus misrepresentation draws from the same initial pool of meaning as does artistic commentary.

Here is a more intuitive argument for a stronger conclusion, which equivalently considers transformations of *HS itself* with respect to the field. An initial guess at, or recognition of, a hypothetical subject matter HS can only be tentative, until one is able to cognitively *transform* HS, in some standard way, into something that *matches* some actual shape and the like in the relevant concrete artifact A. Thus either artifact A must directly match HS in some respect, or it must match some standard or *meaningful* transformation of HS (where a transformation is *meaningful* just in case it tracks values of a field appropriate for the medium, style, and so on of the artwork).

But meaningful transformations of HS are, at least tentatively, part of the *medium content* of a potential artwork rather than of its subject matter: transforming HS into something else in a meaningful way is a way of *commenting* on it, or at least of seeing it *in a new perspective*. Thus the ability to perceive A *as a transformed HS*—to perceive it in that medium content perspective—could be regarded as being a necessary cognitive skill in the stage 2 matching process.

Hence a stronger conclusion can be drawn—not just that misrepresentation draws from the same initial pool of meaning as does artistic commentary, but that it is specifically the commentative possibilities themselves that determine the range of possible cases of misrepresentation. Or to put the matter another way, a case of misrepresentation *just is* a case where the hypothetical subject matter HS has to be significantly transformed in some tentative medium content way to achieve matching with artifact A, but where that transformation cannot be explained away in stage 3 of the analysis as a genuine case of a medium content change of orientation.

6. *Actual Changes in Field Orientation*

One other kind of case should be discussed, to further solidify the connection of orientational concepts with more miscellaneous artistic factors. These are cases where an already existing UP-US artwork undergoes some *actual—* rather than merely *interpretive*—change in its field orientation, to produce an IP-US artwork that nevertheless has the same intrinsic orientation and subject matter.

For example, in traditional nondigital photographic media, a photograph exists first as a photographic negative (whether black and white or colored), from which positive prints may be made having inverted light or color values relative to their respective negatives.[27]

Thus if the positive prints are regarded as being UP-US works (see the previous discussion as to how accurate color photographs are paradigm cases of UP-US works), then a relevant negative is an IP-US form that is a field-inverted form of its corresponding UP-US print, but which has the same intrinsic orientation and hence the same subject matter. For example, an experienced darkroom worker will routinely look at the physically dark sky and light foliage in a black-and-white negative, and *interpret* its subject matter as being light sky and dark foliage—which would be an IP-US interpretation of the physical negative.

Nevertheless, as in the Marilyn case discussed, any such IP-US form *could* also be interpreted as a UP-IS form, in which a negative is viewed as representing an artwork "in its own right," having *dark* skies and *light* foliage as its subject matter—in spite of the fact that normally this would be an implausible or even illegitimate artistic interpretation of the negative, in that most photographers regard negatives as mere intermediaries in their production of a final positive print.

7. *The Special Case of Spatial Orientation Properties*

In the specific case of *spatial orientation* as a subject matter factor, some care is needed to distinguish that content factor *as such*, from the logical or semantic structure of the current orientational analysis, which is using a more abstract form of concepts such as that of uprightness, and of the intrinsic top of the relevant subject matter factor. For example, a picture whose realistic subject matter is a prone, *non*upright person (in the everyday sense that the person is not standing upright) would have a subject matter

27. Other traditional fine art printmaking media, including etching and lithography, provide similar examples in which a printing plate may have inverted values relative to the final prints made from it.

that nevertheless would count as being *logically* upright in the relevant sense, since its content is a correct representation of the subject matter.

As an aid to clarifying this distinction, one may imagine the subject matter elements of a picture, including the prone person, as being enclosed in a rectangle that is the same size as the picture. That rectangle has an intrinsic orientation because its field top has a salient property not possessed by its other sides, namely that when it is aligned with the intrinsic top of the relevant *spatial field*, the subject matter may be seen in its *correct* prone, "everyday" orientation. Hence the relevant field top is also an intrinsic top, and its alignment with the intrinsic top of the field entails that it is also logically upright.

8. The Iteration (Nesting) Issue

Any theory of the nature of artworks must be able to cope with (what could be called) the *iteration* or *nesting* issue, namely that the subject matter of an artwork may itself be an artwork—or at least, a representation—that in turn has its own subject matter. For example, section 4.3 mentioned the case of Velasquez's painting *Las Meninas*, in which a representation of a painting is included as part of the subject matter of the work. In such a case, the physical painting has a *triple* rather than a double content—and so on for further possible iterations or nestings.

In the present theory, the handling of such cases is straightforward. Double content artworks involve three orientational items for each subject matter factor, namely an environmental field, an artwork, and its subject matter, which in a "perfect realism" case would have all three tops in an identity alignment with each other. Further iterations or nestings simply add one more such identical orientational item for each iteration.

Also, at each stage further possibilities of interpretive ambiguity are added, since the initial concrete artifact now has to aspectually represent three or more levels of content. For example, in the triple case, a spatially inverted painting of a picture could be interpreted as an IP-US1-US2 case, or as a UP-IS1-US2 case, or as a UP-US1-IS2 case. Each additional level of subject matter is intrinsically represented by the level immediately prior to it.

12.6. THE NATURE OF A MEDIUM, AND OF ARTISTIC STYLE

In the previous two sections it was noted that the idea of *artistic realism* provides a useful initial guide in understanding artworks and their orientational

factors. However, that initial realistic guide takes no account of the unique characteristics of *particular art media*, such as the visual arts, differences between photography, painting, watercolor, pastel, etching, drawing, and so on, with other distinctive differences for nonvisual media such as various kinds of music, dance, architecture, and literary art media such as novels, plays, or poems.[28] Thus a question arises as to how each medium is able to preserve realism in the *subject matter* of artworks using the medium, in spite of these media-specific differences.

Presumably an optimal solution to that question would preserve the realistic assumption as far as possible, while nevertheless resolving the issue in terms of a single general kind of factor that determines such media differences. The purpose of this brief section is simply to point out that such a general answer to the question is now available in orientational terms.

Sections 12.4 and 12.5 showed in a particular case (the reddish Marilyn picture) how any *nonrealistic* elements in a picture may be explained in terms of a *changed field orientation of the picture itself*, or of some particular element or elements of the picture, rather than having to assume that the *subject matter* is unrealistic. Or, in medium content terms, an artist is free to *comment on* the unchanged subject matter by making implicit use of the *inverted picture-upright subject matter* (IP-US) orientational mechanism.

But, as was pointed out in chapter 5, an artistic medium is *itself* a language, or a series of related expressive factors, which may be thus used by an artist to *comment on* some subject matter. Hence my claim is that an art medium is simply the *collection* or *group* of such *characteristic expressive factors*, which could be thus used in orientational ways by individual artists for their own commentative purposes. Or in more explicitly orientational terms, a medium is a *group of characteristic environmental fields*, each of which is so structured that its salient top is a realistic element, but with its other elements being *divergent* from that realistic case in characteristic, medium-specific ways.[29]

Then in a normal use of a medium, the realistic intrinsic top of the artwork is field aligned with one of those (broadly) *inverse* field elements, rather than with the realistic field top, hence making use of the IP-US mechanism in which such characteristic field-related media effects will be interpreted as part of the *commentary* rather than as part of the subject matter.

For example, a linear pencil drawing of a reclining woman might make use of medium-characteristic linear patterns—including roughly parallel lines plus cross-hatching—to show the naturally shaded contours of the

28. See chapters 5 and 6 for more on artistic media.

29. Though strictly speaking the realistic top is not itself relevant to a medium, since characteristic medium effects only appear in artwork field orientations that are *non*upright, that is, aligned with field elements other than its realistic top.

body. Thus in place of alignment with the continuous-tone shading that would be the realistic field top, the intrinsic top of the picture is instead aligned with a broadly inverse, *divergent* form of that shading, in which the relevant *discrete linear patterns* have replaced the continuous tones.

This medium-specific orientational account can also explain how someone who is unfamiliar with the medium of drawing might mistake the result for a picture of a woman with linear patterns on her body. Such a person would be interpreting the physical drawing as being an *upright picture–upright subject matter* (UP-US) picture rather than an IP-US picture, and hence be assuming that the drawing is a completely realistic picture of its (on this interpretation) apparently linearly patterned subject matter.[30] But parenthetically, in this case the usual IP-US versus UP-IS duality does not come into play, because by hypothesis the mistaken viewer *is unsure* as to what the intended subject matter is, and hence can apply only a default UP-US interpretation to the drawing.

One further refinement should be introduced into this orientational account of a medium, so as to make it more cognitively realistic. Rather than supposing that there is a particular field for every possible picture element, instead, one could appeal to *schematic* or *stereotypical* fields, each of which encapsulates some general *class* of divergences from realism, such as the linear-pattern divergence of *any* linear drawings from *any* kind of continuous-tone subject matter. Then a medium is a group of such related schematic divergence fields, each of which includes both an appropriate field and a particular range of *alignments* in that field by characteristic artwork tops.

As to the merits of the current approach to the nature of a medium (in addition to the advantages discussed in chapters 5 and 6), it solves one of the most significant problems about artistic media in general, namely, how it is possible to represent virtually *any* kind of subject matter within the limited expressive resources of a particular medium. Clearly resemblance theories of representation are unable to explain this, since any drawing, for example, more resembles other drawings than it does any normal subject matter.

However, by partitioning off medium-specific limitations as *ways of commenting on* subject matter, as is theoretically made possible by a double content orientational theory, such limitations of a simple resemblance theory can be overcome.

Turning now to artistic *style*, whether a general style such as impressionism in painting, or an individual style such as that of the impressionist painter Monet, such styles could naturally be regarded as being more specific subdivisions within the divergence fields that characterize an individual medium such as oil painting, as discussed above. Thus the characteristic ways

30. A related case of correct versus incorrect interpretations was discussed in section 5.4.

in which impressionists use such a medium will generate a more specific group of schematic divergence fields—chosen from the full range of possibilities of a medium—and then an individual style by a particular artist will further subdivide that group in characteristic individual ways. Of course, much more could be said about these matters,[31] but the current points should be sufficient to show at least the basic outlines of a double content theory of artistic style.

12.7. ASPECTUAL AND INTRINSIC FORM VERSUS SUBSTANTIVE CONTENT OF ARTWORKS

The recent discussions of aspect representation by concrete artifacts have concentrated on broadly *formal* characteristics of the resulting content, such as the orientational structure of artistic commentaries, or of subject matter misrepresentations. Also, the intrinsic representation by an artwork of its subject matter also generates broadly formal subject matter characteristics. However, though clarity on these theoretical matters is important in developing the basic structure of a DC theory, it must not be forgotten that all such broadly formal structures in artistic content—whether in medium content, or in subject matter—are mere tools to be used by artists for their own purposes (presumably usually in implicit or unconscious ways).

As explained in chapter 5, the more substantive artistic or aesthetic kinds of content of an artwork, including such matters as the expressive intentions of the artist and the resulting emotional content of the subject matter, must somehow *themselves* be represented by the relevant concrete artifact, so that the formal structures provided by aspect plus intrinsic representation can only provide a minimum scaffolding for such substantive representation.

Nevertheless, the current account does provide one clear and theoretically principled way in which to distinguish artistic form from content, whether the distinction is interpreted as distinguishing artwork structure from subject matter content, or as a distinction between formal versus substantive aspects of an artwork's subject matter itself.

On the present view, formal considerations are provided by the orientational scaffolding, "content" considerations (in the usual sense, as contrasted to form) are provided by an artist's decisions as which specific orientational structures will best enable her artwork to express the substantive content that she desires it to express, when it is appropriately interpreted by her artistic audience.

31. Though chapters 5 and 6 did discuss stylistic and expressive features of artworks in connection with the concept of medium content.

To be sure, these points do not directly address another common mean-ing of "form," namely that in which it concerns the *interrelations* of the parts or aspects of an artwork that together make up its "content," in another pos-sible "form versus content" distinction. But the discussions in the following two sections will show how the DC theory is also able to handle ways in which artistic content involves inseparable interrelations.

12.8. INSEPARABILITY VERSUS INDEPEN-DENCE OF SUBJECT MATTER

There is still an important remaining issue about artwork-subject matter (AS), or intrinsic, representation that needs to be resolved. One major theme of the present book has been that an individual artwork is *inseparable* from, or *neces-sarily co-occurrent with*, its own individual subject matter (for example, as dis-cussed in chapters 1 and 2, and most prominently in chapter 6 with the "twofold" thesis for visual artworks). But at the same time, another major theme of the book has been that an artwork and its subject matter play complementary and relatively independent roles with respect to a possible series of related art-works, in that one can distinguish a possible range of artist's (medium-content-based) commentaries on a given subject matter from the subject matter itself (as in chapters 5 and 6), which distinction has been shown, in section 12.4, to be closely related to the oriented subject matter invariance (OSMI) principle, according to which the same oriented subject matter can occur in distinct art-works that each have *different* field orientations in appropriate respects.

As a preliminary step in removing the appearance of any conflict here, distinguish cases of sameness of subject matter where "same" means *identi-cally* the same, that is, having *all* properties in common, from other cases where it simply means *descriptively* the same, that is, falling under the same classification, or having *some* property (rather than all properties) in common. The inseparability thesis claims that no artwork can have *identically* the same subject matter as another, but of course this does not rule out that the subject matters of distinct artworks might have or share some of their properties or classifications.

For example, Cezanne produced a series of paintings of Mont St. Vic-toire in France, each of which may be described as having "the same subject matter" (namely the relevant mountain) in a generic or classificatory sense, so that each shares at least one subject matter property. While at the same time, each such painting may also be described as providing a *distinct painterly commentary* on that same generic subject matter. So one can distinguish the common *generic* subject matter of each painting from its own completely spe-

cific subject matter, which it possesses only with respect to its own, equally specific painterly commentary on that specific subject matter.

However, more investigation is still needed, because if each subject matter was only associated with a set of ordinary, *non*relational content properties, then it would be possible for two distinct artworks Ai and Aj to be distinct because of their different medium content property sets P(Mi) and P(Mj), yet nevertheless have the *same* subject matter, that is, have a single *joint* subject matter property set P(Si)—hence violating the inseparability requirement for medium content and subject matter, since that subject matter property set P(Si) would be shared by both artworks, and hence co-occur with both medium content property set P(Mi) and with the distinct set P(Mj).

In order to explain what went wrong in this initial view of the properties associated with a given subject matter Si, recall the discussion of inseparability in section 6.4, in which it was noted that a viewer's seeing of visually construed subject matter is *"inseparably linked* to the very picture that she is currently seeing, since it is the subject matter *as construed by that very picture* that constitutes the 'subject matter' as seen by her." Thus insofar as subject matter is to be explained in terms of an associated set of content properties, those properties must reflect and include the *integral relations* of a given subject matter Si to its own unique artwork Ai—and hence to its associated medium content property set P(Mi).

What this means is that every *non*relational property Pk in the Si property set P(Si) must be paired with a corresponding *relational* property RPk(P[Mi]), which relates it to the unique relevant *medium content property set P(Mi)* for that particular artwork Ai. Thus, for example, the generic property of "being Mont St. Victoire," as possessed by the internally represented mountain X', must be paired, in the subject matter property set P(Si), with the relational property of X' of "being Mont St. Victoire *as construed by picture Ai*," so that subject matter property set P(Si) has as two of its members *both* property Pk *and* its corresponding relational property RPk(P[Mi]).

Moreover, since inseparability is a symmetric relation, similar points must apply to the relevant *medium content property set* P(Mi) as well, for as noted in section 6.4, ". . . any given visual construal is *inseparably linked* to the subject matter about which it is a construal. For it would not be *a* visual construal unless it was about (or, represents) *some* particular subject matter, and it could not be identified as *the particular visual construal that it is* independently of the one particular subject matter that it represents." Thus, for example, the generic *non*relational medium content property Pq of "being a visual commentary on Mont St. Victoire," as possessed by all of Cezanne's paintings of that mountain, must be paired, in the medium content property set P(Mi), with a *relational* property RPq(P[Si]) of "being a visual commentary on the *particular* Mont St. Victoire-related subject matter Si."

To complete the clarification, it only remains to specify that *all* of the relational property members of a given subject matter set Si must relate the subject matter to the *same* single medium content set Mi—and similarly for Mi with respect to Si. Thus, in sum, each set Mi and Si is *inseparable* from the other, while yet there are also *non*relational properties Pk in each such subject matter set Si—one for each of the corresponding relational properties—which can explain any senses in which distinct subject matter sets Si and Sj might be classified as being the same or similar in some respect or feature (with similar points applying to medium content sets).[32]

One further distinction, a tripartite one, would be useful in comparing different artworks with respect to their nonrelational subject matter properties. Two artworks are *generically* the same/similar if they share some *small percentage* of such properties, as with various paintings or pictures of Mont St. Victoire from different perspectives; *specifically* the same if they share some higher percentage of properties, as with same-perspective pictures of the mountain having some minor differences; and *maximally* the same (with maximal specificity) if they share *all* of their nonrelational subject matter properties.

The third kind—of maximally the same/similar artworks, which share all of their nonrelational subject matter properties—is of particular theoretical interest in distinguishing both artistic commentary from subject matter, and in the closely related "orientation-theoretic" distinction of variable field orientation for artworks versus invariant orientation for subject matters (as with the oriented subject matter invariance or OSMI principle). Conceptualized either way, the basic idea is that the *whole* of the nonrelational subject matter of an artwork may be commented on in various ways that are *independent* of that subject matter.

Call this whole, nonrelational subject matter of an artwork its *subject*. Then we may investigate the independence of an artwork from its *subject*, while also accepting that artwork and *subject matter* (which includes the relational properties) are inseparable.

This concept of the subject of an artwork is not merely of theoretical interest. For in making creative changes in an artwork, the artist in effect has to decide whether to change the current *subject* of her artwork in some way, or instead whether to change some aspect of her medium-specific *commentary* on the current *unchanged* subject in some respect.[33]

32. To be sure, these formal relations do not by themselves establish a substantive sense in which medium content and subject matter are inseparable; they only provide a convenient formalization of the substantive inseparability that has been argued for on independent grounds.

33. Though inevitably there will be mixed cases as well, in which, for instance, a formalist concern with medium content rather than subject matter would result in artistic decisions that would change the subject matter too. For example, a photographer who rearranges the formal composition of a scene in the camera viewfinder also inevitably changes the boundary elements of her subject matter.

Thus the relevant distinction is likely a pervasive underlying factor in the creative cognition of artists—and hence of interest to artists and educators, psychologists and cognitive scientists as well as aestheticians. Indeed, the invariant subject versus variable medium content distinction is a potentially attractive topic for studies in *experimental* aesthetics, as is the related UP-IS/IP-US duality of orientational forms that shows differing underlying "identifying" perceptual interpretations of a concrete object.[34]

(The two distinctions are of course related by considerations of field orientation of artworks or artwork factors. The "invariant subject versus variable medium content" distinction assumes a relative fixed field orientation for the subject matter, while the UP-IS/IP-US duality assumes a changed, inverted field orientation for one of the forms.)

As to how experiments on these matters might be structured, there are already available in several media various ways of systematically varying individual factors in artworks, while keeping the rest constant. For example, in the visual arts an "image editing" computer program such as Photoshop may be used to alter the color, intensity, geometry, and so forth of an image in various ways, and to varying degrees. Or in the case of music, musical synthesizers are available that can alter the timbre, pitch, and vibrato of individual notes, as well as providing more global rhythmic or harmonic alterations in musical sequences.

Presumably minor adjustments of any such factors would normally be perceived as alterations in the *medium content*—which in these cases would be perceived as *background* or *contextual* changes—rather than as alterations in the subject content itself.[35]

But more major alterations, as in the case of pitch inversion discussed in chapter 10, would likely raise the possibility of *dual* identifying interpretations, either as UP-IS or IP-US forms. Presumably a related practical concern for artists would also arise, namely, how could the artist's *intended* interpretation of such cases be effectively conveyed to the viewer or listener, so as to rule out or prevent such potential ambiguities in genuine artworks (as opposed to ambiguities in test cases in experimental situations) from being perceived as confusing ambiguities by their audience.

34. See section 8.4, and chapter 8 generally.

35. Such studies are closely akin to studies of *perceptual constancies* in perception of normal, nonrepresentational objects, where factors such as different lighting conditions are somehow compensated for so as to make objects look the same in spite of such changes. See, e.g., Vincent Walsh and Janusz Kulikowski, eds., *Perceptual Constancy* (Cambridge, UK: Cambridge University Press, 1998). Such perceptual constancy factors will also be invoked in section 12.10.

12.9. DC THEORY AS AN EIGHT-FACTOR REPRESENTATIONAL THEORY

At this stage it will be useful to further analyze the orientational structure into its minimally necessary components, for though the structure provides a perspicuous and fairly intuitive account of the relevant relations, a complete defense of it would require separate arguments for each of its components in any case. Here is an overview of those components and their interrelations.

Basically the orientational double content theory, when taken apart, is an *eight-factor* theory of representation for subject matters. For any given subject matter, there are two kinds of representation (aspect and intrinsic), two field orientations (one for the artwork, the other for the subject matter), one intrinsic top, one field, and two inseparable contents (inseparable medium content and its inseparable subject matter). Any of these factors could be described or identified in different ways, so there is nothing sacrosanct about the current orientational way of presenting and relating them.[36]

One initial question is as to whether this full eight-dimensional structure, however described, is really necessary to describe the minimum informational content of any *single* artwork (or part or aspect of it). Should the structure instead be regarded as primarily covering a *range* of *possible* artworks, relative to a given hypothetical subject matter, each of which would have different specific field orientation values for its medium content and subject matter, so that individual artworks could be characterized more simply?

Nevertheless, no simpler characterization of individual artworks is possible, for the following reasons. To begin with, the orientational framework may be analyzed as follows for a particular artwork. For the artwork itself, the field orientation of its intrinsic top S (the particular subject matter value) with an element F1i of field F1 may be analyzed as the *value* of that element F1i with which the top S is aligned—call it medium content value MC1i. (For example, in the "reddish commentary on a pink-faced Marilyn" example, the relevant value would be "red" or "a reddish commentary"). Thus to explain medium content, in general we need both the value S and the value MC1i, since otherwise the value MC1i could not be understood as a distinctive commentary on S.

However, those two items by themselves still give an incomplete description of the relevant medium content. Information concerning the relevant field *F1* is needed as well, for example, so that the *relative position* of the value MC1i in the field F1 of elements F1a, F1b, . . . may be established and understood. For example, is the commentary value a relatively *mild* variant

36. For example, section 12.5 discussed a related cognitive process of *matching* through several stages.

on S, or an *extreme* variation on it? Only the structure of F1, and element F1i's position within it, can establish such relational facts, and hence establish the (formal structure of the) meaning of that commentary. Thus overall, *three* distinct items of information are needed to characterize the relevant medium content—and the orientational alignment model of those three items of information is at least one useful way to show their relations.

But a similar analysis applies to the actual subject matter of the artwork: it similarly requires three distinct items of information for its understanding, including a new subject matter value S2i—the value of field element F2i in the artwork's field F2, with which value the top S of F3 is aligned—which expresses the relative field orientation of the subject matter with respect to the artwork, together with the two previously used items of information, namely subject matter S and field F2 (which is not new information since F1 and F2 are qualitatively identical structures). Thus overall, *four* distinct items of information are required to characterize the formal structure and relations of both the medium content and subject matter of an individual artwork—or of an artwork part or aspect, since a combination of many such analyses may be needed to capture its full structure.

The fifth and sixth factors are the two relevant *inseparable* contents (inseparable medium content and its inseparable subject matter) for the artwork in question, which must also be included as distinct factors. The previous four formal items of information make possible, but do not exhaust the substantive content of, these more intuitively meaningful aspects of an artwork, including the actual substance of an artist's commentary on the subject matter (the inseparable medium content) and the ways in which that commentary changes or transforms the conventional subject matter in unique affective and expressive ways (producing the inseparable subject matter). And finally, to complete the eight-factor representational analysis, the two kinds of representation (aspect and intrinsic) must also be included.

As to the issue of how a *series* of such eightfold analyses of parts or aspects of an artwork may be combined to produce an analysis of the *complete* artwork, arguably the issue is a straightforward one, in that the relevant inseparable contents (medium content, or subject matter) in each analysis are *the same*. Or in more metaphorical terms, the inseparable contents provide a *common sea*, which is fed by all of the individual analytical tributaries that combine their effects to produce it.

For example, the substantive artistic content of the background subject matter in a picture cannot be adequately understood other than in terms of its relations both to the other subject matter elements, such as the foreground subject matter, and to the relevant medium content such as the artistic style with which that background subject matter was painted, and how that style interrelates with the style with which all the other subject matter areas were

painted, and with respect to other relevant intentions of the artist, and so on. Thus each analysis A of an aspect or part P of an artwork will provide its own *perspective* on the artwork's two kinds of substantive, common inseparable content because of analysis A's own distinctive formal or orientational qualities, but those two kinds of inseparable content of the artwork itself remain the same through all such specific analyses of the work.

12.10. A NATURALIST ARGUMENT FOR THE DC THEORY

To conclude, it is now possible to argue that a double content theory of representation must be true on broadly *naturalist* cognitive grounds, in that we would not cognitively be able to produce and understand representations in general unless a large central class of them had the proposed double content structure.[37]

The argument for this view is straightforward. The ability to perceive representations as such requires that we have cognitive mechanisms that enable us to *compensate* for the often very significant differences between miscellaneous representations of objects X, and actual or real Xs. Or in more directly perceptual or recognitional terms, it must be possible for us to perceive some artifact A, which is not itself an X, as a *transformed* or *significantly modified* actual X, since this is the only legitimate way in which such non-X objects could nevertheless be *recognized* as having characteristics that are in some way related to X-characteristics.

However, this process, if it is to be a legitimate perceptual or recognitional process—rather than a mere illusory trick or pretense—cannot be explained by postulating merely that the subject matter X makes up the whole representational content of object A. Instead, the relevant transformations or modifications must *themselves* be part of the representational content of A—so that it is a *transformed* X that one genuinely does perceive as the content of A, rather than one's merely having an *illusory* perception of a *non-*transformed X as being the content of A. But then a *double* content theory of representation is required to explain the presence of the relevant transformations, which are part of the medium content of artifact A.

In a broader perceptual context, *perceptual constancy* mechanisms are required so as to adjust for actual variations in visual retinal data if, for example, a person walks by a picture, so as to allow it to appear as having a constant square shape. Here, too, *perceptual transformations* must be involved,

37. The rest of which, on my account, have a single content or delineative structure—except for a few exceptional cases having more than two levels of content.

and be retained as part of one's perceptual information, since one is simultaneously aware, without any illusion, that the picture looks different at different angles even though it still looks square. So the double content *representational* mechanisms are simply an extended version of standard perceptual mechanisms[38] for perception of actual objects.[39]

Seen in this perspective of normal perceptual cognitive processing, the orientational double content theory that has been developed is no more than a convenient way of summarizing and generalizing the structure of these necessary cognitive tasks, so as to reveal their role in our understanding of representations and their contents. Thus the current theory is justifiable at a very fundamental level of cognitive science.

Thus in this broadly naturalistic perspective, the chapter 11 arguments for the legitimacy of the concept of internal representation could be paralleled by a naturalistic argument to the effect that perception of representational objects can best be understood, in its integral connections with perception of nonrepresentations, if perception of, and references to, *internal representational content* are accepted as scientifically legitimate. Hence the account of reference to fictional objects, as discussed in the early chapters and elsewhere, is also defensible on broadly naturalist grounds.[40]

As for other arguments for the general double content (DC) theory, the chapter 5 argument to the effect that intentional, stylistic, and expressive aspects of artistic meaning must be accounted for in some representational way—because there is other way in which a completed concrete artistic artifact could "embody" or contain these kinds of artistic meaning—remains a conclusive one, in tandem with its arguments to the effect that these "commentative" kinds of meaning are distinct from subject matter or referential meaning, so that *two* kinds of content rather than just a single kind must be involved in such artistic cases. Furthermore, such primarily aesthetic arguments for the existence of both medium content and subject matter content neatly dovetail with the more naturalistic orientational arguments just discussed. Thus the resulting DC theory is securely anchored in both aesthetic and naturalistic considerations.

38. See the evidence presented in my paper "The Double Content of Perception," forthcoming in *Synthese*.

39. Indeed, on representational or indirect theories of perception itself, the theoretical connections of perceptions of representations, and of actual entities, would become even closer.

40. For a representational and naturalist account of properties in general, see my paper "A Representationalist Approach to Generality," *Philo* 6, no. 1 (2003): 216–34.

Bibliography

Boden, M. A. 2000. "Crafts, Perception, and the Possibilities of the Body." *British Journal of Aesthetics* 40, no. 3 (July): 289–301.

Borges, J. L. 1985. "Pierre Menard, Author of the *Quixote*." In J. L. Borges, *Labyrinths*. Harmondsworth, Middlesex, UK: Penguin.

Budd, Malcolm. 1992. "On Looking at a Picture." In *Psychoanalysis, Mind and Art: Perspectives on Richard Wollheim*. Edited by Jim Hopkins and Anthony Savile. Oxford, UK: Blackwell.

Carroll, Noël. 1998. *A Philosophy of Mass Art*. Oxford, UK: Clarendon Press; New York: Oxford University Press.

Collingwood, R.G. 1945. *The Principles of Art*. New York: Oxford University Press.

Crittenden, Charles. 1991. *Unreality: The Metaphysics of Fictional Objects*. Ithaca, NY: Cornell University Press.

Currie, Gregory. 1989. *An Ontology of Art*. New York: St. Martin's Press.

———. 1990. *The Nature of Fiction*. Cambridge, MA: Cambridge University Press.

Danto, Arthur C. 1964. "The Artworld." *Journal of Philosophy* 61: 571–84.

———. 1981. *The Transfiguration of the Commonplace: A Philosophy of Art*. Cambridge, MA: Harvard University Press.

———. 1986. *The Philosophical Disenfranchisement of Art*. New York: Columbia University Press.

———. 1999. "Indiscernibility and Perception: A Reply to Joseph Margolis." *British Journal of Aesthetics* 39, no. 4 (October): 321–29.

———. 2001. "The Pigeon within Us All: A Reply to Three Critics." *Journal of Aesthetics and Art Criticism* 59, no. 1: 39–44.

———. 2001. "Seeing and Showing." *Journal of Aesthetics and Art Criticism* 59, no. 1: 1–9.

Dauer, Francis W. 1995. "The Nature of Fictional Characters and the Referential Fallacy." *Journal of Aesthetics and Art Criticism* 53, no. 1: 31–38.

Davies, David. 2004. *Art as Performance*. Oxford, UK: Blackwell.

Davies, Stephen. 1991. *Definitions of Art*. Ithaca, NY: Cornell University Press.

———. 2001. *Musical Works and Performances*. Oxford, UK: Clarendon Press.

Dickie, George. 1984. *The Art Circle: A Theory of Art*. New York: Haven.

———. 1997. "Art: Function or Procedure—Nature or Culture?" *Journal of Aesthetics and Art Criticism* 55, no. 1 (Winter): 19–28.

Dilworth, John. 1980–81. "Representation and Resemblance." *Philosophical Forum* 12, no. 2 (Winter): 139–58.

———. 2003. "Ariadne at the Movies." *Contemporary Aesthetics* 1. http://www .contempaesthetics.org/pages/article.php?articleID=203.

———. 2003. "Ariadne Revisited." *Contemporary Aesthetics* 1. http://www .contempaesthetics .org/pages/article.php?articleID=211.

———. 2003. "A Representationalist Approach to Generality." *Philo* 6, no. 1: 216–34.

———. 2004. "Artistic Expression as Interpretation." *British Journal of Aesthetics* 44, no. 1 (January): 10–28.

———. Forthcoming. "The Double Content of Perception." *Synthese*.

Donnellan, Keith. 1966. "Reference and Definite Descriptions." *Philosophical Review* 75: 281–304.

Evans, Gareth. 1982. *The Varieties of Reference*. Oxford, UK: Oxford University Press.

Feagin, Susan. 1998. "Presentation and Representation." *Journal of Aesthetics and Art Criticism* 56, no. 3: 234–40.

Frege, Gottlob. 1960. "On Sense and Reference." In *Translations from the Philosophical Writings of Gottlob Frege*. 2nd ed. Edited by Peter Geach and Max Black. Oxford, UK: Blackwell.

Gombrich, Ernst H. 1962. *Art and Illusion; A Study in the Psychology of Pictorial Representation*. 2nd ed. London, UK: Phaidon Press.

Goodman, Nelson. 1968. *Languages of Art: An Approach to a Theory of Symbols*. Indianapolis: Bobbs-Merrill.

Harrison, Andrew. 1987. "Dimensions of Meaning." In *Philosophy and the Visual Arts: Seeing and Abstracting*. Edited by A. Harrison. Boston, MA: Kluwer Academic Publishers.

Iseminger, Gary. 1992. *Intention and Interpretation*. Philadelphia: Temple University Press.

Jacquette, Dale. 2000. "Goodman on the Concept of Style." *British Journal of Aesthetics* 40, no. 4: 452–66.

Janaway, Christopher. 1997. "Two Kinds of Artistic Duplication." *British Journal of Aesthetics* 37, no. 1: 1–14.

———. 1999. "What a Musical Forgery Isn't." *British Journal of Aesthetics* 39, no. 1: 62–71.

Kivy, Peter. 2000. "How to Forge a Musical Work." *Journal of Aesthetics and Art Criticism* 58, no. 3 (Summer): 233–35.

———. 2002. "Intentional Forgeries and Accidental Versions: A Response to John Dilworth." *British Journal of Aesthetics* 42, no. 4: 419–22.

Knapp, S., and W. Michaels. 1992. "The Impossibility of Intentionless Meaning." In *Intention and Interpretation*. Edited by Gary Iseminger. Philadelphia: Temple University Press.

Lamarque, Peter. 1996. *Fictional Points of View*. Ithaca, NY: Cornell University Press.

Levinson, Jerrold. 1990. *Music, Art, and Metaphysics: Essays in Philosophical Aesthetics*. Ithaca, NY: Cornell University Press.

———. 1990. "What a Musical Work Is." In J. Levinson, *Music, Art, and Metaphysics: Essays in Philosophical Aesthetics*. Ithaca, NY: Cornell University Press.

———. 1996. "Art as Action." In Jerrold Levinson, *The Pleasures of Aesthetics*, 138–49. Ithaca, NY: Cornell University Press.

———. 1998. "Wollheim on Pictorial Representation." *Journal of Aesthetics and Art Criticism* 56, no. 3 (Summer): 227–33.

Lopes, Dominic. 1996. *Understanding Pictures*. Oxford, UK: Clarendon Press; New York: Oxford University Press.

Margolis, Joseph. 1980. *Art and Philosophy*. Brighton, Sussex, UK: Harvester.

———. 1989. "Reinterpreting Interpretation." *Journal of Aesthetics and Art Criticism* 43: 237–51.

———. 1998. "Farewell to Danto and Goodman." *British Journal of Aesthetics* 38, no. 4 (October): 353–74.

———. 2000. "A Closer Look at Danto's Account of Art and Perception." *British Journal of Aesthetics* 40, no. 3 (July): 326–39.

Maynard, Patrick L. 1985. "Drawing and Shooting: Causality in Depiction." *Journal of Aesthetics and Art Criticism* 44: 115–29.

———. 1994. "Seeing Double." *Journal of Aesthetics and Art Criticism* 52, no. 2: 155–67.

McCormick, Peter. 1988. *Fictions, Philosophies, and the Problems of Poetics*. Ithaca, NY: Cornell University Press.

Meinong, Alexius. 1960. "On the Theory of Objects." In *Realism and the Background of Phenomenology*, edited by Roderick Chisholm, 76–117. Glencoe, IL: Free Press.

Miller, George A., and P. N. Johnson-Laird. 1976. *Language and Perception*. Cambridge, MA: Belknap Press, Harvard University Press.

Parsons, Terence. 1980. *Nonexistent Objects*. New Haven, CT: Yale University Press.

Pavel, Thomas G. 1986. *Fictional Worlds*. Cambridge, MA: Harvard University Press.

Peirce, Charles Sanders. 1931–1958. *Collected Papers of Charles Sanders Peirce*. Edited by C. Hartshorne and P. Weiss. Cambridge, MA: Harvard University Press.

Phillips, Antonia. 1987. "The Limits of Portrayal." In *Philosophy and the Visual Arts*, edited by A. Harrison, 317–41. Dordrecht, Holland: D. Reidel.

Podro, Michael. 1982. Review of *Art and Its Objects*, 2nd ed., by Richard Wollheim. *Burlington Magazine* 124, no. 947 (February): 100–102.

———. 1987. "Depiction and the Golden Calf." In *Philosophy and the Visual Arts: Seeing and Abstracting*. Edited by Andrew Harrison. Dordrecht, Holland: D. Reidel.

Rollins, Mark. 1993. *Danto and His Critics*. Cambridge, MA: Blackwell.

Saltz, David Z., James R. Hamilton, and Noël Carroll. 2001. "Symposium: Staging Interpretations." *Journal of Aesthetics and Art Criticism* 59, no. 3: 299–316.

Schier, Flint. 1986. *Deeper into Pictures*. Cambridge, UK: Cambridge University Press.

Stecker, Robert. 1997. "The Constructivist's Dilemma." *Journal of Aesthetics and Art Criticism* 55, no. 1: 43–52.

Thomasson, Amie L. 1996. "Fiction, Modality and Dependent Abstracta." *Philosophical Studies* 84, nos. 2–3: 295–320.

———. *Fiction and Metaphysics*. 1999. Cambridge, UK: Cambridge University Press.

Van Inwagen, Peter. 1977. "Creatures of Fiction." *American Philosophical Quarterly* 14: 299–308.

Walsh, Vincent, and Janusz Kulikowski, eds. 1998. *Perceptual Constancy*. Cambridge, UK: Cambridge University Press.

Walton, Kendall L. 1984. "Transparent Pictures: On the Nature of Photographic Realism." *Critical Inquiry* 11: 246–77.

———. 1990. *Mimesis as Make-Believe: On the Foundations of the Representational Arts*. Cambridge, MA: Harvard University Press.

Warburton, Nigel. 1988. "Seeing through 'Seeing through Photographs.'" *Ratio* 1 (June): 64–74.

Williams, Quentin. 1995. "Projected Actuality." *British Journal of Aesthetics* 35, no. 1: 273–77.

Wittgenstein, Ludwig. 1922. *Tractatus Logico-Philosophicus*. London, UK: Routledge.

Wollheim, Richard. 1980. *Art and Its Objects: With Six Supplementary Essays*. 2nd ed. Cambridge, UK, and New York: Cambridge University Press.

———. 1987. *Painting as an Art*. Princeton, NJ: Princeton University Press.

———. 1998. "On Pictorial Representation." *Journal of Aesthetics and Art Criticism* 56, no. 3: 217–26.

Index of Subjects

Index of Names